Other Books by Margaret Bourke-White

HALFWAY TO FREEDOM, *A Report on the New India* (*1949*)

"DEAR FATHERLAND, REST QUIETLY," *A Report on the
Collapse of Hitler's "Thousand Years"* (*1946*)

"PURPLE HEART VALLEY," *A Combat Chronicle of
the War in Italy* (*1944*)

SHOOTING THE RUSSIAN WAR (*1942*)

EYES ON RUSSIA (*1931*)

With Erskine Caldwell

SAY, IS THIS THE U.S.A.? (*1941*)

NORTH OF THE DANUBE (*1939*)

YOU HAVE SEEN THEIR FACES (*1937*)

With Father John LaFarge, S.J.

A REPORT ON THE AMERICAN JESUITS (*1956*)

PORTRAIT OF MYSELF

MARGARET BOURKE-WHITE

G.K. HALL &CO.
Boston, Massachusetts
1985

Published by G. K. Hall & Co.
A publishing subsidiary of ITT

This G. K. Hall paperback edition by arrangement with the Estate of Margaret Bourke-White.

First G. K. Hall printing 1985.

Library of Congress Cataloging in Publication Data

Bourke-White, Margaret, 1904–1971.
 Portrait of myself.

 Reprint. Originally published: New York : Simon and Schuster, 1963
 1. Bourke-White, Margaret, 1904–1971. 2. Photographers—United States—Biography. I. Title.
TR140.B6A3 1985 770′.92′4. [B] 84-23482
ISBN 0-8398-2858-6

TO MY MOTHER AND FATHER

ACKNOWLEDGMENTS

I wish to express my sincere gratitude to the many people at *Time*, *Life* and *Fortune* who have helped me; to the unsung heroes and heroines in the *Life* photo-lab for their technical assistance; to Alfred Eisenstaedt for his portrait of me taken for the jacket of this book, for the photographic record he kept during the time of my illness, and especially for his constant encouragement; to Edward Stanley for his thoughtful suggestions over the years; to Betty Hannifin who gave generously of her time and talents; to my two secretaries, Anne Mills and Travis Rogers, for their understanding and expert help; and most of all to the editors of *Life*, first for sending me on many of these assignments and secondly for their graciousness in allowing me to use the photographs in this book. There are many others in Asia and Europe as well as American to whom I am also indebted. They are too many to be publicly acknowledged, but I know they will understand my gratitude.

For Lee Witkin
In Memoriam
1935–1984

CONTENTS

CONTENTS

INTRODUCTION

by Jonathan Silverman

People of Margaret Bourke-White's generation remember her as a dashing war photographer whose pictures of the fighting in Europe appeared weekly in *Life* magazine between 1941 and 1945. Her long struggle against Parkinson's disease, which was the subject of an Alfred Eisenstadt photo-essay in *Life* in 1959 and later adapted for a nationally broadcast teleplay starring Theresa Wright and Eli Wallach, is another major element in the picture of her life that persists. Many people now also recognize her as the photographer (played by Candice Bergen) in Richard Attenborough's epic motion picture on the life of Gandhi.

As *Portrait of Myself* illustrates, there is a great deal more about Bourke-White's life that is worth knowing. More than a decade before World War II began, and nearly twenty years before she covered India's struggle for independence for *Life* magazine, Bourke-White had already emerged as one of the boldest photographers of her era, and one of its most remarkable personalities. Quite remarkable, as well, is the modesty she demonstrates in describing the evolution of her personal success.

The fact is that Margaret Bourke-White was quite famous, almost from the outset of her career as a professional photographer. A young, attractive woman who made her living photographing industry could not help but attract attention. In 1929, one widely circulated newspaper story carried the eye-catching headline: "Dizzy Heights Have No Terrors for This Girl Photographer, Who Braves Numerous Perils to Film the Beauty of Iron and Steel." Nonetheless, the fuss made over her in the press is one aspect of her life

about which Bourke-White is extremely reticent. Publicity per se was hardly her principal motivation.

"It is disastrous to stick to a technique or a formula of which the public approves, simply because the public will buy it," she explained in a resume prepared for potential clients in 1930. "This is a big wonderful world, and people, especially artists, should grow in it, because artists show others the world."

The feverish growth of industry in America in the late 1920s spurred such photographers as Alfred Stieglitz, Alvin Langdon Coburn, Charles Sheeler, Edward Weston, and Paul Strand to incorporate industrial and machine forms in their pictures. Bourke-White's work, however, stemmed from an urge that had little to do with the traditional aesthetics of the art of photography.

"Art can never stand off with skirts spread away from the touch of things in the raw, in the making," she said. "The purpose of art is to find beauty in the big thing of the age. Today that big thing is industry." Above all, in other words, she was interested in capturing the spirit of a uniquely exciting period of history.

As the times changed and the importance of industry decreased, so did Bourke-White's fascination with machines. During the Depression her focus shifted from the drama of industry to the human drama. In the Dust Bowl and the Deep South in the mid-1930s, during the war in Europe, and later in India, South Africa, and Korea, Bourke-White was repeatedly exposed to the tragedies and upheavals of people's lives, and gained extraordinary insight into the elements of the human spirit that prevail in the hardest of times. The ability of people to endure through wars, revolutions, and other conflicts is the central theme of the story Bourke-White tells in *Portrait of Myself*, and Bourke-White's own formidable courage and determination are highlighted as well.

She relates in the book her many close calls with death. She admits to being frightened once or twice, but she never gave in to her fear. Even Parkinson's disease, which forced her to stop practicing her "trade and deep joy," photography, as early as 1957, became a challenge she was determined to meet.

People affected by Parkinson's disease, also known as shaking palsy or paralysis agitans, experience a disturbance of voluntary movement in which the muscles stiffen and moving in general becomes difficult. Although the mental faculties are not affected, they

may seem to be if control of the muscles of speech is lost. The site of the disorder is the basal ganglia, an area of cells in the center of the brain where impulses to move are transmitted to the nerves that control the various muscles. A deficiency of the chemical dopamine in the affected parts of the brain is one of the characteristics of the disease, but giving dopamine itself, unfortunately, has little effect. Only a form of dopamine known as L-Dopa is able to reach the brain, where it is converted to dopamine, and relieves symptoms in about seventy-five percent of the cases. L-Dopa has been in use only since 1968, however, and although it appears to be one of the most effective ways of treating Parkinson's, it came too late for Bourke-White, who was first stricken with the disease in 1952; she was 48.

As Bourke-White explains, the only hope for her, at first, was a program of physical therapy designed to prevent the progress of the palsy that required hours of daily effort. The therapy enabled her to continue working for a while, but by 1956 she could no longer hold on to a camera unless it was securely strapped to her hands.

Although the two cranial operations Bourke-White underwent in 1959 and 1961 enabled her surgeon to treat the diseased parts of her brain with near-miraculous success, over the following ten years the symptoms reappeared and gradually worsened.

Lee Witkin, director of Manhattan's Witkin Gallery, visited Bourke-White in her home in Darien, Connecticut, in March 1970; as he describes her: "She didn't seem ill to look at her; her complexion was pink and glowing, her eyes shone. She smiled one of the loveliest smiles I have ever seen. . . . It was only when she tried to talk and halted after a few words, struggling to go on and unable to, that the tragedy of this dynamic woman struck me. She was, however, greatly annoyed by her handicap, never for a moment defeated. She wished to ignore it."

"During lunch," Witkin goes on, "she would begin to tell charming stories relating to something we were eating or to a subject we were discussing, and though it often became impossible to understand her, we managed through various efforts at joint communication (questions, nods of the head), to get the gist of the tale. When she was thoroughly disgusted with her inability to talk, she would take a deep breath, smile that great smile, and repeat in perfectly good diction: 'Monday, Tuesday, Wednesday, Thursday, Friday, Saturday, Sunday . . .' an exercise her vocal therapist had given her.

A round of applause usually followed that feat, and her eyes would sparkle. It was through those eyes one knew how alive and alert she was."

In January 1971 an exhibition of Bourke-White's work opened at the Witkin Gallery, and the photographer was there for the opening celebration. It was her last public appearance. Shortly thereafter, Bourke-White had a bad fall. Unable to exercise during her hospitalization, she became rigid, and died, in August 1971, of respiratory failure.

Although awareness of Bourke-White and her photographs waned rapidly after her death, she is now beginning to receive wider attention again, both as a pioneering photographer and journalist and as an extraordinary woman. Her voluminous correspondence and other writings (published and unpublished), and her thousands of negatives, many of which have not been printed for forty or fifty years, reveal a great deal, and through them Bourke-White will live on. But *Portrait of Myself* remains crucial to understanding Bourke-White; it is the legend of her life as she saw fit to tell it.

Jonathan Silverman is the author of FOR THE WORLD TO SEE: THE LIFE OF MARGARET BOURKE-WHITE, and Director of Foreign Rights for the Scott Meredith Literary Agency, Inc., in New York City.

CHRONOLOGY

June 14, 1904: Margaret Bourke-White born in New York City.

1906–1921: Grows up in Bound Brook, New Jersey, and graduates from Plainfield High School.

Fall 1921–1922: Attends Columbia University for one semester; takes photography course taught by Clarence H. White; leaves school after death of her father, Joseph White.

Fall 1922–1923: Wins scholarship for year of study at University of Michigan at Ann Arbor.

Spring 1924: Marries Everett Chapman.

Fall 1924–Spring 1925: Moves with Chapman to West Lafayette, Indiana; continues studies at Purdue University. Marriage fails.

Fall 1925–Spring 1926: Separates from Chapman; moves to Cleveland, Ohio; attends Case Western Reserve.

Fall 1926–Summer 1927: Attends Cornell University and graduates with bachelor's degree; decides to pursue photography as a profession.

Fall 1927: Returns to Cleveland to open photography studio.

Winter 1928: Begins her experiments with industrial photography, including Otis Steel Mill series.

Spring 1929: Brought to New York by Henry Luce to work for *Fortune*.

Summer 1930: Travels to Germany and Russia; becomes the first foreign photographer permitted to take pictures of Russian industry.

Fall 1930: Returns from Russia and moves into studio on 61st floor of newly completed Chrysler Building; writes *Eyes on Russia*.

Summer 1931: Returns to Russia to collect material for series of *New York Times* articles.

Summer 1932: Returns again to Russia, and becomes first foreign cinematographer to leave Russia with motion pictures of the country's industrial activity.

Fall 1933–1934: Creates NBC mural in Rockefeller Center depicting the wonders of radio.

Summer 1934: Photographs the Dust Bowl on assignment for *Fortune*.

1935: Begins aviation photography for TWA and Eastern Airlines.

1936: Decides to abandon advertising photography; delivers paper on "An Artist's Experience in the Soviet Union" at First American Artists Congress; meets Erskine Caldwell and begins work on *You Have Seen Their Faces*.

Fall 1936: Signs on as one of first four *Life* magazine staff photographers.

1937: Photographs full-time for *Life*.

Spring 1938: Sails to Czechoslovakia and Hungary with Erskine Caldwell to gather material on conflict in Sudetenland; she and Caldwell write *North of the Danube*.

February 1939: Bourke-White marries Erskine Caldwell.

Fall 1939–1940: Assigned by *Life* to photograph London preparing for war; also travels to Rumania, Turkey, Syria, and Egypt for *Life;* while en route, offered job on Ralph Ingersoll's *PM.*

Spring 1940: Accepts Ingersoll's offer and quits *Life* staff.

Fall 1940: FBI opens dossier on Margaret Bourke-White; Bourke-White and Caldwell travel around United States collecting material that inspires *Say, Is This the U.S.A.?*

Spring 1941: Travels with Caldwell across Pacific, through China, into the Soviet Union; is only U.S. photographer present in Moscow when Germans attack Russia.

Winter–Spring 1942: Lectures widely about experiences in Soviet Union; writes *Shooting the Russian War.*

Late Spring 1942: First woman accredited as a war correspondence to U.S. Air Force; she and Caldwell separate.

Summer 1942: Sent to England to cover arrival of first thirteen U.S. Air Force B-17's, which soon begin bombing raids on Germany.

December 1942: Bourke-White's convoy torpedoed en route to North Africa.

January 1943: First woman to accompany Air Force crew on bombing mission.

Late Summer and Fall 1943: Assigned to Army Supply Services in Italy to cover story of logistics.

Fall 1943–1944: Photographs around Naples and Cassino Valley near war front.

Spring 1944: Writes *"Purple Heart Valley."*

Fall 1944: Returns by convoy to Italy for second war visit.

January through March 1945: Finishes work on the "Forgotten Front" in Italy.

March through October 1945: Travels with Patton's army through Germany.

Winter 1945–1946: Writes *"Dear Fatherland, Rest Quietly"*

Spring through October 1946: First trip to India.

Winter 1946–1947: Tries to write book on India and decides to return to acquire deeper understanding of the country.

September 1947 through January 1948: Second trip to India.

February 1948 through March 1949: Writes *Halfway to Freedom.*

June 9, 1948: Receives Honorary Doctorate of Letters from Rutgers University.

December 1949 through April 1950: Covers South Africa for *Life.*

Spring 1951: Strategic Air Command; experiments with photographing from a helicopter.

June 16, 1951: Receives Honorary Doctorate of Arts from University of Michigan.

May 1952 through January 1953: Covers Japan and Korea for *Life.*

Summer through Winter 1953: Photographs Jesuits for *Life;* feels first symptoms of Parkinson's disease.

1955: Begins writing *Portrait of Myself.*

1957: Last story for *Life:* "Megalopolis."

January 1959: Dr. Irving S. Cooper operates on right cranial area to halt Parkinson's damage.

January 1961: Second operation, on left side of brain, to stem spread of Parkinson's disease.

1969: Official retirement from *Life* magazine staff.

August 27, 1971: Margaret Bourke-White dies in Darien, Connecticut.

PORTRAIT
OF
MYSELF

MY
INVITATION
INTO
THE WORLD

"Margaret, you can always be proud that you were invited into the world," my mother told me.

I don't know where she got this fine philosophy that children should come because they were wanted and should not be the result of accidents. She came from a poor family with a multitude of children, and she had little chance to get an education, although she made up for this after marriage by going to college at intervals until she was over sixty. When each of her own three children was on the way, Mother would say to those closest to her, "I don't know whether this will be a boy or girl and I don't care. But this child was invited into the world and *it* will be a wonderful child."

She was explicit about the invitation and believed the child should be the welcomed result of a known and definite act of love between man and wife (which Mahatma Gandhi believed—I was to learn much later—although Mother never would have gone along with the Mahatma on his ideas of celibacy between invitations. Mother believed in warmth and ardor between married partners).

Mother's plan of voluntary parenthood was so outstandingly

successful in my case that not only did I come along as requested, but I arrived on the specific date that had been decided upon.

This fine flourish to my orderly entry into upper Manhattan was as much the doctor's doing as my mother's. In the early evening of June 13 my arrival was imminent, and the doctor had directed my mother to walk the floor to ease and speed the process. He noticed that my father was placing some packages wrapped as gifts on the dining room table, and inquired about it.

"Tomorrow is our wedding anniversary," said my father.

"Put that woman to bed," ordered the doctor, and devoting himself to postponing my arrival, he held me off till two o'clock the next morning.

This was a good birthday in any case for a little American girl, as on June 14 the whole nation hangs out the Stars and Stripes to commemorate the day when Betsy Ross hung the first American flag. But my friends who know my bad habits, and hear the story of my delayed arrival, are apt to complain that I have never been on time for an appointment since.

I do not know how many joint birthdays, wedding anniversaries, and Flag Days had been celebrated before my mother decided I was old enough to hear her invited-into-the-world theory, but I must have been still quite small. I believe she took the usual road to knowledge, brushing quite hastily through the flowers and the bees, and swiftly made the steep ascent into the more specific pages of the family Medical Book.

This massive Book is one of my most vivid childhood memories. We were not to touch it unless Mother showed it to us. To be given a glimpse into the radiant mysteries of the Medical Book was a reward for good behavior. On such days, my older sister Ruth and I were treated to a graphically unfolding diagram of the physiology of a woman, in which successive leaves were folded back to reveal the muscles, nerves, blood vessels, that lay underneath. On some rare occasion when we had been supremely good children, the last leaves of the chart were folded back, and my sister and I would exclaim rapturously over "the dear little baby" at the bottom of the diagram, neatly curled up and waiting to be born.

Our home was always full of creatures waiting to be born. Mother and Father were interested in natural history, and I caught that interest with such lasting ardor that it nearly made a

biologist of me instead of a photographer. Mother must have been very tolerant, her sympathy for wildlife notwithstanding, to endure the avalanche of glutinous polliwog egg masses, disintegrating fragments of bark dotted with eggs of unknown vintage, and legions of moth and butterfly eggs with which I populated the house. When Mother noticed that one of her children had developed some special interest, she had a wise way of leaving appropriate books around the house. I read the Henri Fabre classics, *The Hunting Wasps, The Life of the Grasshopper*, lived with the Comstock *Handbook of Nature Study*, which I consulted constantly as to the care and feeding of my assorted pets. One summer I raised two hundred caterpillars under rows of overturned glasses on the dining room windowsill, brought each its favorite fresh leaf diet daily, hoping some would complete their dramatic life cycle and emerge as moths and butterflies. Only the rare ones did, but when a telltale wiggle of a chrysalis or a little rattle inside a cocoon indicated that the last splendid transformation was due, our whole family would sit up all night on the edges of our chairs to watch that magic spectacle of damp shapeless creature crawling from its shell, expanding wrinkled wings until a full-blown butterfly took form under our eyes.

My father was an abnormally silent man. He was so absorbed in his own engineering work that he seldom talked to us children at all, but he would become communicative in the world of out-of-doors. We lived during my childhood in a small New Jersey town, Bound Brook, and near us were lovely woods and the low hilly ranges dignified by the name of the Watchung Mountains. I treasured the nature walks Father and I took together. Father could hide in the bushes and whistle birdcalls so convincingly that the birds he imitated came to him. He taught me the names of the stars, and how to distinguish the harmless snakes and pick them up without fear.

Learning to do things fearlessly was considered important by both my parents. Mother had begun when I was quite tiny to help me over my childish terrors, devising simple little games to teach me not to be afraid of the dark, encouraging me to enjoy being alone instead of dreading it, as so many children and some adults do.

Father's contribution to the anti-fear crusade met with com-

plete and unexpected success. With Father's introduction to snake lore, I decided to be a herpetologist and become so much of an expert that I would be sent on expeditions and have a chance to travel. I knew I *had* to travel. I pictured myself as the scientist (or sometimes as the helpful wife of the scientist), going to the jungle, bringing back specimens for natural history museums and "doing all the things that women never do," I used to say to myself. Father aided my herpetology by building wire cages to house my growing menagerie of snakes and turtles. He found me a baby boa constrictor in a pet shop, nonpoisonous as are all boas, but so delicate it lived in a blanket. To Mother, such close association with the snake was doubtless new, but how could she show fear when her child was unafraid? I can still see her reading the Sunday papers in front of the fireplace— this recollection may seem odd to some readers, but to me it seems quite natural—holding in her lap my most elderly and best-behaved snake pet—a plump and harmless puff adder.

If all this seems an excessive dose of wildlife for one household, it was wildlife that brought my two parents together. But for the bird walks in Central Park, which were popular toward the end of the nineteenth century, I might never have been issued that invitation into the world. Love of the birds took Minnie Bourke and Joe White to Central Park in the early mornings before they went to work. As both went to night school—Mother to Pratt Institute, where she took stenography, and Father to Cooper Union, where he studied engineering—the two must have had little time to meet in the evenings. But weekends saw them off on their bicycles for further nature researches in the Catskills. Bicycle riding was considered not quite proper for young girls in the eighteen-nineties, and my English-Irish grandmother, a staunch Baptist, stood at the gate of her little house in lower Manhattan and wrung her hands when her daughter, in a skirt shortened to three inches off the ground, broke the Sabbath to mount her wheel and pedal away. "Minnie was going to the Devil!"

I am fortunate in having a charming photographic record of my parents during their cycling years, for Father was an enthusiastic photographer. The yellowed prints show a youthful version of the features I remember so well, my father with his

high wide forehead, his burning, black, deep-set eyes with their permanently grave expression as though his thoughts were working far away in some distant private sphere of their own, as indeed they were; my mother unself-consciously beautiful in her bell-shaped riding suit with the leg-of-mutton sleeves or her finely tucked shirtwaist with modest lace touches at the throat. Shirtwaists were considered "advanced" and "not quite nice," my mother has noted on the back of one of the photographs. In one fading print she is shown with shoulders draped in a long fringed shawl. "This was an experiment with indoor photography by flashlight," my mother writes. "The shawl was Joey's idea and his arrangement." Her expression in this photograph is so tender and otherworldly that one of my friends who saw the picture recently exclaimed incredulously, "That was *your* mother! She looks like a Botticelli angel." Mother never dreamed she looked like a Botticelli angel or any other angel. She thought herself plain, so much so that in later years she avoided mirrors. Since the shawl picture was taken some years before my invitation into the world, I have no way of knowing whether the resemblance to the angels was there, or achieved by my father's photography. Probably a blend of both. But always the face that looked out over the starched shirtwaists or leg-of-mutton sleeves was shy and eager, full-lipped and wide-eyed, as though everything in the world was new and fresh and worth investigating.

"It was her open and inquiring mind that first attracted me to your mother," my father told me years later, in what must have been a rare burst of confidence, for he was a very reticent man.

During one of the nature rides in the Catskills, the steering gear of Minnie's bicycle broke down and the two left their wheels, took the volume of Ralph Waldo Emerson which they were reading together, and climbed a mountain. On the top of the mountain, Joe broke his customary silence and asked Minnie to marry him.

My father's silence is the quality I remember best in a man who had many strong qualities. It dominated our whole household. Throughout my childhood, everything was geared so as not to disturb Father when he was "thinking." Father was an inventor who worked with printing presses, and the develop-

Even as a baby I loved to climb up high.

My brother Roger tinkering with the sewing machine. This was one of my first photographic efforts.

Mother had lovely chestnut brown hair.

Father and my sister Ruth with Rover.

ment of offset lithography and the rotary press became his life-work. For years he worked to correct inexact processes in multi-color printing, and during this period our house was full of fascinating color tests in varying stages of completion—magazine covers, Maxfield Parrish calendars, as no one ever saw them—in reds and yellows only, or in strident blues with warm tones still to be added.

Father was the personification of the absent-minded inventor. I ate with him in restaurants where he left his meal untouched and drew sketches on the tablecloth. At home he sat silent in his big chair, his thoughts traveling, I suppose, through some intricate mesh of gears and camshafts. If someone spoke he did not hear. His ink rollers and pressure cylinders traveled with him even into his dreams. Mother, who understood him very well (but suffered through his silence: I can still hear her plaintive, "If only Father would *talk* more."), kept pad and pencil always by his bedside for those moments when he would wake for an instant, jot down some arcs and swirls, and fall back asleep. On Sundays, only his back was visible as he stooped over his drawing board.

Now and then Father put the drafting tools aside and took me with him on trips to factories where he was supervising the setting up of his presses. One day, in the plant in Dunellen, New Jersey, where for many years his rotary presses were built, I saw a foundry for the first time. I remember climbing with him to a sooty balcony and looking down into the mysterious depths below. "Wait," Father said, and then in a rush the blackness was broken by a sudden magic of flowing metal and flying sparks. I can hardly describe my joy. To me at that age, a foundry represented the beginning and end of all beauty. Later when I became a photographer, with that instinctive desire that photographers have to show their world to others, this memory was so vivid and so alive that it shaped the whole course of my career.

On several wonderful occasions, Father took me with him to Washington where he made a practice of investigating his own patent rights. To this day, the musty smell of filing rooms brings back the dim recesses of the old U.S. Patent Office with its towering columns of document-filled shelves and its antique white-haired attendant who, Father claimed, knew every patent

When a baby robin fell from the nest, I took care of it until it was old enough to fly. The father robin learned to trust me and would fly right to my lap to feed the baby bird.

by number and could produce anything needed for reference instantly without even flicking through a card file. He needed a good memory just for my father's entries, of which there were, I suppose, hundreds of basic patents concerning printing presses.

If Father had been money-minded, he might have become quite wealthy, but he paid no attention to money, was essentially the inventor and researcher, and made some unsound investments along the way—just how unsound they were came out only when he died. I was seventeen then, just starting college, and I know now that if we had been wealthy, and I had not had to work my way through college as I did after his death, I would never have been a photographer.

It is odd that photography was never one of my childhood hobbies when Father was so fond of it. I hardly touched a camera and certainly never operated one until after he died. Yet he was always tinkering with lenses and working on devices to make exposure settings simpler for the amateur, some of which he had patented. He experimented with three-dimensional moving pictures long before their time, and what a thrill it was when he used us children as guinea pigs for trying out prisms and viewing lenses which created magic effects of depth illusion. When we bought our first car, he was soon so deep in experiments for focusing and dimming headlights that a drive in our new automobile attracted an embarrassing amount of attention. The weird network of rods and shafts with which my father was tinkering covered the hood like scaffolding over a church.

Everything that had to do with the transmission and control of light interested my father, and I like to think that this keen attention to what light could do has influenced me. Father had thought even for those who had to live without light. He built the first printing press for Braille, and books for the blind are printed today on presses influenced by his early patents.

The headlight dimmers, the projectors and camera devices came to nothing because of conflicting patents. But in Father's own field of printing, one development had a close link with photography. During the First World War he built eight small portable printing presses, compact and mounted on trucks. Until then, maps had been printed on great bulky machines far behind the lines, and were outdated by the time they came into use. My

father's presses were sent out as mobile units to the front, the first of their kind, where they turned out fresh charts each day based on aerial reconnaissance photographs. Twenty-five years afterward, when I was covering the Second World War in Italy with the Fifth Army, I came upon presses in trailers hidden away behind projecting rocks and camouflaged with branches, and realized with a catch in my throat that these were the direct descendants of my father's portable presses.

The popular idea of an inventor, I suppose, and certainly it was my idea, is of a personage who sits on a mental Mount Olympus and just invents. Only now, as I am glancing through long-yellowed bundles of letters in an effort to understand him better, do I see another side: the tortured spirit when a piece of work went wrong, the constant preoccupation with the difficulties, the distress (in a letter from Toledo dated 1907) when a press which he had designed to turn out three thousand impressions an hour was producing only two thousand, the constant striving for perfection—for a degree of perfection which only he could judge. I realize now how his entire purpose was focused toward attaining this self-set standard, how deep in him the philosophy was: never leave a job until you have done it to suit yourself and better than anyone else requires you to do it. Perhaps this unspoken creed was the most valuable inheritance a child could receive from her father.

That, and the love of truth, which is requisite No. 1 for a photographer. And in this training Mother shared. When I was a very small child, if I broke a soup plate, Mother would say, "Margaret, was it an accident or was it carelessness?" If I said it was carelessness, I was punished; an accident, I was forgiven. I am proud of Mother's vision in knowing how important it is to learn to be judge of one's own behavior. She did well to see that a habit of truth throughout life is more important than the broken soup plates.

Some of her rules, I believe now in retrospect, were unnecessarily Spartan, but this judgment is made affectionately, for mixed in with the strict regulations there was so much that was good. We were not allowed to wear silk stockings or to read the funny papers. We were forbidden to visit homes of our playmates if their families subscribed to the funny papers. The

comics, Mother believed, would corrupt any artistic taste we might have. "Uncorrupted," as I may be today, I find a comic sheet all but unintelligible, and as a result, a whole host of robust characters in our American folklore are complete strangers to me. I missed many of the early great movie classics, because we were seldom allowed to go to the movies. Movies to Mother were "too easy a form of entertainment for a child." (How shocked she would have been if she had lived to see the television set in so many homes.) If my sister or I took one of those school examinations where you are required to answer only ten questions out of twelve, Mother's comment on hearing of this would be "I hope you chose the ten hardest ones." Reject the easy path! Do it the hard way!

Perhaps because wearing cotton stockings was going at it the hard way, I went through school without getting something I passionately wanted, and the hurt was so deep I find I can hardly write about it today. Throughout all my grade-school and high-school days, I never was invited to a dance. Maybe all the boys who danced came from homes with funny papers. Or perhaps the Spartan aura of my upbringing was too unmistakably apparent. But whatever the reasons, real or imaginary, my suffering was very real. I loved dancing: I danced around the kitchen with a dish towel when I was a youngster, and went to dancing school when I was a little older. Mother said, "If you are a good dancer, you will always get dancing partners!" Everything else came my way, it seemed. I was one of the editors of the high-school paper. I was elected to represent our YWCA Club at summer camp conference—a joyful honor. I had plenty of male partners for picnics, canoeing trips, steak roasts. But dances, no!

Then a dazzling event took place which I believed would change all that. It was as unexpected as my faith in its influence was great. Plainfield High School, New Jersey, where I was then a sophomore, offered each year a prize "for excellence in literary composition." The award was fifteen dollars in books to be selected by the winner, and the contest was open to the three upper grades. Sophomores were never expected to win, against the formidable competition of juniors and seniors, but many of us entered the lists because if we were working on our "prize theme"—which we were supposed to do throughout the entire

semester—we were excused from the usual English examinations. The finished literary effort was to be in the form of a short story, eight hundred words in length.

As unthinking as the neglectful virgins, I sailed through the semester skipping exams and doing nothing on my theme. June seemed very far away. But suddenly it came and with it the final day. Themes were supposed to be handed in during English class, but a short grace period was allowed until 5:30, when the finished composition must be on the front porch of the principal's home.

When school was out at three o'clock, I hurried to a quiet corner of the library with my closest chum, Tubby Luf. Tubby was a great handsome blond girl (not at all tubby), and she counted words as I wrote. The story was about a boy who wanted a dog. That was easy, because I too wanted a dog. By four-thirty I had written my way through the boy-sees-dog, boy-loses-dog part of the theme, and Tubby warned me that I had one hundred and twenty words still to go. This was just enough to polish off the boy-gets-dog section, and with a bare five minutes to spare we deposited the manuscript on the principal's front porch.

When I learned that I had won first prize, my astonishment at my good fortune was less overwhelming than the radiant new future I saw opening up before me. The prize would be my passport to popularity. My career as a wallflower was at an end.

I chose the books. The three I most desired came precisely within the price range: the Dickerson *Frog Book*, the Holland *Moth Book*, the Ditmars *Reptile Book*.

Commencement exercises took place in the evening that year, and were to be followed by a dance. In an auditorium glamorous with green boughs and white carnations, the seniors received their scrolls; then a group of lesser prizes was handed out, and finally my great prize. To the accompaniment of what doubtless were suitable remarks from the principal—but which I never heard—I received from his hands a backbreaking bundle containing three enormously fat green books, tied together with bows of white ribbon. Then the chairs were pushed back, the lights romantically lowered, and the band struck up a foxtrot.

As couples paired up and dissolved into a swaying throng in the center of the auditorium, I took up my position confidently

at the edge of the dance floor, my prize package held firmly in my arms. Throughout the foxtrot I stood serene, expectant. During the two-step that followed, an anxiety—ever so small—raised its shadowy head, and I pushed it back resolutely. This was just the second dance, after all.

Waltzes followed two-steps. One-steps followed waltzes. The floor churned into a tighter mass. The books grew heavier. It never occurred to me to set them down. These were my credentials, my magic carpet into the new life that lay ahead.

In that perverse and illogical way of many dances, the more crowded the floor became, the longer grew the stagline. Only the experienced wallflower can know how painful the sight of a stagline can be. But not one boy—not one human in trousers—came up to ask me to dance.

Finally an older girl, a tall and warmhearted friend of my sister's, came up and volunteered to dance. Here, on this night, to dance with a girl! This was the badge of failure. Through my distress I recognized her kindness; I could not refuse. The books were cached below a potted palm, and as the two of us glided into the central whirlpool, I am sure that she from the bottom of her generous heart wished as fervently as I that we both could be stricken invisible.

CHAPTER II

A
BROKEN RING
AND A
CRACKED LENS

ONCE OFF to college and the spell was broken
—I was invited to dances. Lots of dances. Soon I was going to
dances with just one man. We met in a revolving door. I was
on my way into the cafeteria on the University of Michigan
campus and he on his way out, and he kept the door turning
around with me in it until I had made a date with him. From
that minute on we fell in love so fast there wasn't time to breathe.

Chappie was six feet tall with the shoulders of a football
player, black snapping eyes, and a delightful sense of whimsy.
He was a graduate electrical engineering student, working on
his doctor's thesis in his specialty of electric welding. He played
traps in a college dance band to pay his way through school.

One hears that a girl falls in love first with a man who reminds
her of her father. Chappie—with his gaiety, his sense of fun—was
unlike my father, but when I saw him at his bench in the engi-
neering lab, I knew here was someone who was just the same.
Our dates, day or night, ended up in the lab, where Chappie
showed me his latest microphotographs of wedge-shaped steel
particles fused under the intense heat of his experiments and
clustered in spidery patterns like Japanese silk. He believed
welding would soon oust riveting on much heavy construction,

and a few years later, after our paths had parted, he was to develop the special steels used on the first welded streamlined train. Electric welding was more to him than a method, it was a faith, and this was an attitude toward work I had met before and felt at home with. The mysterious rearrangement of molecules that went on in the burning heart of the weld was more important to Chappie than anything else in the world—except what was happening to the two of us, and that seemed bigger than the world to us both.

We chose Friday the thirteenth of June for our wedding day. We could easily have picked the fourteenth, which would have tripled the anniversary, but "to be married on Friday the thirteenth will be fun," we insisted gaily.

If there was a portent in our wedding date, there was an omen in our wedding ring also. Chappie was very clever with his hands and he decided to make the ring himself. We shopped through the jewelry stores of Ann Arbor for a gold nugget. I remember the circus had come to town that day, and we laughed when we bumped into the elephant parade every time we came out of a jewelry shop. Everywhere jewelers tried to sell us ready-made rings, but finally we persuaded a reluctant shopkeeper to bring out a tray of accumulated gold trash, and in the midst of some cast-off gold teeth we found three small exquisite nuggets. One was the color of butter, the second almost as white as platinum, and the third gleamed up at us, a rich red-gold, asking almost audibly to be selected. It came to seven pennyweight, just right for a wedding ring.

Chappie fashioned the ring charmingly, with tiny hammer strokes making a beaten pattern over the surface. The night before our wedding he took me to the lab to give me a last fitting. He laid the lovely circle on the anvil to round it out, gave it one light tap with his tiny hammer, and our wedding ring broke into two pieces.

In two years our marriage had broken to pieces also. We were up against an age-old quandary which many brides have had to face, but few have met it with less equipment than I. As a nineteen-year-old wife, I knew, I suppose, a surprising amount about the ways of the flying fish and the butterflies, but very little of the ways of humans. I had sailed into marriage with the sun in

my eyes and the wind in my hair, and when I found myself
engulfed in a silver-cord entanglement, I floundered about with-
out a compass.

The situation rose to a swift peak early in our honeymoon.
The crisis broke in a single day—the black day of my life—the
day my mother-in-law decided to clean house.

We were honeymooning in a cottage on one of the lovely
Michigan lakes, close enough to the University so that Chappie
could drive in and play in summer-school dance bands. My
mother-in-law arrived for a visit of uncertain duration. On the
momentous day, Chappie had left the house very early to go to
the University and do some lab work, and I was still in my room
when the mopping and sweeping began. Feeling that I should
be "helping," I dressed hastily, and slipped into the kitchen.
Hesitating to stop for breakfast in the face of the vigorous
scrubbing I could hear from the next room, I plunged into some
ironing I saw waiting to be done.

"Well, Margaret," my mother-in-law's rich contralto sounded
from the next room, "how did your mother feel when she heard
you were going to be married?"

I tried to answer, knowing how different would be the point
of view of the two mothers. "Mother was very concerned at
first because she wanted us to finish school, and because she
thought we were both so young. But when she saw Chappie and
me together and could see we were truly in love, she was glad."

"She's gained a son and I've lost a son."

I could picture my mother-in-law through the wall. She would
be regal and beautiful always—even with a mop in her hand—
with her silver hair piled duchess-high on her head and her
deep-set black eyes flashing. The rich-timbered voice continued
through the wall. "You got him away from me. I congratulate
you. I never want to see you again."

Taking the speaker at her word, I carefully unplugged the
iron, left the cottage, and walked seventeen miles to Ann Arbor
to find my husband. It would have been wondrous luck if I had
happened to have a nickel in my pocket, so as to shorten by
streetcar some of those dusty miles. It would have been better,
too, if I had had breakfast. But somehow, I was sure, when I
found my husband everything would be all right.

Things were never all right. I didn't know what to do; neither did Chappie. With more poise and experience I might have pulled the marriage back on even keel, for the feeling between us was very real and deep. But I see now we were unhappily involved in a classic entanglement that neither of us was sagacious enough to cut through. Nothing in the education of either of us had taught us how to meet the formidable problems of the silver cord.

We were exposed to academic learning of every other sort. We were at Purdue University for a year, where Chappie was teaching and I studying. If I had had friends among other wives my own age, I believe I would have gained a perspective, just from seeing that we all had common problems. But the married student was a lonely oddity in those days, even disapproved of on some campuses.

Though I was no older than my fellow undergraduates, I was separated by an unbridgeable gulf—I was "a professor's wife." I was separated from the professors' wives with whom we associated by an equally great gulf—they were twice, often three times, my age. Twenty years later *Life* sent me to Iowa University to do a picture essay on GIs studying under the GI bill of rights, and there I saw the married GIs living by the hundreds in trailer camps. Their wives were studying, raising babies, participating in the self-government of their trailer communities. How much I could have learned from wives like these. And to have lived in a trailer camp—what paradise!

"Everyone says the first year of married life is the hardest," I reminded myself. I had not expected it to be so hard as this, but surely the second year would be better. The second year was better only because we learned to face the facts more squarely and we recognized the marriage as a failure.

And now that I was facing life again as an individual, I made a great discovery. I had been through the valley of the shadow. I had lived through the loneliness and the anguish. It was as though everything that could really be hard in my life had been packed into those two short years, and nothing would ever seem so hard again. I had risen from the sickbed, walked out into the light, and found the world was green again.

I owe a peculiar debt to my mother-in-law. She left me strong,

knowing I could deal with a difficult experience, learning from it, and leaving it behind without bitterness, in a neat closed room. As I look back, I believe this beautiful rather tragic woman was the greatest single influence in my life. I am grateful to her because, all unknowing, she opened the door to a more spacious life than I could ever have dreamed.

People seem to take it for granted that a woman chooses between marriage and a career as though she were the stone statue on the county courthouse, weighing one against the other in the balance in her hand. I am sure this is seldom so. Certainly in my own case there was no such deliberate choice. Had it not been for a red-gold ring that broke into two pieces, I would never have been a professional photographer.

It was sheer luck I still had that old secondhand camera when my marriage went on the rocks and I returned to college for my senior year. My mother had bought it for me when I was a freshman at Columbia and shortly after my father's death, when it was difficult for her to afford. The camera was a 3¼ x 4¼ Ica Reflex, modeled like a Graflex. It cost twenty dollars and had a crack straight through the lens.

With my senior year still to go before I would get my diploma, it was a sobering thought that I had already been to six universities. It seemed that I had picked up only ill-matched smatterings of knowledge at each of them. My freshman year at Columbia I studied art, and by lucky chance took a two-hours-a-week course in photography under the late Clarence H. White, not because I wanted to take photographs but because the course dealt with design and composition as applied to photography. One doesn't learn much about photography in two hours a week, but Clarence H. White was a great teacher and the seed was planted. At Rutgers, my second alma mater, I attended only summer school and studied swimming and aesthetic dancing. At the University of Michigan, my third, I specialized in herpetology under Dr. Alexander D. Ruthven, later the beloved president of the University. Next, Purdue with Chappie, where I studied paleontology. Then Western Reserve night school, where I worked in the Cleveland Natural History Museum during the day. So here I stood, with my first marriage behind me and my seventh university ahead, poring through the college

catalogs. I chose Cornell, not for its excellent zoology courses but because I read there were waterfalls on the campus.

Arriving in Ithaca, I did what other college students do who are broke. I tried to get a job as a waitress. Luckily for my photographic future, the waitress jobs were all taken. By the time I got to the student library to apply for a tempting forty-cents-an-hour job there, that was snapped up too. I wept some secret tears, and turned to my camera.

I believe it was the drama of the waterfalls that first gave me the idea I should put that old cracked lens to work. Here I was in the midst of one of the most spectacular campus sites in America, with fine old ivy-covered architecture and Cayuga Lake on the horizon and those boiling columns of water thundering over the cliffs and down through the gorges. Surely there would be students who would buy photographs of scenes like these.

I knew so little about photography it seemed almost impudent to think about taking pictures to sell. All fall went into making a collection of a mere eight or ten that I felt were worth presenting. Still I was surprised at the growing feeling of rightness I had with a camera in my hands. I arranged with a commercial photographer in Ithaca, Mr. Henry R. Head, to use his darkroom nights where I could work up sample enlargements of my pictures which he would copy "in quantity" if we ever got orders "in quantity." Mr. Head was a pillar of strength. The minuscule business he got from his end of the arrangement could never hope to balance his generous technical advice.

I belonged to the soft-focus school in those days: to be artistic, a picture must be blurry, and the exact degree of blurriness was one of the features over which I toiled during the long nights in Mr. Head's darkroom, diffusing, printing those celluloids. Ralph Steiner, whom I had met at the Clarence H. White School, a superbly sharp honest craftsman, caustically talked me into a fierce reversal of the viewpoint that a photograph should imitate a painting.

Shortly before Christmas, when I opened my little sales stand outside the dining hall in Prudence Risley Dormitory, my pictures on display looked as much like Corots as my old cracked camera plus some sheets of celluloid had been able to make them.

And if I heard some admiring student murmur, "Why, these don't look like photographs at all," I took it as a high compliment.

The pictures went like a blaze. I organized a staff of student salesmen on a commission basis to help me handle them, prevailed on the College Co-op to carry them, and then made a mistake that nearly prejudiced me against photography forever. Not realizing that the demand was seasonal, I overstocked, and tied up my small capital in print stocks which had no hope of selling for months to come. I grew to hate the sight of those pseudo-Corots piled behind my cot in the dormitory.

Five dollars came in regularly from sales for covers to the Alumni News. I began getting letters from alumni of Cornell who were architects, inquiring whether I intended to go into photography after I got out of school, and stating there were few good architectural photographers in the country. This opened a dazzling new vista. Never had I thought of becoming a professional photographer. Also it opened a new conflict. Should I drop my biology for a field for which I was so little trained? On the biology side I had something that looked pretty close to an offer from the Curator of Herpetology at the Museum of Natural History in New York. But to be a professional photographer—what a tantalizing possibility!

I must get an unbiased opinion of my work, I told myself; these architects were graduates of Cornell after all, bound to be sentimental about pictures of their alma mater. I would go to New York during Easter vacation, walk in on some architect cold, and base my momentous decision on his opinion.

Someone gave me the name of York & Sawyer, a large architectural firm, and suggested asking for Mr. Benjamin Moskowitz. Arriving unwisely late in the day, I went into the upper reaches of the New York Central Office Building, entered a frighteningly spacious lobby, and asked to see Mr. Moskowitz. The tall dark man who came out in response to this request was plainly a commuter on his way to the train. As I outlined my problem, he was unobtrusively though steadily edging his way toward the elevator. I did not realize he had not taken in a word when he pushed the down button, but I was chilled by the lack of response. If the elevator had arrived immediately, I am sure that

the next morning would have found me on the doorstep of the Museum of Natural History, but as we waited, the silence became so embarrassing that I opened my big portfolio. Mr. Moskowitz glanced at the picture on top, a view of the library tower.

"Did you take this photograph?"

"Yes, that's what I've been telling you."

"Did you take it yourself?"

I repeated my little tale, how I was considering becoming an architectural photographer, but first I wanted the unbiased opinion of an architect as to whether I had the ability for the work.

"Let's go back into the office and look at these," said the unpredictable Mr. Moskowitz.

He let his train go, stood up the photographs against the dark wood paneling of the conference room and called in the other members of the firm to look them over. After the kind of golden hour one remembers for a lifetime, I left with the assurance of Messrs. York, Sawyer, and associates that I could "walk into any architect's office in the country with that portfolio and get work."

Everything was touched with magic now. The Cornell pictures, both the blurry and the in-focus ones, sold out in the commencement rush. College over, I took the Great Lakes night boat from Buffalo to Cleveland, and rising early, I stood on the deck to watch the city come into view. As the skyline took form in the early morning mist, I felt I was coming to my promised land: columns of masonry gaining height as we drew toward the pier, derricks swinging like living creatures—deep inside I knew these were my subjects.

One personal task remained to be completed. Cleveland was my legal "place of residence"—that was why I had returned to it—and on a rainy Saturday morning I slipped down to the courthouse, quietly got my divorce, and resumed my maiden name. I used my full name, with the addition of a hyphen. Bourke had been my mother's choice for my middle name, and she always liked me to use it in full.

I had closed the room; I had come out whole and happy with the knowledge of my new strength, and nothing would ever seem hard to me again. I was embarked on my new life.

CHAPTER III

A
BORROWED
CAMERA
AND A BAG
OF PEANUTS

In the mammoth backyard of Cleveland, stretching from the foot of soaring office buildings to the swampy shore of Lake Erie, lies a sprawling, cluttered area known as the Flats. Slashed across by countless railroad tracks and channeled through by the wandering Cuyahoga, the Flats are astir with nervous life. Locomotives slap and shove reluctant coal cars; tugboats coax their bulging ore barges around the river bends. Overhead, traffic roars into the city on high-flung bridges. At the far edge of this clanging confusion, smokestacks on the upper rim of the Flats raise their smoking arms over the blast furnaces, where ore meets coke and becomes steel.

To me, fresh from college with my camera over my shoulder, the Flats were a photographic paradise. The smokestacks ringing the horizon were the giants of an unexplored world, guarding the secrets and wonder of the steel mills. When, I wondered, would I get inside those slab-sided coffin-black buildings with their mysterious unpredictable flashes of light leaking out the edges? Cautious inquiries produced the discouraging information

that women were unwelcome in steel mills, especially in these particular mills, where they had been prohibited ever since a visiting schoolteacher twenty years earlier had inconsiderately fainted from the heat and fumes.

My chief aim was to break down this imperious prohibition. I hoped to earn enough from architectural photographs to pay for the experimental industrial photographs I wanted to take.

The thing I remember best about those early days in Cleveland is the way my high heels kept wearing down slantwise. At the end of each day of toting my portfolio to the offices of architects who were Cornellians or friends of Cornellians, I would end up at a little shoeshine parlor on lower Euclid Avenue, place my feet on a newspaper and hand my shoes to the proprietor. While the heels were being recapped, I made entries for my card file.

In addition to notations on the architects and landscape architects I had visited, my file included cross references recording what costume I had worn that day. Since my wardrobe consisted of a gray suit, which I wore with red hat and red gloves or with blue hat and blue gloves, keeping track of this placed a minimum amount of strain on my documentary abilities. But it was a great morale factor with me to know that any given prospect was going to see me on a follow-up visit in a fresh color scheme. Perhaps by the time I got to a third visit, there would be a job and a check behind me, and that would mean a third color.

On a red-glove day I got my first job. This was to photograph a new school, just finished, which had been designed by Pitkin & Mott, architects and Cornell alumni. Messrs. Pitkin and Mott were almost as new in their business as I was in mine, and therefore it meant a good deal to them to get their schoolhouse published in a national architectural magazine. The editors of *Architecture* had expressed an interest in printing the school if good pictures could be obtained, but those already submitted had been rejected as not up to publication standards. Did I want to take on the job? I did—with joy—at five dollars a photograph.

A visit to the school revealed why my predecessor had had difficulty with the pictures. The building stood in the midst of a wasteland, littered with unused lumber, gravel dug out of the foundations, and withering remnants of workmen's lunches. As

I walked around to look it over, the mud squished over my shoe-tops, but the lines of the school were good. The solution was to photograph it in silhouette against the sunset.

On the first afternoon that a sunset seemed to be shaping up satisfactorily, I went back to the school, only to find that the sun set on the wrong side of the building. I would try a sunrise. For four successive mornings I arose before dawn, hurried to location and found the stubborn sun rising behind overcast. On the fifth morning the sunrise was everything a photographer could ask, but the whole idea proved fruitless because heaps of refuse in strategic places blotted out the best angles on the school.

If only I could supply a few softening touches of landscaping! I ran to the nearest florist, invested in an armful of asters, carried them to the schoolhouse and stuck them in the muddy ground. Placing my camera low, I shot over the tops of the flowers, then moved my garden as I proceeded from one viewpoint to the next. By the time my asters had given up, exhausted, I had completed the photographs of the school from all points of view.

When I delivered the pictures (which of course I took care to do in blue gloves), I don't know who was the more amazed—Mr. Mott or Mr. Pitkin—at the miraculous appearance of landscaping. Publication of the pictures brought more work and a tinge of prestige to the Bourke-White Studio.

At this stage the Bourke-White Studio was a name on a letterhead and a stack of developing trays in the kitchen sink. I did my processing in the kitchenette, the rinsing in the bathtub; and the living room served as reception room when the in-a-door bed was pushed out of the way. Though so far, no one had come to be received. Still, my pavement pounding was beginning to bring some results, mainly from landscape architects who ordered pictures of gardens or estates they had landscaped—and this meant sales to the estate owners, also. My darkroom work I did always at night. This night schedule began with the disastrous discovery that all my swathings of black cloth would not make my kitchenette properly light-tight. Unfortunately I found this out while developing a whole take on one of my early, precious commissions—the fall-blooming roses in Mrs. Willard Clapp's garden. Even my miserably fogged negatives showed how exquisite the

pictures would have been. I had caught that garden just right, early sun dripping through the trees and outlining the garden gate, jeweled drops of dew highlighting festoons of blossoms in their last full-blown peak. Next morning when I hurried back to retake the photographs, I found that a pounding rain during the night had driven all the flower petals to the ground.

One day while I was doing the rounds with my portfolio, I passed through the public square and saw a Negro preacher standing on a soapbox. He was earnestly exhorting the air, but no one was paying the slightest attention to him. Soaring about his widespread eloquent arms and gathered in a bobbing congregation at his feet were flocks of pigeons: what a wonderful picture! But that day I had no camera.

Dashing to the nearest camera store, I begged to be allowed to rent or borrow a camera. The clerk eyed me curiously through his thick spectacles as I explained breathlessly about the preacher and the pigeons, but without delay he reached below the counter and handed me a Graflex. I flew back to the square, pausing only to buy a bag of peanuts on the way, and found to my relief that the parson was still on his soapbox, proclaiming that the prodigal son had returned. His flock had begun to stray, but a few well-aimed peanuts brought them fluttering back, and attracted also a growing crowd of onlookers who cheerfully took over the chore of tossing peanuts, leaving my hands free to finish the photographs.

It was only when I went back to return the camera to the clerk behind the counter that I noticed the remarkably astute and kindly expression in the blue eyes behind the thick lenses. Everything about this camera clerk seemed stepped up above the ordinary as though intensified by some inner magnifying glass as strong as the spectacles he wore. When he moved, he swung strong arms from a powerful barrel-shaped chest. When he spoke, the words streamed out all in capitals, underlined, and sparked with exclamation points. Balding, short, enthusiastic and fiftyish, Alfred Hall Bemis was as eager to give photographic advice as I was to receive it. It was lunchtime, so we went out to lunch, and naturally I told him how I felt about steel mills.

Perhaps if there had been no Mr. Bemis, others would have helped—for I believe a burning purpose attracts others who are

A preacher and his parishioners, Cleveland Public Square, 1928.

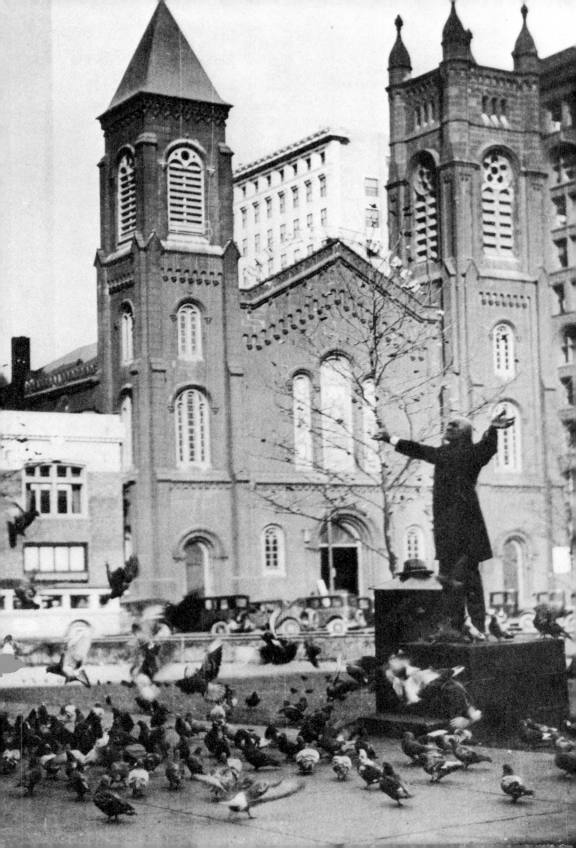

drawn along with it and help fulfill it. But one would need ten others to replace a single Bemis.

Mr. Bemis gave me badly needed technical pointers, but he never failed to recognize there was more to making pictures than technique. "Listen, child," he would say, "you can make a million technicians but not photographers, and that's the truth." Mr. Bemis took one look at my primitive darkroom facilities, salvaged an old chipped-up pair of condensers the store was throwing out, and built an enlarger in my breakfast room. "All we need is a little wood"—he found that free somewhere—"and a camera rack and bellows"—he tore these out of some discarded camera wreck—"shove in a light—and you're on your way."

Beme, as I soon called him, saw to it that I had a hot meal at practical intervals, and when I spoke thankfully of this some years later, he dismissed it with "You were working awful hard, with your weatherboards right down to the sea." He gave me a line of philosophy which I have never forgotten and sometimes repeat to myself to this day. I no longer remember what occasioned it: it must have been some petty affair where I feared possible competition. Mr. Bemis said, "Don't worry about what the other fellow is doing. Shoot off your own guns."

Fate was extraordinarily kind to me in those early Cleveland days. If the morning mail brought an overdraft of eight dollars, before the day was over I was sure to sell a print or two and get a check for ten. Various small magazines in Cleveland began publishing my garden pictures. The Cleveland Chamber of Commerce used my Negro preacher on the cover of their monthly, *The Clevelander*, paid me ten dollars, and ordered more covers.

These extras were helpful, for my hardest problem was to get enough rock-bottom work from the architects and garden owners to pay for the supplies I needed to keep shooting industrials in the Flats. Autumn was advancing and the sky was full of luminous clouds. To this day it hurts me to waste good clouds. On brilliant days, as soon as I finished my regular architectural or garden work, and always on Sundays, I raced down to the Flats and photographed the industrial subjects I loved.

Many of my pictures of industrial landscapes in the Flats were dominated by the rising skeleton of the Terminal Tower, Cleveland's new skyscraper, which would be the central pivot of the

The Flats were a happy hunting ground for pattern pictures of industry, such as this arched railway trestle framing the distant Terminal Tower.

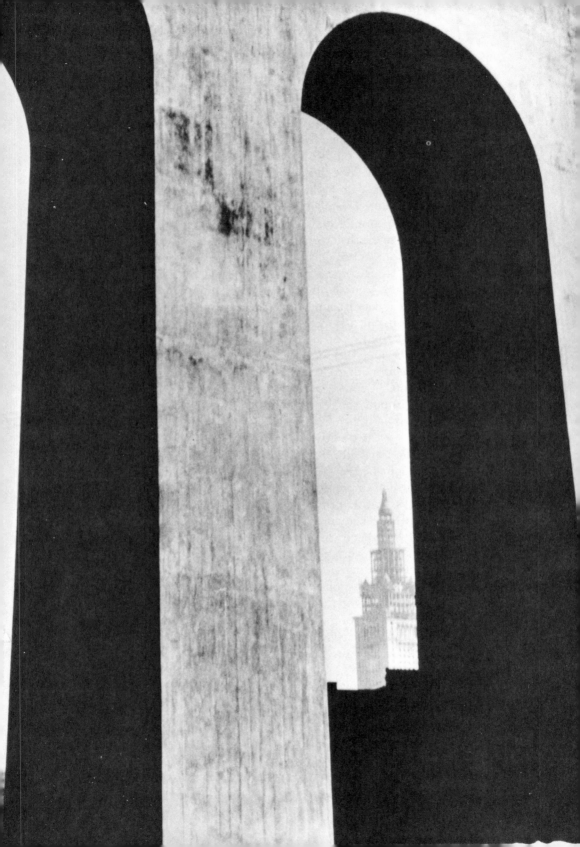

Van Sweringens' growing railroad empire. The "Vans" were figures of mystery: two powerful brothers whom few people ever saw. They were reputed to meet behind locked doors when planning each swift move that resulted in gaining control of another railroad. Only one person was said to be close to them, the equally mysterious Mrs. Daisy Jenks, for whom they had built Daisy Hill Farm, where they all lived. According to the Van Sweringen legend, Mrs. Jenks had befriended them when they were orphaned newsboys. It was said that Daisy designed the private living suites that were being installed high near the top of of the tower. A secret elevator led to these, and the apartments were reputed to be fitted with Turkish baths and such extensive facilities that the Vans "could stay up there a year if they wanted to." Like beleaguered princes in a tower, it seemed to me. Later when the crash came, they were indeed beleaguered, and having a hideaway at the top of a tower didn't help them. They went down with the Depression.

During this time that I was roaming the Flats, no one dreamed of a depression. We were in that last peak of the great boom, and the Vans, through their multitude of projects, had brought a great surge of building activity to Cleveland, and incidentally, had brought a great wealth of construction subjects within reach of my camera. Each trip to the Flats gave me new viewpoints on bridges: it might be the abstract construction pattern of a trestle, the cathedral-like arches of concrete piers which would carry railroad tracks, or the main traffic span of the High Level Bridge like a drawn bow reaching through the sky. It never occurred to me that I could sell these pictures, or that I was doing anything new. These were things I was impelled to take because they were close to my heart, so close that for some little time I was too shy about the photographs even to show them.

Frequently, I caught in pictures the silhouette of the tantalizing steel mills over mountains of ore and coal. Sometimes I ventured as far as the guardhouse with a request to take my camera inside. But I was always turned away at the gate.

Then, unexpectedly, I sold my first industrial picture. A friend urged me to take a portfolio to one of the banks. I could hardly imagine a bank buying a picture. However, Gus Handerson, the public relations officer of the Union Trust Company, needed

Dynamos were more beautiful to me than pearls. Niagara Falls Power Company, 1928.

covers for the bank's monthly magazine *Trade Winds*. He turned rapidly through my photographs, picked a shot of the High Level Bridge, said, "Make us a glossy of this," and with magnificent fairness added, "Send us a bill for fifty dollars." This was five times the price I would have quoted if he had consulted me. That picture paid for a lot of film. But the benefits went deeper than fifty dollars.

Each month I brought in a portfolio of the industrial pictures I had taken, and Gus—and later Don Knowlton, who succeeded him—went through them and picked a *Trade Winds* cover. No one gave me any directions. I was free to use my own imagination, develop my own style. I was away from the usual influences —the art director who hands you a tissue paper layout, the advertiser who wants a situation glamorized no matter how far it may be from real life. These would have been strongly operative, if I had started in New York and been drawn into the advertising agency circuit as I inevitably would have been. During this formative period when I had so much to learn about photography, I was free to make my own experiments and my own mistakes. How many, I was soon to find out.

Now that I had the delightful certainty of fifty dollars a month, I made a down payment on a battered, thirdhand, green Chevrolet coupé which I named Patrick. I added a third color to my wardrobe—purple—a dress I made myself. I hemmed up three new camera cloths, purple velvet to use with the purple dress, blue velvet for the blue outfit, and black velvet for the red. Some weeks later, my realistic photographer friend, Ralph Steiner, passing through Cleveland, talked me out of this nonsense: "What difference does it make what color cloth you focus your pictures with as long as they are good pictures?" But meanwhile I felt very smart indeed taking photographs in my matching ensembles.

When my new client, the Union Trust, called me in to photograph a prize steer in their bank lobby, I chose the blue velvet cloth and matching ensemble as having just the right restraint and richness for a bank. The steer had been raised by schoolboys, and whether it was being exhibited to induce the youth of Ohio to raise more steers or to raise more dollars to deposit in the Union Trust, I never found out. I took one look at that steer in

This dress was purple, violet and lavender. When I wore it to work, I carried a purple camera cloth to match. [PHOTOGRAPH BY EARL LEITER]

his roped-in enclosure—pure jet Lucifer with horns, against dead-white marble—and I decided it would take more than a blue camera cloth to photograph it properly. I fled to Mr. Bemis.

"You will need artificial light, child, a lot of it." I had never used artificial light in my life. "Do you know how to use flash powder? I'll lend you the apparatus" (we had no flashbulbs in those days) "but I don't want you to blow a hand off."

A few minutes of instruction convinced Mr. Bemis that not only would I endanger my own hand if turned loose with flash, but all the depositors in the Union Trust lobby would be placed in peril.

"Can you wait till the lunch hour? I'll lend you Earl."

Earl Leiter was a wizard photofinisher who worked in the spiderwebby darkness of the fifth floor over the store. Among all the varied negatives that cross a photofinisher's table during a day, Earl, in an instant accurate analysis, could pick the right timing and come up with the winning number. Earl's trouble was that with horses, too, he hoped to come up with the winning number. He placed daily bets and lived for the moment in late afternoon when he could phone for news of the races. In all the time I knew him—and he came to work for me later when a studio in the Terminal Tower supplanted my kitchen sink—I knew Earl to make substantial winnings on a horse only once.

Like all good photofinishers, Earl was a competent photographer, and when we reached the bank he took charge of everything. As we climbed into the roped-in enclosure, we drew interested attention both from the friendly noontime crowd and the distinctly hostile-looking steer. Earl helped me set up the camera Mr. Bemis had lent me, got ready to shoot off his flash-pan, looked to me to give me the cue, and saw from my look of stage fright that I had forgotten Beme's directions for the camera. Manipulating the shutter with his left hand hidden under the blue cloth so it would look as though I was working the camera, he set off charges of flash powder with his right. Billows of gray smoke rolled through the bank. Ashes showered down on the shoulders of the depositors, and my blue outfit and blue velvet camera cloth looked as though they had been dipped in a flour bin.

Back on the fifth floor we rushed out a proof. The picture was

no artistic masterpiece, but it plainly showed a discontented steer standing sharp and clear against a vast pillared bank lobby. The bank officials liked it well enough to order 485 copies, which they would get out to a lot of newspapers and schools next day. Could I deliver them tomorrow morning? Oh, of course! Delighted, I ran back to Beme.

"Kiddo, it would take you a week to turn out four hundred and eighty-five prints with that homemade enlarger of yours."

I could not speak for disappointment.

"I doubt if there's a commercial studio in town would take on an order to make four hundred and eighty-five enlargements overnight."

My expression must have shown that I didn't want to let the bank down.

"Come back at six o'clock when the store closes, child. Maybe we can think of something. Glossy prints, they wanted? I don't know whether there are enough ferrotype tins in the city. But come back when the store closes. We aren't licked yet."

At six o'clock Beme locked the store, we picked up Earl, went to Stouffer's Restaurant, and ate a thick steak. Feeling a little like conspirators, we crept back into the store, climbed those five flights of inky steps, and turned on the ruby lights in the darkroom. Earl fitted the negative into the enlarging frame, and Beme hunted out all the electric fans on the floor. We set up a conveyor-belt formation: Earl with his beautiful precision timing struck off the prints, I was permitted to shuffle them about in the rinse water—the spot where I suppose I could do the least damage—while Beme squeegeed them onto the ferrotype tins, which he spread out against walls, over floors and tables, under the blast of the electric fans. The automatic rinsing and drying machines which came out a few years later would have enormously reduced our problem.

At midnight we ran out of squeegee boards. There were a couple of hundred prints still to do. Beme and I went down to the store and borrowed the complete stock of ferrotype tins off the shelves, carrying them up the five flights in several trips. Shortly before daylight the last black steer had peeled off its shiny tin, the prints were trimmed and packaged, and the ferrotype tins that belonged to the store were carefully polished, replaced in

their tissue wrappers, carried downstairs, and put back on the shelves.

After arranging with a trusted porter, whom I knew at the Hotel Cleveland, to deliver the precious package when the bank opened, I started home to get some sleep. I had been too busy to give a thought to the financial benefits of the night's work, but now it occurred to me that 485 enlargements at a quarter an enlargement, plus the fifty-dollar fee for taking the shot, equaled, according to my arithmetic, a Turner-Reisch convertible lens in a Compur shutter with separate elements for the long-focus effects I loved so much. A lens worthy of any steel mill. In an exalted mood, I drove the long way around so I could catch a glimpse of the steel mills on the way. Dawn was coming with a rush as I drove along the upper rim of the Flats. I parked Patrick on a high rise overhanging the riverside plant of Otis Steel. As though sealed away from the daylight, the steel mills lay in a fog-filled bowl, brooding, mysterious, their smokestacks rising high above them in ghostly fingers.

Suddenly the mist was warmed with flame as a line of slag thimbles shot out of the dark and, like a chain of blazing beads, rolled over the tracks to the edge of an embankment, below where I stood. Car after car, they tipped their burning, bleeding loads down the slope, then rattled back to vanish into the murk again.

"This is just the waste," I thought. "This is just what's left over! If the sweepings, the crumbs, can be so spectacular, what possibilities there must be—inside, where those slag thimbles come from!" And I drove home in Patrick, wondering how I was going to get into that magic place.

My photographer friend Ralph Steiner took this shot of me on a rooftop.

CHAPTER IV

THE
ENCHANTED
STEEL MILLS

"Beme, aren't the presidents of banks on the boards of directors of industries, and vice versa?" We were eating goulash in Stouffer's Restaurant. "Someone like the president of the Union Trust, I mean?"

"Listen, child, old John Sherwin is on the board of directors of half the firms in town. More than half, maybe."

"And I photographed Mrs. John Sherwin's garden. Maybe he never saw the picture of the steer in his own bank—that's all public relations—but he must surely know the pictures of his own estate."

"I'd rather do business with the president any day than some whippersnapper down in the aisle," Mr. Bemis said.

"Yes," I said, "especially if it's the president of the bank that you get to introduce you to the president of the steel mill."

And so it turned out. John Sherwin, president of Union Trust, was puzzled that a "pretty young girl should want to take pictures in a dirty steel mill." But he was quite willing to send a letter of introduction to his friend Elroy Kulas at Otis Steel.

Mr. Kulas was forceful, short of stature, able. In the twelve years since he had become president, his company's output of steel ingots had quadrupled.

This of course I did not know, but I knew very well why I wanted to photograph the making of those steel ingots, and Mr. Kulas eyed me kindly while I tried to explain.

I do not remember the words I used, but I remember standing there by his massive carved desk, trying to tell him of my belief that there is a power and vitality in industry that makes it a magnificent subject for photography, that it reflects the age in which we live, that the steel mills are at the very heart of industry with the most drama, the most beauty—and that was why I wanted to capture the spirit of steelmaking in photographs.

He must have been a little surprised at the intensity of this twenty-one-year-old girl, possessed of this strange desire to photograph a steel furnace. And I, too, was a little surprised to find myself talking so fearlessly to the first industrial magnate I had ever faced.

But during my camera explorations down in the Flats among the ore boats and bridges I had done a good deal of thinking about these things. To me these industrial forms were all the more beautiful because they were never designed to be beautiful. They had a simplicity of line that came from their direct application to a purpose. Industry, I felt, had evolved an unconscious beauty—often a hidden beauty that was waiting to be discovered. And recorded! That was where I came in.

As I struggled to express these ideas to Mr. Kulas, I remembered to tell him certain things I had decided in advance I must say—to assure him I was not trying to sell him something, that at this stage I wanted only permission to experiment. And he in turn expressed a polite interest in seeing and perhaps purchasing for the company some of the pictures if they turned out well. I said, "Wait till we see what I get, first." And then of course I heard again about the fainting schoolteacher and about the "dangers": the acid fumes, the overpowering heat, the splashing hot metal. I wasn't the fainting kind, I insisted.

Mr. Kulas turned to the portfolio I had brought, looked at the pictures one by one, and stopped to study a photograph of the Sherwin rock garden. It showed little rills from a spring falling through moss-covered stones, with a little lead figure of a Cupid or nymph guarding each rill.

"I think your pictures of flower gardens are very artistic," said

Mr. Kulas, looking up, "but how can you find anything artistic in my mill?"

"Please let me try."

And he did. He called in some vice-presidents and gave the word that I was to be admitted whenever I came to the plant to take pictures. And then he did me the greatest favor of all. He went off to Europe for five months.

I did not know what a long-term task I had taken on, nor did Mr. Kulas and his vice-presidents. I believe the Otis officials expected me to come down once or twice for a few snapshots, and I came nearly every night for a whole winter. If there had been someone, however kindly, asking how I was getting along, asking to see pictures (when for months there was nothing worth looking at), I could never have taken the time I needed to learn all the things I had to learn. Without knowing it, I had picked the hardest school I could have chosen. The steel mills with their extreme contrasts of light and shade make a difficult subject even today, with all our superior techniques and equipment. But then I had no technique, almost no experience. Also my difficulties were more than technical. The theme itself was colossal. Despite my enthusiasm I needed orientation. I needed to go through a kind of digestive process before I could even choose viewpoints on my subjects.

The mill officials grew impatient. I was doubtless in the way. They were sure I was going to break a leg or fall into a ladle of molten metal. And a girl who came back night after night after night! What kind of pest was that? But the president had given his word. No one could gainsay it. I had my five months.

The first night was sheer heaven. Beme talked about it when we met years later.

"You had a very joyous time watching that steel. We were standing up high someplace and they pulled a furnace, and you were as delighted as a kid with a Fourth of July firecracker. I think you must have pyromania someplace. You grabbed your camera and you were off to a flying start.

"You weren't exactly dressed for the occasion. You had on some kind of a flimsy skirt and high-heeled slippers. And there you were dancing on the edge of the fiery crater in your velvet slippers, taking pictures like blazes and singing for joy."

My singing stopped when I saw the films. I could scarcely recognize anything on them. Nothing but a half-dollar-sized disk marking the spot where the molten metal had churned up in the ladle. The glory had withered.

I couldn't understand it. "We're woefully underexposed," said Mr. Bemis. "Very woefully underexposed. That red light from the molten metal looks as though it's illuminating the whole place. But it's all heat and no light. No actinic value."

So for weeks we struggled with actinic values. We brought in floodlights, laid cables; Earl set off his flashpans. But our illumination was simply gobbled up in the vast inky maw of the steel mill.

One tends to forget how quickly photography has developed as a science. With present-day equipment, steel mills still must be approached with respect, but then, film and paper had little latitude, negative emulsions were slow, there were no flashbulbs, no strobe; the miniature camera was not yet on the market. Stepped-up high-speed developers were unheard-of.

"If only I could go to someone who's been taking steel mill pictures and would be willing to advise me," I said to Beme.

"There isn't anybody like you mean." Mr. Bemis hunted up some shots made by a commercial photographer in the mills in Youngstown, Ohio. "These are the only pictures of the kind that have been taken as far as I know." I turned from them in despair—this was not the way I thought of steel mills, these gray tasteless blotting-paper scenes. "They're what I call map pictures," said Beme. "No drama shown. But probably none called for, kiddo. You're trying to do what nobody's done, to put the artist's touch on what others have thought a very dull mechanical problem."

Each night, Mr. Bemis borrowed some piece of equipment from the store, and we tried it out. "There's no one camera will take every kind of picture," said Beme. "A guy goes out to shoot pictures like you do needs a whole potful of cameras." A lens came in which we thought remarkably "fast"—f/3.5. It would seem quite average today. Beme lent it to me from the store till I saved enough to buy it. We still suffered from meager illumination and from halation; the faster lens helped, but not enough: our shadows were far too dim, our highlights blurred paste. We

heard of an exciting new development in film: infrared. I wired to get some, learned from the research department of Eastman Kodak it was made up only for motion picture film.

I tried closer viewpoints, hoping to get more help from the light of the molten steel. The men put up a metal sheet to protect me from the heat while I set my camera in place, slipping the shield away while I made my shots. The varnish on my camera rose up in blisters and I looked as though I had been under a tropical sun. I climbed up the hanging ladder into the overhead crane so I could shoot directly down into the molten steel during the pour. During some shots, bursts of yellow smoke at the height of the pour blotted out everything in front of the lens; during others, the crane cab started trembling during the vital moments, and all my pictures were blurred.

By this time I was living entirely for the steel mills. The jobs I was able to keep going during the daytime just about paid for the films I shot up at night. And those same films, after exposure in the mills and processing in my kitchen sink, filled up my wastebasket—a gluey mass of sick, limping, unprintable negatives. At the end of a developing session Beme would pick up his hat, light one of his endless cigarettes, and start for the door, saying, "I'm going home to read the whole Book of Job. How Job sat in the ashes. Maybe it will do some good."

And apparently it did, for then traveling salesmen came into my life.

The first of these was H. F. Jackson, long-armed and long-legged, with a profile like Abraham Lincoln. Jack was traveling representative for the Meteor Company, which handled "photographic specialties." When he came to town, Beme called me excitedly. "I used to know Jack when we were both sixteen-year-old kids in Springfield, Massachusetts. He's the same age as me. I haven't seen him in all these years, until he turns up out of nowhere with his case full of samples. I told him about your problem, how you couldn't get enough light. Oh, he could get enough light, he says, to light up a hole in Hades. And he drags out these big magnesium flares with wooden handles, like Roman candles. He's on his way to Hollywood to demonstrate them for the movies. I told him if he would come with us he could see the steel mills, and he fell for it."

We had more than our usual red tape at the gate that night—
a strange guard who didn't recognize our passes, and then phoned
endlessly until he could rouse some higher-up who would admit
Jack. And while all this went on in the drafty guardhouse, a
wet snow blew up, and through the storm we could watch the
rising crescendo of rosy light glowing from the door of the open
hearth, which showed us we were missing a "heat" and would
have to wait three hours for the next pour.

I know of no colder place than a steel mill in winter between
"heats," and no hotter place than a mill during the pour. During
our three hours we roamed the windy catwalks, climbed up and
down ladders with the sleet driving through, and planned our
shots. I was eager to work out a side lighting which would em-
phasize the great hulk and roundness of the ladles and molds, and
still not flatten and destroy the magic of the place. To do that
properly would take two flares for each shot, Jack decided, used
at each side and at varying distances from the camera.

At the end of the third hour, Jack made a heroic decision. In
his sample case were one dozen flares with which he had set out
to conquer Hollywood. He would save one flare to demonstrate
to the movie colony. Eleven he would demonstrate in the steel
mills.

Then in a great rush the pour began. With the snow at our
backs and the heat in our faces, we worked like creatures pos-
sessed. The life of each flare was half a minute. During those
thirty seconds I steadied my reflex camera on a crossrail, made
exposures of eight seconds, four seconds, two seconds, dashed to
a closer viewpoint, hand holding the camera for slow instanta-
neous shots until the flare died.

In the beginning, Beme stood at one end and Jack at the
other, each holding one flare. Then as the metal rose bubbling
in the ladle with great bursts of orange smoke shrouding the mill,
Jack was afraid we were not getting enough fill-in light. So we
took the great gamble: he and Beme held two flares each. The
eleventh flare we saved for that last spectacular moment in the
pouring of the ingot molds—that dramatic moment when the
columns of tall tubular forms are full to bursting, each crowned
with a fiery corona of sparks, and the cooling ladle in one last
effort empties the final drops of its fiery load and turns away.

The towering smokestacks of the Otis Steel Company, Cleveland, Ohio.

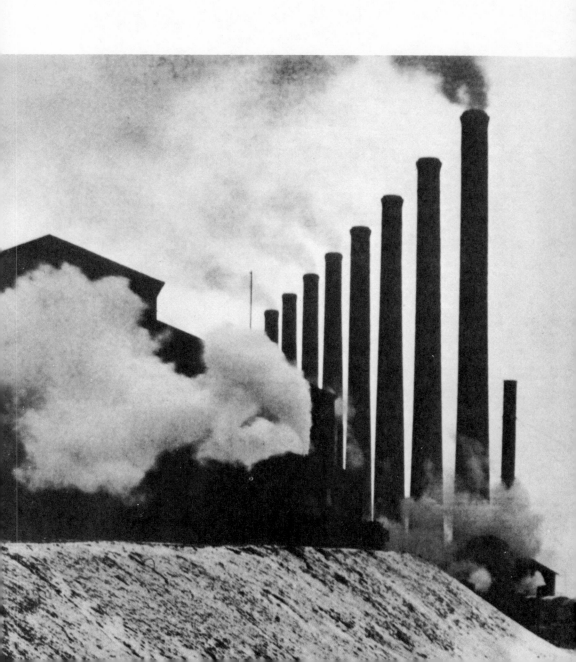

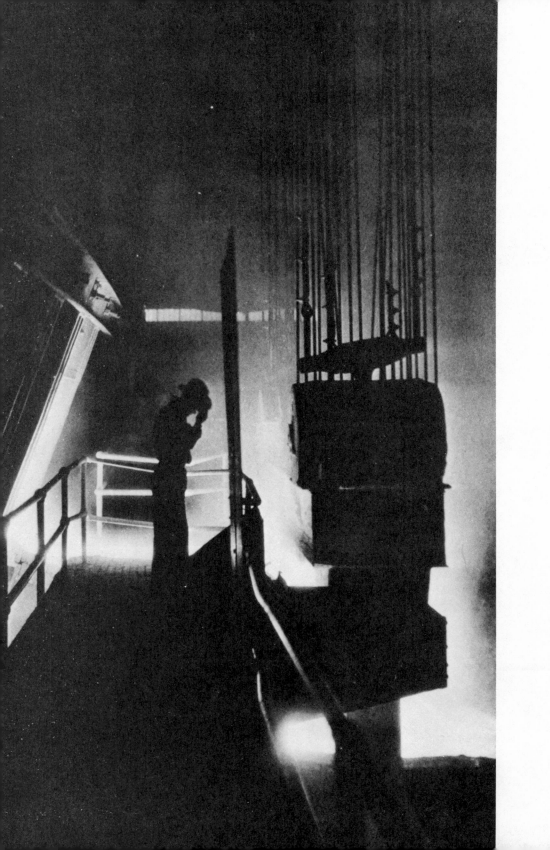

Pouring the heat. Open hearth mill, Ford Motor Company, Detroit.

200-ton ladle, Otis Steel Company. This picture won the Cleveland Art Museum award and was used by Fortune *in the prepublication dummy.*

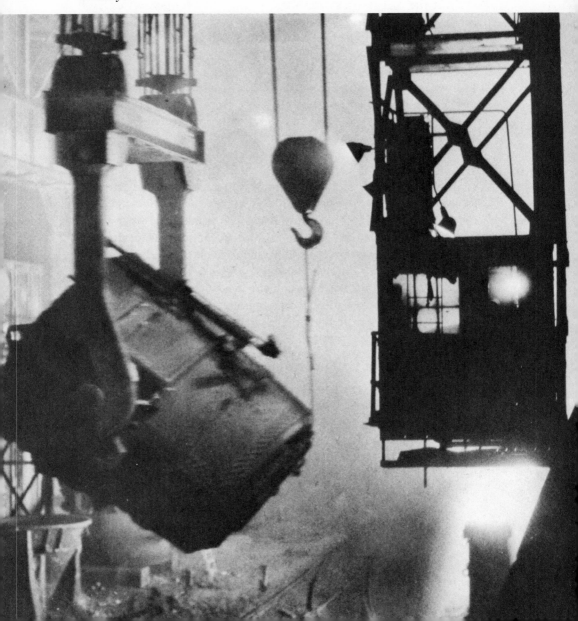

The next night we developed the films, and there it all was: the noble shapes of ladles, giant hooks and cranes, the dim vast sweep of the mill. There was one moment of anxiety, when we developed the negative we had taken with the eleventh flare. It was filled with black curving lines, as though someone had scratched it deeply with his fingernails.

Beme couldn't make it out. "The film seems to be damaged in some manner."

"But the marks are so regular," I said, "like looped wire. Each one is a perfect curve."

And suddenly I knew. I had photographed the actual path of the sparks.

We reached our next roadblock after Jack had moved on to Hollywood (his company, I am glad to add, had sent him another sample case from Chicago). We were printing up our results. "Beme," I said, "these enlargements look terrible. So dull and lifeless." I couldn't understand it.

"The paper doesn't have enough latitude," said Beme.

This was Steiner's mince pie all over again. Shortly before I took my steel mill pictures, Ralph Steiner experienced extraordinary difficulties in photographing a piece of mince pie. His mincemeat looked like coal, the crust like plaster, the final effect completely un-pielike. Steiner, always a meticulous craftsman, made many experiments until he analyzed the problem. I remembered he had told me that photography is a funneling process. The light range in nature (which the eye with its elastic aperture can see) is longer than any film can record; but the film can accommodate a far longer range than the more limited paper emulsion will hold. Steiner had concluded that with existing paper emulsions it was impossible to print a satisfactory picture of a piece of mince pie. He had solved the problem by asking the ladies of the *Delineator*, for whom he was taking the picture, to bake him a special pie with lots of light nutmeats and the palest raisins, and extra-dark spices in the crust. Thus, by funneling down the light scale in a piece of pie, he got his pictures.

But I couldn't funnel down a whole steel mill. With Jack's help we had squeezed the lights and shadows into some sheets of film, but they still had to be tailored to a piece of paper.

In this new crisis Mr. Bemis triumphed again. He produced another salesman. Charlie Bolwell was as plump and pink-faced

as Jack had been lean and gaunt. For thirty years, popular, good-natured Charlie had traveled back and forth across the nation, selling photographic supplies for Agfa. After the fullness of his service, his company retired him; Charlie found he couldn't settle down. "He's taken on a kind of missionary job for a Belgian paper that's new in this country," Beme phoned to tell me. "This Gaevert paper is supposed to have a richer emulsion, heavier deposits of silver. It has what Charlie called 'the long gray scale.' "

These were magic words. My heart beat faster and I could hear Beme's voice growing excited on the other end of the line. "I told Charlie, 'I know someone needs that long gray scale awful bad,' and Charlie said, 'Lead me to him.' I told him, 'It's a her.' I showed him some of the prints we'd made, and he's under the impression he can do better. We're perfectly willing to let him try, aren't we, kiddo?"

Yes, we were willing. We would have a steak in Stouffer's Restaurant and then come out to my kitchenette. In concluding these arrangements, Beme all but sang into the phone, "Best of all, Charlie has innumerable samples to donate to the cause."

Charlie Bolwell donated more than his paper samples to the cause. He taught me how to print. He showed me how much can be done with a hand gliding through the shaft of light that falls from enlarger to paper, how one moves the fingers to keep the "dodging" imperceptible, masking off thin portions, burning through the too-dense highlights. He showed me what the warmth of a palm in the developer will do, coaxing up a difficult area of the enlargement. From Charlie I received a new conception of darkroom work, as though your hands—working in the laboratory—have become an extension of the lens that took the picture, as though it were all one conscious stream of creation from the judging of the light when the picture is taken to that final sparkle in the tray when your print is what you want it to be.

By the time Charlie Bolwell had rescued my pictures and was on his way with a lightened sample case to make other converts, Mr. Kulas was back from Europe and quite naturally expressed some curiosity to see what that girl had been doing for five months in his steel mill. I picked the twelve best shots, put them on fresh white mounts, made a new red dress to give me confidence—and the dreaded, hoped-for appointment was made.

Beme drove to the mills with me and waited outside in Patrick
—"to be with you in spirit," he said. I got out of the car, and
picked up my portfolio.

Beme could see I was trembling. "Child, you've come through
with an armful of pictures the like of which no one has ever
seen until now. Now run along."

I walked over the long, long narrow wooden trestle that
spanned the yard of the mill to the office building. I remember
waiting inside Mr. Kulas's office, but standing near the entrance
and behind a screen, while he finished with some other people.
Then my turn came. I remember his surprise and pleasure in the
pictures. He said there had never been such steel mill pictures
taken. He wanted to buy some of them. How much would they
be? I had given this a lot of thought. I have always had the phi-
losophy that either one does things free—for a gift, or when some-
one cannot afford to pay—or else charges what the work is
worth. There is no middle ground. And I told Mr. Kulas this.
I assured him I would give him the pictures gladly, but if he
wished to pay, the price would be quite a lot. Because of the
amount of time and supplies that had gone into the work, I had
decided it should be one hundred dollars a picture.

"I don't think that's a lot," said Mr. Kulas, "and in any case
I am glad to have the chance to encourage you in your pioneer
work."

He picked eight photographs, commissioned me to make eight
more, and laid plans for a privately printed book on *The Story
of Steel*, which would be sent to his stockholders and would
contain my photographs.

I was back again on the wooden trestle. Beme says I came
running like a madwoman to tell him the news. We tore into
town and bought a bottle of champagne and raced up to the fifth
floor to tell the news to Earl. I had never had champagne before,
nor had Earl.

Beme pulled the cork, and the champagne gushed to the ceil-
ing and sprayed all of Earl's negatives hung up to dry.

The phone rang. Earl disappeared to answer it and came
running back with a dazed and ecstatic expression. This was his
great day, too. He had won eighty-four dollars on a horse named
Heat Lightning.

Electric welder, Lincoln Electric Company, Cleveland, Ohio.

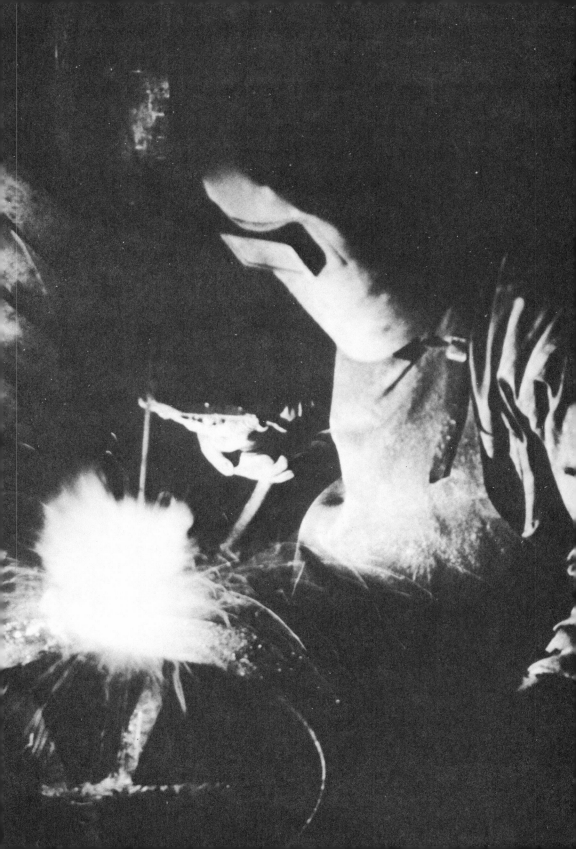

CHAPTER V

FORTUNE

BECKONS

IN THE LATE spring of 1929, I received a tele-
gram from New York: HAVE JUST SEEN YOUR STEEL PHOTO-
GRAPHS. CAN YOU COME TO NEW YORK WITHIN WEEK AT OUR
EXPENSE. It was signed: HENRY R. LUCE and under his name:
TIME, THE WEEKLY NEWS MAGAZINE. I very nearly did not go.
The name of Luce meant nothing to me. Of course I knew
Time, which was then five years old. A trip to the public library
to look through back files confirmed my impression that the only
important use *Time* made of photographs was for the cover,
where the portrait of some political personage appeared each
week. I was not the least bit interested in photographing political
personages. The whole dynamic world of industry lay before
me. My discoveries had just begun. All over America were rail-
roads, docks, mines, factories waiting to be photographed—
waiting, I felt, for *me*.

Within that very fortnight, my Otis pictures had run in the
roto sections of several Midwest newspapers, and I had had some
interested nibbles from industrial firms. The most intriguing
of these were Chrysler Motors and Republic Steel. Both plants,
I was sure, would be sheer heaven to photograph, and I greatly
hoped their inquiries would materialize as jobs. This seemed no
time to go dashing away from home base.

For two days Mr. Luce's telegram lay unanswered. Then the yeast of New York began to work. Why turn down a free trip to New York? I could always use the opportunity to call on some of the big architects if I didn't like whatever Mr. Luce had in mind.

With the inevitable portfolio of my most recent work under my arm, I arrived in Manhattan and hunted up the small and rather drab office building on 42nd Street near Second Avenue where Time Inc. occupied a modest section of floor space.

I was received by two very tall and distinctly unusual-looking young men. Both seemed to radiate an extraordinary quality of restless imagination, although in other ways I guessed their personalities were quite dissimilar. One I judged was as young as I, in the early twenties. He was lithe in his movements and slender, with a headful of tight, short black curls and a profile of almost Grecian regularity. He had a spirit of fun-making about him, of delight in the ridiculous, which I felt from the first words he spoke. He was introduced to me as Parker Lloyd-Smith.

The other was Henry Luce. He was perhaps a year or two under thirty, strikingly powerful in build, with a large head over large shoulders. His words tumbled out with such haste and emphasis that I had the feeling he was thinking ten words for every one that managed to emerge. He began questioning me at once. Who was I and what was I? Why was I taking these industrial pictures? Was it just for fun? Was it my vocation? Or was it my profession? I solemnly assured Mr. Luce it was my profession, and a very serious one.

He went on talking in that abrupt and choppy manner so characteristic of him, racing from one thought to the next, breaking off into short silences, then leaping again from point to point in a kind of verbal shorthand. He left such gaps that at first I had difficulty in following him. Then suddenly I became accustomed to his manner, and it all swung into focus. I knew why I had been called to New York, and my heart skipped a beat.

Mr. Luce and his associates were planning to launch a new magazine, a magazine of business and industry. They hoped to illustrate it with the most dramatic photographs of industry that had ever been taken. They were breaking away from the practice most magazines had followed in the past of picking up illustra-

tions at random, almost as an accidental sideline. Instead, pictures
and words should be conscious partners. The camera should
explore every corner of industry, showing everything, Mr. Luce
explained, from the steam shovel to the board of directors. The
camera would act as interpreter, recording what modern indus-
trial civilization is, how it looks, how it meshes. Did I think this
was a good idea, Mr. Luce asked me, pausing for breath.

Did I think this was a good idea? This was the very role I
believed photography should play, but on a wider stage than
I could have imagined. I could see that this whole concept would
give photography greater opportunities than it had ever had
before. I could see, too, that it would make unprecedented de-
mands on the camera. Photography would have to stretch itself
and grow. I was proud that this was my craft and I would be
growing along with it.

In a room without windows back in some somber area of the
building, Parker Lloyd-Smith, who was to be managing editor
of the new magazine, had been working for some months on
dummies. He was assisted in this by a nimble-minded, resource-
ful dark-haired girl named Florence Horn, a specialist in business
research. Mr. Lloyd-Smith brought out the dummies to show me,
their black ruled squares where the photographs would be. The
next prospectus would be the crucial one. This would be shown
to advertisers to learn how they reacted toward the idea of the
new magazine. Might he use my steel pictures in this dummy?
Indeed he might. The name of the new publication was not
decided. But one thing was decided right on the spot. I was to
begin work on the new publication almost at once.

When I was back in Cleveland with the good news, my friends
shared in my rejoicing. I wrote my mother: "I feel as if the world
has been opened up and I hold all the keys." I was so happy I
was almost afraid to walk across the street, for fear I would be
run over before I had a chance to embark on this wonderful new
life.

It seemed miraculous to me that these editors and I should
meet and join our forces at just this time—I with my dream of
portraying industry in photographs, and they with their new
magazine designed to hold just such photographs. And yet I
recalled that my father had told me of incidents where two in-

ventors on opposite sides of the world and with no connection
with each other would sometimes work out the same thing at the
same time. The world is ready for it, my father had explained.

My father was very much in my mind during this whole
period when I was concentrating on industrial photography.
Many times, after a job which had given me special satisfaction,
I felt a deep sadness that I could not show the photographs to
my father. I was sure my feeling of at-homeness with machinery
was something I had absorbed as a youngster on those shining
occasions when he had taken me through factories. My love for
industrial form and pattern was his unconscious gift. Now more
than ever before, with this suddenly widened canvas on which
to work, I wished he could see where his influence had led.

A letter from Parker Lloyd-Smith brought the good news that
the response to the dummy had been splendid. They were going
ahead with the project. Our baby had a name: "Fortune." "If it
isn't a success," one of my Cleveland friends remarked, "people
will be calling you Miss Fortune."

Eight months before the infant *Fortune* was due to appear, I
went to work for it. On the Fourth of July, 1929, I met Manfred
Gottfried in New York, and we took the Boston night boat to
start out on the first *Fortune* assignment—shoemaking at Lynn,
Massachusetts. "Gott," who for many years to come would be
chief of Time Inc.'s enormous foreign news service, had been
one of the first *Time* reporters when that magazine had made its
debut in 1923, six and a half years ahead of *Fortune*. Mr. Luce
had described Gott to me as a "pillar of strength." I was delighted
to find this "pillar of strength" could dance. We danced our way
to Boston on the night boat, and it was a lovely way to embark
on a new life with a new magazine.

The next subject was glassmaking, and my next writer escort
was Dwight MacDonald, fresh out of college, and "a rough
diamond," Mr. Luce had told me. I met the rough diamond in the
early dawn on the station platform at Corning, New York, and
I remember how his suitcase, when subjected to a violent search
for some elusive memo, suddenly fell wide open, and well-used
shirts and pajamas began flying out all over the floorboards.

In the electric light-bulb plant, we were fortunate in finding
an artisan of a vanishing craft, a giant of a glassblower who stood

high on a pedestal and with the power of his lungs and the skill of his lips, blew golden-hot glass nuggets into huge bulbs, street-light size. The making of all other types of light bulbs was mechanized, and within weeks of our visit, these last handmade, or mouth-made, streetlamps yielded to mechanization also.

The next subject was orchid raising in New Jersey, which I covered with Parker Lloyd-Smith. How delighted we both were when we discovered baby orchids were raised in test tubes, row upon row. Next day I was off with Florence Horn to the Atlantic Coast fisheries in New London, where I climbed slippery moun-tains of freshly caught fish to get photographs, and Florence researched the new freezing process which was about to revolu-tionize the whole food industry.

We were storing up stories to serve as a backlog when *Fortune* began publication, half a year hence. During this prepublication period, as well as later, Archibald MacLeish wrote many *Fortune* articles. We worked together in the Elgin Watch factory, where we were both enchanted by the exquisite shapes of minute watch parts. With his hearty warmth of manner, his powerful frame, and his face still bronzed from his recent mule trip under the Mexican sun, Archie MacLeish was very unlike my idea of a poet. (The muleback trip resulted in his narrative poem *Conquis-tador*, which four years later was to bring him the Pulitzer poetry prize.)

From the Lilliputian world of watch parts, I plunged into the huge subject of showing an industrial cross section of an entire city. South Bend, Indiana, was selected, and Harry Luce came along to work with me on the story, which would come out under the title "The Unseen Half of South Bend." Luce was in-trigued with the idea that there was a world many Americans had never been shown—even those who participated in it, for they saw their own facet at close range, but never the integrated whole. We explored everything from automobile factories and foundries to toys and fishing tackle. From time to time, in getting permis-sion to photograph factories, we experienced some difficulty in explaining what *Fortune* magazine was going to be. "Oh, a sort of industrial *National Geographic*," people would say. Harry Luce, after a visit to the South Bend Chamber of Commerce, came back mildly chagrined that the head of the Chamber had

Plow blades lined up for their bath of red paint at the Oliver Chilled Plow Company, used by Fortune *in the South Bend story.*

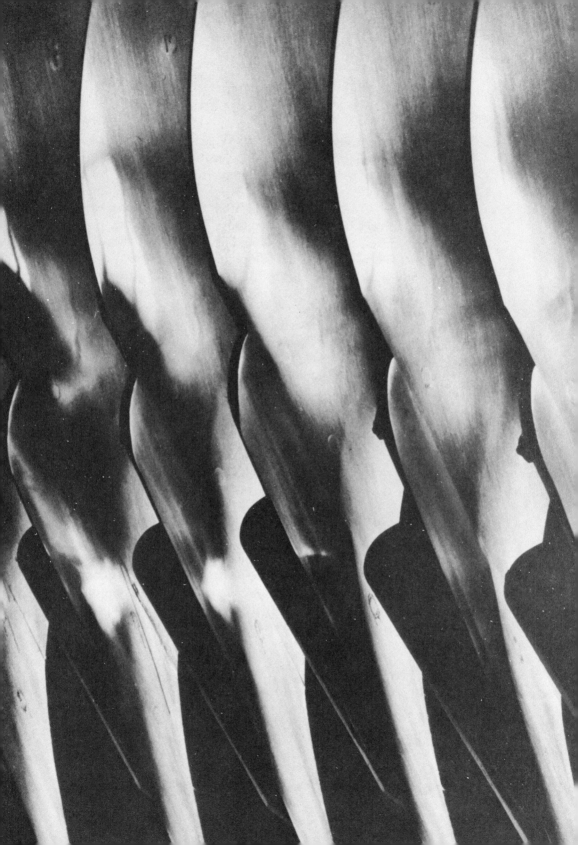

never heard of *Time* magazine—then six years old and very successful.

Harry Luce carried my cameras as we photographed the factories. They were something to carry in those days. My mainstay was a 5 x 7 Corona View (and still a great camera) with extra bellows extension to accommodate convertible Bausch & Lomb lenses, a sturdy wooden tripod with massive tilt-top head, and a weighty box of 1,000-watt Johnson Vent Lites strung up with masses of reinforced, heavy rubber wiring.

One day during our visit to a foundry, we had just begun to photograph the pouring of a ladle of molten metal into a row of sand molds, when the mechanism holding the ladle slipped and the red-hot metal started splashing out all over the floor. With a gallantry I have never forgotten, Harry Luce dashed forward, grabbed my bulky camera and light stands out of the path of molten metal and swept all the equipment back to safety.

I can well imagine the flood of invitations that would overwhelm Mr. Luce if he should decide to visit a factory today, but then, in the summer of 1929, with the debut of *Fortune* still half a year away, things were a little different. After a busy morning photographing some factory, we would hear the noon whistle blow. The shop superintendent, or whatever minor functionary had been guiding us, would scurry off, leaving us to forage for ourselves. Harry and I would hunt until we found some pushcart or vending wagon that sold to the workmen, and join the line to buy sandwiches and a bottle of coffee.

But South Bend was not without hospitality. Mr. Vincent Bendix, head of the Bendix Brakes Company (Bendix Aircraft was to follow), invited us to his home. He was out of town at the time, but he wanted us to see it anyway. For Mr. Bendix, owning this home represented the exact fulfillment of a youthful ambition. It was the largest house in South Bend. As an impoverished youngster, he had delivered newspapers to the doorstep and had resolved to own it someday. And now, in strict accordance with the American legend—he had built his vast business from small beginnings and with success—he had achieved the house of his boyhood dreams.

In the absence of Mr. Bendix from South Bend, a stately, silver-haired office official, whom Harry and I nicknamed the

Grand Mogul, was appointed to take us to the Bendix home. Our guide took his assignment seriously. The furniture was swathed in summer dust covers, and the rugs were rolled and stacked along the walls. Against our protests, the Grand Mogul insisted on wrestling with the largest and finest of the Oriental rugs, which he spread out for us to look upon.

Next we were conducted to the swimming pool, splendid in the August noonday sun, though empty. I do not know whether Harry Luce himself owned a swimming pool at that time, but if there is any truth in the legend that he had made himself three times a millionaire before he was thirty, he could certainly have possessed a pool if he had wanted one. I shall always carry the mental picture of Henry Luce, standing on the edge of that blazing rectangle, fidgeting in his yearning to escape, but gazing courteously into its white-tiled depths.

In a sweet-smelling woodworking plant, Harry was pleased when we ran into quantities of Singer sewing machine cabinets under construction. "All through my childhood, even in tiny villages in the interior of China, I saw that big *S* for Singer." (Mr. Luce was born in Canton of missionary parents.) "I used to marvel that these sewing machines could come halfway round the world to a Chinese family. I suppose many of those I saw were made right here in this factory."

As we toured the factories, I was impressed by Luce's special quality of eagerness. On arriving at each new plant, he would hurry through, his leonine head thrown forward between his huge shoulders, his questions tumbling over one another. It seemed to me he was curiosity personified, curiosity magnified into a giant, as though he were being curious in advance for all his readers.

Sometimes this giant of curiosity made mistakes, as in a caption he wrote under one of my Dodge Company pictures. When the South Bend story was published, *Fortune* received a flock of letters from readers, pointing out that the object in the foreground which had been labeled a crankcase was actually an engine block. Today a point like that would be snapped up and checked by a researcher long before it reached print.

The whole approach to the South Bend story caught my imagination and taught me a great deal. Earlier, when working

by myself on industrial subjects, I would have gone through factories such as these, spotted the points where I could make striking compositions, and taken my pictures. Working for the integrated whole required a much wider conception. It added another dimension to photography. It gave the camera one more task: pictures could be beautiful, but must tell facts, too. And the idea of searching to record "the unseen half" was, I decided, an invaluable habit for a photographer to form for use in many places besides South Bend.

An important item, and an exciting one, in planning a new magazine is the choice of the first story for the first issue. I am very lucky to have had the chance to take the photographs for this keynote spot twice in my lifetime, here with *Fortune*, and six years later with *Life*.

With *Fortune*, the decision for the lead was made very carefully. Essentially it must be an industry at the heart of American life and economy. Photographically it must be an eye-stopper—an industry where no one would dream of finding "art."

Our first candidate was International Harvester. Tractors and mechanized farm machinery were certainly close to the American economy, and the subject gave us a running theme which I could photograph, from the factory to the wheat harvest. But we were still running into occasional red tape and delays in getting permission to take pictures for this magazine nobody had yet seen. When the tractor company proved "stuffy," as Parker expressed it, we switched from wheat to hogs.

Hogs were a wonderful choice. Certainly most of our readers would not expect to find beauty in the Chicago stockyards. But to Parker and me, the interior of the Swift meat-packing plant, where we spent a week, had a Dantesque magnificence. Daily some twenty thousand pigs went the way of all pork flesh, and were carried in solemn procession along the assembly line. Parker called it the "disassembly line" and pointed out in the piece he wrote for *Fortune* that "each pig was divided and subdivided as exactly as a suburban real estate development."

As I made pattern pictures of giant hog shapes passing through a corona of singeing flames, or under the flashing knives, Parker Lloyd-Smith, looking like a London fashion plate that had been set down in the most incongruous place possible, gathered his research.

The immaculate Parker Lloyd-Smith went into every nook
and corner of the meat-packing plant but one. On our last day
of work, we peeped into a building, hitherto unvisited. Count-
less times we had heard the well-worn adage that the Swifts used
all of the pig but the squeal. The sight that faced us proved it.
Before us were pungent macabre mountains—rich tones of ochre
in the yellow light—mountains of the finest pig dust. This was
the last of the pig: the scraps, the leftovers, soon to be mixed in
meal, fed to livestock including presumably pigs, whereupon as
though following some Oriental doctrine of death and rebirth,
it would continue its endless reincarnation as meat and meal again.

Parker Lloyd-Smith took one sniff, bolted for the car and
put up the windows tight while I took the photographs. He had
a long wait, for the yellow light had low actinic value and I had
to make time exposures. When it was over, I left my camera
cloth and light cords behind to be burned.

After we returned to New York, the hospitable Swift officials
sent us prize steaks from their finest prizewinning steer. Parker
took them to the chef at the "21" Club and gave a party at which
the prize steaks were ceremoniously eaten.

At a luncheon with Parker Lloyd-Smith, Tom Cleland, the
noted typographer and *Fortune*'s first art director, sketched on
the tablecloth his idea for *Fortune*'s first cover: the wheel of
fortune, to be done in bronze tones on a golden background.
Parker tore off the piece of linen and framed it for his apartment.

Then a twist of the fateful wheel nearly cost us *Fortune*
magazine when it was still three months unborn. The event took
place in late fall. I was in Boston at the time, doing a job for the
First National Bank: a series of architectural photographs of their
newly decorated lobby, which would run as ads in forthcoming
issues of *Fortune*.

While I was in Boston, I acquired a new and glamorous boy
friend from Harvard who was going to take me to a football
game. Hoping to be able to make a few searching remarks to my
escort during the game, I had been secretly cramming—whenever
I had a moment—on a slender volume entitled *How to Under-
stand Football*.

I had so many pictures to take to finish up the bank job that
I decided to work at night. The chief electrician of the bank
generously consented to stick with me the whole night through.

We could work better at night anyway, we both decided, for there would be no one to get in our way.

Expecting to see the bank lobby deserted after nightfall, we were astounded to find it full of vice-presidents and other bank officials running about, conferring, leaning over their desks, darting here and there with memos. Since my time exposures in the cavernous bank lobby had to be very long, I found this quite a nuisance, as I had to cap my lens every time a vice-president dashed in front of the camera. Undoubtedly the vice-presidents found my lights an equal nuisance, for I used strings of 1,000-watt Vent Lites (this was before the flash and strobe era) and these were blazing in their faces. But they seemed too preoccupied even to complain of the lights.

My electrician, however, had no hesitation about registering complaints from our side. He was a stout, little barrel-shaped man who had been a professional bicycle rider in his youth. He took a strong stance beside the tripod and muttered every time a bank official rushed in front of the camera, "Oh, give the little girl a break."

Finally one vice-president paused to talk back. As though he were addressing a very little girl indeed, he said, "I guess you don't know, the bottom dropped out of everything." The bottom dropped out of what? "The stock market! Haven't you read the papers?" I hadn't. I had read only my football guide. "They're carrying everything away in a basket."

With these words, the official ran back to his worried conferences, and my aide and I returned to our task of sweeping the field free of people for each photograph.

The significance of the stock market crash may have been lost upon me, but it certainly was not so with the editors and stockholders of our publishing enterprise. They had a worried conference of their own in which the fate of *Fortune* hung in the balance, but happily they decided to take the risk, go ahead just as planned, and bring out Vol. 1, No. 1 in February, 1930.

Years later, after both *Fortune* and *Life* were on a substantial basis, I happened to tell this incident to Roy Larsen. "To think," he said, "you must have been the only photographer in the whole United States who was *inside* a bank that night."

History was pushing her face into the camera, and here was I, turning my lens the other way.

Log rafts on their way to the paper mills cluster like lily pads on the surface of Lake St. John, Canada. Newsprint story for Fortune.

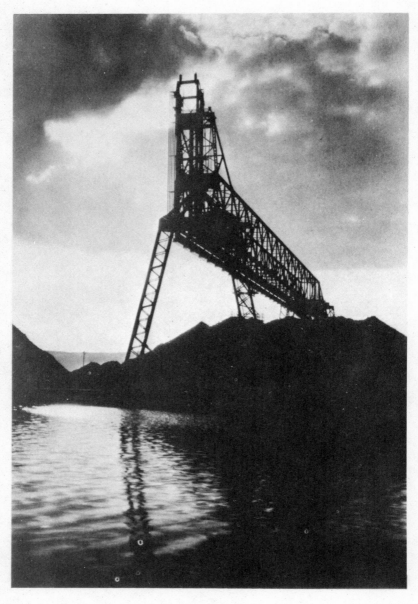

A coal rig rises like a dinosaur on the shore of Lake Superior. Used by Fortune *in the Great Lakes story.*

George Washington Bridge, photographed for Fortune's *story on the Port of New York.*

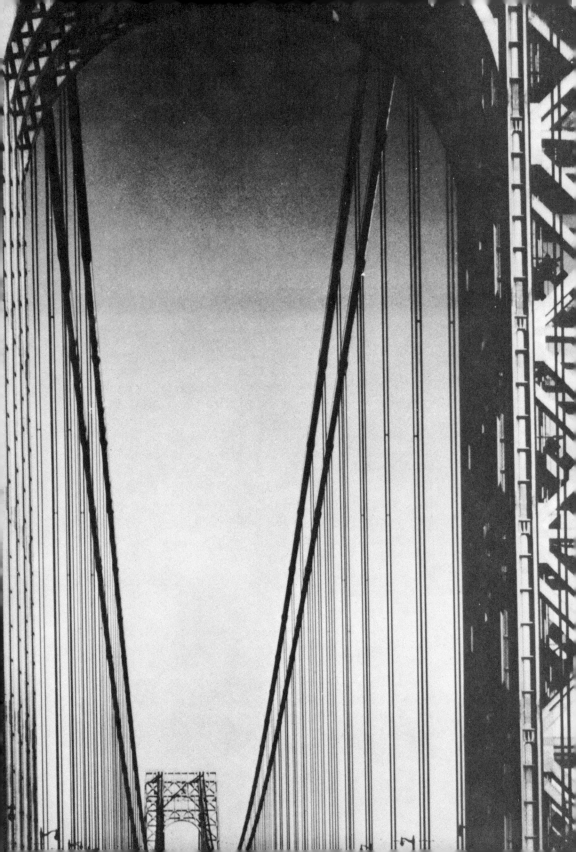

CHAPTER VI

SKYSCRAPERS
AND
ADVERTISING

Hɪsᴛᴏʀʏ had been on my side longer than I knew. She had allowed me two years from the time of my graduation from college to make my industrial explorations before ringing down the curtain of depression on the expansive twenties. She had pushed me around the corner into the meager thirties, and even though I did not always heed her or hear her, she was making of this something more than the turn of a decade. She was building in enough social ferment to keep photographers busy in many countries for many years. But meanwhile, there was still some of the bounce of the boom period left, and I am grateful to her for getting me to the right place at the right time to photograph a most curious event—a heaven-climbing contest which could take place only in America—indeed, only in Manhattan, where a tight little island must pile itself layer on layer upward if it was to grow at all.

In this battle of the skyscrapers, the chief contenders were the 927-foot Bank of Manhattan and the unfinished Chrysler Building, slated to rise to more than 1,000 feet, and I was brought in as a sort of war correspondent on the Chrysler side. The scene of battle was that relatively narrow band of atmosphere ranging from 800–1,200 feet above the sidewalks of New York. Who can doubt that this was a forerunner of the contest for

outer space which would follow after a quarter of a century? Then, as now, a principal target was prestige. A skyscraper was a tall and strong feather in the cap of that ultra-rare individual who could afford to build one.

For forty years the championship was held at 792 feet by a tower ornamented in the Gothic style and erected literally on dimes and nickels: the Woolworth Tower. Certainly Mr. Walter Percy Chrysler was aware of the stupendous advertising value generated when the world's highest building bears the name of your product. And this was where I came in.

A dastardly rumor had been circulated, undoubtedly by some busy banker, that the Chrysler Building would not actually surpass the Bank of Manhattan, despite the Chrysler claim of total supremacy at 1,046 feet. The insinuation was that the Chryslers were merely pasting on an ornamental steel tower to gain the few feet needed to make the world's record. I had been photographing the mile-long Chrysler factory in Detroit and was given the job in New York of taking progress pictures of each stage of construction to show that the tower was an integral part of the building. The Chryslers need not have gone to such lengths to prove their supremacy, because in one short year it did not matter anyway. All the man-made structures of this planet would be topped by a spire rising to the magnificent height of 1,250 feet, freezing the world's altitude record to date, and built by a man named Smith.

Fortune ran one or two of the Chrysler Building pictures. I don't know whether the photographs proved anything except that a photographer has to work in all kinds of weather. I had to take pictures during the midwinter of 1929–30, 800 feet above the street, working on a tower that swayed 8 feet in the wind, often in subfreezing temperatures, but all this did not bother me too much. Perhaps it took more out of me than I was aware. I recall one occasion when I had worked all day on an open scaffold and then descended fifty steps of unfinished stairway under my own footpower. After summoning a cab, I found I could not make the step from the curb into the taxi. I fell and cut my shins, a trivial thing, but often I am impressed with how the human body will store its little infirmities until there is time to deal with them.

Heights held no terrors for me. I was lucky in having a God-given sense of balance and also a great deal of practice in my childhood. My sister Ruth and I had a pact to walk the entire distance to school and back on the thin edges of fences. It was a point of honor to dismount only for crossroads and brooks. Here on the heights of the Chrysler tower, I had additional instruction from the welders and riveters who gave me a valuable rule which I have often remembered and acted upon: when you are working at 800 feet above the ground, make believe that you are 8 feet up and relax, take it easy. The problems are really exactly the same.

On the sixty-first floor, the workmen started building some curious structures which overhung 42nd Street and Lexington Avenue below. When I learned these were to be gargoyles à la Notre Dame, but made of stainless steel as more suitable for the twentieth century, I decided that here would be my new studio. There was no place in the world that I would accept as a substitute. I was ready to close my studio in Cleveland in order to be nearer *Fortune*, but it was the gargoyles which gave me the final spurt into New York.

It was surprisingly difficult to get my studio space. The Chrysler people seemed to think that since I was female, young, and not too plain, I would surely get married before much time went by. That would put a stop to all this photography business, and then who would pay the rent? *Fortune* helped me to get the studio space. This did not mean any concession on the part of my august landlords, in the size of the rent, which was as high per square foot as any in the city. It was just that the privilege of paying rent became mine.

My first step was to apply for the job as Chrysler Building janitor. This was not because I wanted to run up and down its seventy-seven stories with a floor mop. I wanted to live in my studio, and there was a New York City law which stipulated that no one could live in an office building except the janitor. I was turned down for the position of janitor. Some other more fortunate tenant, perhaps one of the Chryslers themselves, had beaten me to it. I loved my studio so that I hated to go home at night. Frequently I worked the whole night through until dawn came and the mist rolled back revealing the great city below.

Working from the modern gargoyle outside my studio window, the sixty-first floor of the Chrysler Building, 800 feet above the sidewalk.
[PHOTOGRAPH BY OSCAR GRAUBNER]

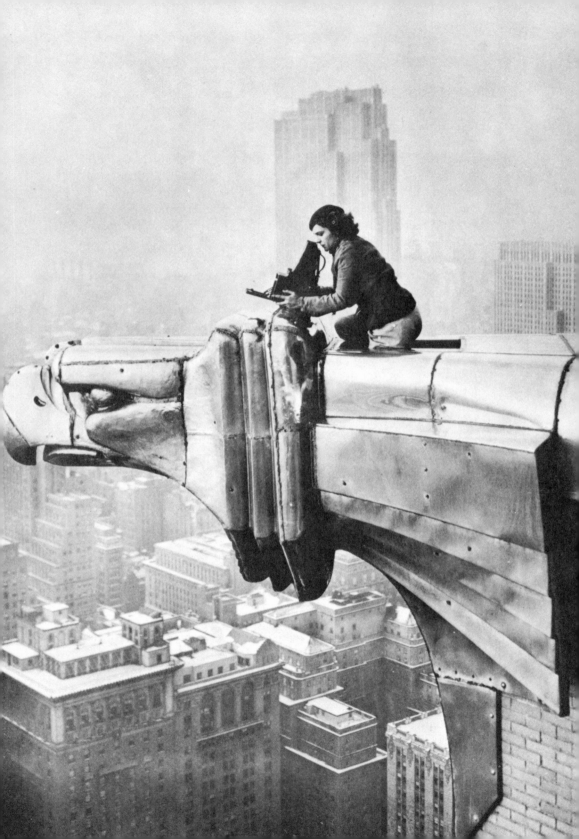

I would brush my teeth, run out for a hot breakfast and come back to work. I hoped this was legal.

It turned out that I had not one but a pair of gargoyles resplendent in stainless steel and pointing to the southeast. This was certainly the world's highest studio, and I think it was the world's most beautiful studio, too. It was furnished and decorated in the most modern simplicity by John Vassos, who is a man of considerable designing talent and also a dear friend. Vassos has a strong feeling for unadorned materials. I had a clear glass desk, a tropical fish tank which was built into a wall, and natural wood and aluminum were used everywhere.

I loved the view so much that I often crawled out on the gargoyles, which projected over the street 800 feet below, to take pictures of the changing moods of the city. I had a large terrace where I gave parties and a small terrace where I kept two pet alligators which a friend had sent me from Florida. The alligators, plus a few turtles, reminded me pleasantly of the herpetology days of my childhood. At feeding time, I tossed the alligators big slabs of raw beef which they playfully tore from each other. They grew very fast and ate a great deal, even bolting down several of my turtles, shell and all. I thought they would find this meal quite indigestible, but they calmly slept it off. It astonished me to find the law of the jungle operating in a penthouse at the top of a skyscraper.

No one, so far as I know, achieves a penthouse studio without acquiring a couple of husky advertising accounts to keep it going. My two accounts were Buick cars and Goodyear tires. It was inevitable that I would slip into advertising work as soon as I moved to New York, particularly since the larger industries in the Cleveland, Akron and Detroit areas, where I had already done a considerable amount of work, had accounts with advertising agencies in New York.

The real gift of the advertising business to me was practice in precision. I never felt I was a very good advertising photographer, but the practice I got while I tried to be a good one was invaluable. I have always been glad I stayed in Cleveland and close to the industries of the Midwest until my style and, even more important, my convictions were formed. But once in the advertising field, I was glad to have a chance to learn so much in a very stiff school. ·

In taking advertising pictures, if you have to photograph a surface of polished silver, it must look more like silver than silver itself. This is difficult because the mind's eye fills in the glossy surfaces with more light than is actually there. The more direct light you throw on the subject, the more like a black mirror it becomes. You need indirect light and big sheets and white tents for reflectors and a prayer that you don't find the image of yourself and your camera in the negative when you develop the film the next morning. If your subject is soup, it must out-soup any you ever dreamed of, with fragrant fumes rising straight from the film gelatin. If you photograph a rubber tire, it must look more like rubber than rubber itself. This became my specialty.

In my glorification of the rubber tire, I concerned myself not only with the rubbery aspects of the tire itself but with the tire tracks and the tire's supernatural powers. These were tires that had a built-in magic called "The Goodyear Margin of Safety." A car equipped with these tires stopped almost automatically before running down helpless pedestrians and always, in stopping, allowed just the right amount of space on the street for the enchanted slogan "The Goodyear Margin of Safety," which the airbrush man would letter in before the ad reached the *Satevepost*. And oh, the darling little children who fell off their tricycles or their bicycles or tripped on their roller skates square in front of an oncoming car. The Goodyear Margin of Safety saved their lives every time.

This magic margin worked for adults, too. Our favorite character was the American housewife carrying home her groceries. Over and over she flung herself in front of cars for us, spilling a veritable cornucopia of groceries: potatoes that would roll and eggs that would smash.

I remember a gigantic production, a rainy day scene for which we made king-size arrangements such as getting permission to rope off a whole city block on the upper East Side. We chartered a bus and filled it with professional models as passengers who expressed emotions of horror when our housewife slipped in the wet street. As the crowds of bystanders gathered, we put them to work, too, expressing as much horror as they were capable of. One of our leading characters was the policeman, a model of appropriate build who wore a hired police uniform and slipped instantly into postures of great drama on demand.

The rain petered out before we got well started, and we bought a couple of lengths of garden hose and got permission to connect them in somebody's cellar. We had our policeman model thoroughly hosed down, and I was adding a last-minute touch with a little watering can to create artistic drops tumbling off his hat, when a real policeman appeared and demanded our license. What license? The one for turning on a hose in the street. What should we do? In a wordless exchange of messages it became quite clear to the policeman that this would be worth his while. It was. With extreme tact, he left. One minute later I wished he had stayed. The departure of the policeman was a signal for all the children from blocks around to come pouring in. This was a severe problem for me. Several good takes were ruined by the surge of children into our working area, pushing each other, overflowing into the picture. In my efforts to shoot over their heads, I jumped on the hood of a car parked by the curb. An angry man snarled that I must get off his car. His equally angry wife rose to my support. It wasn't his car, it was her car. The young lady could stay there as long as she liked. This brought about a lively scuffle between the two. While I was deeply grateful to my benefactress, I did wish the two of them would carry on their argument somewhere other than in front of their car, where they effectively blocked off the scene I had been trying for so long to photograph.

Small wonder that after a session like this I welcomed the chance to go quietly to jail. This involved the problem of getting before and after shots for a hair tonic ad. The regular model agencies had no man on call who was willing to emerge from this job as hairless as a billiard ball. The pictures, of course, would be taken in reverse. Finally we managed to get permission to press our search behind prison walls, and there we found a cheerful convict overwhelmed to obtain legally a fifty-dollar nest egg in exchange for losing all his hair. He was a lifer and had plenty of time to grow it back.

The chief question to answer when taking advertising pictures was "Is it convincing?" Since much of this work had the aspects of a madhouse, I especially welcomed that word "convincing." Passing this test I always felt was valuable experience for a photographer.

My most unusual job, and one which no one expected to be convincing, was to photograph a knight in shining armor in Central Park. This was one of a series of six institutional ads which I did for the Scripps-Howard newspapers, and I can no longer remember what the idea was behind the ad, but I suppose the symbolism is clear whether the shining armor is worn by Scripps-Howard or by Sir Galahad.

The agencies had no one on call who could handle a horse and manage shining armor, too. Finally I found some friend of a friend who was intrigued by the problem and began researching all possible sources of shining armor in New York. He investigated stage armor at the costume companies, and backstage opera supplies, discarding them all as unworthy. Then he visited museums until he found a well-fitting and authentic steel suit and secured permission to wear it. Getting a horse was easy. There was a riding academy close to the Park. It was no fault of the horse that it had learned nothing of knight errantry during its lifetime beat around Central Park. The hoist used in medieval times to raise a king into his saddle was naturally unobtainable. It was a tribute to the horsemanship of our knight that he managed to mount the terrified, charging beast before the stable was knocked to pieces. Once in the park, the horse and rider looked splendid against the trees and sky. And only after it was all over, I learned that the armor, which had seemed to be molded to his figure, gouged and pinched at all the joints every time the horse made a movement. When I think of the willingness with which he cantered for me in spite of these tortures, I look back on it as an act of purest twentieth-century chivalry.

The medieval knight galloping through Central Park in his shining armor may have seemed misplaced by a few centuries to startled pedestrians, but to me he was no more incongruous than the shiny automobiles, strictly twentieth-century, which I photographed for the advertisers. Truly these were enchanted motorcars. No sorrow ever befell their occupants. The joy on the faces of the drivers and the driven was indelible. As with the world of Buddha while he was still an earthly prince guarded from any knowledge of unhappiness or want, life with the right motorcar held no poverty, no old age, no grief. The lucky passengers who motored through the advertising pages were

perpetually headed toward paradise, where all they had to do was smile, smile, smile.

I, too, should have smiled. The jobs rolled in—so many of them I had to increase my staff of two to eight in order to handle them, and then I had to take still more jobs to pay the larger staff. The highest studio in the world was fast becoming the highest squirrel cage in the world.

In the reception room of my studio I had a lovely rug of an unusual raspberry shade, which Vassos had done some little searching to find. For days at a time it disappeared from sight under protecting newspapers and inroads of whatever product I happened to be photographing at the time.

On one occasion this was chewing gum, tens of thousands of slabs. While doing this job I could not restrain frequent glances over my shoulder to make sure my mother was not walking in the door. Actually, I knew very well that she was at her home in Cleveland Heights, Ohio. In my childhood my mother had been so strongly anti-chewing gum that my sister Ruth and I had to park our gum on a telegraph pole a block away from home to be picked up next morning on the way to school. Even in my lofty penthouse the sense of disobedience remained.

In rapid tempo the chewing gum was elbowed out by an impressive collection of star sapphires. Then there was an invasion of cosmetics with twelve hand models reaching their twenty-four flawless hands toward the nail polishes. Nail polish gave way to an enormous medieval lace tablecloth. Kings and popes had eaten from it. This priceless dining cloth was followed by Chesterfields—smoking was good for you in those days. The cigarettes bowed out to Oscar of the Waldorf, who came with a strawberry mousse in dry ice, followed closely by the food editor and her helpers from the *Ladies' Home Journal*, for whom I was photographing the strawberry mousse in color.

Photographing anything so perishable as ice cream in color, in the early '30s, was an heroic undertaking because of the interminably long exposures, which involved making three separate color plates representing the three primary colors to be matched up later. The equipment was crude, the lack of uniformity in the color emulsions was maddening, the awkward glass color plates were so slow that the only answer was to pour

on more and more light and hope for the best. Few dishes of ice cream would stand up under such treatment. I was not too badly off with a great cumbersome specially built camera, nicknamed the Queen Mary, which had the advantage of exposing three color plates simultaneously. Oscar Graubner, my excellent darkroom technician, calculated that the mousse needed a full ninety-second exposure, even with all our blazing floodlights. A pat on the mousse by Oscar of the Waldorf, a pat on the wing of a Vent Lite by Oscar of the Bourke-White Studio and we were off. We sat on the floor in an anxious semicircle. I held the shutter control in my hand as I counted off the lagging seconds. I could see the mousse softening, but it was giving me all it had. On the eighty-fifth second, like an Alpine avalanche, it slid majestically downward, collapsing in rivers of pinkest foam. I had pushed the trigger just quickly enough to catch the image of the mousse intact with a little blur—that hint of movement which has became so popular in recent years. When it was all over, the ladies of the *Ladies' Home Journal* said, "Dear Miss Bourke-White, if we had only known of the temperature difficulty, we could just as well have photographed a pudding!"

I often thought that foods I photographed worked as hard as any living models I ever saw. There were the artistic grapes which had been O.K.'d as a background and therefore mustn't be removed until we got an O.K. on the new foreground. The grapes deteriorated from back to front, fortunately. While we made our shots, we had to use a fan to keep the clouds of fruit flies out of the pictures. Then there was the regal lobster who overstayed his welcome, but the less said of him the better.

The food pictures, whatever their individual difficulties may have been, were always on the credit side of my personal ledger. I was getting valuable experience with color at its awkward age. Instead of making garish imitations of nature, which I have always felt was a mistaken use of the medium, I was working in a situation where I had the greatest freedom of arrangement. This gave me a chance to think first in terms of abstract color pattern and then build my composition with color in the front of my mind. From the start, I felt that color photography was a separate medium, as different from black-and-white photographs as movies are from stills. It ought not to be used as a fancier edition of some

snapshot that could be taken as well in black and white. Color should be used in its own creative way to realize the full potentials of the medium, and now after a quarter of a century these potentials are greater than any of us could have foreseen.

I have often wondered what readers of the women's magazines would think if they knew how the foods pictured in glowing color were handled, squeezed, patted into shape, glued, propped up, mauled, varnished. The greatest expert at this was Fanny Herrick at the *Delineator*, for which I did a monthly food page in color until the magazine folded, shortly after *Life* began. Whatever the photographer's eccentric needs, she could fill them with artistry—and, best of all, durability. When Fanny went out of her way to prepare something particularly delicate with a frothy topping like a feather in lightness, you could bet your bottom dollar that if you walked over and touched it, you would find it approached the strength of concrete. Fanny's foods wore well. So did Fanny. I just loved her.

Only once can I recall an occasion when I or anyone else wanted to eat the food I photographed. I had spent the morning in New Jersey, trying out the very first airplane camera of my life. The pilot took me on a dry run with several aircraft and decided I would do best from an open cockpit. This was the first open cockpit I ever shot pictures from and, I am thankful to say, the last. I stood erect on the back seat, roped to the seat frame and chassis, with the windstream searing me through the middle. When we landed I could hardly stand. Trembling with fatigue, I got into a taxi and headed toward New York. I was already late and dared not take time to eat. When I arrived at the *Delineator*, I found our subject—a big fish—was already laid out and waiting for me to give decisions on final details. The fish reposed in splendor, encircled by rings within rings of tasty tidbits. My eyes could move no farther than the pearly, pebble-sized potatoes dotted with parsley, glistening with melting butter, which this time were warm and real. The sight made me so hungry I couldn't think of it as a picture. I couldn't even answer people's questions about what to do until somebody asked, "Miss Bourke-White, we held up on these lemon slices because we felt that both the little potatoes and the lemon touches would be too much. It should be one *or* the other. Which do you prefer?"

"Oh, certainly use the lemon slices. We need that hint of yellow," and I scooped up all the little potatoes and gobbled them down.

I attached great importance to appropriate costumes for each many-faceted day, for I loved clothes. But sometimes changing took a little figuring out, as on the day when I photographed the George Washington Bridge. This was part of a picture story for *Fortune* on the Port of New York. The bridge was under construction then and breathtakingly beautiful, with no floor yet built but with the gossamerlike cables gracefully strung from bank to bank. I had been waiting for just this phase of the construction, and it was my bad luck that it came in midwinter on a zero day and also when I had an engagement at the French Consulate for lunch. To the windswept bank of the Hudson I brought everything I thought I would need for both engagements. I spent the morning perched high over the ice-flecked Hudson River on the mighty cables, which, on closer acquaintance, I found to be not gossamer at all but as thick as tree trunks. Just before noon I descended and hopped into a cab. Having requested the driver to keep eyes front, I changed my clothes as we drove to the French Consulate and arrived comfortably in time for the *pâté de foie gras* which opened the feast.

With each new advertising assignment, it seemed that the props grew bigger and bulkier until it became imperative that I get more floor space. It would not have occurred to me to look lower than a penthouse. Finally I discovered, at 521 Fifth Avenue, one of those odd and beautiful floors that sometimes exist on top of skyscrapers, housing a bit of machinery and never meant for a tenant. Its only disadvantage was that it was above the elevators, and to get to it you had to climb a steep flight of stairs. But once you were up there, it was gorgeous. Though it was a mere forty stories high instead of sixty-one, as my Chrysler Building penthouse had been, it was still the highest studio of its kind in the city and probably in the world. I marvel that this seemed so important to me then and so unimportant later. Again John Vassos decorated my studio, simply and colorfully, keeping the dramatic sweep of the place. The lofty ceiling, which soared overall at a height of 20 or 30 feet, Vassos did in a wonderful dark blue which became shadowy and mysterious, or vibrant

with light, as the time of day moved onward. It had tall slender cathedral windows and even an outside terrace to accommodate the alligators.

I was living a sort of double life now. As always, half of my time each year went to *Fortune* through an arrangement which I had asked for from the very beginning so I could do other jobs, and which had worked out most satisfactorily for both *Fortune* and myself. During the other half of the year I wrestled my way through the mad world of advertising. I was always glad when *Fortune*'s time rolled around again.

Fortune assignments always had some new viewpoint and were exciting to do. They made refreshing interludes for me between the sieges of advertising. When *Fortune* was launched in 1930, many people said the magazine could last only two years. Why they always picked two years I do not know. The reason they gave was that by then all the industries would be covered and there would be nothing new left to photograph. After much more than two years, there was plainly no danger of running out of subjects for *Fortune* stories. And in a deeply personal way I knew I would never run out of subjects that interested me while on this earth. I would always have zest for as much of our dramatic world as I could place within lens reach.

Although subjects for *Fortune* had not run out, after two years, time had run out for *Fortune*'s first editor. Somehow the enchantment of living had faded for Parker Lloyd-Smith. No one knows why on a humid September morning, just before sunrise, Parker should have jumped from his fifth-floor apartment window, leaving only a cryptic note: "My Lady Mother—It's so hot. . . ." What unbearable problem was he escaping from? He was brilliant, young, with an independent fortune, and a fascinating job. After pouring his singular talent into the creation of the magazine, did he lose interest when his child began to walk, run, need more editors, become more impersonal? His accomplishments had seemed so perfect up to now, perhaps it was hard for him to face any aging, any flaw in the perfection.

Years later, a close colleague on *Fortune* told me she believed he had been planning his suicide for months. He was taking flying lessons, somewhat uncommon in those days of 1931, and, still more uncommon, he was buying his own plane. Was he pre-

paring his last great flight out over the ocean, pressing on as far as his plane would go until he lost himself in sky and sea? No one knows.

I heard the news in Geneva, where I was visiting the League of Nations. I could hardly believe it then, and after all these years, I hardly believe it now. To this day, when some droll little thing takes place, peppered with a special whimsy, I look around for Parker to share it with, and miss him afresh.

CHAPTER VII

THE COUNTRY
OF THE DAY
AFTER
TOMORROW

I‌N THE EARLY thirties, when *Fortune* was in
its infancy, the land of tantalizing mystery was Russia. No for-
eign photographers had been allowed across Russian borders to
take a direct look at what was going on under the Soviet Five-
Year Plan. Foreign engineering consultants—mostly Americans—
came and went with comparative freedom. But for the profes-
sional photographer from the outside world, it was a closed
country. Nothing attracts me like a closed door. I cannot let my
camera rest until I have pried it open, and I wanted to be first.

With my enthusiasm for the machine as an object of beauty,
I felt the story of a nation trying to industrialize almost over-
night was just cut out for me. Peasants who had been taken
from the plow and put on the punch press—how did they man-
age this jump of centuries? Although my approach was non-
technical, I had been in factories enough to appreciate that indus-
try has a history—machines are developed and men grow along
with them. Here was a unique opportunity to see a country in
transition between a medieval past and an industrialized future.

No one could have known less about Russia politically than
I knew—or cared less. To me, politics was colorless beside the

Iron puddler at Red October Rolling Mill, Stalingrad, U.S.S.R., 1930.

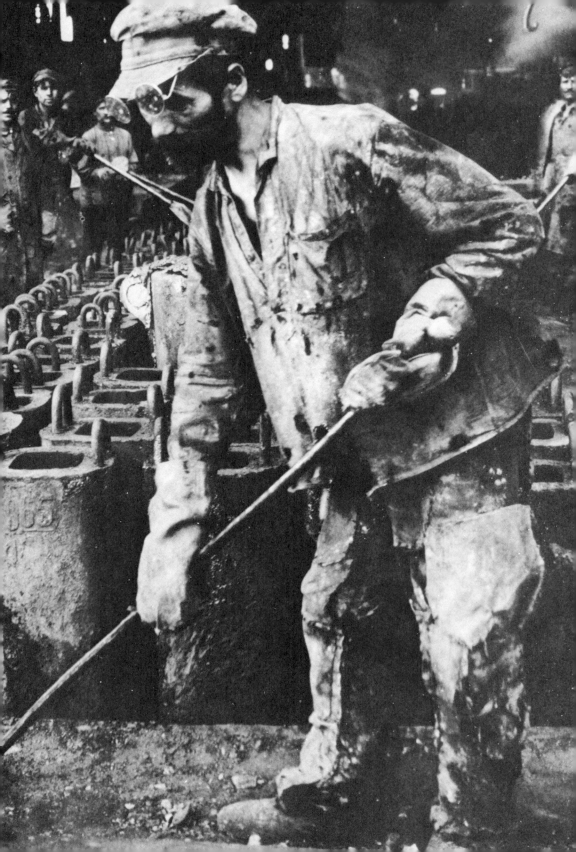

drama of the machine. It was only much later that I discovered
that politics could be an absorbing subject, with a profound effect
on human destiny.

The person most helpful in giving me background on Russia
was Cleveland's live-wire city manager, Dan Morgan. From him
I got some conception of the tremendous range of heavy indus-
try being built with the technical assistance of American firms.
There was virtually a little Cleveland within Soviet borders.
Warner & Swasey and Foote-Burt were tooling up Stalingrad.
Two of Cleveland's leading construction companies, McKee and
Austin, built some of the biggest installations in the Soviet Union
—from steel mills in Siberia to oil refineries on the Black Sea.

Detroit, too, was prominently represented by Ford; Schenec-
tady by General Electric. Ford's industrial architect, Albert
Kahn, was laying out the entire group of factory buildings for
Stalingrad, now Volgograd. The Newport News Shipbuilding
Company was furnishing what were then the world's largest
hydroturbines for Dnieprostroi, and the huge Dnieper Dam was
erected under the experienced direction of Col. Hugh L. Cooper,
builder of America's Muscle Shoals.

These great American builders and their staffs of engineers
and planners were not, of course, dangerous Reds, or even
fellow travelers. They were not working for ideological or
propaganda purposes, but strictly for business reasons or—as the
Marxists might have said—"the profit motive." The role played
by American industrialists in building up the Soviet giant cannot
be overestimated.

The idea of running photographs of the sprouting industries
of the U.S.S.R. intrigued *Fortune*'s editors, but they had grave
doubts whether I could get anything done. They were sending
me to Germany to take pictures of industry, and I decided to
push on from there. I had applied for a Russian visa six months
earlier at Intourist, the Soviet travel agency in New York. In
Berlin, I was puzzled when I discovered my visa was not waiting
for me, because the Intourist official had been so enthusiastic
about my industrial photographs. "Your pictures will be your
passport," he kept repeating.

Not only was there no visa at the Soviet Embassy in Berlin,
but the officials there had never heard of my grand plan to

chronicle Soviet industry, or of me either. I opened up the ever-present portfolio of my industrial work and was told again my pictures would be my passport. The Embassy officials dismissed me courteously with instructions to return the day after tomorrow. I returned the day after tomorrow and continued to do so for five and a half weeks.

I woke up before dawn one morning and restlessly started walking from the Hotel Adlon past the Brandenburg Gate and up Unter den Linden. As I passed under the window of the Soviet Embassy, I heard a whistle over my head. I looked up, and there, at the window, stood the Soviet consul. He was waving a piece of paper. It was the telegram granting my visa.

I bought a cheap trunk and filled it with canned food. I had been warned that if I traveled off the beaten path, I would find near famine conditions. That night I left for Moscow.

During my trips in the early thirties—and I made three brief ones—Russia was always the land of the Day After Tomorrow. I suppose the underlying cause for the many bureaucratic delays was fear of taking responsibility. The confusion was deepened by a novel experiment designed to get rid of bourgeois Sunday. People took their "day of rest" every five days, not on the same day but staggered. The purpose was to make work continuous. The result was highly discontinuous. It seemed a puzzle ingeniously designed so that the man you wanted to see on any particular day was away enjoying his day of rest. I have never known anything since to compare in sheer difficulty with my assignments in Russia: the baffling postponements, the mysterious absence of reasons. It was a valuable experience, and I am glad to have had it so early in my work. Russia was a lesson in patience.

Even getting to one of these evaporating appointments was a feat. Taxis were rare and apt to break down on the way. Next choice was a droshky, a carriage so worn it seemed a breath would blow it to pieces. You were at the mercy of the bearded driver who might dump you out halfway to your destination if he thought his horse was tired. The next possibility was to get on a streetcar if you could get the conductor to stop when it was literally dripping with human beings.

I remember a day when my interpreter and I squeezed into

one of these bursting streetcars. The conductor held out her hand for our fare: "Ten kopecks."

"We do not have change," said my interpreter. "But here's a ruble."

"But I cannot take the ruble. I cannot take tips. It's against the law."

"What shall we do? We have no kopecks."

"Get off the car." The conductor stopped the car in the middle of the crowded street, and in true Russian fashion, the passengers discussed our dilemma.

While the debate raged, streetcars halted, traffic slowed to a standstill. Finally, the passengers rose unanimously to our support. We could stay on the car. We could keep our ruble. The car started and the blocked traffic rolled into motion again.

With all the absurdities, there was a quality about the people I can only call exasperating charm. On my visits to the various commissars, I was always received hospitably. Inevitably, I was told two things: one was to return the day after tomorrow; the other was that my pictures would be my passport. Yet I was fortunate in having something as tangible as my pictures of American steel mills, factories and refineries to show what I wanted to do photographically in the Soviet Union. I began getting very limited permission to take pictures in and around Moscow. On alternate days, I did what little work I could, and on the Days After Tomorrow, I visited the Commissariats of Heavy Industry and Railroads, pressing for a big tour with proper authority to travel and take pictures.

During these visits, scores of admiring Russians crowded in to examine minutely my pictures of American factories, while I slipped in reminders that there were many beautiful pictures to be taken in Soviet factories. I had come for only a few weeks, and already half of my time had trickled uselessly away.

"Yes," the officials would say. "The *Amerikanka* is right. The great Lenin said, 'Time is our most precious possession.' "

I don't know whether it was the counsel of the deceased Lenin that took effect or my persistence, but finally the Day After Tomorrow really came, and I set out to tour the industrial centers with a highly competent young girl interpreter, my trunk of food, my bulky camera cases, a sheaf of permits and, most important, that portfolio of photographs that indeed was

to be my passport. The pictures soon became dog-eared and battered, but they opened many doors.

Everywhere I traveled, I heard about the *Amerikanskoe tempo*. It was the watchword of the hour, the ultimate in praise. In Stalingrad, particularly where the factories were modeled after Ford in Detroit, the workers adored the conveyor belt as a symbol of the Amerikanskoe tempo. The workers who gathered in crowds made suggestions, smoked cigarettes, eulogized the conveyor, broke into oratory at the very sight of it, did everything but run it.

At Dnieprostroi, during the first month, half of the locomotive cranes were busy picking up the other half that had broken down on the job. The workmen were like children playing with new toys. In the power installations, they acted as though throwing on a new generator was like turning on an electric fan. The endless meetings to decide whether or not to use a new tool exasperated the American technicians; tools were hard to get. The tractor was the object of special reverence, but still the tractor operators ran them up and down the fields like racing cars until they broke down.

Machine worship was everywhere; it permeated even the classic Russian ballet. Little girls with gear wheels in gold or silver painted on their chests danced Machine Dances. The people were worshiping at new shrines with the fervor of religious zealots. It was as though they needed to replace their religion—which was being taken away from them step by step. They looked on the coming of the machine as their Saviour; it was the instrument of their deliverance.

Anyone who was in Russia during this phase of the industrial program was entitled to the gravest doubts that anything could be made of such a mess. But after one year's interval, on a return trip to do six illustrated articles for the Sunday *New York Times Magazine*, I found significant changes. The workmen were beginning to operate the machines instead of marveling over them; the conveyor belts moved. There was nothing yet to match our familiar American scene of the production line, with rows of men on each side popping nuts and bolts into place along a steadily moving conveyor. Still there was less oratory, and more tending to business. Tractors were treated less like fiery steeds and more like instruments of agriculture.

Of course, people who want to learn can move mountains. This is true of nations as well as individuals. But with the Russians it was especially dramatic because the goals were so high. The Soviets were still a long way from the Amerikanskoe tempo, but with the *piatiletka*, the Five-Year Plan, Russia was entering a technological race, with the United States as the principal contender.

"The capitalist world is crumbling" was a convincing slogan if you had never been taught anything else. A great rash of posters broke out illustrating this theme. My favorite poster showed a plump capitalist in a top hat, tumbling through space in the midst of falling bricks from a collapsing skyscraper. I took it home and hung it in my skyscraper studio as a grim warning to my capitalist friends. It bore the slogan: "The Five-Year Plan is driving the coffin nails of World Capitalism."

Great prestige was attached to literacy. In the Ural Mountains, where the Magneto-Gorsk steel mills were under construction, I saw night classes in reading and writing held in the nearby villages. The pupils were middle-aged peasants; the teachers, high-school girls.

It is sad that with the coming of literacy, it was thought necessary to curb freedom of speech and to restrict freedom of ideas. The threat of ruthless force is a sorry platform for a new nation.

On one of my Russian trips, I made a movie—or tried to. Having brought in the first photographs to be made by a non-Soviet citizen, I was ambitious to do the same with a newsreel or travelogue. Movies were my latest passion. I had been experimenting with simple patterns in industry, which I hoped would result in a new kind of educational movie "short." Eastman Kodak had plans for an educational department and had shown a good deal of interest in my experiments. They generously gave me free film for this and the work in Russia.

The movies were not very good. Fortunately Eastman Kodak was able to salvage something it could use in its school program. I did all the wrong things: used big cameras, big films, big tripods. I composed each scene with lengthy care and took innumerable static views, forgetting that the important word in motion pictures is motion.

Having concentrated on industry in my earlier trips to the U.S.S.R., I decided this time to see the countryside and the peasants who lived on the land. I went south to the mountainous state of Georgia, which was the last of the major republics to come into the Union of Soviet Socialist Republics and whose people are independent and proud.

The fiery Georgians are large-eyed and handsome, and sing and joke more often than their countrymen to the north. They are often at emotional swords' points with the sterner northern Russians and consider themselves superior. They are immensely hospitable. In Tiflis, the President of Georgia, Gherman Andreevich Magalablishvili, and his seven commissars helped me arrange my trip and at the last minute decided to go with me. Several of the commissars had studied abroad and spoke French and German. The President was not an admirer of Stalin, although Stalin, too, was a Georgian. I later learned that he was "liquidated" in the notorious purges of 1938.

The President and his party took me on a horseback trip through the southern slopes of the Caucasus Mountains. My equipment was strapped on a couple of horses. When I was shooting, the equipment I needed most seemed always to be strapped to the wrong horse. At night we slept in caves. If we ran short of food, the President ordered the peasants to bring a live sheep. They cut off its head on a stone and roasted the meat over a fire. We ate it in delectable chunks. As we rode through the mountains, we passed little villages where the peasants sat on the roofs of their homes and sang to us. Their favorite song, and mine, was one they have been singing for many years. The words of the chorus are:

> *Mama, I want to go to America*
> *To bring back an American girl*
> *Who will come and sit beside you.*

It was unprecedented for them to have an American girl to sing it to, and this was cause for celebration. At each village, we dismounted and sang the song over the excellent local wine. In the Caucasus Mountains, you drink from a pointed wine horn which must be drained at one draft. Then you tip the final drop out on your thumbnail to prove you have drunk it all. Since I

*Dnieper Dam construction, first Five-Year Plan, 1930. In the fore-
ground is chief consulting engineer, Col. Hugh L. Cooper.*

*A blast furnace under construction in the Ural Mountains as part of
the first Five-Year Plan, 1931, Magneto-Gorsk, U.S.S.R.*

was their guest, they toasted me repeatedly. Each one had to drink only the toast he made, but courtesy demanded that I gulp down a hornful on every toast. This was no small feat since they toasted not only me but my parents and grandparents and cousins and uncles and the husband they hoped I would have.

By the merest chance, I happened to hear of Stalin's birthplace. In those days, the Soviets had not yet awakened to the high publicity value of building up their leaders as personages. Interest in family details was discouraged. I dared not appear too anxious. I knew the village of Didi-Lilo would make wonderful travelogue material, and I was sure it was a subject never taken before. The village was a small one, on the slope of a hill, and crammed full of Dzhugashvilis, Stalin's family name. Later, I was to hear that a bitter rivalry existed between Didi-Lilo and nearby Gori, both claiming to be Stalin's birthplace.

I was shown the mud hut where my guides told me little Josef, or Zozo, as his mother called him, was born. It was little more than a potato cellar, half underground, with an earth floor and a chink in the roof to let out the smoke. I met the sheriff who, years before, had arrested Stalin's father, a cobbler, for not paying his taxes. Stalin's mother had moved to Tiflis, but his great-aunt greeted me. With her bent shoulders and voluminous gray wool scarves wrapped around her head and neck, she looked like some great land turtle about to tuck itself into its shell. While I photographed the village, she prepared a meal of cereal and fat lamb scattered with pomegranate seeds. Stalin's relatives joined in the feast, the men seated cross-legged with me on the floor, and by Georgian custom, the women relatives standing near and serving.

True to form in the Dzhugashvilis' village, I was subjected to a drinking bout. Although the great-aunt did not sit with us, she stood and drank with us. At the end of the meal, she proposed a threefold toast: first, to their guest from across the seas; second, to their illustrious relative who had departed to Moscow; and third, to herself, because she was the oldest member of the party and needed the toast the most.

After all the joggling on horseback, my cameras were getting very balky, and by the time I reached Tiflis, where Stalin's mother was living, I had to coax and wheedle them to work. Ekaterina Dzhugashvili lived in a palace. The great rambling

Stalin's great-aunt, photographed in Didi-Lilo, 1932.

building in the middle of a garden was largely taken up by offices, but the old lady was given an apartment of two small rooms on the ground floor. The apartment was curtained in lace; there were antimacassars on the chairs, and small lace pillows were piled neatly on the bed. The walls were covered with pictures of Stalin, photographs and cartoons. Stalin's mother had never quite understood what her son's job was. She had wanted him to become a priest and had sent him to study with the Jesuits. She was deeply hurt when he broke away to join the revolutionary movement, and began robbing post offices to further his revolutionary work.

Stalin's mother was bewildered at being photographed and insisted on changing her clothes. She got into a long black dress and scarf, typical Georgian women's attire, black robe and bonnet edged with white lace. Where had I come from? She had heard of America, but she didn't know where it was. We went out into the garden in the fading light, and I tried to photograph her coming down a long flight of steps. There was scarcely a ray of daylight left. And as I cranked away while she did her little sequence, my movie camera leaped open and coils of Stalin's mother came out on the ground. I barely managed an abbreviated retake before sundown.

When I reached Berlin, on my way home, transatlantic phone calls started coming from New York. A transatlantic call was a great rarity in those days. The first call was from Fox-Movietone, offering to buy my film "sight unseen." This was followed by similar offers from other film companies. I should have placed it then and there, while the excitement was running high. But no, I was a perfectionist. I was going to supervise the cutting and editing of the film myself; then I would see about marketing it.

After I arrived home, executives of all the major companies phoned me frequently to find out when I would be ready to show my film. After a while just their secretaries phoned me. Finally, there were no more calls. The news interest had faded. I was left with my films and my bills. I had been hiring expensive help, professional film cutters and editors, each one supposed to be that "wonder boy" who could give a touch of greatness to any film footage. I could afford it no longer. I put the films back in their round tin boxes and decided to write them off as a loss.

Ekaterina Dzhugashvili, mother of Josef Stalin, photographed in Tiflis, 1932.

Then, the wheels of history turned. The U.S. recognized the U.S.S.R. There was a sudden wave of interest in Russia. The motion-picture companies began calling again. When a subsidiary of R-K-O made an offer, I jumped at it without delay. The film was made into two shorts called *Eyes on Russia* and *Red Republic*. My movie fever had burned itself out. I have never touched a motion-picture camera from that day to this.

Several years afterward, a newspaperman who is a friend of mine was traveling in the interior of Brazil. He walked into a tiny movie theater, and on the screen was my Russian film. He told me that the film had been broken and spliced so often, and the movements were so jerky, that he expected to see Stalin's great-aunt shinny up a tree and have a custard pie thrown down her decolletage.

CHAPTER VIII

MOTHER

SHORTLY after my ill-starred experiment with motion pictures, I suffered a great personal loss which drove any lesser troubles from my mind.

It was hard to imagine Mother ever would die. She was so vital and buoyant, so full of plans and interesting ideas. Mother taught herself Braille and worked with blind students to keep occupied with something useful after her children were grown. She took a teaching position in Watertown at the Massachusetts School for the Blind, Perkins Institution, where she was much loved. I can still hear her telling me about the blind children, "It's so important to arouse their *curiosity*, Margaret." Being a born teacher, Mother was deeply concerned about the tendency of the blind to develop an overplacidity in the face of their great tragedy.

As if this work were not enough for a woman over sixty, she began going to summer school, sometimes to the University of Chicago and sometimes to Columbia University, where she studied child psychology and the psychology of the blind.

I remember one summer when the heat was excessive. Worried, I phoned her at Columbia, and learned she was taking a swimming lesson. "Don't worry about me, Margaret," she said. "Today I've been closer to heaven than I ever expected to be. I floated on my back for the first time."

Another summer when Mother came to New York to attend Columbia, I was in the midst of a job for Eastern Air Lines. Mother had never been in an airplane, and she was as eager as always to experience something new. For her first flight she

should have something special, and this particular airplane job was just the thing.

Eastern Air Lines had hired me to photograph their airplanes over each main city on the route. I had done Miami and New Orleans on the Southern run and was just then working over New York. It was a lovely kind of photography. I flew, strapped into a small plane, in close formation with one of the big passenger planes. My pilot flew me over it, under and around it, to get the effect of the big plane looming large in the foreground with the skyscrapers below. Where there would normally be passengers in the big plane, I was inviting a number of my friends to fill up the window spaces. They were thrilled at this rare opportunity to look down on New York—in those years, the middle thirties, the regular passenger flights did not go directly over the city.

For Mother, this flight was especially appropriate. As a born New Yorker, she would be looking down on the land of her childhood, in lower New York—the old ninth ward. She would be seeing it from a viewpoint she never could have dreamed of as a child. While I was circling over the city to get various effects of brilliance and shadow, Mother would be able to look down into the deep canyons and try to pick out the place where she was born.

The arrangements were made. Next day she would be registering at the University, and the day following we would fly. Mother went to Columbia to register as planned. In a certain seminar for which she enrolled, the class included many friends from former years who had special affection for her. Registration over, Mother rose to her feet and asked to be excused from her first day of class, "because my daughter is going to take me for my first airplane flight." Then her heart failed her and she fell to the floor, unconscious, and without regaining consciousness, she died two days later.

I shall always be grateful that she was among friends, so that I had this way of knowing she did not suffer. I believe if Mother had had to select the way she should go, she would have chosen some such way as this—eyes looking forward to an ever-expanding horizon, exploring still, even in the last conscious moment of her life.

CHAPTER IX

ASSIGNMENT
TO THE
DUST BOWL

ONE STORY which *Fortune* sent me out to
cover was in a sphere quite new to me and left a very deep im-
pression on me. This was the great drought of 1934. Word of its
severity came so suddenly, and the reports we had were so scanty,
that *Fortune* editors didn't know exactly where the chief areas
of the drought were. Omaha, Nebraska, seemed as good a start-
ing point as any, since it was in the middle of the corn belt. I
left on three hours' notice and on arrival in Omaha found that
the drought extended over a vastly greater area than we had
known when I was in New York. It ran from the Dakotas in
the North to the Texas panhandle. I was working against a five-
day deadline, and it was such an extensive area to cover that I
chartered a plane to use for the whole story.

My pilot was a barnstormer of the old school, who earned his
livelihood by stunt flying at country fairs. His tiny two-seater
was a plane of the old school, too—how old I fortunately did not
know until the job was done, when I learned the Curtiss Robin
was considered extinct long before the drought reached Ne-
braska. But luckily, unaware of this, I did not worry on the
long hops except about such basic matters as choosing the right
place and getting to it in time for the right photographic light,
and keeping my film holders freshly loaded and ready for what-
ever we might meet. The unloading, boxing and reloading was

[OVERLEAF] *Drought erosion, South Dakota, 1934.*

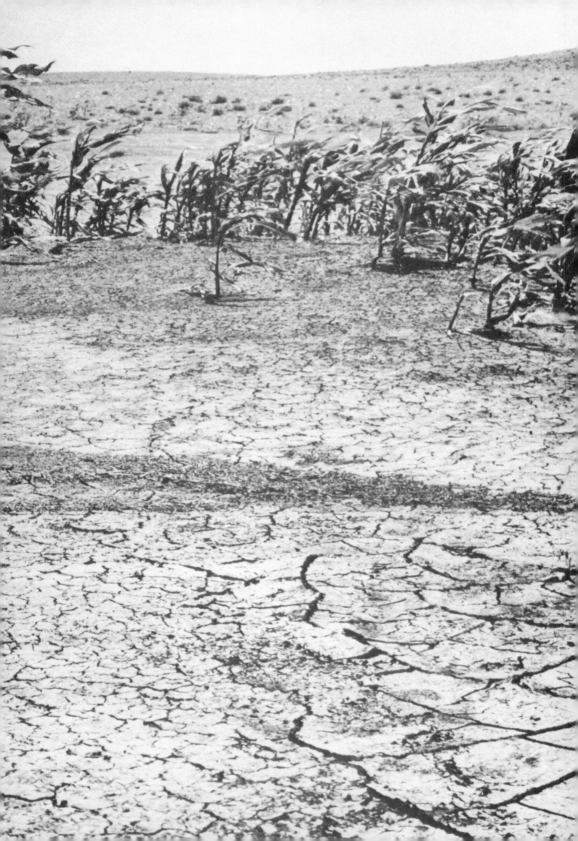

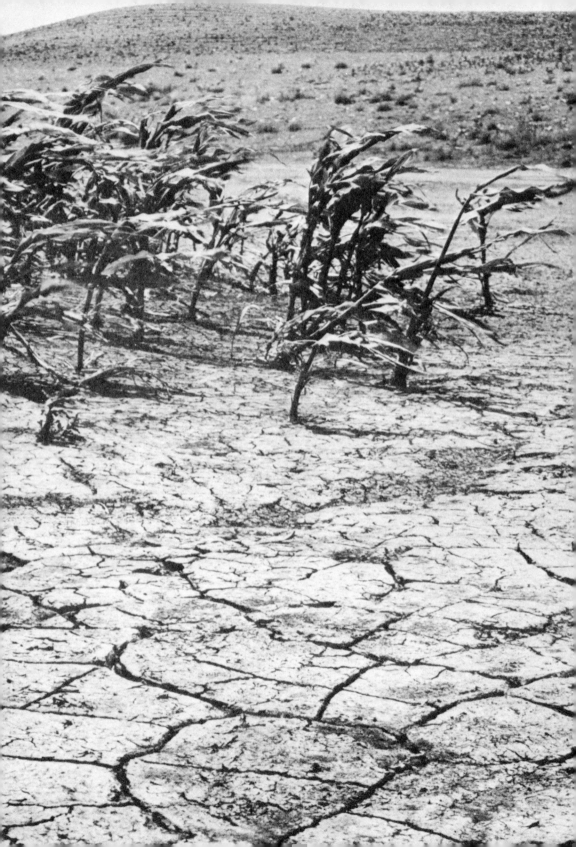

an almost continuous process, which I had to do with my hands and films hidden from the light inside the big black changing bag I carried in my lap. Like woman's work it was never done, and I kept at it whenever we were aloft. The little Robin held up quite well. Crash it finally did, but very gently and only after sundown of my last day. By then I had my pictures and my disturbing memories.

I had never seen landscapes like those through which we flew. Blinding sun beating down on the withered land. Below us the ghostly patchwork of half-buried corn, and the rivers of sand which should have been free-running streams. Sinister spouts of sand wisping up, and then the sudden yellow gloom of curtains of fine-blown soil rising up and trembling in the air. Endless dun-colored acres, which should have been green with crops, carved into dry ripples by the aimless winds.

I had never seen people caught helpless like this in total tragedy. They had no defense. They had no plan. They were numbed like their own dumb animals, and many of these animals were choking and dying in drifting soil. I was deeply moved by the suffering I saw and touched particularly by the bewilderment of the farmers. I think this was the beginning of my awareness of people in a human, sympathetic sense as subjects for the camera and photographed against a wider canvas than I had perceived before. During the rapturous period when I was discovering the beauty of industrial shapes, people were only incidental to me, and in retrospect I believe I had not much feeling for them in my earlier work. But suddenly it was the people who counted. Here in the Dakotas with these farmers, I saw everything in a new light. How could I tell it all in pictures? Here were faces engraved with the very paralysis of despair. These were faces I could not pass by.

It was very hard, after working with the drought and with the people who must weather it through, to return to the advertising world again and glorify that rubber doughnut on which the world rolled. The time was drawing near for another *Satevepost* tire ad, and up in the penthouse the Bourke-White Studio must dedicate itself afresh to the making of giant mud pies.

Some readers may remember—and if they do not, they need count it no great loss—the tire ads of the early to middle thirties

in which a Gargantuan tire track ran across two center pages, the imprint so big it looked like a road in itself. My assignment in making these was to capture the very soul of the tire, its footprints on the sands of time. But there were no timeless sands up in the penthouse, and ordinary sand would not stand up under the merciless spotlights. By kneading putty with clay and adding various other mysterious oily ingredients as well as a few handfuls of plebeian mud, the resourceful Oscar made a durable base for our miniature road. It was no reflection on the quality of Oscar's pungent dough that I found I could no longer summon up any enthusiasm over the imprint of an idealized tire on a road of putty. My mind was on another road clogged with fine-blown topsoil and imprinted by the wind.

While Oscar gave the dough a final kneading, I placed the last little touches—toy automobiles to make the huge tire even huger by contrast, tiny roadside weeds tucked in to lend a note of freshness. At last all was ready. We had to work quickly now before the dough stiffened. Between us we rolled the mud pie into a long roadlike shape which caught and preserved the track of the tire.

But not of *any* tire. Not of a real tire. Nothing so simple as that. To make the tire track pictures, I was supplied with a wooden dummy. This was hand-carved for me at considerable expense in the Akron factory. Its diamond tread was sculptured extra deep so that the photograph would show the crispest, most "convincing" tire track the nation's motorists had ever seen.

But not for a moment must the track-making dummy be confused with the rubber dummy I was furnished when I made a picture *of* a tire. This, too, was hand-molded for me in the Akron factory and at even greater expense—high in four figures, everybody said. This costly rubber gem was fatter than any tire you ever saw. The use of this special tire resulted from a curious rivalry which was running its course among the advertising agencies. It was based on the assumption that the fatter the tire the faster the public would run to buy it. When a competitor's ad appeared with a tire fatter than ours, the Akron factory built for me a still plumper model with of course a still smaller hole. The optimum in obesity would soon be reached. One more plumping up and there would be no hole left in the doughnut.

Then a rising star in the advertising business made a courageous and revolutionary proposal. "Let's photograph a real tire," he said.

For me this was the turning point. The circle of madness was closing on itself. Rubber was chasing rubber around a vacuum. I longed to see the real world which lay beyond the real tire, where things did not have to look convincing, they just had to be true. I felt I could never again face a shiny automobile stuffed with vapid smiles. Never again could I build and rebuild the road that led nowhere.

Then I had a dream. I still remember the mood of terror. Great unfriendly shapes were rushing toward me, threatening to crush me down. As they drew closer, I recognized them as the Buick cars I had been photographing. They were moving toward me in a menacing zigzag course, their giant hoods raised in jagged alarming shapes as though determined to swallow me. Run as fast as I could, I could not escape them. As they moved faster, I began to stumble, and as they towered over me, pushing me down, I woke up to find that I had fallen out of bed and was writhing on the floor with my back strained. I decided that if a mere dream could do this to me, the time had come to get out of this type of photography altogether. If I believed in piloting one's own life, then I should go ahead and pilot mine. Since photography was a craft I respected, let me treat it with respect. I made a resolution that from then on, for the rest of my life, I would undertake only those photographic assignments which I felt could be done in a creative and constructive way.

Later that day the phone rang, and appropriately enough it was one of the advertising agencies. A new job had come up— a series of five pictures to be taken in color. Despite my resolve, it was impossible not to feel some curiosity and I inquired about the fee. The fee was to be $1,000 a photograph. I had never received $1,000 for a single picture. I hesitated only a second. It all flooded back, the grotesque unreality, the grief. Why should I go through that again? I found it was not too hard to say, "No, thank you." I recommended another photographer who I thought could do the job well, and I hung up.

Good. I knew now what I would not do, and it was time to figure out what I should do. The drought had been a power-

ful eye-opener and had shown me that right here in my own
country there were worlds about which I knew almost nothing.
Fortune assignments had given me a magnificent introduction
to all sorts of American people. But this time it was not the cross
section of industry I wanted. Nor was it the sharp drama of
agricultural crisis. It was less the magazine approach and more
the book approach I was after. It was based on a great need to
understand my fellow Americans better. I felt it should not be
an assignment in the ordinary sense but should be as independent
of any regular job as my steel mill pictures had been.

What should be the theme, the spine, the unity? I did not
consider myself a writer. I felt this book had to be a collabora-
tion between the written word and the image on the celluloid. I
needed an author. Yet curiously enough I gave very little
thought to what kind of author. I knew it must be someone who
was really in earnest about understanding America. But a good
writer or a merely competent writer? A novelist or a nonfiction
man? A famous author or an obscure one? To all these things
I gave no thought. I simply hoped that I would find the right one.

It seemed a miracle that within a week or two I should hear
of an author in search of a photographer. He had a book project
in mind in which he wanted to collaborate with a photographer.
I gathered he had paid little attention to the possibility that there
might be mediocre or gifted photographers in the world. He just
wanted to find the right one—someone with receptivity and an
open mind, someone who would be as interested as he was in
American people, everyday people.

He was a writer whose work had extraordinary vitality, an
almost savage power. He was the author of an exceedingly con-
troversial book which had been adapted into an equally contro-
versial play. Among the thousands who had seen the play or
read the book were many who considered the characters exag-
gerated, the situations overdrawn. The author wanted to do a
book with pictures that would show the authenticity of the
people and conditions about which he wrote. He wanted to take
the camera to Tobacco Road. His name was Erskine Caldwell.

CHAPTER X

THE
ROCKY ROAD
TO
TOBACCO ROAD

I COULD HARDLY believe this large shy man with
the enormous wrestler's shoulders and quiet coloring could be
the fiery Mr. Caldwell. His eyes were the soft rinsed blue of
well-worn blue jeans. His hair was carrot—a subdued carrot.
The backs of his hands were flecked with cinnamon freckles—
cinnamon which had stood long on the kitchen shelf. His whole
appearance suggested he was holding himself ready to step back
at any moment and blend into the background, where he would
remain, patient and invisible, until he had heard what he wanted
to hear or experienced what he wanted to experience. Later I
learned this was just what he had a special gift for doing. His
voice matched his appearance. He spoke softly when he spoke
at all.

His seeming mildness and gentleness came as a surprise against
the turbulence of his writings. Hoping to ease the painful bash-
fulness I so strongly felt in him, I suggested it was cocktailtime.
No, he seldom drank. This astonished me in the face of the
Bacchanalian scenes in his books.

I was equally surprised that, humorist though Caldwell was
known to be, his tight-locked face suggested a man who rarely

laughs. I remember saying to myself, "This is going to be a colorless and completely impersonal type of man to work with." But I didn't care what he was like as long as we worked well together. I knew (and I knew I wasn't supposed to know) that he did not particularly like my photographs. Caldwell's literary agent thought I should hear the worst before I began, and he told me in secret. Well, that didn't bother me. There were a lot of my pictures I didn't like either—the grinning models, for example.

Another difficulty, and again I was informed in confidence, was that Mr. Caldwell did not like the idea of working with a woman. As a countermeasure he planned to hedge himself in with a second woman, a sort of literary secretary with whom he had worked in Hollywood. She would take shorthand notes of important conversations and keep identification data. (She was to go out of my life as abruptly as she came into it, and I no longer remember much about her except that we called her Sally.) If Erskine Caldwell had further misgivings about my pictures, or about my being a woman, which I could not change, he did not give voice to them. We set a date to start work on the book: June 11, 1936.

June eleventh was five and a half months away. As meticulously as though we were leaving next week, Erskine Caldwell set the details. We would meet in Augusta, Georgia, early in the morning in the lobby of Augusta's best hotel. We would look over the Tobacco Road country and then circle through all the cotton-growing states in the Deep South. Mr. Caldwell expressed the hope that the delay would not inconvenience me. He had several pieces of writing he wanted to finish before we started in on our book project.

I, too, had things to finish and was thankful for the extra time. First I had the trifling item of a penthouse to get rid of. Then, I wanted to make my exit from the advertising business as orderly as possible. Though I had come to dislike advertising, there were a lot of people in advertising whom I liked very much indeed. Especially certain very talented art directors who had taught me a great deal, men such as the many-faceted Gordon Aymar at J. Walter Thompson in the early '30s who had helped me over my earliest advertising hurdles. Then there was

the imaginative, humorous and very knowing Chris Christensen
of the Kudner Agency, with his tremendous experience in how
to use photography. Chris had helped me out of many scrapes,
even some occurring outside the work I did for him. Now that
I had stepped out from under the perpetual crises in this turbu-
lent world, I wanted to lay my advertising jobs to rest in seemly
tranquility.

The chores of disengaging myself from my immediate past
were moving so smoothly that I found I had time to slip away
to South America, to take pictures for an educational project
on coffee growing. I came back from this pleasant South Amer-
ican interlude refreshed and with my spirit restored.

I returned to spectacular news. We were going to have a new
magazine. The idea had been germinating at *Time* and *Fortune*
for some time, but now it was to be a reality. The new baby
magazine had as yet no name, and its form was amorphous but
the direction was clear. It would tell the news in pictures, but
it would try to go much further than that by illuminating the
background that made the news.

I remember the excitement with which Ralph Ingersoll took
me to "21" and told me about it. Ingersoll had been appointed
Fortune's editor when Lloyd-Smith had left that post vacant by
his suicide. In recent years, Ralph had become Harry Luce's
chief assistant and this new magazine was his special charge. It
was midafternoon, and "21" was almost empty and very quiet.
We sat in a shadowy corner and both talked our heads off for
the rest of the day.

As when *Fortune* was in the planning stage, now again with
this new unnamed magazine waiting to be born, I could almost
feel the horizon widening and the great rush of wind sweeping
in. This was the kind of magazine that could be anything we
chose to make it. It should help interpret human situations by
showing the larger world into which people fitted. It should
show our developing, exploding, contrary world and translate it
into pictures through those little black boxes we photographers
had been carrying around for so long. The new magazine would
absorb everything we photographers had to give: all the under-
standing we were capable of, all the speed in working, the imag-
ination, the good luck; everything we could bring to bear would

be swallowed up in every piece of work we did. And then, under the stress of it all, we would go out and push back those horizons even farther and come back with something new. I know nothing more satisfying than the opportunity to lay a few small foundation pebbles when a new magazine is about to be born. Lucky me, to have had this rewarding experience twice in my lifetime.

This was a year unlike any year I have ever lived through. Perhaps the very fact of having made a definite choice in my own life had cleared the way so I could be receptive to the best of everything that came: the wonderful opportunity to work with Erskine Caldwell on the book and now this splendid advent of a new magazine which would set its stamp deep on photography, just as we photographers, to some extent, would set our stamp on the young, elastic publication. My cup was running over.

Publication date for the nameless magazine was still more than half a year away, but the office was a beehive. Experimental layouts were being drawn up all over the place, and all sorts of pictures were being swept into them. Pictures representing everything, in my case, even some photographs I had taken of the Olympic contenders including the great Jesse Owens and the equally great Glenn Cunningham under training as they prepared to go overseas for the Olympic games. I had taken them for a news agency, but this did not mean that I was trying to become a sports photographer. I remember Harry Luce's surprised expression.

"Why, Maggie, I see you are taking sports pictures now."

It was fun for me to see them going into a layout.

The budding magazine took over my darkroom equipment: the sinks, the enlargers, the sharp cutting knives, the tanks, the dryers. These became the nucleus of its first photo lab.

With me, in the great transfer, went four former members of my staff: Oscar Graubner, who for the first several years of the magazine was chief of the photo lab; Cornelius Wells, a youthful lab assistant; Thomas Styles, an excellent printer and enlarger; and, most important, my secretary, Peggy Smith Sargent, destined to rise high in the responsible and difficult job of film

editor for *Life*. She had come from the Pacific coast, where she had worked for a Hollywood director, and was in New York looking for a job. I remember she came up to my studio dressed in a brilliant green suit. It was in the middle of one of our advertising crises, with phones ringing on all sides, and no one had time to answer them. Nor did anyone have time to interview her. Miss Smith, which then she was, sat down to answer the phones, and from then on, one could hardly remember a time when she hadn't been there.

And now, more than twenty-five years later, here she sits in her busy office, womanly and wise, like the high priestess of the world of celluloid negatives, which is what she really is. Through her magnifying glass, she peers into the gelatinized secrets of each inch-square patch of film at that crucial point where story line first meets picture. Thousands of films pass under her magnifying glass each week, and she selects for first printing the negatives she thinks are best, partly for their composition and beauty, but mainly through her insight into the personality of the individual photographer and his way of working. Usually I object when someone makes overmuch of men's work vs. women's work, for I think it is the excellence of the results which counts. And yet, in this case, truly this is a woman's job— this supersensitive "feel" for what the photographer was after, even though he might be half the world away. There is only one such post on the magazine, and there is only one Peggy Smith Sargent. It gives me a satisfying sense of basic continuity when I think of my two key people initiating methods in the two key fields of this new magazine—Oscar with his film processing and Peggy with her film editing. Peggy generously gives me credit for having helped her learn to judge films and composition.

When it took over the photographic equipment and the staff members from my studio, there was one thing the new magazine definitely did not want to acquire, and that was my pair of alligators which had grown to be enormous and savage. The magazine promised to find homes for them, and in no time at all they had run down satisfactory housing arrangements in an experimental school.

There were also some assorted turtles. Peggy, who had a personal friendship with the turtles (they had lived under her desk

and bumped into her legs and taken lettuce leaves from her noon-
day sandwiches), felt they were her responsibility. She investi-
gated fountains and decided the one at the Loew's Lexington
movie theater was the most suitable. She paced the grandiose
lobby, waiting for a moment when all the people present seemed
to be looking in another direction. The moment came, she hur-
ried to the splendid fountain and slipped in her reptilian load. It
was only later that she found out that all but one were land
turtles.

Finally the anonymous stranger to whom we had all pledged
our allegiance found a name. There had been a number of sug-
gestions, each one more cumbersome and unwieldy than the last.
The closest candidate was "The March of Time," a name that
had been used for Time Inc.'s newsreel. Publication date was
drawing closer, and nobody had the ghost of an idea what to
christen the infant soon to be born. Then, at just the perfect mo-
ment in time and space, the venerable magazine of humor, *Life,*
was about to declare itself out of business and was searching for
a buyer. Harry Luce hesitated not one moment. He bought the
magazine only for its name. The new magazine would be called
Life. Of its staff only two were transferred to the new *Life*—
Bernard Meurich, a C.P.A., and his sister, Madeline Auerbach,
whom all of us find charming even though it is she through
whom we channel our expense accounts.

In the midst of all this happy activity of preparation, one thing
pleased me above all others, the fact that my new editors-to-be,
Dan Longwell and John Billings, were much interested in the
collaboration between Erskine Caldwell and myself and were
enthusiastic about the possibility of running a spread of our book
in the magazine.

As with any change of direction in one's life, there were a
thousand insistent last-minute details. I wanted so much to come
to the book project with all the mind and ideas and serenity that
I was capable of. A few more days would wind up everything.
After all, it was nearly half a year ago that we had set our start-
ing date. Maybe Mr. Caldwell also had extra things to do; I
could always ask.

Through his agent, I learned that Mr. Caldwell was already in
Georgia, staying at his father's house in the tiny town of Wrens.

I phoned Wrens and got Erskine Caldwell on the line. I explained about the new magazine starting and all the circumstances and said, if it was all the same to him, I would like to have one more week. Instead of the eleventh, could we begin, say, the eighteenth? The frozen wordlessness at the end of the line conveyed to me we might never begin at all. I could hardly believe it. Heavens, I had been planning toward this for all these months! Several long telephone conversations between the literary agent in New York and Mr. Caldwell in Georgia verified my fears. It was all off. At least, it was off until some mythical time when it would be "more convenient" for all parties. I was sure that meant off, period.

What had I done, what had I done! To me it seemed not unreasonable that a date made half a year ahead, with a trip to another hemisphere in between, could be just a little bit elastic. To wreck the entire plan because I had requested postponement for a few days! But reasonable or unreasonable, that was not the point. To have our idea die stillborn, that I could not bear. With Erskine Caldwell already down South and just around the corner from Tobacco Road, there was nowhere unobtrusively to corner him for a little heart-to-heart chat. It was plain that I had worn out my welcome on the telephone. All means of communication seemed to have failed me.

I did the only thing I could think of to do. It was a long chance, but I would try. First I must rule out of my mind every thought except of things I absolutely had to do before leaving New York. I went ahead just as I had planned. It took a tight-packed four days. I had kept clothes and cameras packed, and when my chores were done, I jumped on the plane at midnight.

The hot sun was rising as we landed at Augusta, Georgia. I checked into the shiny, newly varnished "best" hotel and found, on inquiry, that Wrens was six miles away. Over my breakfast I composed a letter as quiet in tone as I could make it. I had come in the hope we could reconsider. I so wanted to start our important work with the slate wiped clean so that I could give my entire attention to this project of ours. Everything was in order now. Summer would be without interruption. I hoped he would believe me and see that I was deeply sincere in wanting to do the book and do it as well as it could possibly be done. I added

that I would be at the hotel in case he wanted to send me a message.

I tried unsuccessfully to get a Western Union messenger. The one mail delivery a day did not leave until afternoon, and I wanted Mr. Caldwell to get my note early in the day. I finally secured the personal services of a young lad who swept out the post office. The idea of going on his bicycle to deliver the letter in exchange for five dollars seemed fine to him, as it did to me, and I sat on the porch of the hotel watching him pedal furiously away until he disappeared in his own trailing plume of dust.

It was still not quite eight o'clock. The day dragged on. There were dull-looking movies, but I dared not leave the hotel to go to them. Normally I love walking down Main Street in a town where I have never been before, window-shopping and strolling around the drugstore. But today I dared not take my eyes off the telephone operator at the hotel desk. I thought I would never escape this day, which showed no sign of ending. At six o'clock in the evening, a large figure in a loose blue jacket came into the lobby. His face was flushed with sun and shyness. We went into the coffee shop, sat down at the counter and ordered hot coffee. While we waited to be served, Erskine Caldwell looked quietly down at his hands. We drank our coffee in wordless communication. When the last drop was drained, Erskine turned to me and smiled.

"That was a big argument, wasn't it?"

I nodded.

"When do you want to leave?"

"Now."

And so we did.

CHAPTER XI

"YOU

HAVE SEEN

THEIR FACES"

W<small>E</small> <small>DROVE</small> until midnight and then checked in at a small hotel which we were lucky enough to find open. I remember my midnight impression—the wide porch of graying woodwork, square-cut wooden pillars a bit off plumb. Plainly the home of some departed family had been salvaged to make the little hotel. A soft damp breeze touching me everywhere like the moist palm of a warm hand made me sleepily and pleasurably aware I was in the Deep South. I was in a new land, a land that had a pace of its own. Its own special enchantment hung over it.

In the morning this film of mystery was dispelled, and the rather ramshackle building where we had spent the night was much like a hundred others which one sees throughout the South. Erskine drove his Ford to the front of the hotel and started loading up. The residents of the town from one end of the short main street to the other gathered to see the largest stack of assorted baggage the townspeople had ever known to be packed away in a single automobile. Sally, the literary secretary, refereed the operation efficiently. She supervised a small squad of bellhops out of uniform as they tucked valises, cameras, lighting equipment, sweaters, films and tripods into every inch of the car except the front seat and a kind of nook in the back seat amidst the precarious towers of luggage. Someone would have to sit there. Sally volunteered.

With Erskine Caldwell in sharecropper country while working on You Have Seen Their Faces.

"I'm the hired help," she said. "Hired help sits at second table. I'll sit in the back seat."

I fear no one contradicted her, not even out of politeness.

Just before the takeoff, I leaped out of my front seat and ran back to the trunk compartment to check the position of two glass jars containing egg cases of the praying mantis. I was photographing the life cycle of the mantes, and since they were due to emerge soon—only the mantes knew when—I dared not leave them behind. While I was tucking them in so they would ride smoothly, the lid of the trunk came down on my head. Not hard enough to do any real damage, but hard enough to make me want to avoid trunk lids from then on.

Erskine gave a delighted chuckle. Why, he can laugh after all, I said to myself, and Erskine said, "I hope something funny happens every day like a trunk lid coming down on Margaret's head."

I could think of no suitable reply, but inwardly I thought, after all, I'd been ready to trade in almost anything for the opportunity to work on this book, and if getting whammed on the head with the rear end of a car was part of the price of admission, I guessed I could take that too.

For the next several days we took a meandering course off the beaten highways from Georgia to Arkansas. During this time I was groping to read the mind of this enigma of a man. I wished I could divine how he "saw" the broader outlines of the book. Certainly the material was very rich and to me quite fresh and new. And yet I like to have the feeling of architecture while I work—of shaping up a group of photographs so that they form a meaningful whole. I was sure Erskine had the same feeling, but he did not talk about it readily. Several times he asked me if I had suggestions. I wished I knew enough to make suggestions. I was just getting my bearings. But if I was not making suggestions, I was making a very careful study of my author-partner, trying to guess what was in his mind. In this field of trying to guess what's in the mind of a quiet man, I felt relatively competent, for this was an area in which my silent father had given me a lot of practice. I longed for the time, which I was sure was not far away, when my horizon would be widened by looking through the eyes of another, as people do who work in partner-

ship. Meanwhile, I was happy to be moving in a sphere which seemed both so worthwhile and so promising.

We had been on the road for four days when we reached Little Rock, Arkansas. On the morning of the fifth day, Erskine came up to my room, as he always did, to help me down with my cameras. But this time he wanted to have a talk. I remember how we sat down on the wide windowsill of my second-floor room overlooking a street lined with shade trees. Erskine told me what was on his mind. He said he didn't think we were getting anything accomplished. He felt like a tourist guide just showing somebody around. He thought we should give the whole thing up.

I was thunderstruck. How could I have been so obtuse as not to even guess things were so far off the track? I tried desperately to tell him how much this meant to me, this opportunity to do something worthwhile, but I wasn't making much sense, because, of course, I was crying. Then suddenly something very unexpected happened. He fell in love with me. From then onward, everything worked out beautifully.

Something unexpected happened on the sixth day too. At the hotel desk, Erskine received the surprising information that "the other young lady" had checked out at three o'clock in the morning. There was a note.

Sally explained she was tired of sitting in the back seat. She could work with one temperamental writer, or one temperamental photographer, she wrote, but nobody could compel her to put up with two temperamental artists in the same automobile in the summertime in Arkansas.

From now on there were no more surprises, except personal and pleasant ones. The work was flowing along, a wide stream, with the deepening understanding between us.

Whether he was aware of it or not, Erskine Caldwell was introducing me to a whole new way of working. He had a very quiet, completely receptive approach. He was interested not only in the words a person spoke, but in the mood in which they were spoken. He would wait patiently until the subject had revealed his personality, rather than impose his own personality on the subject, which many of us have a way of doing. Many

times I watched the process through which Erskine became ac-
quainted with some farmer and the farmer's problems.

Erskine would be hanging over the back fence, and the farmer
would be leaning on his rake, the two engaged in what I sup-
pose could be called a conversation—that is, either Erskine or
the farmer made one remark every fifteen minutes. Despite the
frugal use of words, the process seemed productive of under-
standing on both sides. While this interchange went on, I lurked
in the background with a small camera, not stealing pictures
exactly, which I seldom do, but working on general scenes as
unobtrusively as possible. Once Erskine and a farmer had reached
a kind of rapport, I could close in quite freely for portraits, and
perhaps we would be invited into the tiny one-room sharecrop-
per's home, which gave me a chance to photograph an interior.

Erskine had a gift, over and above the Southern tongue with
which he was born, for picking up the shade and degree of in-
flection characteristic of the state in which we were working.
His proficiency surprised me because he was uninterested in
music. But in this he had a musician's ear. This was a useful talent
in an area in which you are considered an alien and treated with
appropriate distrust if you come from only as far away as across
the state line. The people we were seeking out for pictures were
generally suspicious of strangers. They were afraid we were go-
ing to try to sell them something they didn't want and fearful
we were taking their pictures only to ridicule them. Reassuring
them was a very important part of our operations, and a re-
assuring voice in their own mode of speech eliminated many a
barrier. Of course, no amount of doctoring could disguise my
mode of speech. I was unmistakably a Yankee, "down South on
her vacation," Erskine would say. I could be labeled only as a
foreigner, and sometimes I am afraid I acted like one.

I remember one occasion when we went into a cabin to photo-
graph a Negro woman who lived there. She had thick, glossy
hair, and I had decided to take her picture as she combed it. She
had a bureau made of a wooden box with a curtain tacked to it
and lots of little homemade things. I rearranged everything.
After we left, Erskine spoke to me about it. How neat her bureau
had been. How she must have valued all her little possessions
and how she had them tidily arranged *her* way, which was not

Sharecropper couple: "A man learns not to expect much after he's farmed cotton most of his life."

my way. This was a new point of view to me. I felt I had done violence.

As we penetrated the more destitute regions of the South, I was struck by the frequent reminders I found of the advertising world I thought I had left behind. Here the people really used the ads. They plastered them directly on their houses to keep the wind out. Some sharecropper shacks were wrapped so snugly in huge billboard posters advertising magic pain-killers and Buttercup Snuff that the home itself disappeared from sight. The effect was bizarre.

And inside, the effect was equally unexpected. The walls from floor to ceiling were papered in old newspapers and colorful advertising pages torn from magazines. Very practical, Erskine explained to me. Good as insulation against either heat or chill, and it's clean and can be replaced for next to nothing. I had the uneasy feeling that if I explored around enough, I would find advertisements I had done myself.

I remember a little girl named Begonia, with whom I struck up a kind of friendship. When I asked how big her family was, she informed me she had a "heap" of brothers and sisters but hadn't ever counted them. Among the uncounted, I learned, was her twin sister. They went to school on alternate days, so as to share their single nondescript coat and their one pair of shoes. And here, right behind Begonia's wistful little face as she told me this, was this spectacular and improbable background showing all the world's goods. Begonia and her sister could look their walls over and find a complete range of shoes, jackets and coats. But never would they find that real coat and real pair of shoes which would take the second twin to school.

The Buttercup Snuff advertised on the outside of their house—that they would have. In an impoverished Southern household, snuff is frequently bought ahead of food. It dulls the pain of aching teeth and empty stomachs as well.

As we drove off, I glanced back over my shoulder. The snuff-wrapped shack looked like an immense cocoon which I felt might at any moment hatch a giant bug that would walk away with the house.

Cocoons were on my mind. At my side in the front seat I carried the glass bottles I had cared for so tenderly, each with its twig bearing a praying-mantis egg case the size of a golf ball. Ever since my childhood days when raising insect pets had been my hobby, I had wanted to take pictures of the metamorphosis of insects, and now with the new magazine coming out, I was glad that I had elicited Mr. Billings's interest in photographs of the life cycle of this dramatic insect. I was especially anxious to catch this hatching, because of a small tragedy which took place just before I left New York, wiping out a whole generation of mantes. The massacre occurred when writers, researchers and layout men were just settling into *Life*'s new offices, and the

A boy in his newspaper-insulated home, Louisiana.

place was a whirlwind of plaster and paint. The exterminator arrived, someone jerked a careless thumb, and by mistake he went into the office I was using to house my praying mantes. Five egg cases had hatched during the night, and I came in to find piles of the fragile miniature creatures, perhaps a thousand, lying on desks, chairs, bookshelves, the floor, each one perfectly formed but rigid as a wire hairpin.

So it was natural that I should look down at frequent intervals to check the precious cargo. Emerging insects wait for no man. Following a mysterious timetable which only praying mantes can read, some minute weather change may unlock the door of the tough cocoon case, and out they come. Fortunately, when the first baby mantis wrestled its way free, we were on a back country road with a split-log fence perfect for holding the egg cases in position. I began to photograph the pouring river of midget creatures. Slithering out of their protective sheaths, they began climbing with great effort on their new and tender legs, dragging themselves upward on the shoulders of their brothers till they reached the upper air with its space and light. There they rested, some two hundred of them, each smaller than your fingernail.

I, too, rested and, looking up, saw we were surrounded by a solemn ring of little children who had collected silently to watch and now began delightedly singing out, "Look at the little devil horses! Oh, look at the little devil horses!"

I was glad my insects had hatched out here so I could learn this charming name for them.

I received a new name too. I have been Peggy or Maggie to friends and colleagues, but Erskine, wanting his own name for me, called me Kit, because he said I had the contented expression of a kitten that has just swallowed a bowl of cream.

Finding a nickname for Erskine Caldwell was much harder. Nothing can be made out of "Erskine" but Skinny, and even though he was anything but skinny, he had been called that by everyone most of his life. I disliked the name and searched for another. We tried "Skeats" for a while, but it never seemed to belong to him. Skinny he was and Skinny he remains.

Skinny and I hoped to find a chain gang somewhere on the

The captain stands guard over a Georgia chain gang.

road. One could never get any precise information. There were just enough objectors to the idea of chaining men together like teams of oxen to make a sheriff think twice before helping a photographer find such a controversial subject. So when Erskine and I were exploring some back-country roads one day and rounded a curve, all but running down a chain gang in tattered stripes, we were lucky indeed. They were chained man to man, each with his soup spoon tucked in his iron ankle cuff. The sudden sight was almost too theatrical to believe. They looked as though they had strayed from an M-G-M group on location.

Our reception was just as theatrical. The very unpleasant captain of the gang demanded our permit to photograph chain gangs, and began waving his rifle wildly at us and shouting threats. When he yelled that he would blow off our tires, Skinny and I left, and returned, driving past in a zigzag course. The captain fired several rounds toward the wheels of the car. Whether they missed by design or accident, we decided this was the time to try to get a permit. Erskine recalled that an acquaintance of his school days had become a political personage in a town not far away. The handy friend took us in to see the Commissioner, and when we left, we carried a document which was fine indeed with stamps and seals. As we drove back to our location, I decided I could risk my right arm by hanging it out of the window and waving our license like a flag of truce. The captain looked at the document with rage on his face and felt the seals with an exploring thumb.

"The Commissioner, what the hell," he hissed, "he knows I don't know how to read."

So it was up to us to read and reread the permit aloud with such dramatic expression there was nothing the captain could do except allow us to bring out cameras and take photographs.

Twenty years later, while working on *Life's* segregation story in the South, I found the road gangs again. Little had changed except for one detail. I had never before heard of segregated chain gangs. But now there were black chain gangs and white chain gangs. A newly arrived prisoner could shoulder his pickax and take his place on the road with the comforting assurance that the convicts with whom he would be so intimately bound would match him in skin color.

Anyone who has driven through the Deep South is familiar
with the religious signs which punctuate the highways. We
wanted to take a look at the religion behind the road signs.
With the Negro churches this was easy and pleasant. Visitors
were always welcome, even a visitor who came loaded with
cameras. There was sure to be good hymn-singing and a fire-
eating preacher. When the fiery sermon whipped up the parish-
ioners to fever pitch and left them thrashing about on the floor
in a religious frenzy, it all seemed close to some tribal ritual, as
though the worshipers still answered to the rhythm of the jungle.

There is a white counterpart which fewer people know,
furtive, shamefaced and hidden. Visitors are unwelcome. The
churches are hard to find. It was something of an achievement
when Erskine and I discovered the Holiness Church with a small,
all-white congregation in a stony South Carolina town. The
church matched the town—bleak and built of splintery boards
which had never been painted. We made our great find on a Sun-
day morning. Everyone was already in church. I tucked a small
camera into my jacket, and Erskine filled his pockets with flash-
bulbs. Finding the church door locked from the inside, we leaped
through the open window and started taking pictures at once,
Erskine changing flashbulbs as though he had been assisting a
photographer all his life.

It was a strange little scene. Women were careening about in
their cotton print dresses, and several times they nearly threw
me off my feet and all but knocked my camera out of my hands
as they waved their Bibles and shrieked their "Praise Be's." The
worshipers were running the whole gamut of religious frenzy
from exaltation to torpor. Some were writhing on the floor in
that state of religious ecstasy known as "coming through." The
minister, having whipped up his flock to this peak of hysteria,
was overcome with exhaustion and sank down on the platform
of his pulpit, where he held his head in his hands. Both men and
women began rolling about on the floor, chanting their "Amens"
in voices fading from hoarseness. Finally, the hallelujahs began
dying away, and each amen was fainter than the last. The min-
ister was beginning to stir in his coma. Plainly the time had
come to leave. We sailed out through the windows the way we
had come in, and in a matter of minutes we were out of town.

I was amazed that we had been able to bring it off successfully. There was one item of my photographic equipment which I believe helped us. Synchronized flashbulbs in 1936 were somewhat new to photographers and new enough to me so that I underexposed some of the pictures, and only Oscar, working in the darkroom, managed to salvage a few of them. Certainly a backwoods congregation had never seen flashbulbs. Under the sway of the sermon with its fearful warnings of hell to all who did not mend their sinful ways, these worshipers must have thought we were avenging angels come down in a blaze of light in direct response to their preacher's fiery words.

Long after the excitement of jumping through the church windows to get the pictures has mellowed down in memory, I find myself still thinking of that bleak and splintery church on its plot of stony ground. The pitiful masquerade of religion I witnessed there has left its vivid image deep in my mind. It is obvious this shoddy little ceremonial re-enacted each week in the name of religion, was the very antithesis of religion, but to me it is full of meaning. It illuminates the spiritual poverty of people who have no other emotional release, no relaxation and laughter, no movies or books and, far worse, no educational or other inner equipment with which to change the course of their meaningless lives. Worshipers come to church, bowed down with problems, and are given the church floor on which to throw themselves and drown their troubles in religious ecstasy every Sunday morning. Seen in the context of this barren existence, the drab little church is an ironic symbol.

Many times in sharecropper country, my thoughts went back to the Dakotas, where the farmers were stricken with the drought. Their very desperation had jolted me into the realization that a man is more than a figure to put into the background of a photograph for scale. The drought-ridden farmers had contributed to my education in a human direction, and here with the sharecroppers, I was learning that to understand another human being you must gain some insight into the conditions which made him what he is. The people and the forces which

Tenant farmer's wife: "I've done the best I knew how all my life, but it didn't amount to much in the end."

shape them: each holds the key to the other. These are relationships that can be studied and photographed.

I began watching for the effect of events on human beings. I was awakening to the need of probing and learning, discovering and interpreting. I realized that any photographer who tries to portray human beings in a penetrating way must put more heart and mind into his preparation than will ever show in any photograph.

Back in New York, Erskine took me to the theater to see *Tobacco Road*. He made a practice of dropping in at widely spaced intervals, particularly when new actors replaced the old, which had to happen now and then because of the play's phenomenally long run. (One actor had actually died onstage.) When *Tobacco Road* reached the end of the road, it had chalked up more than 3,000 performances in New York City alone, and such odd mementos from the stage sets as a well, a shack, and a wagon wheel had gone to the Smithsonian Institution.

Between the acts we ran into a friend of mine from Atlanta who was a typical Southerner, if I ever saw one. I introduced him to Mr. Erskine Caldwell, but it was obvious as he talked that he did not realize he was speaking to the author. Sam explained he had heard so much about the play, he thought he ought to come and see for himself whether it was true or false. "Because I come from just that part of Georgia," said Sam, "I would know better than anybody."

"How do you find the play?" I asked.

"Oh, it's greatly overrated," said Sam. "It's not true to life at all, it's greatly exaggerated." And, muttering "greatly overrated" to himself, Sam went happily back to pull the second act apart, all unknowing that he had been expressing his opinions to the man who started it all.

Erskine was pleased. It is very seldom, he told me, that you have the opportunity to hear critical or derogatory remarks face to face. In the early years of the play, he used to skulk around between acts hoping to overhear adverse reactions.

"You don't learn much from praise," he said. "You learn from adverse criticism. If people are aroused and angry and take the trouble to let you know about it, you know you've made a dent. If it doesn't evoke any reaction, what use is it? If a book or play

evokes a strong reaction, that's one of the highest tributes your work can have."

We plunged into writing captions for the book, and ours was a real collaboration. We did not want the matter of whether the pictures "illustrated" the text, or the words explained the pictures, to have any importance. We wanted a result in which the pictures and words truly supplemented one another, merging into a unified whole. We had a kind of ritual about this. We would arrange eight pictures in the middle of the floor. We backed away and, sitting against the wall separately, wrote tentative captions and then put them side by side to see what we had. Many times the final caption was a combination of the two—the thought mine and the words Erskine's, or vice versa. Occasional captions were all mine, and I was proud indeed when either my thought or my way of expressing the subject stood up in the final test. But it made no difference who contributed what, because by now we were sure that the book had unity.

"This book has to have a title, you know," Skinny said one day.

I had been so deep in finishing the pictorial touches that actually I had never given any thought to the title. But Skinny had. In fact, the title came to his mind two years before he met me. I learned what it was only when we went to see Viking Press, the publishers. I still recall the little scene vividly: the rather severe vestibule of the office, the exhilaration of completing a big piece of work which was a milestone in my life.

"The title is *You Have Seen Their Faces*," said Skinny. "How do you like it?"

The name implied just what I had been searching for as I worked. Faces that would express what we wanted to tell. Not just the unusual or striking face, but *the* face that would speak out the message from the printed page.

Since Skinny valued brickbats above praise, I was glad for his sake that when the book came out, a fair number of them appeared in the book reviews. There was the editor of a South Carolina newspaper who called the book "a new slander on the South." There was the reviewer who advised Mr. Caldwell "to go back to his novelistic knitting." And the commentator who, choking on his own vituperative prose, ended up, "Fie on Mr.

Caldwell!" And since we were rating brickbats so high, I was glad to get my share of them too. There were many variations of the question which all serious photographers are asked in many forms: Why take pictures of the bad things in life? Why not find something more pleasant to photograph?

The version I enjoyed most came from an interior-decoration magazine which scolded me for taking pictures of sharecroppers' tumbledown shacks: Why didn't I choose some modern living room which would certainly be decorated in better taste and more typically American?

The most intriguing comment of all came in the form of a letter which started out: "Margaret Bourke-White is a Yankee and doesn't know any better, but Erskine Caldwell is a born Southerner and he *does* know better." It went on to accuse Mr. Caldwell of building a stage set of the church, hiring actors and bringing me South to photograph the performance.

The other side of the ledger was more crowded. I don't think either of us was prepared—certainly I wasn't—for the wide response the book received. The editorial page of the Philadelphia *Record* reminded its readers that "it was a book—Uncle Tom's Cabin—that roused the world to the menace of slavery." There is today another kind of slavery, the editorial pointed out, "and there is no better way to gain an understanding of it than by slowly turning the disquieting pages of this book."

It was high praise when Harry Hansen wrote in the *World-Telegram*, "The pictures have the quality of the very finest portraits. They depict man and the intention of his soul." I hoped to continue to earn it. In any case it was a clear and even inspiring statement of what I wanted my camera to do in the years to come.

Erskine and I were particularly happy when reviewers treated the book in terms of collaboration, as did Malcolm Cowley who wrote, "This book belongs to a new art, one that has to be judged by different standards," and the *Boston Transcript* which wrote, "This is the South seen through the magic bitterness of text and the magic eye of a camera." This was just what I had hoped—that through the fusion of words and pictures, we would create something new.

Now the book had a life of its own and was no longer a per-

sonal thing. It had grown bigger than the two of us. Already it was reaching out, influencing others, and soon was to influence some United States legislation, a source of quiet pride to both of us.

Just how far its influence reached I was not to learn until twelve years later, when I was in Africa working on a picture essay of South Africa for *Life* magazine. With racial tensions running high, it required all the diplomacy I had to get the pictures I needed. I had completed my portraits of the higher-ups, but I could find no channels through which to meet native Africans and the "coloreds," and without this contact I could not get a balanced story.

I remember feeling quite desperate as I walked along a Cape-town street down near the piers. Suddenly a native African woman came up behind me and spoke my name. She had recognized me from a newspaper picture. She pulled from her blouse a well-worn copy, obviously widely-circulated, of *You Have Seen Their Faces*. Through this unexpected contact, I was able to complete my story. I am sure that many of these people could not read the book, but still they knew it. They believed I would be trying to get to the truth of a question, and they trusted me.

CHAPTER XII

LIFE BEGINS

THE FIRST ISSUE of a magazine is not the magazine. It is the beginning."

With these words of introduction from the editors, *Life*'s Vol. I, No. 1, came into existence on November 23, 1936. A few weeks before the beginning, Harry Luce called me up to his office and assigned me to a wonderful story out in the Northwest. Luce was very active editorially in the early days of the magazine, and there was always that extra spark in the air.

Harry's idea was to photograph the enormous chain of dams in the Columbia River basin that was part of the New Deal program. I was to stop off at New Deal, a settlement near Billings, Montana, where I would photograph the construction of Fort Peck, the world's largest earth-filled dam. Harry told me to watch out for something on a grand scale that might make a cover.

"Hurry back, Maggie," he said, and off I went.

I had never seen a place quite like the town of New Deal, the construction site of Fort Peck Dam. It was a pinpoint in the long, lonely stretches of northern Montana—so primitive and so wild that the whole ramshackle town seemed to carry the flavor of the boisterous Gold Rush days. It was stuffed to the seams with construction men, engineers, welders, quack doctors, barmaids, fancy ladies, and, as one of my photographs illustrated, the only idle bedsprings in New Deal were the broken ones. People lived in trailers, huts, coops—anything they could find— and at night they hung over the Bar X bar.

During the mornings I worked on the inspiring high earthworks of the dam. At noon when the light was too flat for

Fort Peck Dam, Montana. This picture was Life's *first cover, November 23, 1936.*

photographs, I rode off on horseback through the endless level stretches which would be reservoir when the work was finished. When I had used the sun's last rays to the utmost, I would turn up at Bar X or the Buck Horn Club. The Buck Horn employed a college football star as bouncer, and at the Bar X the four-year-old daughter of the barmaid spent every evening seated on the bar. At a little distance from town in Happy Valley, I could photograph fancy ladies. Breakfast could always be obtained in a tiny lunch wagon at the edge of an eroded gully. I ate the construction men's special—waffles piled with whipped cream and enormous pecans.

A telegram came from Dan Longwell, indicating that the editors were very uneasy about what should be the opening subject in the new magazine. He wanted to know what I had. I wired, "Everything from fancy ladies to babies on the bar." When the editors saw my pictures, they wrote the following introduction:

If any Charter Subscriber is surprised by what turned out to be the first story in this first issue of *Life*, he is not nearly so surprised as the Editors were. Photographer Margaret Bourke-White had been dispatched to the Northwest to photograph the multi-million dollar projects of the Columbia River Basin. What the Editors expected were construction pictures as only Bourke-White can take them. What the Editors got was a human document of American frontier life which, to them at least, was a revelation.

These were the days of *Life*'s youth, and things were very informal. I woke up each morning ready for any surprise the day might bring. I loved the swift pace of the *Life* assignments, the exhilaration of stepping over the threshold into a new land. Everything could be conquered. Nothing was too difficult. And if you had a stiff deadline to meet, all the better. You said yes to the challenge and shaped up the story accordingly, and found joy and a sense of accomplishment in so doing.

The world was full of discoveries waiting to be made. I felt very fortunate that I had an outlet, such an exceptional outlet, perhaps the only one of this kind in the world at that time, through which I could share the things I saw and learned. I know of nothing to equal the happy expectancy of finding something

The Bar X, New Deal, Montana. The baby on the bar in Life's *first photo-essay brought some protests from readers.*

new, something unguessed in advance, something only you would find, because as well as being a photographer, you were a certain kind of human being, and you would react to something all others might walk by. Another photographer might make pictures just as fine, but they would be different. Only you would come with just that particular mental and emotional experience to perceive just the telling thing for that particular story, and capture it on a slice of film gelatin.

There is nothing else like the exhilaration of a new story boiling up. To me this was food and drink—the last-minute feverish preparations, the hurried consultations with editors, not so much for instructions as to sense how they "saw" the story, and to get that suggestion of a spine, that sense of structure, that indefinable, inspired plus which one somehow absorbs from the finest editors.

A steel "liner" designed to carry a fourth of the Missouri River in a vast irriga-

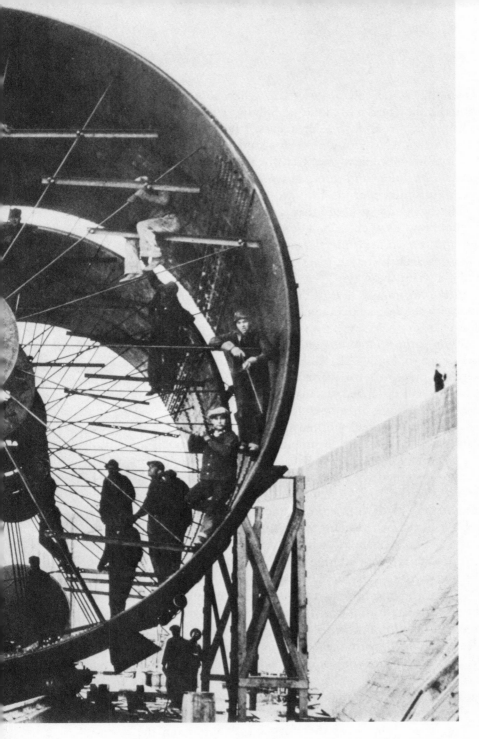

tion project. Fort Peck Dam under construction, Life, *Volume I, Number 1.*

Then the momentous decisions to make about supplies: which cameras, film, and what kind of lighting equipment to take.

Often in the explosive departures, I felt as though I had been tossed into a whirlpool with all the stuff and could only hope the essential items stuck to me. Usually they did, largely because of Oscar Graubner—and later, other equally wonderful darkroom people watched over me.

There was always more than a person could do, it seemed, but I would find I somehow had done it and was on my way, breathing and recovering and relaxing and catnapping, and even with some research material, maps and clippings which I could read and study on the way.

In the beginning of *Life* there were only four photographers, and with the magazine coming out every week, there was a great deal to be done. We went on story after story, one after another, and our paths seldom crossed.

I came to know Alfred Eisenstaedt first—dear, gentle Eisie, with his great gift for piercing through to the hidden hearts of those he photographed, his masterful technique on the miniature camera which was then new in this country.

Tom McAvoy had worked for *Time* in Washington and was transferred from *Time* to prepublication *Life* magazine.

Peter Stackpole, a youngster then on the Pacific coast, had been so intrigued with the building of the exquisite Golden Gate Bridge that he took a marvelous series of photographs which caught the eye of *Life* editors, and he was given a job on *Life*.

Bostonian Carl Mydans was a newspaper reporter before he was a photographer. He narrowly missed being on the original *Life* photographic staff. He arrived on the scene one day after the first issue of *Life* hit the newsstands.

One of the finest things about working with *Life* was the way we were treated as adults. I was given an enormous amount of freedom of choice when it came to assignments. Sometimes the ideas originated with the editors and sometimes with me. If I dreamed up an idea for a story which I thought would be a good one, I researched it and hunted up people who could give me background on it, and then went to the editors with my idea. If they thought it made sense, they sent me out on it.

The larger portion of the story ideas came from the editors, but this did not mean that I had to accept them. Occasionally I

turned a story down, but I did this only if I felt the idea was a synthetic one that originated in an office armchair and was not a slice of real life. But this was rare. Most of the assignments offered to me were exciting and tantalizing ones, and I was frequently picked out for the photo-essay type of story which I had felt was in a way my "baby," since doing the Fort Peck picture essay for the first issue of *Life*. When the editors called me in on a story which they referred to as the "Bourke-White" type of story, this made me very proud.

Up to now I had never worked on stories where the news timing was of paramount importance, but my next batch of assignments had to do with people and events in Washington. Plunging into the news world was for me a very exciting thing. Although I had been thinking of picture stories in connection with news in the broad sense, that is, having a news peg with which to place the story in time and space, this had the now-or-never atmosphere. For photographers, this was a world of its own, or rather, a war of its own, with added stress when the target had something to do with Washington, or the administration, or, most backbreaking of all, with the President himself. For picture sessions, a very limited amount of time was rigidly set, and photographers of all kinds were rabidly intent on squeezing every usable second out of the meager allotment.

Usually I was the only woman photographer, and the technique I followed was to literally crawl between the legs of my competitors and pop my head and camera up for part of a second before the competition slapped me down again. At least, the point of view was different from that of the others whose pictures were, perforce, almost identical, and, anyway, I've always liked "the caterpillar view."

It was surprising to discover that photographers whose work involved the news in any way formed a kind of caste system, with newsreels—the Brahmins—at the top, and the still photographers—the untouchables—at the bottom. Even on the bottom rungs, the newspaper stills ranked higher than the magazine stills. And when TV came along, another rung had to be added at the top of the ladder, and even these highest-caste photographers are split between black-and-white and color, with color on the topmost peak.

When President Roosevelt's second inauguration was to take place, Dan Longwell worked some persuasive magic and actually got me a little blue chip of cardboard which allotted to me a space on the high platform. Inauguration Day dawned with the heaviest rainfall since Taft became President in 1909. My photographer's sense impelled me to get to the spot very early, because I could see there would be the worst-possible photographic conditions to deal with. When I arrived on the dismal scene, I was fortunate to find a little boy to help me up with all my equipment to the highest stand, which was splendid indeed with its unbroken view to the inaugural platform on the White House portico. I had my largest cameras and tripods, knowing that long steady exposures would be necessary in this dullest of all possible daylight.

I got everything arranged and waited complacently for the other photographers to arrive. By now the crowds in the Capitol Plaza were packed so tight they formed a solid roof of umbrellas. We still had ten minutes before the show would begin, and I was wondering where my colleagues were. In less than another minute they appeared, scaling the platform like a pack of orangoutangs and taking up their places with their heavy gear. Suddenly I found myself being pushed away and had to cling to the handrail so I would not fall off the platform. A very aggressive young man, a movie photographer, walked up and pushed me aside so he could take the place where I had been standing. I brought out my ticket and he produced an identical one. My cries were drowned in the lashing rain, and there was no time for arguments anyway. The inauguration had begun. Immediately I made a run for one of the lowly still photographers' stands. This time there was no little boy to help me with cameras, but somehow I made it with the heavy gear and reached the humble platform just in time to catch the ceremony.

When it was over, one thing happened, so unexpected and wonderful that I was sure it had saved the day for me. To the delight of the soggy crowd, President and Mrs. Roosevelt stepped into an open car, facing the rain along with the rest of us. By extraordinary good luck, the President's car passed within perfect focusing range of the spot where I stood. FDR was at his best, waving and smiling, and there could be no question that this was the key shot of my day. No one else, I was

sure, had got anything else just like that. Joy overwhelmed me—until I got to the darkroom and saw that I had underexposed this negative so badly that only a trace of the image appeared, just enough to show how wonderful the picture would have been. But the general view of the inauguration over the sea of umbrellas, of which I had expected nothing—that *Life* used as a double-page spread.

The Louisville flood burst into the news almost overnight. I caught the last plane to Louisville, then hitchhiked my way from the mud-swamped airport to the town. To accomplish the last stretch of this journey, I thumbed rides in rowboats and once on a large raft. These makeshift craft were bringing food packages and bottles of clean drinking water to marooned families and seeking out survivors. Working from the rowboats gave me good opportunities to record acts of mercy as they occurred.

I found that three-quarters of the city was inundated. Downtown Louisville was a beleaguered castle surrounded by a moat. The office of the *Courier-Journal,* which was still managing to turn out newspapers, kept a kind of open house for anybody from the press, near or far, who had no place to lay his head. Reporters slept on desks or in any available corner on the floor. I staked out a claim to a desktop which seemed about my size, but it was a long time before I was able to go to sleep on it, because I was so busy photographing members of the press and their makeshift quarters. I was pleased that *Life* ran a spread on the working press.

This was one of the three most disastrous floods in American history, but, as always, the small things stand out in one's mind. On climbing through the second-story window of a pet shop, I was startled to find scores of canaries, their full-feathered wings spread out in the exquisite patterns of Japanese silks, beautiful even in death. Another sort of beauty in death, a beauty which was indeed in the eye of the beholder, I encountered when by chance I entered a funeral parlor and found the undertaker trying to find words to express his shock when he saw a body floating past his door, maneuvered it in with a long broom, and discovered it was a dear neighbor. He performed that last of all services, which he was so particularly qualified to perform, for his friend and, gesturing toward his worktable, said, "Doesn't

she look beautiful? I've made her look fifteen years younger."

There was the irony of the relief line standing against the incongruous background of an NAM poster showing a contented family complete with cherubic children, dog and car, its printed message proclaiming, "There's no way like the American Way."

To me this mammoth flood was another bitter chapter in the bleak drama of waste of our American earth, which I had watched unfolding and had tried to record since the drought. The juxtaposition of blowing soil and rainfall, of eroded farmlands and inundated cities, made an ominous continuing pattern.

In general, the farther away I am sent to cover an assignment, the better I like it. However, one of the most exciting episodes I ever had a chance to cover broke virtually under our office windows. It was a true-to-type old-fashioned muckraking story, unfolding just across the Hudson River, on the sprawling Jersey side. Tales were reaching us of reporters being beaten up, of photographers having their cameras snatched away from them and jumped on. It seemed almost as though Jersey City was fast becoming a private kingdom with its mayor as its ruler.

Mayor Hague was an outstanding member of a type of vanishing American. He was the last of the big city bosses. He was a mayor with whom no one could argue, whose last word was "I am the law," and he meant just that. With the country's largest per capita police force at his back, nine hundred strong, rare was the constituent who talked back.

For my part, I could hardly believe there would be any physical violence, but I was just as pleased when, on the first day, C. D. Jackson accompanied me across the river to make sure that I got started right. We were given a grand tour of nine miles of waterfront, the terminus for eight railroads, and a visit to the impressive Margaret Hague Maternity Hospital which the mayor had named after his mother. We were given a grandstand view from the balcony of a modern and dramatic delivery room, where we watched a baby being brought into the world by Caesarean section, something which neither C. D. nor I had seen before. Obstetrical care was given free to needy mothers, and for those who did pay, the charge was never higher than

thirty-five dollars. I was glad to see the Mayor's concern that children in his city get a good start in life, but I was startled to find that his concern for the very young stopped abruptly at the doors of the hospital.

Almost within the long shadow of the Mayor's monument to his mother was a confused area of two- and three-storied houses of rickety wood, with outside stairways and a nightmarish, high, open wooden platform connecting one family dwelling with the next. It was whispered that this was the center of the child labor area, but no one used this phrase openly. It was benignly referred to as "home industries."

Under the rotting roofs of this dinosaur among residence buildings, many a white-faced child toiled away making artificial flowers, kept home from school because only with the help of the children could the family make two dollars and a half a day, the absolute minimum on which the entire family could keep itself alive. How I longed to get a camera inside one of these homes, but that would have to wait a bit.

At the beginning of my assignment, I was plainly the Mayor's pet. I accompanied him to all his speeches and sat in the front row and jumped up with flashbulbs ready when he made one of his authoritative gestures. As he bellowed out his message, he stood against a background of striking banners, with slogans: CITIZENS OF JERSEY CITY ARE ALWAYS ONE HUNDRED PERCENT AMERICAN, and REDS, KEEP OUT!

During these first days when I was *persona grata*, I enjoyed the dubious privilege of a police escort, which met me every day when I stepped out of the Hudson Tube, and tenderly moved my cameras from the subway car into the king-sized limousine waiting at the curb.

But once I had satisfied myself that everything I needed in the way of pictures on the Hague side of the ledger was taken, I managed to give my bodyguards the slip. I had arranged in advance for helpers who knew the waterfront well. Chief among these was a reporter from one of the Jersey City newspapers, who, since he could not use this material for his own paper, welcomed the chance to add his efforts to mine so the story would see daylight. Together we raced to the shipping docks, which I wanted to see again at closer range.

These docks were enormous and handled large quantities of shipments for foreign ports. At the dock I found many of the great crates that lay ready for shipment were addressed to cities in the Soviet Union, to Odessa and Sevastopol. One great piece of oil machinery—a giant cylinder bearing the stamp of Amtorg, the Soviet trading agency—made a dramatic and informative picture. It was so placed and so big on the dock that I could photograph it showing the Manhattan skyline right over it. This pinned down the location as the Jersey City waterfront beyond argument. Probably all this material was routine shipping, but I marveled at a despot who could thunder out to his constituents in the evening, *"Now is the time to strike at Red invasion,"* and then do business with Red Russia next morning.

I was so afraid my police escort might catch up with me that I dared not complete a single roll of film. As soon as I got three or four shots on a roll, I dispatched one of my helpers over to New York with it. I knew that it was inevitable that I would be arrested before long, so I worked feverishly to expose all of the skeletons in the closet before I might be dragged away from the scene.

From now on, it was cops and robbers. I managed several shots in the rattletrap building, some showing three generations making lampshades, ceilings and walls dripping with highly combustible paper lampshade parts. Here I did not pause even to reload cameras, but handed them with the exposed films still inside to my helper, who stuffed them out of sight somehow and made his escape. I still had two cameras in reserve, and I was poking the lens of one of them into the cavelike dwelling of the violet makers—a place so snowed under with artificial violet petals that if anyone had struck a match, it would have fused off the whole building. I had just finished with violets when the city's finest caught up with me. I was taken straight to police headquarters. I was not beaten, and the cameras were not jumped on, but they might as well have been, because they were torn open, the film ripped out, which of course ruined them instantly on exposure to the daylight. I was able to watch this scene of destruction in comparative calm. Thanks to our pony-express system, the key shots were already crossing the Hudson River by ferry to safety in Manhattan.

CHAPTER XIII

HIS
EXCELLENCY
AND THE
BUTTERFLIES

WHEN HIS EXCELLENCY Lord Tweedsmuir, newly appointed Governor-General of Canada, decided to take a closer look at his far-flung dominion than any of his predecessors had done before him, he planned his tour as though he were writing one of his own adventure stories. Known better to the reading public under the name to which he was born, John Buchan, he had somehow found time in an incredibly busy career to write some fifty books—biographies, historical novels, mystery thrillers. Several of them were made into movies, of which the most popular was *The Thirty-Nine Steps*, a tale of suspense and spies. In addition, he had been a war correspondent in World War I, when practicing members of this profession must have been a great rarity. King George V was his personal friend and conferred on him a baronial title and then packed him off to hold one of the biggest jobs in the British Empire.

The Thirty-Nine Steps was my favorite movie long before I ever dreamed I would be accompanying its versatile author through more than a thousand miles of Arctic tundra.

Back in the dark ages of the middle thirties—when *Life* was less than one year old—the idea of going to the Arctic for a pic-

ture story was in somewhat the same category as an assignment to the moon is today, definitely not to be viewed as impossible, but rather as something on the difficult list.

The adventurous viceroy's tour through the barren reaches of the top of the world commenced so quietly and with such an absence of fanfare that by the time news of it reached the Time & Life Building, His Excellency was already aboard an antique wood-burning steam wheeler, threading the reedy marshes of the Athabaska River, heading "down North" toward the Arctic Ocean. The problem was to get me there.

The editors arranged to have a small plane on pontoons waiting for me as soon as I crossed the Canadian border, in which they hoped I could catch up with His Excellency. It all seemed delightfully cops-and-robberish to me—the idea of chasing the Governor-General down the waterways of Canada, like a character lifted straight out of a John Buchan thriller, in which the hero was being chased by international spies, hunted out by low-flying airplanes.

Everybody at *Life* was thrilled about this unusual story. Even Mr. Billings laid down his Olympian reserve. I still can hear the happy excitement in his voice as he plotted out my itinerary on maps and charts: "Great Slave Lake, Great Bear Lake, you're really going to be way up north when you get there. Better pack plenty of warm clothes. But I don't know—it will be summer in the Arctic."

How warm is the Arctic summertime? How light is the light of the midnight sun? There was no time to get authoritative answers to these important questions. Oscar, in *Life*'s darkroom, made some shrewd guesses as to the photographic supplies I should take, and I packed my ski suit, which I was to work and sleep in for days at a time. Last of all I packed my butterflies.

I was in the midst of photographing the life cycle of the mourning cloak butterflies. They were in the chrysalis stage, but little telltale wiggles showed they were getting ready to hatch at this most inconvenient of all times. I had raised them from eggs to caterpillars, to chrysalis, and if I missed getting pictures of these as they hatched, I would have to wait another year to complete the series, and heaven knew what I might be doing then.

Lord Tweedsmuir, Governor-General of Canada, during his tour through the unpopulated valleys of the world's top, studies his route on a map of moosehide made for him by Eskimos.

To circumvent any possible prohibition against carrying insects across the border, I scattered the ten chrysalises through a case of peanut flashbulbs, assured that there they would get some air and room if they started hatching before I could get back to them again. I flew into Canada by passenger plane, and was picked up by the small pontoon plane. My pilot followed the lazy curves of the river, and almost immediately all signs of human life and civilization seemed to drop away until ahead we spotted the S.S. *Distributor*, which carried the viceregal party. The *Distributor* was the lifeline to the far North. It managed to get in two trips to deliver groceries and other essentials during the brief summer thaw, before the great freeze-up sealed the tiny missions and trapper camps away from the world again.

My pilot set the airplane down lightly on the river beside the boat, and I was dragged aboard with all my gear. Once I was on board, life slowed down to the leisurely pace. Even the mourning cloaks, influenced perhaps by the increasing coolness, slowed down their mysterious life processes and seemed content to wait for whatever nature might bring.

From the very start there was a kind of affectionate friendship between His Excellency and myself. I found him a wiry, astute man of few words. He was indexing the manuscript of a biography of Augustus that he had recently completed, and he spent the greater part of the day at the stern of the boat, an excellent place to write undisturbed. A long narrow table had been contrived for him with a couple of planks, and there he sat with the fluttering little white paper markers of his index all over the place. Our cargo almost swallowed him up. His spare form was all but lost in the midst of the pig crates, the cage of chickens, the tractor, the assortment of agricultural implements which surrounded him. Several times I tiptoed up and photographed his expressive back, but I never interrupted him while he was working.

Whenever we arrived at one of the sparse and very tiny towns, His Excellency would disembark with his aide-de-camp and others of his party and make a speech, always the same speech, and take a quick trip around the community, with whatever priests, nuns and missionaries and other inhabitants of this area had gathered to meet him. On one occasion when I was taking

photographs, I called out to His Excellency to ask him to stand on the gangplank a second longer while I got a better viewpoint. He consented graciously, but a half hour later when we re-embarked, I got a scolding from the aide-de-camp. He reminded me that His Excellency was the direct representative, the very symbol, of the King. "Americans never seem to understand this." The great fault I had committed was to address His Excellency before he addressed me. One must wait until royalty opens the conversation. I was so taken aback that I burst into tears.

My unintended rudeness toward royalty notwithstanding, the symbol of the King took considerable interest in my butterflies. Their metamorphosis had slowed down a little, due to the cooler climate, but once more they had started wiggling and I knew their transformation was due soon. I taped up the ten on the rail of the upper deck, got all my photographic equipment ready and in focus, paying particular attention to the larger camera with its long bellows extension that I would use on the emerging insects. The sun shone throughout all the twenty-four hours now except for fifteen minutes of Arctic twilight in which the world became slightly grayed and then burst into color again after the quarter of an hour had passed. My vigil was continuous. His Excellency lent me books to read, including his own *Green-mantle* and *The Thirty-Nine Steps*, which I took great delight in rereading. I seldom left my deck chair even to eat a meal. My fellow passengers kept me nourished while I waited.

On his daily constitutional around the deck, His Ex, as we called him, would call out to me, "Hey, Maggie, when is the blessed event coming?"

The captain of the ship offered to stop the vessel as soon as I started taking pictures, so I would not be troubled with vibration.

On a Sunday morning, when we were in the middle of Great Bear Lake, almost precisely on the Arctic Circle, the first chrysalis started to split right down the back, and soon the others followed. And then began their twisting and writhing, fighting to get out of their outworn shells. Under our eyes the swollen wing veins began dilating until the little crumpled stumps of wings had grown to full size. All this was happening so fast that I hardly had time to look up, but when I did, I saw that His

His Excellency took a great interest in my butterflies. Everyone helped when they hatched aboard ship in the Arctic.

Excellency was on my right side holding reflectors as I worked, and on my left was the aide-de-camp, handing me things as I needed them. At the end of twenty minutes, we had ten beautiful mourning cloak butterflies. The captain started the boat again and the engines began to turn. "For thirty years," he said, "I've sailed this ship, and I never stopped it even if a man fell overboard, and here I stop it for a damn butterfly." The butterflies took kindly to meals of sugar-and-water sirup, unrolling their tongues like elephants' trunks, and sucking up the sweet

mixture. I was sure that these butterflies were farther north than any butterfly had ever traveled.

At Fort Smith we picked up mail and telegrams and an Anglican minister and his bride, who were being dispatched to a more northerly post. The radio operator climbed up to the deck and with a wide smile said, "We have been searching all over for someone who fits this telegram." And walking up to me, he said, "We've decided you are the likeliest candidate." The address read, HONEYCHILE, ARCTIC CIRCLE, CANADA, and the message inside said, COME HOME AND MARRY ME. Signed Skinny.

At Fort Norman I received two cables. One from my editors, which delighted me, asked me to charter a plane and fly over the Arctic Ocean to see what it looked like in the summertime. The second telegram was addressed HONEYCHILE, ARCTIC REGION. This one was in a darker mood. When in heaven's name was I coming home? He missed me, he loved me, the new apartment he was moving into was an unfinished cathedral without me. Why wouldn't I come right straight home and marry him? Unsigned.

Dear me. We had talked this over so often. I did not want to marry again. It was not that I was against marriage, despite my initial unhappy experience. But I had carved out a different kind of life now. To me it was of the utmost importance to complicate my living as little as possible. The very secret of life for me, I believed, was to maintain in the midst of rushing events an inner tranquility. I had picked a life that dealt with excitement, tragedy, mass calamities, human triumphs and human suffering. To throw my whole self into recording and attempting to understand these things, I needed an inner serenity as a kind of balance. This was something I could not have if I was torn apart for fear of hurting someone every time an assignment of this kind came up.

It was this emphasis on coming home in his telegram that concerned me most of all. The marriage part could be judged on its own merits when the time came, but the insistence on homecoming was something else. There was a puzzling insecurity in this withdrawn man which I was sure held a threat to my future work. I wanted no conflict of loyalties—that would be too painful. My first loyalty was to *Life*. There was no secret about

it. My professional work came first. This is certainly not a unique problem, and I'm sure that many professional women, and men too, have had this difficulty in one form or another. How they resolve it is a highly personal thing. Dashing off at a moment's notice around the globe is wonderful if you are doing the dashing yourself. But if you are the one who stays behind, it must be hard to bear.

As we worked our way north, distributing our assorted supplies, no matter how small the hamlet, even if only a Hudson's Bay fur-trading post, a couple of clapboard houses and a church and radio tower, someone would climb aboard asking, "Is there anyone in your party named Honeychile?"

Dependent on each other as the residents of the Arctic zone were in those days, the dispersal of news assumed an over-the-back-fence quality. With radio stations hundreds of miles apart, everybody within reach listened in whether the messages were for their station or not, and they heard Skinny's telegrams to me as well as my affectionate replies. Where radio left off, the moccasin telegraph took over. So my warm wooing through the Arctic zone was followed and enjoyed by all.

At Tuktoyaktuk, our most northerly port of call—a mere land spit curving out into the Arctic Ocean, covered with Eskimo dogs straining so wildly at their chains that it seemed as though they would tear their rocky promontory right out of the sea—the viceregal party prepared to fly south. Since this was about as far north as we could go without taking off for the North Pole, I released the four surviving butterflies here, so they could continue the trip under their own wingpower.

They were launched with a suitable ceremony, after eating their last breakfast of sugar-and-water sirup with a few drops of rum added. His Excellency and the other members of the viceregal party stood at attention while four slightly intoxicated butterflies took off in a wavering flight pattern and fluttered in a vaguely northbound course, navigating, we hoped, toward the North Pole.

With the departure of His Excellency and the four butterflies, I set about to charter a plane as *Life* had directed. Chartering a plane in the Arctic was not easy, I soon discovered. There were very few planes that far north, and these flew the Royal

Canadian mail. The pilots could take on a limited amount of charter work, as long as you agreed to give priority to outposts where the pilot had to deliver the mail.

These early bush pilots were a remarkable race of men who had to fly by their fingertips over terrain never adequately mapped because it disappeared under its great ice load for ten months out of the year. The flyers did anything from rushing an expectant Eskimo mother who might be in need of a Caesarean operation several hundred miles for medical help to stuffing a whole yelping protesting dog team into the tail of the plane to fly them inland to some fur trapper.

While searching for an airplane, I ran into two extraordinary characters who became my partners in this enterprise. The first was a full-fledged bishop, who commuted at regular intervals to London, where he reported directly to the Archbishop of Canterbury. Once every other year he flew to the most desolate and remote corners of his diocese to minister to his Eskimo communicants. Following the custom by which a bishop takes the name of his diocese as his surname, he was known as "Archibald the Arctic." His Grace was a spry, gay, resourceful little man, as businesslike as a corporation executive.

The other member of our party was a British composer who wrote travel books in addition to writing music. He was Dr. Thomas Wood, whose book, *Cobbers* on Australia was widely read through the British Empire, and the fruits of this trip were intended to provide a volume on the Dominion of Canada. "Doc" was plump, wonderfully genial, quick with repartee, and warmly sensitive to the needs of others. It was only after I had come to know him better that I learned how little of the world filtered through those round blue eyes of his. He was almost blind. Doc had never flown before. He had wanted for his first flight not merely some routine airplane trip such as a ferry flight over the English Channel, but something very special. As it turned out, this trip was indeed special.

Doc went off with the bishop and negotiated for an airplane. With the combined resources of the Church, *Life*, and the world of music and letters, we chartered a plane of ancient vintage, with the old-fashioned corrugated aluminum walls, flown by Art Rankin, who was blond, handsome and experienced in the

barren lands bordering the Arctic Ocean. He was an excellent pilot and, at the time of writing, is traffic manager for the great network of Trans-Canada Air Lines.

While they were away on this errand, I fell heir to a perfect Arctic costume. I had dropped in the tiny clapboard Hudson's Bay store which sold everything from powdered milk to sewing machines. A trapper who was buying canned groceries came up to me and in the midst of his almost unbearable shyness burst out that I was the same shape and size as his wife. I could think of no suitable reply to this. Then he told me his sad little tale. Some years earlier, he had induced his wife to come up from their home in Minnesota to join him. In preparation, he had arranged for an Eskimo woman to make one of the beautiful hooded fur parkas styled like a dress, which usually they made only for members of their own families. The trapper's wife arrived, took one look at the Far North and went back to Minnesota. The dress had been lying ever since on the back shelf of a trading post called Coppermine, and if I happened to show up there and would give the storekeeper a letter he had written, I could have it.

Since Coppermine was several hundred miles away over a seldom-traveled portion of the Canadian Arctic, it seemed unlikely that I would ever be able to collect my parka. But when the bishop returned with Art Rankin and a copilot, I learned that Art had to throw off a mailbag there. At Coppermine, the bishop took the opportunity to give a service in the little Coppermine church, and I presented my letter to the storekeeper and received the dress. It was made of the smoothest caribou fur, trimmed with darts of white reindeer breast, and very beautiful. The hood was edged with wolverine fur, which, aside from being very flattering to the face, has the practical advantage of not frosting over with the breath. Close to the sea as we were, there was a penetrating coolness even in summer, and I was glad to have my fur parka to slip on over the ski suit I was wearing. It had only one disadvantage. Photographers need lots of pockets, and Eskimo women don't put any in their parkas (except for the big pouch they sometimes put in back to hold the baby, and mine wasn't that kind), so whenever I reached into my ski pants for a filter or lens, I had to pull up my fur dress in a most inconvenient and unladylike manner.

In the Far North, I wore a parka of caribou trimmed with white reindeer breast and a hood lined in wolverine fur. This lovely outfit was given to me by a trapper. Photographed by His Grace Archibald the Arctic.

Once we were airborne and headed toward Cameron Bay—a tiny town 350 miles away, where the bishop planned to deliver a sermon—he settled back in a single chair in the rear of the plane and composed his sermon, which he would deliver in an Eskimo tongue. Then His Grace took a siesta. Art had removed the door, leaving a big square gap to take pictures through. As an extra precaution, he had tied a strong rope around my waist in case I fell out. When Doc thought I was leaning out imprudently far, he would grab hold of my caribou skirt and gently drag me back.

The low sun poured streams of thick gold flowing sluggishly like molasses. Below us were curving paths and whorls of floating ice patterned like the lacy penmanship exercises of the old Spencerian system. These were not icebergs, but it was impossible to gauge how big the pieces of ice were or how they had come to drift in such entrancing patterns; they were, I suppose, obedient to some ghostly, hidden current moving sluggishly in the depths of the sea.

I was very busy photographing these spindling trails and was describing them to Doc, who was begging for details like a man thirsty for color, and I was glad to be there to administer to his remarkable inner eye. Then I realized there was no more color to describe. We were flying—drifting, it seemed—in our antique aircraft through a world of pearly radiance where it was impossible to tell where the sky ended and the sea began. Then ice and sea and sky lost their boundaries and all turned gray together. We had run into one of those sudden treacherous fogs that begin rolling in from the open Arctic just after the midnight sun has passed. With the magnetic pole only about 200 miles away, there was nothing for Art to do but look for a place to bring the plane down as quickly as possible.

Art was putting the plane into searching dives and spins downward. I looked over and reported while Doc held tightly to my caribou parka. Once I caught a glimpse of two rocks side by side, lashed by an uneasy sea, as Art swooped down for a closer look. He didn't like what he learned, apparently, and on we flew. All of us knew quite well we were using precious gas as we looked for a haven rather than be driven to land on the open sea. Then we found it. A rocky crescent the shape

of a quarter-moon, curving protectively around the sliver of an inlet.

"That's our future home," shouted Art. I leaned out and I took one swift shot of the rocky crescent in the empty sea before Art brought us down. As though he were jumping from a canoe to the grassy shore of a shallow brook, Art leaped from the pontoon to the stony bank with the painter in his hand, quickly tied our aircraft to the rock and then got us out promptly. He directed us to follow him off the pontoons. "Don't fall in," he called out. We all had heard that strong swimmers become helplessly paralyzed in less than four minutes in Arctic waters.

I have often wondered what kind of people I would want to be with if I were cast on a desert island. These were four perfect people for the role. The bishop did just what only an Anglican bishop would think of doing. He pulled out his Episcopal banner from his suitcase and claimed the island for his Church. He looked around for something on which he could hang the banner, but there was nothing higher than the yellow Arctic poppies which were then in their short-lived August profusion. He hung the Church pennant on the propeller of the airplane. Having ministered first to his Church, he turned next to minister to his fellowmen. In the English language, that meant tea. So the bishop set out to collect driftwood for kindling. It would be hard to imagine a more incongruous sight than the bishop, dressed perfectly in his black leather jerkin, his beehive-shaped hat, with the heavy golden cross which always swung from his neck, scrambling over the wild rocks picking up little twigs. There is almost no driftwood on the rim of the Arctic Ocean, but somehow His Grace managed to find enough to brew a pot of tea, which helped us all. Over tea, the pilot briefed us on the situation. This he did superbly. Without minimizing the more serious factors of our unlucky predicament, he told us how things stacked up without alarming us either.

We were on one of the barren Lewes River islands, and about 300 miles from the nearest known habitation. He had tried to report our forced landing, but our radio was not strong enough to make contact. He could hear the Coppermine station calling us, but they couldn't hear us. They would talk to us every hour on the hour for five minutes, they announced, keeping the

channels open in the hope of picking us up. The fog could last for six hours or six weeks. The plane carried the regulation iron rations—for one man for twenty days. But of course, Art added jokingly—we were all of us trying to joke by that time—he could divide the rations into five equal piles on different points of the island, for each of us to eat slowly or quickly as we wished.

At this point the copilot reported two unexpected assets. One was a large Arctic hare which he had glimpsed, and since there was no chance for it to get off the island until the freeze-up, this would guarantee us one day of grace. The other was a fresh-water spring.

From that hour we began what in retrospect seems like a strange timeless existence. With no regular night to divide up the days, but just the two hours of semidarkness, we lay down on the rocks and napped whenever we felt sleepy. I was surprised at how much fun we had. The bishop told wonderful stories. Doc composed little nonsense songs, and we all came in on the chorus. We devised games, built piles of rocks for targets and had stone-throwing contests. Probably never on a desert island has there been such an adequate supply of photographic film, and all our activities were thoroughly documented.

Art always hung on the radio, trying to contact the outside world. It was strange to hear the voice speaking to us when we could not answer back, calling, "Art Rankin's plane unreported. Please come in, Art Rankin."

Each hour the sending station talked to us for five minutes, passing on to us what little scraps of weather information they could, since in those days there were no adequate weather forecasts for the polar region. In one broadcast, after giving us the weather, they announced a message for Honeychile: "When are you coming home?" Signed Skinny. That was a question we all wanted answered.

"We should tell him to come here," said the copilot dryly. "Here we have a bishop to marry you."

It was toward the end of what I guess was the second day when the fog lifted just a little. Art called us in a great hurry and said we were to leave immediately.

Our island had hardly disappeared into the distance before we flew into torrents of rain. If we had been a few minutes later in

making our takeoff, I doubt if we could have reached our destination. After two hours of flying, the short twilight began closing in, once more blotting out the sea beneath, but this time with the added threat of growing darkness. It was a miracle when through the driving storm we saw below us the tiniest-imaginable settlement on a little finger of rock. Just two frame buildings, one with a steeple, and a handful of Eskimo tents. We circled in for a landing.

The Hudson's Bay store was deserted. Apparently no one had expected us, and they had all gone fishing except for a young Eskimo named Mark, who was in charge of the building, half store and half house. His Grace, who had finally succeeded in reaching his flock, in what was probably the most difficult and tortured trip a bishop ever had to make to bring salvation, found there was no one there to receive it.

Plainly, his parishioners had departed in a hurry, leaving unmade cots and a mountainous accumulation of pots, pans, knives, forks, dishes.

His Grace spoke sternly. "If we can't have godliness, at least we can have cleanliness," and he started to wash the dishes. Doc and I tried very hard to help him, but he was a difficult man to help. He reached for knives and forks by the handful, doused them, and threw them on the kitchen table with a vehemence that kept us ducking. I had never before seen a bishop wash dishes in such a mood, and certainly I hope never to see such a sad sight again.

We explored our hut. There was no danger of starving here. There was enough canned food for several winters. There was even more—a dusty Victrola of the hand-crank kind and a wealth of aged records—so we held a dance. Airmen, I've often noticed, have a wonderful sense of rhythm and are always good dancers. Maybe I had to come all the way to the Arctic to accomplish it, but I was no wallflower here.

The weather began to clear. Filling our tanks from a cache of gas which had been left three years before by a whaling vessel, we took off for Aklavik. There, our party, by now bound together in ties of great affection, had to separate. At last, I was able to telegraph the message that I had started home. At Yellowknife, where we touched down for food, fuel and messages, the

radio operator wasted not a word in asking questions. With a broad smile, he handed me my Honeychile cable. It read, DON'T SPARE THE HORSES.

Back in the U.S.A., I stopped at the Chicago airport to change planes for New York. The announcing system was blaring its loudest. The crowds were so noisy that I could not catch a syllable. Someone was being paged. There was a familiar yet unfamiliar ring about it. Then the din battened down a little and I heard, "Paging Child Bride, eastbound passenger for New York. Paging Child Bride. Will Child Bride kindly step to the ticket counter?" I went to the counter and claimed my telegram. It read, "WELCOME, WELCOME, WELCOME, WELCOME."

CHAPTER XIV

LOVE

IN RENO

Finally a time comes when it is just too troublesome to remain unmarried. For me, this time came when Erskine and I were returning on the *Aquitania* after half a year in Europe. I had been covering the Sudeten crisis for *Life*, and together, Erskine and I had been collecting material for a new book we were working on, called *North of the Danube*.

The *Aquitania* slipped into New York harbor early in the morning and was boarded by a contingent of ship's reporters and photographers. For once, I found myself on the opposite side of the lens and camera. Reacting for a change, not as a news-gathering photographer but as a private citizen, I found myself unreasonably annoyed when the ship's photographers whipped out tape measures and measured the distance from Erskine's cabin to mine. When the reporters, in all kindness, took an "eventually, why not now?" attitude in their questions, I was irritated to the marrow.

Forgetting for the moment that I was resenting an invasion of privacy to which I had subjected untold scores of unwilling victims without giving it a thought, I blurted out in a childish way, "I'm not going to marry him, no matter how many photographers and reporters want me to."

Why should I marry this fascinating, gifted, difficult man? There were plenty of reasons why I should *not* marry him. Erskine had a very difficult attitude toward my magazine, a kind of jealousy, not toward any man, but concentrated on *Life* maga-

zine itself. Our friendship had been strewn with danger signals—
the unpredictable, frozen moods that seemed to have no traceable
cause in a world of reality, the unfathomable silences ending only
in violent tempests. I could not put out of my mind the difficult
situations that had taken place on this very trip. Many times,
it seemed to me I was bringing only half of myself to the sub-
jects I wanted to understand and photograph. My first thoughts
had to go toward Erskine and his moods, and my fondest hopes
were that the hidden glaciers would not come to the surface in
the middle of an important series of pictures.

The memory was still painful of the Easter trip we had
planned to take to a village on the Hungarian border of Czecho-
slovakia. Erskine had been interested in seeing village life. When
the man who was acting as Press Officer for the Czechoslovakian
government arranged to send us to a village on the Hungarian
border, Erskine was delighted and so was I. Then the Press Of-
ficer and his wife decided to go with us to make sure everything
on the trip went well. All I could do was to hope and pray that
Erskine would last without having one of the great freeze-ups.
We got splendid pictures, and Erskine was interested in what we
had found. Through the inevitable lengthy dinner that capped
the day, he had been chatting happily with our host and hostess.
Over coffee and liqueurs, the cool breeze began to blow. His face
turned white and his skin was drawn, and the Press Officer and
his wife began asking themselves agonizing questions: "What
could we have done to offend Mr. Caldwell?" I was particularly
troubled because this couple was so hospitable and kind. I am
sure Skinny did not intend to cause this distress. I believe he was
largely unaware of what was happening, for basically he was
sensitive and almost uncannily perceptive about others. But this
ungracious behavior prevented the closeness to the people we
should have had. I felt my pictures lacked the depth I wanted
to give them. Later, when *North of the Danube* came out in
book form, I believed that it added little to the understanding
of this interesting country facing a crisis. Certainly nothing of
the loving thoroughness went into *North of the Danube* that
went into *You Have Seen Their Faces*.

I think it was the innocent victims of Erskine's moods that
distressed me the most. I could not forget incidents such as the

evening a *Life* writer, a worshiping disciple of Erskine's, joined us for supper. For some reason that no one could define, he was subjected to a Class A freeze-up. The *Life* writer and I manufactured conversation as long as we were able, until finally all three of us lapsed into silence and longed for the meal to end so we could escape. I felt there must be some reasonable limit to how far one maneuvers to serve the moods of another.

Basically, my feeling was that here was a fine and very worthwhile man, whose inner insecurity was beginning to act as a blind against the world. He often told me that he had no close friends. Perhaps it was this essential loneliness that sharpened his need of me.

I remember poignantly one occasion on which I tried to leave him. My mind was made up, but how would I break the news? Erskine was driving me from the Pacific coast, where I had done a *Life* story on Hollywood, to an airport in Arizona. As we threaded our way through a channel of somber buttes rising from the desert floor, I was trying to find the words.

When I got up my courage and told him my decision, he stopped the car and we talked it out on the empty sandswept road. My ears still ring with his agonized words, "You can't leave us, Kit. You can't leave *us*." He was right. I couldn't—not yet.

It is often said that a woman is most strongly drawn to the man who needs her the most. I had always considered myself too selfish to be governed by such a motive. But there must be something to it. Perhaps if I became his wife, it would lighten the burden of insecurity which he seemed unable to cast off. I would not be satisfied until I had explored all possibilities thoroughly. If marriage would help, I was willing to try.

I had a plan. If Erskine would consent to it, I felt that our marriage would have a chance. He did consent to it and we boarded a plane for Nevada. Erskine chose this state because it issues wedding licenses immediately.

Once on the airplane, I worked on the plan and drew up a sort of marriage contract. The first point was that if some difficulty arose between us, we must talk it out before midnight; two, he should treat my friends as courteously as his own; he must attempt to realize and control his fluctuating moods, and there

must be no attempts to snatch me away from photographic assignments.

We were flying over the great desert reaches of Utah and Nevada when Skinny signed this formidable document, and at least that was behind us.

The plane would make a fuel stop in Reno.

Nobody wants to be married in Reno, so while still aloft, we borrowed the pilot's chart and hunted for a town within a hundred-mile radius which had a pretty name. We were both delighted when we found Silver City within the mileage limit.

At Reno, we made our way to the courthouse and with our license received a slender volume called *Cupid's Cook Book*. We stepped into a taxi and told the driver we wanted to go to Silver City.

Being wise in the ways of his special world, the taxi driver realized that we were much too friendly to be in Reno for the usual purpose. He was a practical man and said, "Silver City's a ghost town. If you two think you're going to get married in Silver City, you may be disappointed because there aren't any ministers there. You better take your minister along with you. And you will need witnesses. I can be one of them but you better find another."

The taxi driver took things into his own hands. We were passing through famous old Carson City, and in the sprawling old hotel the taxi driver found a minister sitting right in the lobby. This was no ordinary minister. He was also a State Representative who had come to Carson City for a convention. He was delighted to officiate at this totally unexpected wedding and entered into our plans with cordial enthusiasm.

As we drove toward Silver City, the landscape became wilder. It was growing late in the afternoon, and we still had a considerable distance to go. Erskine said, "Cattle trading isn't legal after sundown, and I want this marriage to be legal."

We rounded a curve and there was Silver City, hanging on a bluff above us, looking so charming that both of us knew that this was the perfect town. It was indeed a ghost town, deserted but for a few durable citizens. On the highest bluff was a church. The door was locked.

The taxi driver searched the town and found a small tobacco

Erskine and I went to Hawaii for our honeymoon.

shop open. He came running back to us to bring us the good news. The woman who ran it had the key to the church, and "Also," said the driver, "she's a nice, clean woman. She can be one of the witnesses."

Erskine and I were enchanted with the church. The seat cushions had slid off the benches onto the floor, and the dust of years had accumulated. Through the windows we could see the glorious panorama of bluffs and mesas and desert patches, stretching as far as the eye could reach. The golden coin of the sun was barely touching the rim of the horizon, and its measured descent took just time enough to suit Erskine's requirement that we be married before sundown.

CHAPTER XV

I

PHOTOGRAPH

STALIN

The first trip Erskine and I took together after our marriage carried us almost around the globe. We were headed toward Russia on an extraordinary hunch of Wilson Hicks, my picture editor at *Life*. With World War II in full swing in Europe, and the non-aggression pact between Germany and Russia in existence, Wilson was quite sure that things would vitally change, that Germany would be fighting Russia and that Russia would become a key country in the march of the war. Also, he felt I could make some valuable comparisons between the Russia of ten years ago and contemporary Russia, which was almost as much of a mystery as before. Erskine had always been eager to go because his books were read widely in the Soviet Union.

Since most of Europe had fallen to the Germans by the spring of 1941, we had to go the long way around and enter war-torn China at Chungking, flying across Inner Mongolia, skirting the edge of the Gobi Desert, flying over Sinkiang, the Soviet-Chinese border province, until we entered the southeastern door-way of Russia at Alma-Ata.

Even in the dusty Asian town of Alma-Ata, I could see that an important change had taken place since my last trip of ten years earlier. In the central square stood a statue of Stalin in

heroic proportions. Other large statues of Stalin dotted the parks and crowded the post-office lobby. Where there wasn't room for a statue, a life-sized painting was installed, usually showing the benign Stalin, surrounded by flowers, and smiling at small children. I recalled that in the time of the first Five-Year Plan, great red banners formed the backdrop of every schoolhouse auditorium and factory meeting hall, with silhouettes of Lenin and Marx. Now it was Lenin and Stalin—or only Stalin.

Among the many new developments, I found Stalin's birthplace had developed, too. This I discovered when we traveled to Gori. A remarkable shrine of marble and glass soared over the unpretentious wooden house where Stalin was said to have been born. The skylight was decorated with hammer and sickle set in leaded glass panes. Covered with a red-embroidered bedspread was the bed where little Josef was supposed to have come into the world.

I recalled the controversy between Gori and Didi-Lilo for the honor of being Stalin's birthplace. Whatever the rights and wrongs of the dispute, there was no denying that Gori was a more convenient birthplace for worshipful pilgrims to visit than the remote village I had been taken to when I photographed Stalin's great-aunt and all the relatives.

Exactly one month after Erskine and I entered the country, war broke out between Germany and Russia. Wilson Hicks had made a shrewd guess when he foresaw that the non-aggression pact would collapse and Germany and Russia would be fighting each other. Immediately on the outbreak of hostilities, the military authorities issued a ukase forbidding the use of cameras; anyone seen with a camera ran the risk of being seized and imprisoned. Here was I, facing the biggest scoop of my life: the biggest country enters the biggest war in the world and I was the only photographer on the spot, representing any publication and coming from any foreign country. I felt sure I could cope with the anti-camera law somehow. But the first problem was to be allowed to stay on the scene of action.

When a war breaks out, an ambassador always has to evacuate somebody, and there was hardly anybody left but us. The American Ambassador, Laurence Steinhardt, called us to the Embassy in Moscow. Erskine counseled me, "Don't talk too much. Let the

Ambassador feel he's doing his duty. The less we argue, the better chance we have."

Ambassador Steinhardt warned us that it was his duty to protect the lives of American citizens. "No one knows how soon Moscow will be bombed," he said. "And when it begins, the loss of life and destruction are bound to be terrible. There are still two seats left on the train to Vladivostok; it might be your last chance. However," he continued, after a meaningful pause, "if after thinking over the perils to which you are exposing yourself, and if after seriously weighing the dangers involved, it is your considered action to stay, our Embassy will help in every—"

He had no chance to finish, for within the next instant, the United States Envoy and Plenipotentiary Extraordinary found himself being kissed by a photographer.

During the first few weeks of bombing, it required something of a military maneuver to be able to see the raids at all. Erskine and I, along with everyone not actually on the rooftops for fire-fighting duty, were ordered underground into the shelters.

The Russians are nothing if not thorough. When the sirens sounded, the blackout wardens would search our hotel apartment to make sure we were not staying in our rooms during the raid. Of course, in our own Embassy, we were free of such restrictions, and I could stay aboveground to photograph the nightly spectacle in the heavens.

One night, Erskine went off to the radio station to give a broadcast to America, and I stayed alone on the Embassy roof and began putting my camera to work. Incendiary bombs were falling, and flames began shooting up in scattered spots, giving me pinpoints of light on which I could focus on the ground glass of the view camera. The drone of German planes sounded overhead, and the beams of searchlights swung upward, crossing and recrossing, until the whole sky was covered with a luminous plaid design.

I cannot tell what it was that made me know the bomb of the evening was on its way. It was not sound and it was not light, but a kind of contraction in the atmosphere which told me I must move quickly. It seemed minutes, but it must have been split seconds, in which I had time to pick up my camera, to climb through the Ambassador's window, to lay the camera

down carefully on the far side of the rug and lie down beside it myself. Then it came. All the windows of the house fell in, and the Ambassador's office windows rained down on me. Fortunately, a heavy ventilator blown in from the windowsill missed me by a comfortable margin. I did not know until later that my fingertips were cut by glass splinters. I only knew the shelter in the basement would be a very pleasant place to be. Getting down the grand staircase over the piles of broken glass in my open-toed sandals was the longest journey of my life.

At dawn, Erskine got back from the radio station. The all-clear sounded. We were about to start home, when it suddenly occurred to me that I was leaving a lot of good news pictures behind. It was too dark to take photographs, so I went back, and on the highest piles of glass I placed a note: "Don't sweep up glass until I come back with camera." I returned later in the day, took my shots and hurried them off to *Life,* which ran a lead story showing these first pictures of the bombing of Moscow.

The most useful feature of our hotel suite was its delicate balcony, which faced the Kremlin, the onion-shaped domes of St. Basil's, Lenin's tomb and Red Square—giving a magnificent Moscow panorama against which I could photograph air raids. The balcony had elements of history. Trotsky had stood here, giving a last address before his fall from power. Here, Charles and Anne Lindbergh had faced the enthusiastic crowds on their historic flight around the world as a husband-and-wife team.

The hotel suite possessed a Czarist magnificence. Cupids swung from the chandeliers, and the drawing room was furnished with a grand piano, a great white bear rug, and many statuettes of Ural Mountain marble. Its prominent feature was a gold-fluted pillar bearing on its summit a bust of Napoleon.

I did my developing in the enormous cave of the bathroom. Taking a bath was difficult because the tub was always full of trays of developer. In the morning, the ceiling was dripping with films that hung from cords stretched back and forth between the high water pipes and pinned to the edges of towels and window curtains. My working was made more complicated by the fact that the air-raid alarm usually caught me with three or four film packs in the tub in the process of developing. I would dive under the bed to hide away from the dutiful inspectors. While the

search went on, I counted the seconds and minutes, hoping I could get back to the tub before the films were too badly over-developed.

Erskine thought it undignified to crawl under beds. His choice was the corner behind the sofa. To make sure he was thoroughly hidden, he pulled the bearskin rug over his head and shoulders. There he would sit, in all his dignity, staring from the corner like a big Russian bear.

The nights took on a curious routine. While the action was still confined to the outer defense rings in the distance, I had a multitude of preparations to make. All the art objects had to be moved against the far wall and under the piano. After my experience with miscellaneous articles shooting inward at the Embassy, I did not wish to be knocked out with a brass lamp or agate inkstand.

It is strange how in a bombing everything in the room seems to rise up against you and become your enemy. The Napoleon pillar was too heavy to move, and in the darkness and the vibration, I feared Napoleon more than Hitler.

When the bric-a-brac was stowed away, the room was my workshop. Once I began viewing the skyline through the ground glass of the camera, my world became one of composing streaks and dashes of light, of judging the lengths of exposures, of trying to make each sheet of film bring out the most dramatic portions of the spectacle of lights unfolding before the lens.

I would creep out on the balcony quietly so as not to attract the attention of the soldiers on guard in Red Square below, and place two cameras shooting in opposite directions so they would cover as much of the sky as possible. Usually I set two additional cameras with telephoto lenses on the wide marble windowsill. How I used them would depend on the size of the raid. To me, the severity of a raid was measured by whether it was a two-camera, three-camera, or four-camera night. But I never operated all five cameras at once. My fifth camera I transferred to the Embassy basement. The possibility of being left without a single camera grew to be an obsession, so I took care to divide the risk.

Every night there was something to photograph, because whether it was a light air raid or a heavy one, the Germans managed to aim at least one bomb at the Kremlin. I remember

one spectacular night when the Germans dropped eleven para-
chute flares like mammoth blazing parasols floating to earth and
lighting up the whole central section of the city. With flares
overhead, you feel absolutely undressed. You feel the enemy can
see you wherever you are. The German bombers were droning
overhead as though they were looking for something.

Then the loudest bomb scream I have ever heard sent me
running back to an inside closet, while the bomb executed its in-
terminable descent. When it landed, my cameras were blown
into the room by the bomb blast. I hurried out to the balcony.
Just within the Kremlin wall, an enormous plume began rising
into the air. It seemed to hang there, frozen against the moonlit
sky, until stones and boards began dropping out of it. The
Germans had scored their hit and blown up a Kremlin palace.
It was not the palace where Stalin had his offices, but one occu-
pied by the Kremlin guard. Neither this nor any other hit made
on the Kremlin was ever permitted by the censors to be released
in news dispatches.

There is something unearthly about being on an open roof
or balcony during a raid. The sky is so startlingly big, with its
probing spears of searchlights and lines of fire, that man seems
too small to count at all. In the first look at war, one feels im-
mune; the spectacle is so strange, so remote, that it has no reality
in terms of death or danger. But how quickly this feeling of
immunity vanishes when one sees people killed!

Air raids affect people in various ways. Some grow very hun-
gry afterwards. Others become sleepy. I was one of the sleeping
kind. When the guns grew quieter, I would drop off at once,
often right on the windowsill beside the cameras. Sometimes a
wave of planes would come back, and the blasting of the guns
on the rooftops nearby would jar me awake. I would start up
to see the square below dancing with fireflies as the shrapnel
tinkled down on the pavement. But as soon as the sound grew
softer, I would be back in slumber on the marble ledge, my
cameras, set for time exposures, still recording any streaks of
light that might flash through the sky.

When my husband got back from broadcasting, we would get
into the wide bed that had held the Lindberghs, and Trotsky.
We were very comfortable under the yellow satin quilts as we

[OVERLEAF] *During this spectacular night bombing in July 1941, the
Germans dropped eleven huge parachute flares over the Kremlin, light-
ing up the whole central section of Moscow.*

dozed off. Finally, at dawn, we would hear the loudspeaker above us call out, "The enemy has been beaten back, comrades. Go home to your rest." As confused voices rose from thousands of people leaving the immense subway shelter, we would fall into a deep sleep.

On previous trips to Russia, I tried in a routine way to get permission to photograph Stalin. I had never had even an acknowledgment of my request.

Success came finally shortly after Russia entered the war, when she felt she needed American good will. It was during this brief honeymoon period that President Roosevelt sent Lend-Lease Administrator Harry Hopkins to Russia as his personal envoy. Hopkins really went to bat for me and prevailed upon Molotov to get permission to photograph Stalin.

I gave some thought to what I should wear. Knowing that Russians like red, I put on red shoes and tied a red bow in my hair.

The Kremlin car called for me and drove me through the Kremlin gate to the palace where Stalin had his office. An escort of soldiers took me up in a little gilt, red-carpeted elevator to the second floor.

I was led through a long, winding hall. I must have passed a hundred doors. Each corridor branched off at an oblique angle. At each turning, soldiers telephoned ahead that we were on our way. I was sure that no one got into the Kremlin who wasn't wanted there. The numbers on the doors grew lower; as we passed numbers 12, 11, 10, I wondered whether Stalin would be behind No. 1. However, I was taken into No. 2, where I waited for two hours.

I go to every important portrait appointment with a conviction that my cameras are going to cease functioning—a dread that never leaves me, even after years of experience, and this time I was certain that nothing would work when I was face to face with Stalin. During the wait, I polished my lenses, checked my synchronizers, powdered my nose, glanced in my mirror to make sure the little red bow was on at just the right angle. At last a Red Army officer, wearing an impressive collection of medals, came for me.

I had just time to remind myself not to be nervous when I

was whirled through door No. 1 into a long, bare room. There
was little furniture except a long table, covered with green felt,
and a large globe of the world on a pedestal. I was conscious
of Mr. Hopkins standing at my side, but it took me a moment
to find Stalin. I had seen so many giant statues of him that I had
come to think of him as a man of superhuman size. I looked
instinctively toward the ceiling, then lowered my eyes and saw
Stalin. He was standing very stiff and straight in the center of
the rug. His face was gray, his figure flat-chested. He stood so
still he might have been carved out of granite.

There was nothing superhuman about his size. My own height
is five feet five, and Stalin was shorter than I am. My first reac-
tion was "What an insignificant-looking man!" Then, in the
next minute, I decided there was nothing insignificant about
Stalin. Many correspondents and others I had talked with won-
dered whether Stalin made his own decisions or was merely a
figurehead. One look at that granite face, and I was sure that
Stalin made all the decisions. I was struck by his wide, Mongolian
cheekbones which gave an illusion of size. I was surprised to
see that he had pockmarks. He wore boots and a plain khaki
tunic. I noted he was the only person I had seen in the Kremlin
wearing no medals.

As I began working, I tried to draw Stalin into conversation
through the Kremlin interpreter. I mentioned having photo-
graphed his mother while she was still living, in Tiflis. At this
disclosure, the Kremlin interpreter exclaimed with astonishment,
"His very own mother! His real mother!" But Stalin spoke never
a word. His rough, pitted face was as immobile as ice.

I asked him to sit down, hoping that would make him more
relaxed, and when he didn't, I repeated my request through the
interpreter. Stalin showed no inclination to oblige me. I was
desperate to find something to make that great stone face look
human. Then a little thing happened to help me.

As I sank down to my knees to get some low viewpoints, I
spilled out a pocketful of peanut flashbulbs, which went bounc-
ing all over the floor. The Kremlin interpreter and I went
scrambling after them. I guess Stalin had never seen an American
girl on her knees to him before. He thought it was funny, and
started to laugh. The change was miraculous! It was as though

a second personality had come to the front—genial and almost merry. The smile lasted just long enough for me to make two exposures, and then, as though a veil had been drawn over his features, again he turned to stone. I went away thinking this was the most determined, the most ruthless personality I had ever encountered in my life.

It was almost half past nine when I left the Kremlin, and the *Luftwaffe* had been calling regularly at ten o'clock each night. I couldn't take a chance on developing my precious films at the hotel; to have an air-raid warden break into my bathroom and tear me away from a half-developed negative of Stalin was more than I could risk. I drove to the American Embassy where I would not be interrupted. The alarm sounded just as I drove through the gates. The Embassy was deserted. Everyone had gone off to shelters. The Ambassador and Mr. Hopkins were Stalin's guests for the air raid that night in the super-deep shelter far under the subway, reserved for the highest Soviet officials.

The chauffeur helped me set up my laboratory in the servants' bathroom in the Embassy cellar. The negatives of Stalin were so irreplaceable—should anything go wrong—that I did not have the courage to plunge them in, sink or swim, a whole film pack at a time. I began processing them one by one.

It was a busy night outside, and I could hear the rhythmic booming of the guns as I worked. And when finally long descending shrieks began, I was glad the cellar window was sandbagged. Wouldn't it be fantastic, I thought, if Uncle Joe got fogged by a fire bomb? After four hours, the raid ended.

As the night wore on, I grew hungry. In the excitement of the appointment, I had entirely forgotten to have supper, and I couldn't remember whether I had eaten any lunch. It should be easy to get something to eat in your own Embassy, I thought, but the steward had gone off with all the pantry keys in his pocket. One rarely used icebox in the basement had been left unlocked, but it contained only a bowl of rice of doubtful date.

At 5:00 A.M. it occurred to me that I should send *Life* some kind of description of my remarkable evening, since my editors would hardly be familiar with the inside of the Kremlin. I searched throughout the cellar for something to write on, and found a big, brown paper marketing bag. I was dazed with

Josef Stalin, photographed in the Kremlin, August 1, 1941.

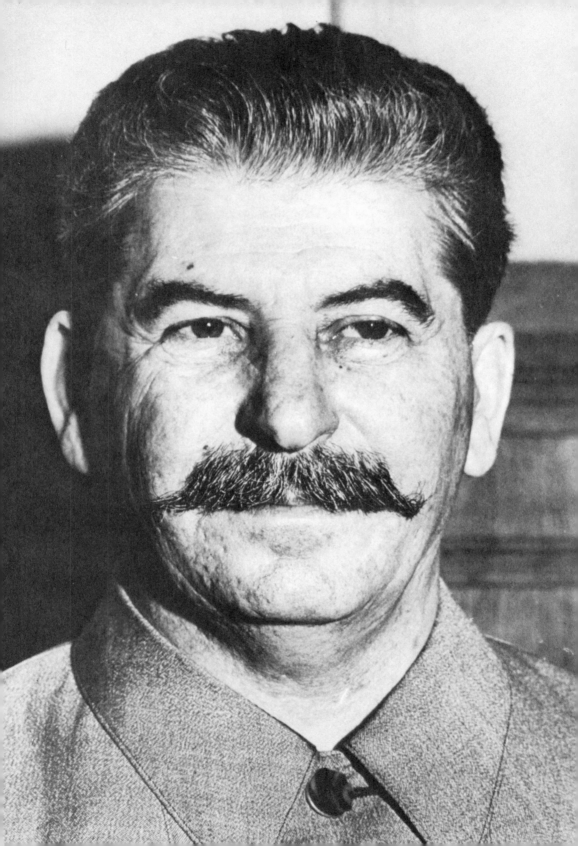

sleepiness, but I managed to scribble a short account of my exciting appointment. I was so weary that the words must have been almost illegible, and yet somehow, the editors back in New York made sense out of it.

Mr. Hopkins had promised to take the films back to Washington in the plane with him. I found him upstairs in the Embassy having breakfast, where I turned over the precious package to him. In less than two days, the films were in *Life*'s hands.

It was incidents like this which made me feel my office was just around the corner. It was uncanny the way everything reached *Life* just as needed. And the editors tied the pictures into the news so well! I had no sooner made and dispatched a series on Russian churches than Roosevelt made a speech on the importance of religious freedom. With one thing after another, *Life* had a world exclusive that lasted for weeks and weeks. The breaks went all our way; there was such an abundance of material: women painting false windows on every flat rooftop as camouflage, the staff of the Bolshoi Theater using their immense curtains and all their stage scenery spread over the Red Square and the Kremlin walls to confuse German pilots, the first German prisoner to be captured, the first German plane shot down.

The factories whose birth pangs I had witnessed ten years earlier were being evacuated wholesale to Siberia, where they would be as far out of reach of the enemy as possible. Endless lines of boxcars with heavy machinery and workers and their families rolled eastward into Asia.

In accordance with the "scorched earth" policy, by which anything useful should be blown up in the path of the enemy, the Dnieper Dam was demolished. The Russians wept when this news was published. When finally, after much begging, we got permission to go to the front, we passed scores of "scorched earth" villages reduced to patches of ashes.

At the front, which was then near Smolensk, I made the acquaintance of what Russian war lore knows as General Mud. We traveled to the front over rivers of maple icing turned to glue, along what were once known as roads. We drove through plains scattered with helmets of the dead, and battlefields that looked like the end of the world.

Skinny and I bought our Russian fur hats in Archangel for the home-ward trip by convoy through the Arctic.

When General Mud began giving way to General Winter, we returned to Moscow and prepared to come home. We both had lecture tours coming up, and we had to get back the fastest way possible. Even the most stimulating travel in foreign countries, I find, sharpens the desire to return to your native land, where, with an instinct deeper than reason, you feel you really belong. The fastest way home was not very fast. We went by slow convoy of twenty-two cargo ships—escorted by two destroyers and a cruiser, in case of submarine activity—from Archangel through the Arctic Ocean and the North Sea to Scotland. From there, we flew to Portugal.

We found Lisbon packed with travelers forced to wait weeks

to get accommodations. Worried, we entered the office of Pan American Airways. My husband inquired about the reservations for Mr. and Mrs. Erskine Caldwell. The clerk shuffled through a bundle of cards. Looking at me in a condescending way, he said, "There's only one reservation being held, and I think, Mrs. Caldwell, that your husband has the priority."

I begged the clerk, "Please look once more. There must be a reservation. Please do something to fix it up."

"No," he said, eying me coldly. "There's only one more place being saved, and that's held for a lady from Russia."

I thought, "Heavens! Who's scooping me?" And I asked, "What's her name?"

He said, "Her name is Margaret Bourke-White." And so I was able to come home, too.

Erskine cabled our secretary from Lisbon: ARRANGE SUNDAY DINNER WITH BOTH STEAK AND FRIED CHICKEN, ALSO ALL KNOWN FRUITS AND VEGETABLES BOTH IN AND OUT OF SEASON. We flew to the Azores, on to Bermuda and on across the Atlantic. We had completed our trip around the world, and arrived in time for Sunday dinner.

CHAPTER XVI

THE LECTURE
CIRCUIT

Eating that dinner was about all I had time to do before throwing some clothes in a bag and returning to the airport. The evening of that very day saw me embarked for St. Louis, where I was to give a lecture to the Junior League at ten the next morning. I hadn't counted on being booked as closely as this! I had given occasional lectures before but only after the most painstaking preparation, and had never been signed up for a full-fledged tour like this one. After our globe-circling trip, I was so weary as to be uncontrollably irritable. On a night flight, I usually drop off to sleep the minute the plane leaves the ground, but this time I got angrier and more sorry for myself with each mile we flew. I could not discipline myself enough to plan my speech in my mind. Drab St. Louis, in the half-light of dawn, matched the drabness of my spirits. But there was one unexpected bright object in the picture. The hotel where I registered had given me a room and a luxurious bath, done in many shades of lavender tile with a sunken lavender bathtub. I ordered an immense breakfast—including Texas pink grapefruit—and placed it next to the tub where I could soak and eat simultaneously.

My morale was rising now, and with it my conscience. It wasn't the fault of my audience, I told myself, that I had come home scarcely twenty-four hours before I was scheduled to give a speech. And I must not take out my ill temper on them. Then the extreme of self-pity gave way to the opposite extreme of worrying for fear the audience would not get their money's

worth. A lecture is usually fifty minutes or an hour long, and I had barely enough material to keep me on the stage for twenty minutes.

Then I was there and the audience was there and it had begun. The listeners never moved from their places, nor did I. Finally, something made me look at my watch. I had been talking for two hours and twenty minutes.

From this time on, I was in full swing. With this bursting out I had discovered that lecturing was doing something very important for me. It was helping me sort out my impressions in answer to that invisible response of an audience, which, unseen and unheard, exerts such power on the speaker. And although I never allowed myself to speak for two hours and twenty minutes again, after each of these long journeys to distant countries or to the war, I came back so crowded with impressions that had to be shared that I would have thrown them out to a convenient taxi driver or the corner policeman if I had not had lectures coming up.

The first lecture after a big trip told me what I wanted to know—the relative importance of the events I had been through, the human beings who stood out as the most vivid or moving, the details I could draw on to make my points come alive. Once I made the discovery that my experiences would unfold of themselves on the platform, I never allowed myself to prepare too specifically. I wanted to be surprised, too.

Two things I planned in advance: the opening episode and the closing one. I divided the subject matter roughly into three or four blocks, and I was always careful to figure out my transitions in advance so that I would know where I was going. But beyond this, not a word—either in my mind or on paper. I used to walk across the stage saying to myself, "I'm going to have fun. I'm going to have fun." And I found that if I did, my audience usually had fun, too.

Shifting from the camera to the lecture platform after a big assignment was a happy arrangement for me. Most of the situations I was sent out to cover were in the heart of the news, which meant I could come back with material that was always timely and dramatic. On a photographic assignment, I threw myself so intensely into the business of taking photographs that I could

not have done it, year in and year out, without growing stale.
Instead of taking a vacation in the usual sense of the word, which
interested me very little, I liked throwing myself just as whole-
heartedly into a field completely different from photography.
Lecturing meant I was building on my experiences, but in an-
other dimension.

Of course, I am at the very core a photographer. It is my trade
—and my deep joy. Other media, such as lecturing—and later,
writing—grew out of my picture assignments. The pictures came
first, the necessity for words later. My earlier books were essen-
tially picture books with captions and a limited amount of text.
Eyes on Russia, published after the first Russian trip, had a very
short text. A large portfolio of loose-leaf pictures which came
out at about the same time had no text other than a brief intro-
duction and captions. In my book *Shooting the Russian War*,
published after our wartime trip, words and pictures began to be
more evenly balanced. In two later war books, *"Purple Heart
Valley"* and *"Dear Fatherland, Rest Quietly,"* about Italy and
Germany respectively, the writing became a more important
part of the book.

I thought my lectures might serve as a first draft for a book.
Since they were entirely extemporaneous, I tried taking a steno-
typist on tour with me to make a word-for-word transcription.
But I was amazed to find that all life had evaporated from the
typewritten page. I made the discovery that speaking is an en-
tirely different medium from writing. Writing has a shape and a
set of laws utterly different from speaking.

One thing that did help me very much was recordings of radio
interviews that I made after each big trip while the experience
was still fresh. They preserved a certain flavor in the choice of
words which was invaluable later when I was writing.

Traveling the lecture circuit is governed by the strictest show-
must-go-on tradition. Trains may fail to connect, planes be
grounded; you push your way onward by bus, caboose or camel.
Sometimes the adventures you intend to relate from the plat-
form pale before the sheer difficulties of getting to the lecture
on time.

I remember one short journey between Evanston, Illinois, and
Evansville, Indiana, when everything hinged on a tight connec-

tion in Chicago. I missed the last train from Chicago and was un-
successful in chartering an airplane. I hurried to the Stevens
Hotel, believing the world's largest hotel would be able to help
out in any emergency.

The bell captain rose to the occasion. He had a car and could
take me if the night manager was willing.

The night manager—who, with his carefully groomed goatee,
looked like a character out of a detective story—not only was un-
willing; he was shocked. He looked up at the tall, handsome bell
captain and down at me and said, "Young lady, do you usually
travel around by yourself like this?"

"Oh, yes. Yes, but we don't have much time."

"You travel all alone?"

"Yes, I've been around the world several times and at the war.
But please, I have a lecture in Evansville at 9:30 tomorrow
morning. I'll miss it if we don't start right away."

I won, but almost lost my victory by asking for two blankets
and a pillow to make up a bed on the back seat of the car. The
little goatee twitched with suspicion, but the blankets and pillows
were ordered. By the time we were ready to leave, the entire
night staff of the Stevens had lined up along Michigan Avenue
to wave us off.

I can sleep on anything moving as long as it's moving in the
right direction. I woke up once or twice and asked how we were
doing. We had a good chance, the bell captain said. At 9:15, we
reached Evansville. I streaked through the hotel lobby with a
fresh suit over my arm, and buttonholed the manager. "Can you
give me a lot of help in the next ten minutes? I need my suit
pressed and I need breakfast. Send a maid; she can hand me my
scrambled eggs in the shower."

I walked on stage only nine minutes late. When I told my lis-
teners the saga of the journey, they agreed with me that it was
easier to go from Siberia to the Sahara than from Evanston to
Evansville.

Sometimes there was unexpected adventure on the platform
like the time in Sioux Falls when I was in the midst of describing
an air raid and began slowly and mysteriously to sink through
the floor before the horrified eyes of my audience. Investigation
showed that the stage had been improvised from two separate

elements pushed together and the patchwork disguised under a
rug. I was able to assure my audience that the perils of the bomb-
ings had nothing to match the excitement of Sioux Falls.

I cared particularly about wearing smart clothes on the lecture
platform. I loved having my clothes designed by an outstanding
designer. The year the war ended, I went on a spree in Paris.
After all, these were my working clothes, I told myself—formal,
informal, costumes in which I would arrive, costumes in which
I would depart, hats for luncheon lectures, hats for travel.

With a bulging suitcase of new clothes and several hatboxes,
I started on a coast-to-coast lecture tour. I changed trains at
Chicago, and my sister Ruth met me at the station for a little
visit between trains. We had just long enough to see my baggage
on board and to get a sandwich. Ruth and I said our goodbyes. I
went to my compartment, where I made the shocking discovery
that my big suitcase with all my lovely clothes had been stolen.
I rushed to the platform of the moving train. Ruth, unfortu-
nately, was out of sight. I shouted to anyone who would listen,
"Get the police! My bag is stolen. Police! Police!"

To my surprise and admiration, at the next signal stop the
train paused briefly to take on a couple of police investigators
who searched the long train without results. It did me no good
to learn that clothes were "hot" and would go for a pittance. I
was not at all cheered by the prospect of a Dior sold in a side-
walk transaction.

Worst of all, I was not even wearing one of the Parisian suits,
but my oldest and most frayed tweed, which had already seen a
long and useful service. At least the thief had the good taste to
leave me the hot hats.

From then on, during my entire swing through the United
States, I gave every lecture in my tweed suit with one of the
Parisian hats. I may not have looked so glamorous as I had hoped,
but my sad story was received with oceans of sympathy from the
men as well as the women in the audience. Two days after I
arrived home, the bag appeared at the end of the railroad line in
San Francisco, as mysteriously as it had disappeared. It was in-
tact, but by then my last lecture was given; the tour was over for
another year.

Almost every lecture tour took me through the Middle West.

My sister Ruth lives in Chicago and my brother Roger is in Cleveland. When I was in either city there would be a short lay-over or at least time for a little visit on the telephone. As young-sters, the three of us darted off in all directions with very little brother-and-sister relationship. No doubt we were influenced by my mother's belief in personal independence. The years have brought us together in a very happy way.

My tall and handsome brother, Roger, is an engineer with an inventive turn of mind much like our father's. He has carved out a very fascinating career for himself with one of the plastics. His new material is reinforced with tiny fibers of glass and is lighter than aluminum and stronger than steel. At the same time, it is an excellent electrical insulator. He has named it Glastic. Some years ago, Roger rented the corner of a factory to experiment with his Glastic. Soon he was renting half the factory and now he is in his own factory. He has married a lovely girl nicknamed "Mike," although she is very un-Mikelike to me, and they have two handsome and brilliant sons.

Roger is interested in everything. His hobbies range from the difficult art of raising pet hermit crabs to designing sailing kayaks and racing them on Lake Erie.

My sister Ruth, in Chicago, has been with the American Bar Association for twenty-five years and is its administrative secre-tary. Earlier, while at the University of Michigan editing the *Michigan Law Review*, Ruth had taken some courses in law. When she came to the home office of the American Bar Associa-tion in Chicago, she edited its official Annual Report for many years.

Ruth is one of the best editors I know. She has a gift for mak-ing suggestions and corrections without interfering with what the writer had in mind. I have never sent a book to press without the manuscript's passing under Ruth's wise eyes, and her com-ments have not only insight but humor.

Ruth has another gift which has delighted me from childhood. She is the family bard and wrote letters home from school in rhyme, which she could handle as easily as prose. Ruth is much better at this kind of thing than I, but on one occasion when I was in my last year of college, I wrote a verse that saved me my diploma.

To graduate from Cornell, I needed one more credit in a foreign language, in my case French. That was the year I was starting my photographic business on the campus, and I simply couldn't put my mind on French. Finals were just around the corner. I would have to do something spectacular.

Knowing that my professor liked French verse forms, I decided to compose a poem in French. I soon discovered that French poetry has its own particular difficulties, even for those who speak French well. I did the next best thing: I composed a triolet in English. On the day of the final, I left my answer sheet completely blank except for these eight lines:

> *When first I tried, I did not guess,*
> *French verse would be so hard to master;*
> *Of more than common stubbornness,*
> *When first I tried, I did not guess.*
> *Did mute E bode such sore distress,*
> *Elision promise such disaster,*
> *When first I tried? I did not guess,*
> *French verse would be so hard to master.*

My French professor passed me with a D. The only trouble is that now that I have become a world traveler, it would be much more useful to me if I spoke French, for one so seldom has the opportunity to address others in triolets.

CHAPTER XVII

THE FLYING
FLITGUN

E<small>RSKINE</small> had a favorite saying which he re-
peated very often—so often that I think he convinced himself
of its truth. "The life of a writer is just ten years," he would say.
I did not agree with him at all. To me, the life of a writer—like
that of the professional in any other creative field—is just what
he cares to make it.

It was about ten years before the outbreak of World War II
that Erskine's powerful writings threw the searchlight on a
hitherto ignored segment of American life. His book *Tobacco
Road*, made into a play, had brought home to millions the plight
of sharecroppers and tenant farmers in the South. Whether from
Erskine's belief in the limiting of creativity to a decade, or from
some other cause, at the end of ten years a change did take place.
It seemed to me that Erskine was writing new books of old
stories—a repetition of earlier Tobacco Road themes—that he
was barricading himself from new experiences. Though there
was still much warmth between us, Erskine's frozen moods were
just as unaccountable and difficult as in the beginning.

It took the war actually to separate us. The attack on Pearl
Harbor took place and our country was in the war. For me,
there was no other choice than to offer my special skills wherever
they might be useful. I wanted to go overseas. Erskine wanted
to accept a Hollywood offer. He saw to it that I had a very
profitable offer, too. He bought a house in a lovely part of

Arizona as a present for me. I wouldn't accept the Hollywood offer; I couldn't accept the house, which I felt was another set of golden chains.

I believe by this time both of us began to realize we were leading two separate lives that no longer fitted together. We had had five good, productive years—with occasional tempests, it's true, but with some real happiness. I was relieved when it was all over and glad we parted with a mutual affection and respect which still endures.

Now I could put personal problems behind me and get back to work. *Life* worked out a wonderful arrangement with the Pentagon in which I would be accredited to the U.S. Air Forces. With my love for taking pictures from airplanes and of airplanes, it was perfect. Both the Air Force and *Life* would use my pictures.

In the late spring of 1942, when I was accredited, the first uniform for a woman war correspondent was designed for me. I was amused, but also rather pleased, by the seriousness with which the officers in the Army War College approached the design of the uniform. A Captain Quirk and several lieutenants brought out bolts of cloth to decide just what the well-dressed woman war correspondent should wear. They decided to follow the basic pattern of an officer's uniform, except that women would have skirts as well as slacks. The blouse and slacks would be what is called "green" in the Army, with "dress pinks" (a lovely gray) for special occasions. There was a great deal of to-do about buttons. Would we be allowed to wear officers' gold buttons with the eagle or plain buttons matching the uniform? Finally it was decided we would wear gold buttons, and on the shoulders, instead of the insignia of Army rank, we would wear war correspondents' insignia. Once these decisions were made, women war correspondents' uniforms were modeled after this first one. Abercrombie & Fitch entered the project with enthusiasm and turned out the first uniform.

War correspondents had what is known as assimilated rank, which entitled them to officers' mess and officers' pay—except you had to be captured to collect the officers' pay. During the early part of the war, we were lieutenants and were swiftly

raised to captains. Before the war ended, we had been promoted
to lieutenant colonels.

I flew to England, and my arrival coincided with that of our
first thirteen heavy bombers, the B-17s. In England, I stayed at a
secret American bomber base, and made occasional short trips
to London. On one of these, I photographed Winston Churchill
on his sixty-eighth birthday. His Minister of Information, Bren-
dan Bracken, arranged for me to take the picture on Churchill's
birthday, thinking the First Lord would be more relaxed.
Churchill was a difficult subject: nervous and tired—understand-
ably so, because the British Navy was having a bad time with
enemy submarines. In addition to Churchill's impatience, I was
having trouble coaxing a sticky shutter into action. So I was
grateful that I got one good picture of the fine old man with a
birthday carnation in his buttonhole, which *Life* used for a cover.

Another portrait subject was Haile Selassie, "King of the
Kings of Ethiopia, Lion of Judah, the Elect of God," who was
in exile in London. After the portrait, his Imperial Majesty cour-
teously helped me and my gear to the elevator, although he was
so small he could almost have been tucked into one of my camera
cases.

I was always glad to get back to the air base, because my heart
was there with the crews and the big lumbering airplanes and all
the dramatic activity. On one occasion, royalty came to us at
the airfield. King George VI, touring American air bases, saw
me taking pictures and said, as I learned later, "Who is that
woman with the remarkable hair?" To have a king admire my
hair and an emperor carry my cameras was more than I had been
accustomed to.

A tribute of a different sort which I cherished was the request
of a bomber crew to name their airplane. Already on the field
were some famous names: *Berlin Butchershop, Deutscher Clean-
ser*, whose battle records matched their titles. When I came up
with the *Flying Flitgun*, the crew members accepted the name
with heartwarming enthusiasm. They ran out to their bomber
with pails of paint, and on the nose of the B-17 they painted a
bright yellow flit-gun, spraying down three exotic insects, with
the faces of Hitler, Mussolini and Hirohito. Next they painted
"SAY WHEN" on the bomb-bay doors and "Peggy" on the No. 3

*Accredited as a war correspondent assigned to the Air Force. This first
uniform set the pattern for woman war correspondents.*

engine. This last I took as a great compliment. There are only four engines to a crew of twelve on a B-17, and they were usually named for fiancées and wives. Now we were ready for the christening. We all agreed that the Fortress should be christened with Coca-Cola as more typically American than champagne. And then of course we had no champagne.

Like everything else in the Army, the christening went through channels. Quartermaster was called upon to pass a ruling authorizing me to break the Coke bottle, for in the Army, while Coca-Cola was expendable, the bottles were nonexpendable. Group Armament issued a directive permitting me to crack the Coke over the front guns. Weather picked us a day, just bad enough so that the airmen would not have to go on a mission, and just fair enough so that the christening party would not be rained out. Group Transportation agreed to move the piano and all other musical instruments available to the central runway. Defense prepared a dispersal pattern for evacuating the field in four directions in case of an air raid. Intelligence wrote a christening speech, and the Commanding Officer of the 97th Bomb Group, Col. J. Hampton Atkinson, agreed to read it. The C.O., a serious, almost taciturn officer from Texas, delighted us all by reading the speech with expression and dramatic gestures. When the final, unexpectedly flattering lines were read—"May the *Flying Flitgun* bring to the enemy the devastation its godmother has brought to the 97th"—I mounted a high ladder to the nose of the bomber and swung the Coke over the right front machine gun. To my relief, the bottle broke as clean as though it had been cut with a blowtorch.

Next morning, the heavy weather lifted. I went out very early to the *Flitgun* and at the request of the boys signed a bomb which they would drop on an airframe factory, their target deep in Germany. I wasn't entirely happy about autographing the bomb, but I knew the crew believed it would bring good luck. With the hazardous mission ahead, I would not subtract one iota from the morale of the crew. In stately procession, like great lumbering elephants spaced wide apart, the B-17s took off down the runway. Now I was like a wife or fiancée: of all the Flying Fortresses, the *Flying Flitgun* must come home.

By late morning, the Fortresses were straggling in. I had been

The christening of the "Flying Flitgun." The officer is Colonel (later General) Atkinson.

around airmen long enough to know one should not talk too much if things had gone badly. This could be ascertained without a word when the men climbed out of their planes sullen and silent. But if things had been good . . . well, with the *Flying Flitgun* they had. I could hear the crew laughing and kidding from far down the field as I ran to the ship. The men were terribly excited. They had shot down their first enemy fighter, "and only two minutes after we delivered your bomb to that German

factory," Captain Hofman told me. The formation of Fortresses was attacked by "a skyful of Focke-Wulf 190s." The Captain described it to me. "The air sure was crowded. It was like a convention over the target—lots of people." An F-W rolled up for a belly attack on the *Flitgun*, so close the ball-turret gunner, Sergeant Froelig, could see the white borders of the swastika.

"There he was, smack in the gunsight." Even the silent Sergeant had become voluble. "I just pulled the trigger and peppered him till he reeled off and went down, tail over wing."

The Sergeant was too busy defending his quadrant to even mention over the interphone that he had bagged a Jerry. But the other crew members told me there was one startling unbelievable moment just two minutes from the target on the homeward stretch—at a time when communications are kept religiously clear—when they heard a voice, tuneful, wandering, and very strange. It was Sergeant Froelig on the interphone, singing.

During all this work with the U.S. Air Forces overseas, I was given extraordinary assistance. My accreditation was a unique one, as war photographer directly assigned to the Air Force, with the Pentagon as well as *Life* using my pictures. I was allowed to do everything I required to build up my picture story: photograph the early dawn briefings, go on practice flights, whatever I needed except the one thing that really counted. I was not allowed to go on an actual combat mission.

"To be a woman in a man's world," as people often phrase it, is usually—I have found—a distinct advantage. There are a few exceptions, and my present difficulty was a classic example. In a combat situation, men tend to overprotect, and no overprotected photographer, male or female, can get pictures by remote control.

In the early weeks of my work with the heavy bombers, no one from the press was allowed to go on missions. Then the ban was lifted, as it obviously had to be. There was not a whisper of a double standard in the directive, but as though written in invisible ink, it was there for all Air Force officers to read. Male correspondents who applied got permission. My requests got me nowhere. Yet I was fully qualified to cover a mission—perhaps more than they—not in the sense of woman against man, but because the Air Force was my explicit assignment, my special job

and trust. I had to go on an actual combat mission. This was the heart and core of it all. On the first day the ban was lifted, two newspapermen flew the mission. They went in two different airplanes to the same target. Only one came back. This did not help my chances any.

There comes a time in any such impasse when one should stop begging for a while and give the problem a rest. I recognized this as the most tactful course and followed it. But the pain of leaving pictures undone which my magazine needed went very deep.

Then something loomed so spectacular, so tantalizing, that it overshadowed even the importance of going on a mission. I dropped my request and made another one.

The war was soon to open on another front with an invasion of the North African coast. This plan was one of the best-kept secrets of the entire war. On the American side of the Atlantic, few people knew; even my home office did not know. I was assuming a great responsibility to jump to another continent without consulting my editors in New York. But I had not an instant of doubt. If the Air Force would have me, I wanted to come right along.

For the invasion, I yearned and prayed that being a woman would make no difference. Then one evening, Gen. Jimmy Doolittle, recently appointed Commanding General of the Eighth Air Force, turned up in the officers' lounge.

I had met him through Eddie Rickenbacker on the Indianapolis Speedway some years earlier. His wife Jo had embroidered my name on her famous tablecloth on which she worked the signatures of scores and scores of Doolittle friends. I knew Jimmy well enough to be sure my sex would not prejudice him against my request to go along on the coming invasion. He gave me permission to go, without any red tape.

I assumed I would fly to the African front with the heavy bomb group—going in the *Flitgun* would be perfect. But no— the high brass were determined on one point. No one could tell what kind of resistance we would meet. I should be sent by sea in convoy—the nice safe way.

The upshot of that was that those who flew—and this included most of the brass—stepped out on the African continent with their feet dry. I had to row part of the way.

CHAPTER XVIII

WAR
AT SEA

Our convoy was large, with an airplane carrier, several troopships, and such a body of corvettes and destroyers that we sailed forth like some great feudal family of ships with bodyguards and retainers dispersed to the far horizon.

I was on the flagship, a vessel built for peacetime pleasure cruises, which now was performing a wartime miracle by stuffing six thousand British and American troops belowdecks and in the hold. In addition she somehow packed away four hundred nurses, along with the first five Wacs to be sent overseas into a war zone, and two women from SHAEF—both very pretty ones— the statuesque Elspeth Duncan from the clerical staff, and Kay Summersby, General Eisenhower's sparkling Irish driver.

I was billeted with some Scottish nursing "sisters," as they called themselves, and we were lucky because we had a cabin, however crowded. When I came in with my gear, the sisters were unpacking, and they looked up wistfully at the slacks I wore with my war correspondent's uniform. When they found I could wear them at my own discretion (which was most of the time), they were openly envious. They too had slacks with their uniforms, but "Old Battle-Ax," their matron, had forbidden them to wear them for anything but a torpedoing. As we chatted, one very tiny and compact sister, with a determined air about her, crawled into her bunk hours before we even left the dock, tucked her Bible under the covers with her and prepared to be seasick. She need not have prepared. It was all being prepared for her.

Even our troopship's captain, who had spent all his life at sea, had never met such a continuously savage storm. He had guided ships through bursts of great violence, but this tempest raged relentlessly for the full five days of our zigzag course to Gibraltar. The waves piled up in rising cliffs, sixty feet high, with spume blowing off like snow in a blizzard. Down in the trough you felt you would never see the sky again. Up on the peaks, you caught a second's flash of other ships bobbing like celluloid toys. The aircraft carrier rolled so crazily it seemed a miracle she did not overturn completely. On the wildly pitching little corvettes, the men, we learned, were lashed to the decks.

On our own ship with its reminders of past elegance, a colonel and the nurse he was dating were hit in the head by an overstuffed sofa they had just vacated. The grand piano began charging about like a savage beast eluding a group of infantrymen who tried to ambush it, until it crashed against the wall with its legs broken. The grand staircase was a mantrap breaking the bones of its victims—arms and legs and in one case a skull.

Through all the wild weather, and no matter how seasick the nurses were, lifeboat drills were called two and three times a day. Grabbing guidelines strung along the decks, we marched in as strict formation as we could manage, to our boat stations. For fourteen minutes, while the ship dipped and churned and green-complexioned nurses and soldiers hung on the ropes, we stood—or rather clung—in rigidly enforced and total silence until dismissed. Then back to our cabins, drenched with spray from the sea and rain from the sky, and with the sick nurses diving into their bunks, when another call would pull everybody out again. I thought this was overdoing discipline a bit, that it was cruel to the sick nurses, some armchair admiral's idea. I was soon to change my mind. On this discipline, thousands of lives would depend.

Mess was served in the grand saloon twice during the twenty-four hours to those who had confidence they could keep their meals down. (For belonging to this small proud minority, I thanked the ghosts of my Irish ancestors, deep-sea sailors for many generations back, who—I liked to believe—had passed on their general durability and wanderlust to me.) Dining in the grand saloon exposed us to the unpredictable hazards of flying

crockery. Plates soared from one table to the next, scattering soup and food generously as they went. The frequent sound of china, falling in great crashes like backstage comedy effects, enlivened the trip. I don't know how many dishes it takes to feed six thousand troops, but there cannot have been many left when we reached Gibraltar.

"The storm is lucky," everybody who could still walk and talk was saying. "We don't have to worry about getting torpedoed in a sea like this. No sub could hold its aim long enough to hit us." They were closer to the truth than they knew.

Once through the slender neck of Gibraltar Straits into the calm Mediterranean, almost immediately there were hints of underwater mysteries. Late in the afternoon our corvettes and destroyers scampered off to the horizon, dropped a smoke bomb to mark the spot and circled the gray smoke plume like a school of sharks. But what the spot was, and what came of it, we were not told; the Admiralty volunteers little in the way of information, even if you're a participant.

I went to my cabin to check one last time on my musette bag. We had been instructed to keep one always ready, packed with soap, extra socks, concentrated chocolate. I threw out the socks and most of the chocolate and put in one small camera and some rolls of film. This meant leaving five other cameras behind. If I made the request, I would be granted permission to carry one more piece of equipment, but I did not ask. Knowing how carefully every foot of space was allocated, I was afraid if anything really did happen, a camera case might displace a person.

There was one lens I hated to leave behind, even though it would not fit the small Rolleiflex I was carrying. It was a big old telephoto which somehow was so perfect for portraits that I had used it over the years, fitting it to successive cameras as the old ones wore out. It had photographed almost every famous person in the world: Churchill, King George of England, Haile Selassie, Madame and the Generalissimo Chiang Kai-shek, Stalin, the Pope, Franklin D. Roosevelt; I threw the soap out and crammed the lens in.

One last preparation. I visited the C.O. of Troops, along with two other newsmen on board, and we secured permission—in case of enemy action—to break out of line, go up to a spot just

under the Captain's bridge and cover the attack from there. Now there was nothing left to do but go to the farewell party. Next day we were due to land in Africa.

At the well-blacked-out party, being a member of the fourth estate, I was given a niblet of inside information. For three days we had been followed. And by more than one submarine. How many, our officers could not determine—"but subs are supposed to travel in packs of eight or twelve," my informant told me. That afternoon we had scored a "probable." "So if we got it," the officer said with a laugh, "we have only seven or eleven still to contend with." We said good night all around, and went to our bunks.

The torpedo came almost softly, penetrating the ship with a dull blunt thud. Yet I am sure everyone aboard said inwardly as I did, "This is it." We knew our ship was gravely wounded. We believed she would die. She had been a person to us—a friend who had protected us as long as she could. And now we were preparing to desert her as quickly as possible.

The sudden sharp list catapulted me out of my bunk into the shambles of a stateroom. One of the sisters found her flash and switched it on, and by its wavering beam we raced into our clothes. (We had been ordered to sleep fully dressed, but few people did.) I remember having to make trivial choices. Should it be the olive-drab work slacks or the dress pinks? Should I wear the trench coat, which was waterproof, or my beautifully tailored officer's greatcoat, which was warmer? I chose the dress coat and the work pants. All this seemed to take a year, but it must have been only a few seconds. The sisters too were leaping into their slacks—and even in our haste the slacks impressed me. The girls were dressing correctly for the torpedoing! Wishing them luck, I threw my musette bag with its camera over my shoulder and dashed out.

Outside the cabin I met a swelling stream of troops, marching as we had all been taught to march, flowing in silence and without panic through stairwells and passages to their stations. I broke through this human river as the Commander of Troops had directed me to do and worked my way upward, hoping there would be a trace of dawn so I could take pictures. I emerged on the top deck under a midnight sky with a moon so

brilliant it gave me the false illusion of photographic light. The ship tilted away from under my feet like a giant silver tea tray incongruously set with big black mushrooms, which I realized were guns on their pedestals. I could not help planning the pictures I would have taken . . . but where was everybody? A solitary crewman appeared, ran toward me and told me I should go to my boat station. When I explained I was the *Life* photographer and had permission to be there, he ran off without a word. At a distance I could hear a blurred voice through a megaphone or loudspeaker. I couldn't quite get the meaning—then I caught it. It was the order to abandon ship.

Later, when I had time to think about it, I marveled at the change in me the instant thoughts of work gave way to thoughts of survival. With the possibility of work, nothing seemed too dreadful to face, but now lifeboat station No. 12 suddenly became the most desirable place in the world to be. My journey down the long sloping deck seemed interminable. I kept barking my shins on metal debris and running into piles of wreckage which I had to scramble over. I dreaded to find my lifeboat already launched. And but for a special difficulty, it would have been. Our lifeboat had been flooded with the torpedo splash, and there was some doubt whether it would stay afloat. As crew members discussed this problem in low anxious tones, my boatmates held strict formation in total silence exactly as we had all been taught in boat drills. I slid gratefully into my place and stood in silence with my companions while the moon beat down on us all.

Just in front of me were two of the sisters, trembling from head to foot with an uncontrollable intensity I had never seen before. "That's real trembling," I said to myself, and noted that only the bodies were uncontrolled. Naturally they were afraid at such a time, but they rose above it and conducted themselves with complete self-discipline.

Then I began to notice myself. "Why is my mouth so dry?" I wondered. "Never in my life have I felt such dryness. This must be fear." It seemed as though I had a second self that stood outside me and monitored everything I did. It spoke to me: "This is one time in your life when you don't have the faintest idea what is going to happen to you. You don't have even a

theory. There's a fifty per cent chance you will live. There's a fifty per cent chance you might die."

In a way I find hard to put into words, the few minutes while we waited to step from the doomed ship into the flooded lifeboat have become for me almost a religious experience. I look back on it as a dividing time in my life—not in the sense of "If I live, it will be on borrowed time"; this was something that went much deeper with me and forged closer links with my fellow man.

We stood—all six thousand of us—at a crossroads, not just between personal death or life but between paralyzing self-concern and that thought for others that transcends self. We were in a situation too vast for any one person to control, a catastrophe where people will show the qualities they have.

For me it was an inspiring discovery that so many people—perhaps all normal healthy people—have a hidden well of courage, unknown sometimes even to themselves. But there it is, waiting to be drawn upon in time of need. This was a night when people drew upon their secret strengths and rose to meet whatever they had to meet. Sharing in this experience with them had a profound effect on my understanding and feeling toward other human beings, and the memory of it will never leave me.

If there was any hysteria on our ship, I never heard about it. Instead I heard incidents like the one of the Wacs. Their lifeboat was overloaded. Two people would have to stay behind. Immediately two Wacs stepped out of line saying cheerfully, "Oh, of course, we can't *all* go." Their lifeboat was lowered away without them.

In our own boat line, we faced a similar overweight problem with the extra water dished in by the torpedo. I could catch only snatches of whispered consultations behind me. Then I picked out the low firm voice of Elspeth Duncan, the tall handsome clerk from Eisenhower's staff. "The nurses are more important than we are," she was saying, and she stepped aside and firmly shoved one of the nurses into her place.

Happily it was decided we should all embark and risk the weight. Under the calm direction of Old Battle-Ax, the sisters' C.O., we climbed over the rail and into lifeboat No. 12. Even though we knew the torpedo splash was there, it was a shock to

find ourselves sitting in water up to our waists. As we started slowly downward, I hugged my musette bag to my chest hoping to keep my camera dry—a task made more complicated by water falling in puzzling big splashes on top of our heads, as though someone were emptying buckets on us. This mystified me till I realized it came from our next-door neighbor, lifeboat No. 11, which crewmen above us were attempting to drain and launch.

During our quivering descent, I could think of nothing but the magnificent pictures unfolding before me which I longed to take and could not. I suppose for all photographers, their greatest pictures are their untaken ones, and I am no exception. For me the indelible untaken photograph is the picture of our sinking ship viewed from our dangling lifeboat—the entire panorama standing out against a backdrop of cumulus clouds so deceptively luminous that I found myself saying, "If it were day, this would be a perfect K-2 sky." As I write this, fifteen years after it happened, I am painfully aware that our marvelously speeded-up film emulsions and stepped-up darkroom techniques would have made this subject—not easy, but just possible.

The scene will always haunt me. The towering hull curved away in a powerful perspective, dwarfing to pygmy size the hundreds of men scrambling to escape down rope nets flung over the side. It seemed to me that every visible surface was encrusted with human beings, clinging or climbing. The water itself was alive with people swimming, people in lifeboats, people hanging to floating debris.

As we dropped closer to the sea, I could see dozens of nurses hanging on for dear life to the bottom of the great nets. One poor girl, on the lowest rung of a rope ladder, was dizzily twirled about and dragged underwater with each wave. In between waves, she must have had only one moment to breathe before getting pulled under again.

Then suddenly we were on the surface of the sea ourselves with a dozen problems of our own to cope with. Our rudder broke, and it seemed we would never pry ourselves away from the suction of the big ship, and when we finally poled our boat free, we were drawn into an entangling dance with lifeboat No. 14.

Then down came the ill-starred lifeboat No. 11, with her

hull plugs improperly replaced after draining. The instant she touched the water she capsized, tossing her load of nurses into the sea, some to drown. All lifeboats within reach began rescuing nurses.

Off in the distance we heard a tragic cry, over and over: "I'm all alone. I'm all alone." We tried to steer our rudderless craft toward the voice, but could make no headway. Then the desperate shout grew fainter until it was swallowed up in silence.

Our boat was so unpredictable without its rudder that I was glad when we drifted close enough to a raft for me to catch a corner while the others pulled the sister on it in with us. The girl's face was grotesquely masked with oil. The nurses wiped it off, and it warmed my heart to see this was my cabinmate—she of the Bible. She had a broken leg, and the nurses behind me held her tight to keep her from bouncing back and forth with each swell.

And suddenly here it was again, the beautiful courage, that special good humor which has its own large part in courage. A soldier swimming to a raft raised his hand with thumb jerked up and called, "Hi, taxi!" An American nurse swimming in her life jacket called out, "Which way to North Africa?" Another nurse shouted back, "Take the third wave to the left."

From lifeboats and rafts came snatches of singing: "You are my Sunshine, my only Sunshine." Sunshine, I thought, that's all I need. We were bailing out our boat with our helmets now, and the nurses and I were taking turns at the oars. The rhythm of singing made our rowing and bailing easier. By now everyone within earshot joined in, and soon from every raft and lifeboat and floating plank came the strains of "Sunshine."

We seemed to be drifting in a vast waterborne theater in the midst of an enormous floating audience. As though from a darkened stage, a voice from the deck of a destroyer bellowed out directions to us through a megaphone. The destroyer had stayed behind to help us. We must keep back. They were going to drop depth charges and would warn us before each charge. Depth charges! That meant they thought the submarine might still be lurking about. An eerie thought, that our enemy the sub might be nuzzling around in the black depths right under our lifeboat! With each charge the sea shook itself violently and

roared, but if there were results, we were given no news of them.

Through the voyage I had harbored the comfortable and completely groundless theory that if we met with any mishap we would have plenty of company. The other members of the convoy would, I imagined, gather about us like a worried and loving family. I now realized the reverse had taken place. And sensibly! When we were struck, the entire convoy, save for the destroyer, had speeded on so as not to risk providing the enemy with additional targets. And now, we learned from the voice through the megaphone, we were going to lose even the destroyer. More, we were going to lose our mother ship, who despite her wounds seemed by her very presence still to protect us. The megaphone was giving us some parting message which we could not completely hear . . . something about towing away the ship . . . something about survivors. To all of us the ship had been human—more than human. When her sagging silhouette was swallowed up in distance, our loneliness was intense. The moon set. The floating theater was a theater no longer. The show was over.

With our useless rudder, we drifted away from the community of lifeboats. I must confess I never expected to see anyone I knew again. I wondered what would happen if we were washed up on some enemy coast. Irrationally I wondered how irritated my lecture manager might be if I did not turn up on schedule, and my editors at *Life*—how would they feel? I had made this move on my own and then failed to show up with pictures. While not shedding a tear about my five cameras which would go down with the ship—that was part of the hazard of war—I grieved disproportionately about the loss of my cosmetics case. It was fitted with exquisitely carved ivory jars made to measure for me when I was in Hong Kong. It had flown around the world and been through battle. Just before I left England, a leather craftsman had covered it beautifully in ostrich. The skin was such a fine one, he had been saving it for his daughter's wedding. But now with the war on, who could tell whether there would be a young man for his daughter, or any wedding? As we washed aimlessly about, drifting, I reflected that waiting for the wedding would have been the lesser hazard. I recalled the one tin of concentrated food I had kept when I tossed out the

rest to make room for films. The can was marked: TO BE CON-
SUMED ONLY WHEN RATIONS OF ANY KIND ARE NOT PROCURABLE.
I vowed to myself not to open it till the eleventh day. Why I
picked eleven I don't know. (I use it now at home as a paper-
weight.)

The first dull hint of dawn over a gray empty sea found us at
our lowest ebb. Then without warning, as so many times during
this night that was like a lifetime, our sober mood was instantly
transformed. Here the catalytic agent was a little Welshman,
Alfred Yorke, quartermaster on the ship and skipper of our
lifeboat.

"Here I am," said Skipper Yorke, "with my false teeth back
on board and no breakfast to put them into."

A nurse shot back, "I bet they're chattering all by themselves
up there now."

Chauffeur Kay Summersby, who could be pretty even through
a torpedoing, announced her breakfast order: she'd take her eggs
sunny side up and no yolks broken.

With sunrise I took pictures of our boatload of waifs. By mid-
afternoon I had the keen pleasure of photographing my fellow
survivors as they waved joyfully at an English flying boat that
spotted us. Help came quickly in the form of a destroyer that
picked us up before nightfall. It was bulging at the seams with
hundreds of soldiers lifted directly from the big ship in a brilliant
rescue maneuver with four destroyers. Some of the troops had
been trapped belowdecks (we never knew how many) when the
torpedo hit. But many had been saved, and the discipline and
absence of panic had a great deal to do with the success of the
rescue maneuvers.

I was given a shining account of the two Wacs who stayed
behind. They laughed, sang, told jokes, ventured belowdecks for
materials and made sandwiches for the men. They brought out
their vanity cases on deck, flapped powder puffs, applied lip-
stick, until the troops were saying, "If a girl can use a lipstick in
a spot like this, you feel there isn't much for a boatload of fel-
lows to be afraid of."

With special satisfaction I learned of the gallant conduct of
one more feminine survivor. With that aloof dignity character-
istic of her kind, the ship's cat hung back on an abutment over

[OVERLEAF] *En route to the North African campaign. Lifeboat crowded
with survivors who joyfully wave to the British search plane which
found us.*

the burning deck until the last living soldier had taken the steep jump down to the deck of the last rescuing destroyer. Then she leaped lightly down to the destroyer and safety.

That night in crowded Algiers all female survivors except the feline one were put up in the only place available—the maternity hospital. I felt sorry for the nurses. They had just fallen into the first real sleep they had enjoyed for many days, when they were awakened by the Germans who flew over and bombed the harbor—inaccurately—with most of their missiles falling uncomfortably close to the maternity hospital.

Before dawn an officer called for me and took me down to the water's edge. There was the slenderest hope that the burning ship might be towed to shore and something salvaged. I was to be ready, if the flames had not spread too far, to guide a group of salvagers with all possible speed in an effort to save my cameras. It was a good plan, but time ran out too fast.

Fifteen miles off shore the ship met her end. A famous salvage officer, Captain Ellsworth, was in charge of operations. With fifty men he worked until the intense heat made work impossible. The decks of the ship began flowing like a steel furnace. The smokestack split in two and both its parts sailed up into the air. Then the great heat set off the guns, charge after charge. The depth charges began exploding automatically, raining the decks with shrapnel, until the rescuers had to escape to their salvage vessel and pull away to save their lives.

But our ship was not through fighting yet. She began sending off her own distress signals, her own parachute flares, as though she knew what was happening to her and was crying for help. Her portholes began melting and flowing down, great tears of molten glass. When the portholes melted, the sea rushed in, and our ship—as though ready to accept her destiny at last—turned over on her side and sank quietly to the bottom of the sea.

CHAPTER XIX

IN THE
GARDEN
OF ALLAH

MY RESCUE from the maternity hospital was carried out promptly by my Air Force friends, who took me for a drying out to an exotic villa overlooking the Mediterranean and with a brook running right through the house. This architectural triumph in tiled gingerbread had been requisitioned by the Allied Air Command for such topflight air officers as the American General Spaatz, the British Air Chief Marshal Tedder and other transient brass.

Right inside the front door I collided with the air officer I wanted most to see: Gen. Jimmy Doolittle. His first words were "Maggie, do you still want to go on a bombing mission?"

"Oh, you know I do," I gasped. "I had given up asking, because I didn't want to make a nuisance of myself all the time."

"Well, you've been torpedoed. You might as well go through everything," said General Jimmy.

In the next minute he was on a field telephone calling through to the 97th Bomb Group—my bomb group—and conveying the glad news that I had permission to fly a combat mission at the discretion of the C.O. This particular C.O. was the same Col. Joseph Hampton Atkinson from Texas who had presided so eloquently over the christening of the *Flying Flitgun*. I had previously discussed with him, while we were still in England, the question of the mission and its importance to my story.

I knew he was in favor of allowing me to do my photographic duty as I saw it.

The important business of the combat mission settled, General Jimmy turned to me and looked me up and down. I am sure I resembled a drowned rat as closely as a female war correspondent can.

"Maggie, what do you need?"

"It would be lovely to be able to sleep in something—pajamas or *anything*."

"Now I know why I've kept my sister-in-law's pajamas all these years," said the General. "She gave them to me for Christmas, but I always sleep raw myself. If you want them, they're yours."

They were dark green silk, huge for me but very beautiful. I still have them.

"What else?"

"It would be nice to change into another shirt," I decided.

Again General Jimmy had just the right article—a shirt with a history. It dated from the time he led his daring raid over Tokyo, earlier in the war. On the homeward stretch after meeting many difficulties, he ran out of fuel, and he and his men had to parachute into the heart of China. He beat his way to the outside world and arrived in Cairo in as meager a wardrobe as the one in which I survived torpedoing. He was to attend a formal dinner that evening, and the clothes problem had to be solved in a hurry.

A local tailor was found who claimed he could put together a uniform in a single day. Precisely at sundown the tailor fulfilled his agreement by sewing the last stitch—in fact, more than fulfilled it, as General Jimmy discovered when he tried to get dressed. The uniform was king-sized in all its dimensions. He had to pin up the pants legs before he could walk and shorten the sleeves to find his hands. General Jimmy is a short man with a powerful torso, but even with his barrel of a chest, he had to put in tucks before he could go to the banquet. He sat down gingerly to the feast as full of unseen—but by no means unfelt—pins as though he were wearing a porcupine suit wrong side in.

The oversized shirt was fine for me with lots of splendid material. With a small escort of airmen who knew where things

were in the town, I went to an Arab tailor for a fitting. Like most tradesmen in Algiers, he spoke French. As the French word for shirt is "chemise," my shirt attained a certain degree of renown as "the General's chemise."

While the alterations on my shirt were being completed, we went off to do some window-shopping, quickly discovering there were no windows left intact and few shops with so much as a yard of cloth to buy. Up near the notorious Casbah a jeweler beckoned us into his shop, and brought out three small cases carefully wrapped in earth-stained linen. In these were his fine pieces, he explained. When the enemy was in occupation, he put only his cheap-jack stuff on display and buried everything of value.

He had lovely old pieces but I had eyes only for one, a bracelet, very old—two hundred years or more—set with four large amethysts, deep purple and flawless, clasped in delicate tracery woven in three colors of gold.

I have never cared for expensive jewelry, although I love to collect unusual pieces on my travels for their own charm or as reminders of the places I have been. But whoever made this bracelet two centuries ago made it for me. It was an extravagance for me but so easy to justify! Certainly a girl who's lost all her clothes in a torpedoing deserves at least a bracelet.

And so, attired in *la chemise du général*, the amethyst bracelet, and my very baggy stained pants, I was flown in a cargo plane to "a secret air base in an oasis in the Sahara Desert." It sounded glamorous, and to me it was.

The oasis was called romantically "the Garden of Allah" and was windswept with stinging sands, hot and chilly by turns, its few buildings in ruins. But to me, with my precious permission I had gone through literal fire and water to obtain, and with my wonderful story ahead to work on, the Garden of Allah had that touch of enchantment the name implies. I had flown there not in a bucket seat of a freight plane but on a strip of that magic carpet the location demanded. An aura of improbability hung over it all.

It was a Garden of Allah where Junkers planes dared fly over so low they barely cleared the date palms. I was walking with the C.O. toward the mess hall when I first saw this. It was star-

tling to look up through the dusk and see those big painted
swastikas right over our heads. There wasn't time to be fright-
ened, and their stick of bombs missed us, but Colonel Atkinson
was choking with frustration. This was our most trying period
of the air war, when enemy planes came uncomfortably close to
outnumbering ours, and the C.O. was aching to "get into those
pestholes where they're based" (which he later did) "and clean
them all out. In war we must keep on the offensive," he told me.

This was the Garden of Allah where the finest dates in the
world grew, exported in peacetime and now blessedly plentiful
for us. Under the soaring date palms our men received their
Christmas packages, a month late but safe, tore them open with
joy, then greeted the contents with wails of anguish. Little
dreaming their menfolk had been transferred to a sunnier con-
tinent, wives and sweethearts—almost to a woman—enclosed pack-
ages of Dromedary dates. One look at the tired old dates and
the conclusion was inescapable that they had crossed oceans and,
like spawning salmon, returned to their birthplace to die. (Even
louder cries of grief came from the boys who received Spam.)

This was a Garden of Allah where Colonel Atkinson became
Brigadier General Atkinson. He had no appropriate insignia in
the desert.

When the directive came through he barked, "Do they think
I go around with stars in my pocket?"

Nor was there any higher officer, as protocol demanded, to
confer the promotion. An Arab craftsman was found, who
hammered out a pair of rough but charming silver stars, and the
C.O. had to pin them on his own shoulders.

This was a Garden of Allah where I got the sniffles. Over-
night this blew up into a roaring cold, and the flight surgeon
grounded me for two weeks. This was standard practice for
fliers. In the unpressurized planes of those days, the descent from
the rarefied atmosphere of high altitude could cost an airman his
eardrums, if he flew a mission with a cold.

I welcomed the fortnight's delay because I had a great deal
to do in preparation for the mission. But before anything else, I
must find out what had happened to the *Flying Flitgun*. One
worries about an airplane, I discovered, when it is your godchild.

The *Flitgun* survived the invasion, I was relieved to learn. But

Brigadier General Atkinson: "Do they think I go around with stars in my pocket?"

she had suffered what airmen regarded as a fate worse than death. She had become a "hangar queen." This sounded glamorous until I learned what it was. A hangar queen is a plane damaged just enough to be grounded and not too much to be a treasure-house of spare parts. No invasion ever carried with it enough spare parts. Obviously getting in whole airplanes is more important. The *Flitgun* arrived intact, participated in the capture of Oran, landed with its fellow B-17s. The bomber crews slept on the ground under their airplanes that night. When the Germans came over and pounded the field, both the crew and the airplane escaped a direct hit, but a small bomb fragment set the *Flitgun* on fire. The crew put out the flames quickly enough, but not before the ship reached that delicate balance between damage and lack of damage that qualified her perfectly for her new role. She fell swift victim to marauders from other B-17s. (A Fortress lands with a cracked panel board. The *Flitgun's* panel will fit perfectly and is ripped out in the dark of the night. A belly gunner needs a new door clasp for his plastic bubble. The *Flitgun's* bubble clasp—removed nobody can say when—is found to be completely interchangeable.) Even the "Peggy" engine itself was looted, and no one knew where it might be flying today. The *Flitgun* had become a hangar queen without even a hangar.

However, the crew of the *Flitgun* carried through on the invasion without a scratch, and that was much more important. The boys were flying as many missions as ever—parceled out to fill gaps caused by casualties in other Fortresses. They lived for the day when they could have their own plane and fly as a unit once more.

Everyone on the post was delighted when the C.O. received his field promotion. His remark to the men—"You take the risks; I get the credit"—was greeted with appropriate guffaws of laughter, but the men knew very well he had taken all the risks and then some. An original and brilliant tactician, he had filled a key part in working out the flying tactics they were now using, and the men had enormous confidence in him.

When the C.O.'s homemade stars were finally ready for him to put on, I decided this was the time to give a party. Only that morning, I had come upon a chance to get spectacular refresh-

ments. An Arab appeared out of nowhere with eggs—lots of them—the old-fashioned kind with shells on them. It had been a long time since the airmen here had met an egg in any form but powder coming out of a can. I sent word to the Arab I would buy all the fresh eggs he had. I chose a place for the party on the edge of a kind of dry gully in the desert, where there were lots of big stones to sit on. The Mess Sergeant helped devise barbecue facilities on a cairn of stones so the eggs could be cooked fresh on the spot. As soon as the General got his stars safely pinned on his shoulders, I did the rounds, passing out an egg a guest as long as they lasted, and took orders as to how each man would like his cooked—"sunny side up," "gently over," any way the guests wanted. I will never live down the embarrassment of it. One after another, we all made the bleak discovery that the eggs had already been thoroughly and undeniably hard-boiled. After the egg fiasco, we went to the fortune teller who had her H.Q. in the palm grove and did a land-office business with the airmen in the Garden of Allah. She peered into the General's palm and told him he would have a long and prosperous life and would come to possess three beautiful gardens, each one bigger than the last. She could have scooped us all if she had told him that three stars would find their way to his shoulders, each one greater than the last. At the time of writing, Lieutenant General Atkinson is head of the Alaska Command and one of the top handful of generals in the U.S. Strategic Air Command.

During the two weeks I was grounded with my cold, I learned as much as I could about working inside the big bomber under conditions I had never met before. As for cameras, the Signal Corps generously—for they were short themselves—offered to lend me any equipment I could use. The Speed Graphic they let me have would be just right for the pictures I wanted to get inside the ship during the mission, showing crew members in action at their posts. For aerials they lent me a pair of K-20s, an Army airplane camera built of rigid metal to withstand the vibration of the plane. The K-20 is no featherweight but was the best camera for the job. The boys warned me that the film lever stiffened and sometimes froze in the 40-below-zero temperature I could expect at high altitudes. They were very

concerned about this and so was I, but with the two, I could alternate and split the risk. In addition to worrying about my camera levers, they worried about my hands. I would be wearing electric mittens, but knowing how it is almost second nature for a photographer to pull off his gloves, no matter what the climate, they earnestly counseled me not to take off my mittens once we rose above 15,000 feet, or I could say goodbye to my hands.

I remember how dramatic and strange it seemed to stand there on the baked Sahara floor and talk about working conditions in sub-zero weather only six miles away—in an upward direction. Within less than a decade everyday civilian passengers would travel at these heights as a matter of course, sealed into heated pressurized cabins. By contrast, we might have been planning to fly our mission in a fleet of aerial covered wagons.

The B-17 was a covered wagon that covered a remarkable amount of machinery. Huge and commodious as it looks on the outside, inside it is as crammed with twisted metal paraphernalia as a junk car lot. To be sure I would be using every working minute to its best advantage, the crew and I held actual dress rehearsals. Sweltering in borrowed high-altitude flying clothes of fleece-lined leather, layer upon layer in overalls, jackets, leggings, boots, leaden in weight, I practiced dragging myself and my hunks of cameras around inside the ship. I had to bear in mind that my energy would be greatly depleted in the rarefied atmosphere, making my clothes and equipment seem still heavier. I had to be sure I was picking spots for taking pictures which I could wriggle into and out of myself.

I had to be drilled in oxygen, using a portable bottle which would give me a few minutes of roving; I had to learn where and how to plug myself back into the permanent oxygen line used by the men, before the other was exhausted. The incentive to master the oxygen technique was strong, since if I made a mistake, I would last about four minutes.

I had to choose, on consultation with the crew, the most important viewpoint of all—the spot to work during the few vital moments when we flew the bomb run over the target. The unanimous decision was the left waist window. This was a spacious opening in the side of the ship, but, like everything else, so filled with its machine gun and other bulky structures

I was flattered when this picture in my high-altitude flying suit became popular as a pin-up.

that it left just a few chinks through which to work. I did not know till later that the crew members had placed bets on me. If we were attacked, would the waist gunner knock me out so that he could defend our airplane, or would I knock out the waist gunner so I would have room to take pictures?

I don't believe I ever thought of this expedition for which we were all preparing as a mission of death. The impersonality of modern war has become stupendous, grotesque. Even in the heart of the battle, one human being's ray of vision lights only a narrow slice of the whole, and all the rest is remote—so incredibly remote.

Other thoughts crowd in with a reality that is not at all remote. You know you may not come back; but that is one of the hazards of the road you have chosen, so you thrust that thought as far into the back of your head as possible. To me the mission was an entry into a different sphere from any I had ever been in or even clearly visualized, one that had its own equipment, its own rules, even its own morals. I approached it all in a mood of great solemnity.

My pilot was a man of destiny although neither of us realized it at the time. He was Maj. Paul Tibbetts, an excessively quiet young man from Florida, solidly built with a strong cleft chin and unusually handsome features. He was a superb pilot and I was glad he would be flying with me.

Although I often sat beside him at mess, had photographed him for a full page in *Life* while we were all still in England, and by wartime standards I had known him for a long time, I seldom heard him speak an entire sentence. A phrase now and then, six or eight words, perhaps. Then, as though taken aback by his own boldness, he would fall quickly silent. But always it was a friendly silence.

As the Major methodically went about his tasks against the theatrical backdrop of the Garden of Allah, no one could have guessed the strange role in history which this shy young man would play. Within less than three years, his would be the hands on the controls that would blast this planet into the Atomic Age. Tibbetts was selected to make secret test drops over the New Mexico desert, and on that fateful day when man made his epochal break with his scientific past, it was Tibbetts who flew

the plane to a carefully chosen pinpoint of sky over Hiroshima. From here was dropped the Pandora's box whose escaping furies never in the history of our planet could be locked back.

On the morning of my mission the awesome task that lay ahead for my pilot was undreamed of. The war was still young. A cool wind was blowing the fine sand in the desert. The veil still hung over the atom.

CHAPTER XX

I GO ON A
BOMBING RAID

The morning of my mission—January 22, 1943—dawned with clear wide skies promising the good visibility I needed. The brassy disk of the sun was just cutting through the monotone of the desert when my several hundred flying companions and I filed into the ruined villa. Here the secret briefings were held. I sat down with a group of airmen on the edge of a large fountain filled with sand. I hoped with all my strength the target would be a newsworthy one. I knew as little about where we would fly and what we would bomb as the men knew.

Each day's selection of target was announced only within minutes of departure time as a safeguard against finding a "reception committee" over the target. The briefing officer removed the coverings from the maps and charts which hung on a wall of elaborate mosaic standing in the wreckage. He traced the flight plan. Yes, indeed, we had a major target. We were assigned to destroy the El Aouina airfield at Tunis. This was the chief air base used by the Germans in ferrying troops from Sicily. Axis planes were based here for their deep probing strikes against us. If we were going to push the enemy off the African continent, we must first knock out this airport. Tunis and nearby Bizerte were on what our fliers called "the daisy chain," a title inspired by the lavish bursts of white spreading antiaircraft fire tossed up into the sky whenever we attacked these twin strongholds. Today we would feint toward Bizerte, hoping to fool the enemy long enough to allow for the quick dash we had to make over our objective. It was decided I would fly in the lead ship.

Today for our mission to Tunis we were still in the great Stone Age of bombing. We were packing old-fashioned bombs in old-fashioned bombers—our trusty B-17s with their defensive cross fire and long offensive range, the planes which our airmen swore by. Our Flying Fortresses were monarchs of the skies, only we did not have enough of them. It was a measure of the importance of our target today that our battle formation numbered thirty-two planes—a record number in those days. Soon more planes would come and the air would thunder with hundreds of them. But today I had a kind of over-the-back-fence acquaintance with many of the B-17s. On our right wing was the *Peggy Dee*, and I knew the original Peggy was the fiancée of pilot Fred Dallas from Houston, Texas.

The lead ship, in which Major Tibbetts was piloting me, was the Gargantuan *Little Bill*. I never found out who Bill was. On our left flank were *Berlin Sleeper II* and *Berlin Butchershop III*. Behind them were *Honeychile III*, *Fertile Myrtle II*, and many old acquaintances. I was sorry not to have the *Flying Flitgun* right off our wing so I could photograph it in action for the lead picture in *Life*. This spot in the magazine went to the *Peggy Dee*. But it was good to know that the *Flitgun* crew were with me on the mission, invisible like the salesman's overcoat on the expense account, parceled out to fill gaps in crews on other bombers.

As soon as we were airborne, I began taking pictures of crewmen at their posts. I wanted to get these shots while I had full use of my hands before donning the clumsy electric mittens at 15,000 feet. We were still at 14,000 when we crossed from friendly to enemy-held territory, although as far as I could see it was the same corroded desert below. The crossing of the invisible boundary line was a signal for the bombardier to disappear into the bomb bay. I knew he was going to remove the safety pins which were installed to keep our bombs from exploding on our friends, in case we were shot down or crash-landed over our own territory. The idea of holding a bomb together with a safety pin intrigued me. I followed him to the great black cave of the bomb bay and squeezed in between the rows of bombs. When my eyes grew accustomed to the dim light, I could just make out the bomb racks stacked neatly like bookshelves in a

public library, and amidst them the bombardier, who was pulling the safety devices out of the bombs. From all of them he removed the yellow tags, which bombardiers always saved as souvenirs, and stuck them in his cap. When he started stuffing them in his mouth, I decided this was the point to take a picture. I checked focus, slipped in a flashbulb and made my shot. To our eyes, which had become adjusted to the darkness in the bomb bay, the flash seemed blinding. Through the interphone strapped to my ears, I could hear the bombardier crying out, "Jesus Christ! They're exploding in my hands!"

While I had not intended to frighten the bombardier out of his wits, I was rather glad of the incident. It neatly contradicted the old wives' tale I had been pestered with ever since my early days in the steel mills and coal mines: the legend that if you bring a woman into a spot where men are doing dangerous work, her very presence will so distract them that they will be careless and have accidents. While I could hardly find it flattering to be put totally out of mind, still I welcomed this evidence that the bombardier had forgotten there was a woman on board, or a photographer, or a combination of both.

An hour later it was I who forgot that anything existed except the need to get pictures. We were sweeping toward the Mediterranean coast. We had made our feint toward Bizerte. We had passed the ancient city of Carthage, a white smudge on the edge of the sea. The watery cross that marked the Tunis lagoon was plainly visible below. We were roaring to our goal, along that invisible road through the air which had been the center of all the planning, the calculations, the guesses, the hopes. Our formation swung into the bomb run, grouped in position to drop its bombs in a preconceived pattern and then take to evasive action.

During the handful of minutes over the target when the interphones were kept clear for only the most urgent directives, the men heard over their earphones a string of high-pitched squeaks unlike anything they had ever heard on a mission before, a voice crazily and indisputably feminine: "Oh, that's just what I want, that's a beautiful angle! Roll me over quick. Hold me just like this. Hold me this way so I can shoot straight down." Airplane photography has been part of my working life for so long, and

operating with a pilot who will put you in position to photo-
graph is such an integral part of it, that for a short time I had
the illusion that the weaving flight of evasive action was carried
on just to help me take pictures—which, in fact, is exactly what
it did. The intricacies of flying evasive action gave me every
conceivable angle from which to take pictures. I was far too
excited about the photographs I was getting to realize I was
speaking out loud. Talking to myself meant talking to the entire
ship, with all of us united by the throat mikes, earphones, com-
munication lines which bound us together. Later, on the ground,
the men told me they had nearly fainted when they heard my
pipsqueak voice come through. Again, flattering or unflattering,
they had completely forgotten there was a woman on board.

Far below our fleet of planes, things were happening which I
could see but not interpret. A white plume rose one mile high
into the sky, and next to it grew a twin plume of black, tipped
with spasmodic flashes of red. The fiery flashes darted higher.
What could it be, I wondered. I'd better take a picture of it,
just in case. And suddenly it dawned on me. These are our
bombs bursting on the airfield. This is our target which we came
to demolish! Then I saw another spectacle still more puzzling.
In the air quite close to us were black spreading spiders, rather
pretty, with legs that grew and grew. I couldn't imagine what
they were, but again I dutifully photographed them, just in case.
Suddenly I realized. This is ack-ack! They are shooting at us!
We were hit twice in the wing, but only lightly damaged. Only
after we were back in the Garden of Allah did I learn the bad
news that two of our airplanes at the end of the formation that
followed us were shot down.

Next day we got the reconnaissance report of our raid.
Timing had been perfect. We had caught the airfield when it
was filled with German troops and planes freshly landed on the
field. We had destroyed by bomb blast and fire more than a
hundred of them. This was the key raid in the air war and pushed
the Luftwaffe off the North African continent. Our mission was
effective and successful.

And so my own. I left the Garden of Allah and started home
by way of Oran, the Gold Coast and South America. Messages
from my New York office reached me along the way. It warmed

my heart to be in direct communication with them again. By now wraps had been taken off, and they knew where I was and the stories I had been covering. The Pentagon had received some of my negatives by army courier pouch, and my editors had already started laying out the story, which was to be a lead. I was to learn later that they were topping the story with high letters like the marquee of a movie theater: "LIFE'S BOURKE-WHITE GOES BOMBING." I was to learn still later that the only thing the censors had cut out was General Atkinson's face. In the picture *Life* wanted to use, the General's face showed only as big as the profile of Liberty on a dime, but since it was believed he was still unknown to the enemy as a personality, the Pentagon had kept him in the realm of military secrecy. The Pentagon's security needs were satisfied and the members of the 97th Bomb Group were filled with glee when *Life's* art department solved the difficulty by painting on the General's face a splendid mustache.

Shortly after I got back to New York, a picture of myself in those high-altitude flying clothes appeared with the *Life* story, and from there it skyrocketed into a brief popularity as a pinup. The reader must forgive me if I cannot conceal my vanity about this—especially since the season was short before my rivals in their bathing suits (or less) displaced me on the walls of dugouts, barracks and Nissen huts, which are their rightful habitat.

My homeward trip was a hitchhiking process, which meant traveling in any army vehicle which had a pair of wings and was flying in my direction. While we were still on the North African coast, I had a heartwarming experience. We had stopped to fuel at Oran. I was wandering about to pass the time when something across the field attracted my eye. It couldn't be! Yes, it was! A jeep driver took me to the spot. The empty hull of the *Flying Flitgun* stood forlornly at the edge of the strip. No Peggy engine, no bomb-bay doors bearing the magic words SAY WHEN, but the painting of the insects with the faces of Hirohito, Mussolini and Hitler stood out clear. Near her stood the newest hangar queen, *Puffin Hussy II*. Some earnest-faced mechanics were delving into the *Puffin Hussy* and pulling out everything of value, moving the various items over and laying them on the ground around the *Flitgun*. To me this was the dawn of hope.

Then suddenly I had no time to inquire what the plans were, no time to scramble around the blackened interior, no time to gaze with nostalgia at the big round gap in front where the Peggy engine had been. A cargo plane had just touched down at the field, and I could go along in it as far as Port Lyautey if I could get myself and my gear packed inside it within the next ten minutes.

So now I shall never know what the future held for the *Flying Flitgun*. I never learned whether the rejuvenation was a success. But I like to think my avian godchild—perhaps with humbler duties as in some lowlier reincarnation—was once again restored to the skies.

CHAPTER XXI

"SUNNY ITALY"

Six months after my return from covering the Air Force in North Africa, I asked to be sent overseas again to the Italian campaign. This time I wanted to record the war on the ground. I had seen the war in the air in all its remoteness, but here was an earthbound world I had not known before. It was like a caterpillar view after you have been photographing skyscrapers.

The very intimacy of the Italian conflict sharpened my awareness of human beings around me, and I began to listen to what people said. I mean really listen. Someone drops a phrase and you say to yourself, "No one else could have said just that thing in just that way. It is like a portrait of the man." Until then, I had considered myself eye-minded and let it go at that, but much as I love cameras, they can't do everything. The American soldier with his bitter humor and his peculiar gallantry had opened my ears.

There was a haunting quality about that phase of the war, with all those American boys against the unfamiliar background of "sunny Italy." I tried whenever possible to capture the special flavor of a situation in words as well as pictures. If a GI in the photograph I was taking made some pungent remark, I jotted it down. I hoped this would enrich the material and help set the mood for the captions which *Life* would write in New York. The important thing was to get the words down while they were fresh in memory. Most of these notes had to be made on the fly, since we were always tearing in mad haste from one spot to another, and that meant writing on my knees while the jeep bucked and pitched over the muddy, disintegrating roads.

Writing in a heaving jeep is not recommended to improve any-
one's penmanship—least of all mine, which is as close to un-
decipherability as anyone's could be. Sometimes there would be
only two or three wildly scrawled letters on a page, or a single
syllable. But no matter how unreadable it was, the sight of those
scribbles would evoke the situation and the people in it. As the
jottings piled up, I could see that sooner or later this was going
to be a book.

My assignment to Italy was an unusual one. A request for my
services came from the Pentagon to Wilson Hicks, then picture
editor of *Life*. I thought this was a great honor, and so did Hicks.
There had been considerable concern in Army circles because
while the heroes in the air had been deservedly glamorized, not
much attention had been given to the man on the ground and
to his importance to the war effort. This was particularly true
of the SOS—the Services of Supply, now the Army Service
Forces—under Gen. Brehon Somervell. Sixty per cent of the war
was a matter of supplying our troops by means of the giant
chain-belt system known as logistics. The SOS was responsible
for delivering to the spot where it was needed anything from a
box of K rations to a tank destroyer. SOS included the Engineers,
Ordnance, the Signal Corps and the Medical Corps.

I was pleased to learn that it was my ability to photograph
engineering subjects that impelled General Somervell to ask for
me. As before with the Air Force, my work was for both *Life*
and the Pentagon. This was an assignment of great scope that
would give me a look at the war from many aspects.

I went to Italy as the supplies went—by way of North Africa.
By coincidence I went by way of the El Aouina airport in
Tunis, the very same airfield which I had seen from a great
height as we wrenched it from the enemy in the bomb raid I
accompanied. It was being put to brisk use ferrying supplies of
all kinds to Italy. The massive debris of Nazi planes smashed in
our raid had been shoved to the sides, leaving the runways open.

While I waited for transportation, I wandered across the road
and was caught up sharp when I saw a graveyard marked with
painted swastikas. They were dated January 22, 1943—the day
of our mission. There is no time in war to use up any pity on
enemy dead, but for a moment those clumsy wooden swastikas

took away the impersonality of war and recalled the day when death rained from the skies. Meanwhile our front lines had moved forward into the "soft underbelly of Europe," and there was nothing left of these men who had been our enemies but pieces of painted wood shaped like swastikas instead of crosses.

I reached Naples just in time to catch one of the most brilliant engineering feats of the entire war—the heroic task of clearing the port for our use after the retreating enemy had sunk a harborful of ships in double-deck fashion, one on top of the other. It was a pleasant surprise to find that the General in charge of this operation was Maj. Gen. Thomas B. Larkin. In the fall of 1936, as a Colonel, he had directed construction of Fort Peck Dam, and it was with his assistance that I got *Life's* first cover picture and first photo essay.

Through the General's office, I was assigned a jeep and an invaluable driver who became my Man Friday throughout this whole phase of the Italian campaign.

Corp. Jess Padgitt from Des Moines was blond, neat and twenty-one. He looked like any nice kid from Iowa and talked about as much as Harpo Marx. He was one of those rare souls who never have to be told anything twice; in fact, Padgitt seldom had to be told anything once. With no previous experience in photography, he noticed that I reached for articles in a certain order. On our second day out, he started handing me these items in that order. I like to have assistants like the Corporal who don't interrupt with chatter while you're working. When Padgitt *did* drop a word or two, I discovered it was well worth listening to.

In the months to come I learned to appreciate a nice deep muddy ditch which I could roll into during a shelling. I learned to take a satisfactory bath in my helmet without upsetting it. I learned to live like a gypsy, out of my bedroll, and to sleep almost anywhere.

When I visited the Engineers, I struck velvet. I stayed in a fourteenth-century monastery with fifty monks and some combat engineers, and I lived in a cell. The plumpest monk I have ever seen, Friar Tuck, the cook, fixed us savory tidbits—especially spinach liberally laced with garlic and heaven knows what mysterious spices, which filled the stone-vaulted kitchen with an overpowering aroma.

The benign atmosphere of the monastery slipped away all too quickly when we started on each day's project. The Germans still held the highest peaks, from which they could look down on our bridge-building and interrupt us with an artillery barrage whenever they wished. The Engineers always said, "Jerry sits up there looking down his gun barrels at us, and he can pick just the man he wants to shoot." ("Or woman," I thought to myself.)

The war had reached a most difficult stage, with our forces trying to crash their way through the ring of mountains that surrounded Cassino Valley. This was an area slashed through with steep gorges and cliffs and turbulent mountain streams. As the enemy pulled out, leaving a chain of demolished bridges, the Engineers with incredible speed put them back in again. This was made possible by perhaps the most revolutionary bridge design in the history of military operations—the Bailey Bridge, which went together like a giant Meccano set.

So much technique is developed in war which has no peacetime use that I am always happy when something useful is carried over into the postwar world. After the war, I was photographing the devastation of Hurricane Edna throughout New England—the swollen rivers, and towns sliced in two. I met many Bailey Bridges, which I recognized as old friends.

Another group of heroes who introduced an original technique was the Grasshopper pilots, known as "the eyes of the artillery." They were a part of the ground war—not the war in the air. This handful of artillery pilots had the ardor of missionaries toward their perilous job. They flew in Piper Cubs, unarmed for lightness. The planes were fragile bundles of featherlight tubing and canvas, highly inflammable. Their only defense was their maneuverability.

Their job was to scout out enemy artillery from above, phoning back the gun positions to our ground crew, who would then proceed to blast the hostile guns to pieces. The pilot over radiophone would guide and correct our fire.

During my five months on the Italian front, the Grasshoppers —frequently Capt. Mike Strok, a fellow Cornellian from Ithaca, New York—flew me over various war-torn areas. Although I had done a great deal of airplane photography, never before had I

had a chance to hang out of an airborne birdcage with complete vision of earth and sky. There were no helicopters in World War II, and it was not until the helicopters came into general use at the time of the Korean War that I had such another intimate view of the earth beneath.

One day I flew in the observer's seat with Capt. Jack Marinelli from Ottumwa, Iowa, who was going to search for a Screaming Meemie—a German mortar that had been harassing our troops. To find it we flew over enemy lines. We picked our course over the crests of hills which surrounded Cassino Valley like the rim of a cup. Highway 6—the muddy road to Rome—wound between bald rocky mountains, and we almost scraped their razor-blade edges as we flew over. We could see Italian civilians picking through the sickening rubble that once had been their homes. Then the land dropped away sharply, and all at once we were high over Cassino Valley. I was struck by the polka-dotted effect of the valley, with hundreds of thousands of shell holes filled with rainwater and shining in the sun. It seemed impossible that so many shells could fall in a single valley. It was as though this valley, in which so many had suffered and died, was clothed in a sequined gown.

"It's been so rough down there," said Captain Marinelli, "the boys are calling it 'Purple Heart Valley.'" (Thereby naming my book, although I did not know it at the time.)

From my overall view of the battleground I could see that every bridge below us had been blown up. The delicate arches of the small bridges were broken through the crest; the larger bridges were buckled like giant accordions. Parallel to each demolished bridge was an emergency bridge which our Engineers had thrown up.

Then we came to a strip where there was no rebuilding at all. The pilot shouted, "That's no-man's-land. They're shelling our men just below, where you see the darker smoke. It's still too hot to rebuild these bridges." We crossed the front, and when we began to see bridges intact, he shouted, "Jerry territory." The Captain found his Screaming Meemie despite its camouflage. He spotted it by the bushes around it, which blew back violently with each gun blast.

From now on, it was a two-way radiophone conversation be-

tween the pilot and the artillery gun crew back on the ground. The pilot gave the command to fire, and the answer would come back: "Eighty-eight seconds. On the way." Those 88 seconds were the time it took the shell to travel its fourteen-mile journey from the muzzle of the Long Tom to the enemy mortar. Those 88 seconds were precious nuggets of time for me, because I could use my cameras while the pilot watched his watch. "We're going to be hanging around here for a while," said Captain Marinelli, "so speak up if you want to be put into position for anything special."

There were many things I wanted to be put in position for. Below us it looked as though white grains of popcorn were bursting all over the valley floor. These were thickest in front of Cassino. The Benedictine monastery which stood at the foot of snow-capped Mt. Cairo was still unbombed, but the towns around it lay in white smudges of wreckage. Captain Marinelli maneuvered the plane so that—strapped in securely—I was practically lying on my side over the valley. I got wonderful views of the battleground, with the white plumes of our smoke shells rising in the foreground, followed by the deadly black bursts that knocked out the Screaming Meemie.

Several times I saw other planes in the sky and called out to Captain Marinelli, but each time, they were friendly planes. The Captain said, "That's all right. Just tell me anything you see."

What I missed seeing was a group of four German fighters. The Captain went into the steepest dive I had ever experienced. It was the neatest maneuver imaginable—diving to shake the Focke-Wulfs, then wriggling our way through a stream bed so we were actually below the treetops, then back to friendly territory and to our own airstrip. Captain Marinelli had accomplished his mission. He had destroyed the enemy mortar and given me some excellent airplane pictures.

After my exciting experience in the Cub, I decided to run down the story still further by photographing the battery that had wiped out the Screaming Meemie at my pilot's command.

I was planning to work all night with the heavy artillery. The target that night was a bridge on the road to Cassino. The crew helped me plot camera positions as close as possible to the muzzle of "Superman," which the big gun was called, and where I would

Hotly contested Cassino Valley. The white puff in the foreground is from one of our shells, fired when my Grasshopper pilot radioed position of the Screaming-Meemie. On the lower slopes of Mt. Cairo is the ancient Benedictine monastery which provided the enemy with a long view of Highway 6, the strategic road to Rome.

not be swept off my feet by concussion. Every time the gun fired, I wanted to get four different effects with four different cameras. Two would be hand-held and two on tripods, one of them at a side-forward angle and one well back for an overall view. The relief gunners who were helping me divided into two sections, and each group manned a camera. The third camera was a Rollei—with a peanut flashbulb for a trace of detail—and operated by Padgitt. I placed him where he could get the gun crew in action just at the moment of recoil, with their eyes tight shut, mouths wide open, fingers in ears against the blinding, deafening blast. The fourth was a roving camera—a miniature—operated by me.

The crew chief called out his commands: "Load! Ready! Fire!" Superman let forth a roar, and each of us from our various locations tried to catch it at the exact instant of firing. After each round, I changed films, reset the focus and figured out new camera angles.

News of the excitement spread to nearby batteries, and their relief crews came up to help during the hours they were off duty. "It's 'Life Goes to a Party with Long Toms!'" the boys were saying.

We had so many signals to one another that finally the boys said, "We think it would be easier if you would give the command to fire." Each time the next round was due, I would yell, "Load! Ready! Fire!" at the top of my lungs, and four pictures would be taken on four cameras while that 155-mm. shell crashed into space.

It was a little after midnight when the Brigadier General of the artillery brigade arrived on the scene. He had heard that some pictures were being taken, and he dropped by to see what was going on. Everybody was so busy synchronizing the shooting of cameras with the firing of guns that no one stopped for formalities with the Brigadier General. So many camera gadgets were being passed from one man to another that soon the Brigadier General found his hands full of film packs, cable releases and film slides. By that time, the enthusiasm for photography had risen to such a pitch that it wasn't long before the General was operating my camera while I was giving the command to fire.

Dearest to my heart were the nurses and doctors in the for-

ward areas. They worked under the most formidable difficulties—rain, wind, endless hours, unseen dangers and the eternal mud, mud, mud. Ten surgical nurses in the newly established 11th Field Hospital were working so close to the front lines that many a wounded GI was brought in and treated within the hour of his wound. These were soldiers who would have found certain death if there had been any delay. Those who could make the ambulance trip went five miles back to the larger 38th Evacuation Hospital. The little cluster of tents marked with their red crosses was ahead of our own artillery. The nurses had to get used to the two-way traffic of shells passing overhead. They learned to tell by sound which were ours and which were the enemy's. But they never could get accustomed to the way their beds trembled at night.

Padgitt and I arrived at the field hospital at dusk after an exceedingly busy day with the Signal Corps, up forward. I decided that a good night's sleep was next on the agenda. We could sleep tonight and work tomorrow. Padgitt went to the enlisted men's quarters nearby. I was billeted in the nurses' tent. I had hardly time to introduce myself to the nurses when a sound of rushing wind came out of the mountains. The nurses fell flat on the ground, and I followed their example. The sound swelled up, carving a screaming path toward us. Then all sound was swallowed up in a deafening roar. I thought the earth would never stop pelting on the tent walls. One end of the tent collapsed, but finally it was over.

As we freed ourselves from debris, I heard Padgitt's voice.

"You all right, Peggy?" And with his help, I gathered up some camera equipment. The shell had fallen only thirty feet from us and had scored a direct hit on the mess tent. All that was left was a perfectly round hole in the ground and cans of rations blown all over the place. But it could have been much worse. Ten minutes later, the night staff would have been in the mess tent for coffee and pancakes.

Fortunately, the operating tent just beyond was intact, although the lights were gone. The camp's improvised electrical circuit had been strung through the mess tent. Some members of the staff were working on the wiring, trying to get the lights back. Sporadically the naked bulb would shine out and fade

again. Meanwhile the surgeons were performing operations by hand-held flashlights.

That German shell was only the first of many that screamed over our hospital all through the night. Every few minutes that bloodcurdling warning would sound overhead, and the entire hospital staff, including Padgitt and me, would fall down flat, then rise to their feet again and try to continue to work. There was much changing and disinfecting of rubber gloves and sterilizing of instruments. No sooner was this done when another whooshlike sound would grow into a rising shriek, and back we would go—flat on our faces again.

It was fortunate that I had independent lighting. I was using peanut flash, and I instructed Padgitt to hold extension cords far to the side to keep the lighting soft. I was operating a Rollei, and somehow Padgitt, in spite of the confusion, managed to keep those connection wires plugged into my battery case. Even when we were lying flat on the ground, I could still manage to lean on my elbows and operate the camera. Never have I seen such a night. There was no time for notebooks, but I kept my ears open as well as my eyes and tucked the phrases away in my mind.

So many wounded were being brought in that the hospital was running short of plasma, running low on oxygen, running short of whole blood and almost out of Type A. The truck drivers and ambulance drivers were donating blood, members of the hospital staff were volunteering to give their blood, and even the gun crews, when they could be spared for a few moments, came in rotation to donate blood.

Most vividly I remember Clarence, from Texas. There wasn't much left of Clarence when he was brought in. His thighs had been nearly severed by shell blast. Clarence had lost so much blood that he was getting whole blood and plasma in both wrists instead of one. When his pale lips moved, Nurse Barnes, a tall, handsome girl from Texas, leaned over to listen. "They're taking my blood," whispered the soldier.

"No, Clarence," said Nurse Barnes. "They're not taking your blood, they're just giving you something to make you stronger."

"Do you learn all their first names?" I asked.

"Always, when they're from Texas." Nurse Wilma Barnes was from Abilene. "It seems to help the boys to know someone

Artillery barrage: supporting fire for an infantry action south of Bologna, Italy, 1944.

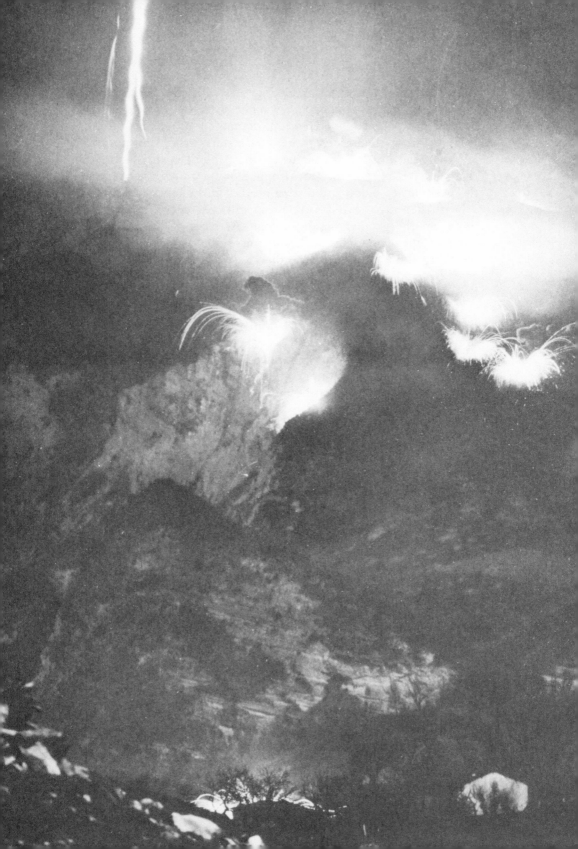

from their own home state is taking care of them." It happened that many of the wounded that night were Texans. This was because the famous 36th Division, composed largely of Texans, was engaged in the fierce fighting on the outskirts of Cassino.

When the next shell sent us to the ground again, I noticed that Nurse Barnes, before she dropped down, took time to check the positions of blood and plasma needles in the boy's wrists, and I heard her say, "Hold your arms still, Clarence," as she lay down on the ground beside his cot. As soon as we heard the bang of the exploding shell, the nurse was back on her feet checking those transfusion needles. I remember scrambling up after her and thinking it was a privilege to be with people like that.

Clarence was moving his paste-colored lips again. Nurse Barnes leaned down to listen. I heard her say in her soft Texas drawl, "No, son, you can't have a cigarette yet. Just wait a little longer." When Clarence was moved to the operating ward, I followed. Padgitt moved my cameras and helped me to get set up in the new location. Then he said, "Can you get along without me for half an hour, Peggy?"

"Of course," I replied. But I was secretly a bit surprised, because never before had the Corporal left me during an emergency. At the end of half an hour, Padgitt came back looking a little pale. It was only later that I found he had given a pint of his blood. His was Type A, the kind they were short of.

The hours crawled on in their grotesque routine. The periodic *whoosh* overhead, the dive for the floor, up again and on with the work. The constant changing of blood and plasma bottles. The surgeons in battle helmets and gauze mouth-masks peering out with tired eyes.

Clarence's breathing was becoming very shallow now. His pallid lips were moving, and Nurse Barnes tried to catch the whispered words. "He's asking for watermelon," she explained. "They often ask for their favorite foods when they are near death," and leaning over Clarence, she said, "They're not in season, son."

"Cover up my feet," the boy murmured. And then, whispering, "I'm so cold," he died.

I took a last picture of those feet still in their muddy boots

and with the boy's own rifle between them, where it served as a
splint for the crushed leg. I knew I was getting dramatic pictures.
If these men had to go through so much suffering, I was glad,
at least, I was there to record it.

Wilma and I stumbled back to the nurses' tent together. Watch-
ing death so close before my eyes, I had forgotten the wholesale
screaming death being hurled down from the mountaintops.
Occasional brilliant flashes threw shadows like those from moon-
light across our path. It seemed quiet and normal to be back in
the nurses' tent again, but not for long. Within minutes came
a sound as though the whole Jerry mountain was rushing toward
us, and we were pancaked under our bunks waiting for the
sweeping terror to spend itself and die.

"I'm going to make my bed right under the cot," said one
of the nurses, dragging all her bedding to the floor and covering
her face with her helmet. It wasn't much longer before we had
all dragged our blankets down in the mud, and all of us stayed
under our beds. "I pity our poor boys up there," said one of the
girls. "Look at us. We've got heat. I worry about those poor
boys in the foxholes. They can't even put on a pair of dry
socks. They can't even build a fire."

I began searching on my hands and knees in the dark for a
safer place to put my cameras. Next to my bunk was a small table
crowded underneath with barracks bags. I pushed away the
barracks bags and put my cameras there. Then it occurred to me
that the spot I had picked for my cameras would be a good place
for me. I had just shoved my cameras out and slid under the
table with all my blankets when Jerry started in again.

"I'm really scared," said one of the nurses.

"Come over and get in bed with me," said Wilma Barnes.
"Then if we get hit, we'll die together."

A new sound was growing out of the mountains, like a giant
stalking toward us, closer and closer, until the last three steps
crashed around us with the loudest sound I'd ever heard. "It's a
creeping barrage," said the girls.

"I'm worried about those poor boys in the hospital, boys still
in shock," said Wilma Barnes. "They can't understand how if
they're really in a hospital, it sounds as if they're in the field."

"Can they tell?" I asked.

"Oh, yes. They lie there and call out the names of the guns."

A throaty reverberation began knocking through the hills. "Theirs or ours?" I asked. "That's thunder," said the girls. It seemed such a benign sound and oddly comforting when the rain started pelting down. "You know what I always think of every time they bring a boy in?" said Wilma. "My kid brother. Especially if the soldier's about the same age. Doesn't it always remind you of your brother?"

And the girls began worrying about their brothers, scattered throughout the various war theaters of the world. I thought I could guess how proud their brothers would have been if they could have seen their brave sisters carrying on while a two-way barrage passed over their heads.

I had my story now. I had completed my assignment. I had heroes, and I had heroines—ten of them. It was time to go home.

On the way home, a cable from *Life* reached me with the good news that the editors were planning to rush the Medical Corps story into the magazine as soon as the films arrived. These had been dispatched through Army channels according to routine procedure. Films taken by war correspondents went first to the Pentagon for developing and censorship; that done, they would be released to the magazine.

I was especially pleased that I had gotten direct quotes that matched the pictures, which *Life* could draw on for captions. There would be a book in it, too, I was sure. There would just have to be. I was so brimful of words and pictures.

When I arrived back in the Time & Life Building in New York, it seemed to me that Wilson Hicks was singularly grave in welcoming me home. "Sit down," he said. "I have something to tell you."

"Good heavens! What have I done wrong?" I wondered.

Wilson Hicks looked down at his desk thoughtfully for a while, as though he were trying to choose the right words. Then he told me they were afraid a whole package of film had been lost. No, it couldn't be true! How could my precious hospital pictures be lost? I recalled that my films had been divided into two packages. Which package was it?

It was ironical that of the two packages, the one that was safe

At an observation post overlooking Cassino Valley, 1943.

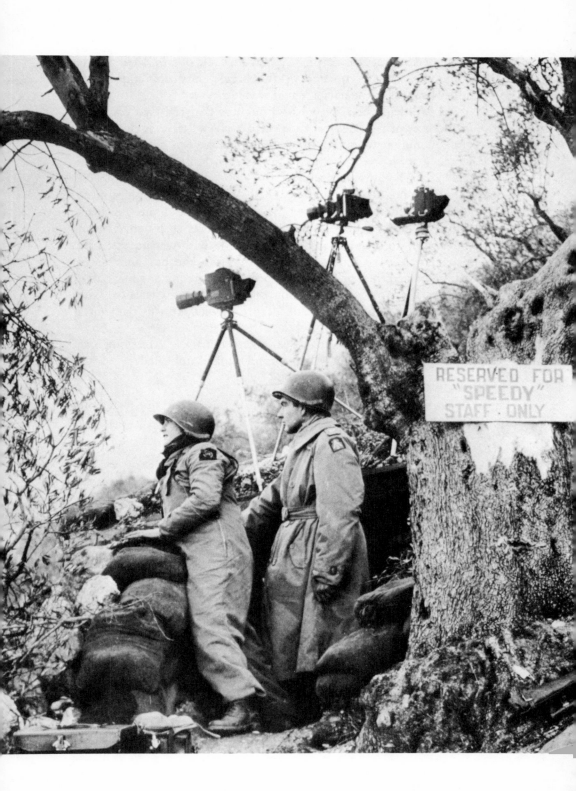

contained more prosaic pictures taken back out of shell range, while the whole sequence of the heroic surgeons and nurses under fire was in the package that was lost.

All *Life* had been able to find out was that the two packages of pictures of the Medical Corps had arrived safely at the Pentagon by military pouch. But somehow between the darkroom, which was on one floor, and the censor's desk, on another, that package of film disappeared.

I was wild. I begged Hicks to let me go to Washington to lead a search. I knew General Somervell would put his back behind it because he had wanted the pictures so much. I went to Washington, and the search was made without success. *Life* managed to salvage a story somehow from the bits and pieces that remained, but of Nurse Barnes, the surgeons in their battle helmets, the truck drivers giving their blood, and Clarence, who wanted a piece of watermelon before he died, to this day not a trace has ever been found.

It does no good when wisecrackers remark, "Anything can happen in the Pentagon." The wound remains unhealed.

CHAPTER XXII

THE
FORGOTTEN
FRONT

Shortly after I left for home, Corporal Padgitt became Sergeant Padgitt. His quiet efficiency in helping me had been noticed in high circles, and he was offered a new post having something to do with photography. The only trouble with it was that it was too far behind the lines. "It sure is funny to be back out of range," Padgitt wrote me. "I keep thinking of the time I put in trying to sleep through that incoming and outgoing mail, not knowing when one of those letters postmarked Berlin was addressed to me."

So he requested to be returned to his old infantry company, which was soon transferred to a very hot front. His unit was ordered to Anzio, which was, in Padgitt's words, "as noisy as New Year's Eve." "Here at Anzio," the next letter told me, "you carry nothing but your gun, plenty of ammunition and a lot of hope."

While at Anzio, Padgitt did receive "one of those letters postmarked Berlin." He was leading a combat patrol when he was severely wounded. He gathered up a liberal amount of shrapnel and mortar fragments in his system, but this bothered him less than the bullet through his shoulder, which severed the nerves, leaving his right arm paralyzed. Despite his wounds, he had completed the mission, and in doing so had covered himself with

glory. But Padgitt said all he got covered with was "blood and mud. They tried to cover me with six feet of dirt and a white cross," he wrote me, "but I hadn't kissed my mom and my girl-friend goodbye, so I just refused."

When *Purple Heart Valley* came out, Padgitt had his own place in the reviews, which was as it should be. John Mason Brown, in the *Herald Tribune* Sunday book-review section, wrote, "to the list of the most likeable characters emerging in works fictional or factual add Corporal Jess Padgitt. . . . That we leave him . . . as 'one more purple heart,' only makes this taciturn but efficient young corporal the more eloquent as a GI's Everyman."

But before my book could be published, it had to be censored. Correspondents, as part of their accreditation, must check with Washington army censors before final publication of articles or books. Getting *Purple Heart Valley* censored was a saga in itself. If I should ever write another book concerning military matters, I shall sprinkle it liberally with sentences of pure gibberish to give the censor something to cross out. Censors are a peculiar breed of mankind. They are born with red pencils in their mouths, and they simply have to use them.

All this I discovered when getting my manuscript of *Purple Heart Valley* passed by the Pentagon. No correspondent objects if censors stick to the rules. Censorship is intended to serve the very important purpose of military security.

There it stops. For example, if you write about a soldier's beautiful brown eyes, the censor is not to strike it out because he prefers blue eyes. My publishers were eager to get the book out so it would be timely, and I was mailing my manuscript to the press censor in Washington chapter by chapter, as quickly as I could get it written.

My first bout with the censor was over the mention of Spam. Since I hadn't thought of Spam as a military secret, this warranted a trip to Washington in person. Those of my readers who had any connection with World War II will remember the unpopu-larity of Spam. There was nothing wrong with it except the frequency with which it turned up in the rations. Spam was a kind of symbol of army chow versus home cooking.

In my manuscript I had described a Christmas party given by

American officers in Naples to which singers from the San Carlo Opera Company were invited. Along with the Italian delicacies, the officers set out platters of Spam. We were amused at the way the opera singers made a beeline for the Spam. The censor cut out Spam ten times, but not without composing a substitute wording, such as "that luncheon meat" . . . "cooked ham" . . . "that product."

I called on the censor in the Pentagon and said, "If Sad Sack can have Spam, I guess I can." And smiling, the censor said good-naturedly, "I guess you can." And he gave me back my Spam. The visits with the censor were always pleasant, but time-consuming for a girl who was trying to write a book.

Friar Tuck was the next to feel the grazing of the censor's ax. Whole paragraphs were deleted. Among the items tossed out was the garlic-flavored spinach. And in another pleasant meeting, the censor acknowledged that there was no military secrecy involved, so I got back the spinach.

In the book, I wrote of taking aerial pictures while the Grasshopper pilot corrected artillery fire during the 88 seconds it took for the shell to leave the gun and reach its target. The censor approved everything with the exception of one small point. "Why should we give away to the Germans the maximum range of 155-mm. Long Toms?"

Why should we indeed? I willingly took out the phrase. The censor wrote in 66 seconds to replace the 88, but it didn't seem right, somehow. I didn't mind a bit coming down to 66, but I wanted to be sure it was a logical change and made sense in artillery terminology. Before leaving Italy I had checked all possible points with the officers in command, not only questions of military security but of technical accuracy as well. I love engineering subjects and all the terminology that goes with them. Besides, I had a bet on with a general that I wouldn't make any artillery mistakes.

After visiting the censor, I called on the editorial staff of the *Field Artillery Journal*, a technical Army publication. The artillery editors had a good laugh. They said, "We could give the censor a list of thirty-eight unrestricted bulletins in which the 155 is discussed in detail. And the Germans have the same thing anyway."

The editors were even more amused at the deletion of some artillery call letters—Mike Uncle Charlie for MUC. The artillery alphabet (A for Able, B for Baker, and so on) is used around the world. The censor gave it back.

By now my manuscript looked like pieces of Scotch plaid— with phrases that were questioned underscored, examined and restored. It was a jungle of colored crayon with notations: "Red means delete." . . . "Blue over red means stet." . . . "Green over blue over red means delete." I chose one of the most marked-up sheets and framed it.

While my experience with the censor was amusing, I found it also alarming. If a censor hasn't learned what is *not* censorable in relatively simple matters, how is he going to know what *is* censorable in the field of military security and recognize what might give "aid and comfort" to the enemy?

At the end of the contest, the total deletions came to two sentences. And these the censor urged me to delete as a favor to him. I had described some joyful American officers in Naples coming home from the opera where they had heard *La Bohème*. All the way home, the officers had burlesqued the singers at the top of their lungs. The censor hoped I would strike it out, as he didn't want it to appear that American officers were having such a good time. I agreed, and with that deletion *They Called It "Purple Heart Valley"* went to press.

As soon as my book went into publication, I was ready to go back to the war. The overall picture had changed considerably. The much-heralded "second front" had taken place in Normandy, along with an airborne landing in the south of France. In Italy we occupied Rome and Florence. But the war in Italy was not yet won. It was moving into its second dreary winter.

Members of the press had transferred almost in a solid block to France, where all the news was. To make it worse, our boys were getting letters from their mothers, wives and sweethearts: "We're glad you're in a nice safe place in Italy—instead of at the front in France." The effect on morale was most unfortunate. The Italian front was grimmer than before, and most of the soldiers there had been through two bitter winters, slogging through the mud and snow and getting killed as often as before. The war had ground down to a struggle of man against man,

patrol against patrol, mortar against mortar. It was known as "the Forgotten Front."

I like forgotten causes when they are good ones. I asked to be sent to Italy. On my arrival in Rome, *Life* cabled me: "Planning to run an indefinite number of pages of 'news-front' on the Forgotten Front." I went happily up to the lines. I think I'm not exaggerating when I say that everyone in the Fifth Army from General Clark down was glad that *Life* was going to do a big story.

The scene of war had moved northward from Cassino to a point ten miles in front of Bologna. These last ten miles were being contested rock by rock. Some of the bitterest fighting was taking place in the ruins of a tiny town, Livergnano—"Liver and Onions" to the boys.

This was the first time I had worked closely with Infantry. In Livergnano I first heard that ugly and so personal *ting* which means you're close enough to the enemy to make small-arms fire worth his while. My previous experiences had been with artillery shells and bombs—which are more impersonal. But these rifle bullets come singing out your name.

There were wonderful subjects for pictures. I remember a waterfall frozen into mighty glass organ pipes. At its base were a few running trickles, which GIs were collecting in their helmets, to take a very cold bath. The unusual amount of snow tested the GIs' ingenuity. The men worked out new camouflages. They whitened their faces, sprayed their clothes with whitewash, painted their rifles and bazookas. Even the mules which carried supplies up into the high peaks were camouflaged with white sheets. Pillowcases cut with eyeholes were tied over their heads, which made them look frighteningly like members of the Ku Klux Klan.

Photographing the mules in the darkness of night presented a problem. Since the enemy was just ahead of us on the back slope of a rather low hill, we did not want them to know that there was any more than the usual activity that night. So I timed my peanut flashbulbs to match the regular harassing fire. We hoped that the lights from the bulbs would be swallowed up in our gunfire.

Most of my work along the lines was done with the celebrated

88th Division, who presented me with their blue shoulder patch. I wore it very proudly, too, through the whole assignment. For the first time, I worked with patrols. I could not go out on them, of course, but I went to the last hopping-off place, the men sometimes maneuvering me into position twenty-four hours in advance, under cover of darkness. I could photograph our supporting fire, and then the men themselves, their weariness, and the work of the front-line medics. Almost always someone in the patrol came back minus a foot which had been blown off by shoe mines. And of course some never returned.

I know of no more inadequate statement than one which frequently appeared in the press. "Routine patrol went out last night." I was always struck by the discrepancy between the terseness of the dispatch and the human suffering involved. Translated into heartbreak and danger, there was nothing routine about it. These were miserable little actions. The objectives were "to make contact with the enemy; to bring back some German prisoners alive, if possible, for interrogation."

I had made what I thought were three hundred exciting pictures. The films were turned over to the press censor in Rome. The precious package went off "red bag" in the official Army pouch to Naples airport, from which it would go by air to Washington. Two or three days later, I went back to Rome, and my good friend Helen Hiett (Waller) of the *Herald Tribune* joined me for an early breakfast.

She had important news, she said. Her manner was grave. This was unlike the Helen I knew who was always so buoyant. Helen said the correspondents had picked her to tell me this news. While she talked, my mind ran around in circles. Whom did she remind me of? Wilson Hicks, trying to find words to break the bad news. Oh, no, it couldn't be! Lightning doesn't strike twice in the same place. But it does. It does, I said to myself, and it has.

Helen had not been able to get all the details, but she told me what she knew. The precious package had gone through Army channels, as always, to our Army Press H.Q. in Rome. The official courier jeep for transport between Rome and Naples airport contained three pouches that night: one for London, and two Washington "red bags," one of these containing my films. Somewhere between Rome and Naples, the red bag with my films was

stolen. No one knows whether the driver stopped for a beer, or what, despite strict orders never to leave a courier jeep unguarded. On the northern run, I learned, there had been so many losses that a new directive was handed down: each courier jeep must carry an officer in addition to the driver; also, the pouches must be locked in a safe box nailed to the floor. No one had the imagination to extend these orders to the southern run until my films were lost.

Rewards were offered over the Army radio, in the *Stars and Stripes*, in the Italian newspapers and Italian-language radio, with no success. My own theory is that the boy of course had his beer, or the equivalent, and that meanwhile some passing Italian thought there was food in that pretty red bag. When he saw what he had, he was frightened and destroyed it.

I managed somehow to pull myself together after this crushing blow, and packed equipment and a clean shirt to go back. I had wired *Life* to make sure they could still use the story if I did it again, for the element of timeliness is very important with a piece like this. The editors cabled in reply that they would use it at any time, but "don't take too many risks."

Up at the front, everybody had heard about it on the radio, and their grief was greater than mine, if possible. There is something demoralizing about going back to a place to retake pictures. You can no longer see your subjects with a fresh eye; you keep comparing them with the pictures you hold in memory. And everything is changed.

The snow had thawed. The organ pipes had melted. Even the famous Italian mud would have helped. The drama of the white battlefields had vanished; the drama of the mud had not yet begun. No longer did soldiers whiten their boots and bazookas; no longer were mules masked like the Ku Klux Klan. *Life* ran a generously large story. But nothing was the same.

I know very well that when you choose to record a war, you must be willing to accept the hazards of war. I think what hurt me the most was that both the losses were due not to war but to just plain, unadulterated carelessness.

CHAPTER XXIII

"WE
DIDN'T KNOW,
WE
DIDN'T KNOW"

I LEFT the Forgotten Front and flew by way of Paris into Germany to the exceedingly lively front on the River Rhine.

The war was racing toward its close in that crucial spring of 1945, and we correspondents were hard pressed to keep up with the march of events. It was truly a *Götterdämmerung*—a twilight of the gods. No time to think about it or interpret it. Just rush to photograph it; write it; cable it. Record it now—think about it later. History will form the judgments.

I was with General Patton's Third Army when we reached Buchenwald, on the outskirts of Weimar. Patton was so incensed at what he saw that he ordered his police to get a thousand civilians to make them see with their own eyes what their leaders had done. The MPs were so enraged that they brought back two thousand. This was the first I heard the words I was to hear repeated thousands of times: "We didn't know. We didn't know." But they did know.

I saw and photographed the piles of naked, lifeless bodies, the human skeletons in furnaces, the living skeletons who would die the next day because they had had to wait too long for deliver-

ance, the pieces of tattooed skin for lampshades. Using the camera was almost a relief. It interposed a slight barrier between myself and the horror in front of me.

Buchenwald was more than the mind could grasp. It was as though a busy metropolis had frozen in attitudes of horror. But even Buchenwald paled before some of the smaller, more intimate atrocity camps.

I remember one we stumbled on just as our Army was in the act of capturing Leipzig: the labor camp of the Leipzig-Mochau airplane small-parts factory. The camp was a modest little square of ground enclosed by barbed wire. The bodies were still smoldering when we got there, terribly charred but still in human form. We learned the ghastly details from one of the few survivors. The SS had made use of a simple expedient to get rid of the inmates all at once. The SS guards made pails of steaming soup, and as soon as the inmates were all inside the mess hall, the SS put blankets over the windows, threw in hand grenades and pailfuls of a blazing acetate solution. The building went up in sheets of flame. Some escaped, only to die, human torches, on the high barbed-wire fence. Even those who were successful in scaling the fence were picked off as they ran across an open field by savage youngsters of the Hitler *Jugend* shooting from a tank. There had been three hundred inmates; there were eighteen who miraculously survived.

To me, those who had died in the meadow made the most heartbreaking sight of all. To be shot down when they were so close to freedom, when the Allied armies were at the gates of the city. It was understandable that the Germans destroyed their bridges to slow up our advance. But to destroy these miserable people—what sense was there in that?

A final touch was added by the retreating Germans. On a flagpole set to one side they had run up a white surrender flag over the acre of bones.

People often ask me how it is possible to photograph such atrocities. I have to work with a veil over my mind. In photographing the murder camps, the protective veil was so tightly drawn that I hardly knew what I had taken until I saw prints of my own photographs. It was as though I was seeing these horrors for the first time. I believe many correspondents worked

in the same self-imposed stupor. One has to, or it is impossible
to stand it.

Difficult as these things may be to report or to photograph,
it is something we war correspondents must do. We are in a
privileged and sometimes unhappy position. We see a great deal
of the world. Our obligation is to pass it on to others.

My mission during this final phase of the war in Germany was
to photograph, from both the air and the ground, each main
industrial center as we captured it. A department of the Air
Force, called by the formidable initials USSTAF (which stood
for United States Strategic and Technical Air Forces) put at my
disposal a small observation plane. The pilot had a fortunate gift
for skirting shell craters when we had to land on some densely
pockmarked field to refuel. We carried our gas with us in jerry
cans along with our bedrolls and rations. *Life* planned to use my
aerials of ruined cities and factories for a photo essay to be called
"The Face of the Moon." USSTAF would use my work as part
of a far-reaching analysis of heavy bombardment.

The top experts of USSTAF must have known—but certainly
I did not—there was something in the wind that would make
even this thundering poundage obsolete. The endless mash of
devastation I saw below me as I flew would make one wonder
why there should be any need of improvement on old-fashioned
bombs.

In the early 1930s, when *Life* magazine was still unborn and
Fortune was in its infancy, the editors of *Fortune* had sent me to
photograph the *Reichswehr*, the German Army, which was
using its ingenuity to the full to evade the restrictions of the
Versailles peace treaty. The Allies' purpose was to insure, after
World War I, that a militant Germany never again could rise
to threaten the peace of the world. The Germans were pro-
hibited from having heavy artillery, military planes and tanks.

I found them practicing with all sorts of tin and paper con-
traptions—wooden machine guns, papier-mâché tanks and toy
airplanes as targets for dummy antiaircraft guns. All this was part
of the relentless effort to keep their men trained in war—an effort
that bore fruit in the rise of Hitler, culminating in World War II.

Now in March, 1945, when I arrived at the front on the Rhine,
Cologne was split in two by the opposing armies. The German

Army clung stubbornly to the east side of the Rhine while we held the western bank with its famous cathedral. The twin towers of the cathedral remained miraculously intact, though bombers by the thousand had come and gone.

Inside the cathedral, the floor was strewn with rubble, and I found some GIs celebrating their victory in gushing champagne.

"Champagne is a military necessity," shouted one of the boys, and he waved me to join them. Another added, "We've had so much champagne, we're brushing our teeth in it."

"This is the beginning of the Through-the-Looking-Glass country," I thought, "the place where you brush your teeth in champagne!"

"There are vaults and caves full of stuff under these streets," said another soldier. "Everything a person could want. We haven't had time to go through half of it yet. Let's go looting."

This was my introduction to a very interesting sidelight of war—the world of looting. In other countries through which the war carried me, looting never became the big-time obsession it was in Germany. But now we were in the country of the enemy, the enemy from whom we had suffered so much and who had stolen so much from other vanquished countries.

My GI companions and I started for Höhe Strasse. We ran past the skeleton of the 4711 Cologne building and stooped low as we hurried through open portions of Cathedral Square. The Germans had direct vision on us once we left the cathedral. They were likely to drop in a mortar shell or two, if they saw signs of life. The boys led me to a stone pile which looked exactly like any other stone pile. They pulled stones away until they found a little opening. We let ourselves down through a hole, down a ladder, through another hole, and down a precarious stairway until we found ourselves in a third subbasement below the street.

This weird cave was a cross between Macy's bargain basement and your grandmother's attic. There were piles of folded lace curtains, boxes of damask tablecloths and napkins, chests of flat silver, cases of wine, lots of cheap red cotton flags with swastikas machine-stitched on them in black. I was shooting with my Rollei and with a peanut flash. With every blaze of flashbulbs I caught glimpses of GIs searching through the confusion, un-

corking bottles and poking their way from one cavelike chamber to the next. One of the soldiers helped me climb through a chink in the wall into a vault where furs were stored. I was having hard work to estimate the footage and keep my camera properly set for it, but I kept on shooting one roll after another, pointing the lens toward what seemed a blizzard of fur, as the boys embarked on a search for mink.

They were unsuccessful in finding any mink, but one soldier held up one of those scraggly, nondescript little pieces and asked me if I wanted it. I didn't care for it. I thought it looked a trifle on the vulgar side and trashy. The GI tucked it under his arm. Months later in Paris, I learned it was platinum fox, appraised at $2,000, and the soldier had given it to a French actress for reasons which were quite clear in his mind at the time.

In the cave of furs and oddments, I had caught sight of just one thing I wanted. It was a mammoth Nazi flag in heavy silk, ornately bordered with white fringe cord. A few weeks after our looting party, my huge Nazi flag, by that time elaborately autographed by war correspondents, famous pilots and assorted notables, disappeared from my barracks bag, and I learned a fundamental lesson about loot. It is almost inevitably stolen from you.

From the day of the cave exploration, I became very much interested in looting as a by-product of war. I suppose it should have shocked me, but it didn't. There is a curious psychology about looting. "To the victors belong the spoils" is only part of it. For weeks, months or years that enemy has been shooting away at you. When you move into his hometown, you feel you own it. You're overwhelmingly curious to see how he lived and what kind of fellow he was. It becomes a fever, highly contagious.

The cellars were astonishing in the prosperity they showed. In a house in Frankfurt, which we correspondents had requisitioned as a press center, the cellar was a veritable cornucopia of good things. Two of everything: two fur coats, two evening wraps, piles of white bed linen and table linen. They must have bought up every useful article they could find as a hedge against inflation.

Of course, everybody looked for iron crosses and dress swords. Any enemy decoration always makes the best-possible souvenir. To me, even more interesting were the civilian medals. Mother-

hood medals for Childbearing; fatherhood medals for Reliable Service; National Sacrifice medals. The need of incentive must have been great, if the Nazis had to turn out decorations in such variety and numbers. The civilian medals were of cheaper material than the military ones. They became flimsier and trashier as the years of war advanced. You could almost read the collapse of Germany in its medals.

War makes its own morals. Looting has its own code of ethics. First of all, you don't call it looting, or stealing or appropriating or requisitioning or scrounging—but liberating. The rules of honest liberating are quite strict, though largely unwritten. You don't liberate anything from a house that has people living in it, but if the house is empty—indicating the people have run away— or if the house is partly wrecked, it is fair game.

Looted wine has first priority whether or not you brush your teeth in it. Unusually troublesome items were left behind, like the fine china demitasse cups of which the Germans are so fond. That was my specialty. I love coffee, and I loved the little coffee cups. I wasn't above taking some clean linen from a cellar hideaway. Most of it carried embroidered monograms. I had a regular procedure of tucking fresh linen into my bedroll and leaving well-used linen behind. I often wondered what those German housewives thought when they came back and found the wrong initials.

Highly desired was a liberated car. This was usually not looted but arranged through Military Government, for we needed transportation. The difficulty was that the car was always breaking down in inconvenient places. You simply sought out one of the huge bombed car lots of automobile wreckage and poked through it, hoping to liberate a fender or a crankshaft or whatever it was you needed. Sometimes you could liberate a good tire.

We correspondents and officers often talked about the looting fever, and wondered if we would drop our looting habits when the war ended. We talked about whether we'd have to nail down things in our own houses, if any of us visited each other.

The zenith of looting was achieved when we took Munich— Hitler's hometown. Munich, where it all began in 1920—the rise of Hitler, the Nazi *Putsch*, the Hofbrauhaus, the home of Heinrich Hoffmann, Hitler's personal photographer, and the

rustic house which had been occupied by "Strength-Through-Joy" Ley, which was next door to the luxurious home which we requisitioned for a press camp. When I made my airplane pictures, I flew over these Nazi shrines like a tourist, with a Baedeker tucked into my safety strap.

Hitler's private apartment was taken over by the Rainbow Division for a headquarters. They had earned it by capturing the city. Here there was loot with prestige—such high-quality loot that nothing else could compare with it. I arrived on the scene a day late because I had to get my airplane pictures first, and when I got to Hitler's flat, the place was swept clean. Every movable article that was not too heavy or too inconvenient to be liberated had been removed by GI collectors. I was just about to leave in discouragement when I found a pile of Bohemian glass plates in a pantry closet—very large, very lovely and very inconvenient to carry. Then I spotted an even more cumbersome art object; it was a pair of weighty dancing girls with floating skirts, cast in bronze.

Then the Rainbow Division boys urged on me still another art object. It was a tall green metallic nude from Hitler's study. They wrapped it expertly in blankets, along with the dancers and the Bohemian glass plates. I sent the unwieldy booty to Paris by courier plane, planning to pick it up on my way home after the war ended, an occurrence that was expected any day now.

Replacements were pouring in to take the place of the soldiers who had fought overseas for so long. A kind of deterioration took place. The newcomers had little appreciation of the rule that looting is the province of the soldier who has been fired on. They had never heard of the liberator's code of behavior. The replacement troops began looting the looters.

Somewhere between the airfield at Munich and the airfield at Paris, my Hitler souvenirs evaporated. We should say they were liberated a second time. To anyone who did not know they were Hitler's, the statuary was just a pile of heavy junk to be ditched at the next stop. I wish that the green looters who stole them from me at least had known that they came from the home of the Führer. I grieved about these losses for a while, and then I decided that I really did not want any ghoulish reminders of Adolf Hitler.

When the war ended, the transformation took place that we had talked about. We stopped stealing. Our thirst was quenched, the curiosity satisfied. The craze faded away in dull colors, and we returned to normal standards once more.

After V-E Day, I went to Essen to do a story on the Ruhr, and stayed in the fabulous Krupp castle, Villa Hügel, home of the dynasty of munitions makers. The very name of Krupp suggested the crunch of a military boot on gravel. For over a century, the Krupps had been the chief source of Germany's military might, and in the years building up toward World War II, Krupp had supported the rise of Hitler.

There was a certain fitness in the Allied Control Commission's requisitioning of Krupp's mansion for a headquarters. One of the Commission's chief purposes was to undo the very militarism the Krupps stood for, and to insure that never again would a dictator rise to power on the myth of race supremacy.

Target teams were arriving at Hügel to ferret out the scientific discoveries of the enemy, to investigate everything from submarine parts to infrared detection; financial sleuths arrived, with the purpose of unraveling Germany's tangled economy and to capture the big financial figures behind the scenes, such as Schacht and Stinnes, who went into hiding, and of course, Alfried Krupp himself. Krupp was now under house arrest.

While Herr Krupp was confined to the servants' quarters, I occupied his suite in the castle, and I slept in Herr Krupp's bed. The Krupp suite was without question the most remarkable billet in all my experience as a war correspondent. There were twenty walnut wardrobes which lined a dressing room two stories high. The lofty ceiling was painted with a goddess rocking dangerously on a crescent moon, her hair pinned back with a star.

Herr Krupp's taste in bathrooms was in keeping with the décor. Never have I seen so many faucets, levers, sprays, showers, gooseneck water taps. And they were all of gold. The tub itself was hollowed out of an enormous slab of marble, and could be rocked back, forth and sideways. Various golden attachments made it possible to get a squirt of water in any direction that the armament king might wish.

Directly down the hall was another suite as spectacular in size and furnishings. Alfred Krupp, the grandfather, had designed it for his imperial friend, Kaiser Wilhelm II. The bathroom fittings were less pretentious than in Herr Krupp's bath, but equally luxurious. And on the bathroom floor was a little white wolf rug. The sleeping chamber was hung with tapestries depicting the Garden of Eden. When the Kaiser opened his royal eyes after a restful night at Hügel, he could lie in bed and study the priceless needlework which covered his bedroom walls, the life story of Adam, the first recorded Jew.

The Villa Hügel had its own private railway station, large enough to accommodate two private railroad trains, Herr Krupp's and the Kaiser's. The overall effect of the estate was a cross between Versailles and Valhalla.

Odd as it may seem, it was in the lush setting of Hügel that looting became a thing of the past. Some young American officers with previous experience in hotel management took charge of the mansion when it was requisitioned. They fixed up the vast ballroom as an information center. They brought out enormous tablecloths for the 100-foot dining room table where the experts and investigators would have mess. They unpacked and counted the silver tableware and the many many gold ice-cream spoons. They inventoried everything: the impressive yachting trophy presented by George V of England in 1901; the coffee service contributed by Kaiser Wilhelm, with his imperial profile engraved on each bowl and pitcher; the silver cup presented by Adolf Hitler, with his profile inlaid in a medallion. These temptations to anyone who might be loot-inclined were put behind double-locked doors.

Young Alfried Krupp was in line with the times in his use of concentration camps as a source for slave labor, even reaching as far as Buchenwald on occasion. Efficient in all things, the company was efficient in exterminating workers who had worn out their usefulness. They were lined up around a shell hole, their wrists tied together with telephone wire, and then shot in the back of the head so they would fall neatly into the hole. Most of the exterminating was done by a Gestapo gunman named Paschen, who took enormous pleasure in these assignments. I was in Essen when he was captured by the CIC. He had

a face that looked half finished, and when he was taken prisoner, he wept great tears.

But of course there was never any need for steelman Krupp to meet triggerman Paschen on either a social or a business basis. The *Arbeitsfront* handled all labor problems in Essen. It was fortunate for Alfried Krupp that he was under arrest when the Essen shell holes filled with bodies were found, because that saved him from the unpleasant task required of other leading citizens, including the Mayor of nearby Duisburg, who were called out to help dig up the bodies and give them a decent burial.

During my stay, Alfried Krupp was allowed to spend just one hour in the mansion. This was at my request, as I wished to photograph him against the background of family portraits. Alfried Krupp was young then, only thirty-eight, and he had succeeded to the Krupp throne during World War II. Handsome, in a bloodless way, he had a look of bred-out aristocracy.

While I worked, I questioned him. He evaded as long as he could the embarrassing subject of forced labor. He called it by the prettier name of "foreign workers." He claimed that they came voluntarily and were paid more than his regular workers. These were tall stories. He added that the only inconvenience the foreign workers suffered was when they were bombed and their barracks set on fire by Allied air raids.

As Krupp gave insolent answers to my questions, I marveled at his audacity. How could he think any informed person could believe he didn't know about the atrocity camps? I was reminded of a comment: "The Germans act as though the Nazis were a strange race of Eskimos who came down from the North Pole and somehow invaded Germany."

Krupp mumbled, "There might have been a few psychopaths —yes, there might have been a few maniacs who misinterpreted the instructions." Yes, he had heard rumors—that much he did not deny.

"In our country," I said, "we have public-spirited citizens who will protest when something happens they think is not right. Why didn't you investigate?"

"The SS would have said it wasn't my duty."

I had heard enough of this, and I had him sent back to the servants' quarters.

[OVERLEAF] *The living dead of Buchenwald, April 1945*

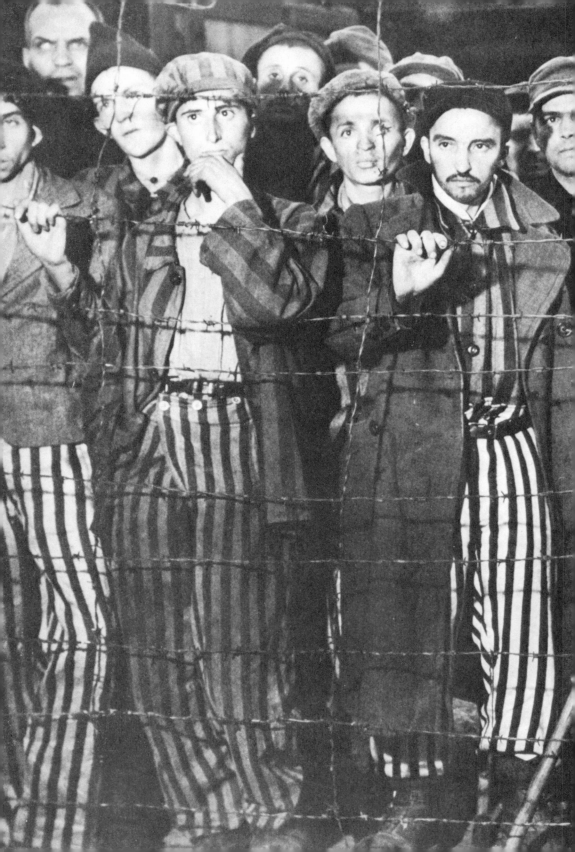

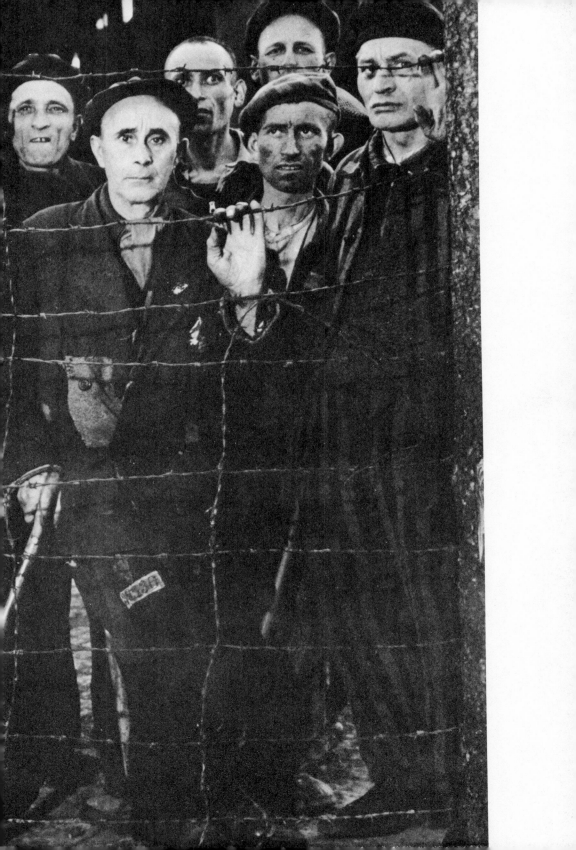

Some months after I had returned home, and my book *"Dear Fatherland, Rest Quietly"* came out, the U.S. Treasury made use of it in the Nuremberg trials. The haughty Herr Krupp was required to stand before a military tribunal while the chapters concerning him were read aloud, and he testified to the truthfulness of the statements.

For a new book, this was indeed a captive audience—of one.

Villa Hügel was such a showplace that we had many visiting notables, among them Field Marshal Montgomery, who came to inspect the wreckage of the Krupp plants. After the inspection, the Field Marshal and four accompanying generals proceeded to Hügel, where we had a large reception for him. We had a few problems preparing for that party. We knew that the Field Marshal was an absolute teetotaler. We compromised by serving tea and peanut-butter sandwiches for all who wanted them—and to the rest of the guests nothing stronger than wine. Oh, but such wine! The Krupps must have had a connoisseur's taste or else expert advisers. Some of the rarest wines in the world were in their cellar. They were museum wines—and every drop was bottled sunlight.

After the refreshments, we took our guests on a tour of the castle. They saw everything from the steam-heated swimming pool to the twin suites for Krupp and the Kaiser. And then the unthinkable happened.

For weeks we had lived at Hügel in the midst of all the luxuries, all the portable souvenirs, without so much as a single golden ice-cream spoon finding its way into anybody's pocket. But on the grand tour of generals through the castle, one of them, an American wearing two stars, caught sight of the little white wolf rug on the Kaiser's bathroom floor. Picking it up was obviously impossible in the company of so much other rank. He motioned to his aide and jerked his thumb. The aide, understanding perfectly, rolled up the rug and carried it away under his arm. The indignation of all of us was without measure. There was special scorn on the part of the soldiers, with whom only action under fire carries with it the right to loot. "And that big wheel," the boys said, "never heard a gun fired unless it was in a parade."

The long old-fashioned war was over now, and the age of

nuclear fission was beginning, with its stupendous potentialities for peace or war, but no more promise of solving human problems than the war that had just ended. Those of us who had covered World War II and its aftermath, whether correspondents, investigators or soldiers, never dreamed that so many objectives our boys fought to win would be phantom victories—scattered to the winds.

Who would have guessed that the powerful financial figures —who were the main underwriters of the Nazis and who were run down so triumphantly by our experts at Hügel—would be reinstated in their positions of influence? I doubt whether Herr Krupp himself dared expect that his twelve-year prison sentence, given him at the Nuremberg war criminal trials, would be revoked, and in less than three years he would be back at the helm of his massive network of martial industries.

Even the shell holes filled with dead would be conveniently forgotten, and the recollections of the concentration camps would be blurred with time and incredulity. The world would need reminders that men with hearts and hands and eyes very like our own had performed these horrors because of race prejudice and hatred.

CHAPTER XXIV

THE BIRTH

OF

TWIN NATIONS

I was glad to turn from the decay of Europe to India, where *Life* next assigned me. I had always thought of India as an old country. It was a discovery to learn she was also a very young one. My insatiable desire to be on the scene when history is being made was never more nearly fulfilled. I arrived there in 1946 when India stood shining and full of hope on the threshold of independence. I witnessed that extremely rare event in the history of nations, the birth of twins. I had a historical drama to photograph, with a full cast of characters, including villains and one of the saintliest men who ever lived. And when the saint was martyred, I was near.

Gandhi's death marked the end of an epoch. I was privileged to record its final two years. They were the key years, covering the vital cumulative period with various clashing forces: Hindus and Muslims, Congress Party and Muslim League, princes and peasants, British business and colonial interests, and in the background, the British Cabinet Mission going through the solid, dignified gestures of partitioning and surrendering an empire.

It took me two years to appreciate the greatness of Gandhi. It was only in the last act of the drama, when he stood out so bravely against the religious fanaticism and prejudice that I began

to glimpse his true greatness. He was an extraordinarily complex person, with many contradictions in his nature. Some of his opinions I found difficult to reconcile. One was his opposition to industry and scientific agriculture. That an emergent nation like India needed modern industry seemed to me self-evident. This conviction of Gandhi's that machinery was intrinsically evil particularly disturbed me because of my love of the machine and my belief in what it could do for man.

Photography demands a high degree of participation, but never have I participated to such an extent as I did when photographing various episodes in the life of Gandhi.

I shall always remember the day we met. I went to see him at his camp, or ashram, in Poona where he was living in the midst of a colony of untouchables. Having thought of Mahatma Gandhi as a symbol of simplicity, I was a bit surprised to find that I had to go through several secretaries to get permission to photograph him. When I reached the last and chief secretary, an earnest man in horn-rimmed spectacles, and dressed entirely in snow-white homespun, I explained my mission. I had come to take photographs of the Mahatma spinning.

"Do you know how to spin?" asked Gandhi's secretary.

"Oh, I didn't come to spin with the Mahatma. I came to photograph the Mahatma spinning."

"How can you possibly understand the symbolism of Gandhi at his spinning wheel? How can you comprehend the inner meaning of the wheel, the charka, unless you first master the principles of spinning?" He inquired sharply, "Then you are not at all familiar with the workings of the spinning wheel?"

"No. Only with the workings of a camera."

The secretary fell into rhapsody. "The spinning wheel is a marvel of human ingenuity. The charka is machinery reduced to the level of the toiling masses. Consider the great machines of the factories, with all their complex mechanisms, and consider the charka. There are no ball bearings; there is not even a nail. The spinning wheel symbolizes what Gandhi calls 'the proletarianism of science.' "

It was useless for me to protest that I had a deadline to meet, that this very evening a package of film must be at the airport to be placed on a certain transoceanic plane that would be met

at the airfield in New York, rushed to the *Life* photo lab, processed through the night, and in the morning, a scant forty-eight hours after the taking of the photograph, finished prints of the Mahatma at his spinning wheel would be lying on the *Life* editor's desk.

As the secretary became more involved in his oratory, I grew desperate. "The charka illustrates a major tenet of Gandhi's. When individually considered, man is insignificant, even like a drop of water; but in the mass, he becomes mighty and powerful, like the ocean."

"You will make me drop photography and take up spinning," I said politely, wondering when we could get back to the appointment.

"That is just what I wish to do," said Gandhi's secretary.

I know when I'm licked. "How long does it take to learn to spin?" I asked wearily.

"Ah," said the secretary, "that depends upon one's quotient of intelligence."

I found myself begging for a spinning lesson.

"I must compose editorials for Gandhiji's weekly magazine, *Harijan*," said the secretary. "I have a deadline to meet. Come back again next Tuesday."

Somehow I persuaded Gandhi's secretary that my spinning lesson must start this very afternoon. It embarrassed me to see how clumsy I was at the spinning wheel, constantly entangling myself. It did not help my opinion of my own I.Q. to see how often and how awkwardly I broke the thread. I began to appreciate as never before the machine age, with its ball bearings and steel parts, and maybe an occasional nail.

Finally, my instructor decided I could spin well enough to be brought into the presence of the Mahatma. There were two injunctions I must faithfully follow. I must not speak to the Mahatma, as this was Monday, his day of silence. And I must not use any form of artificial light, as Gandhi disliked it. I could see from the outside that Gandhi's hut was going to be very dark indeed (a perfect job for Tri-X and souped-up developers, which then we did not have). I pleaded with Gandhi's secretary to allow me some lighting equipment, and finally he allotted me three peanut flashbulbs.

I found the inside of the hut even darker than I had antici-
pated. A single beam of daylight shone from a little high window
directly into my lens and into my eyes as well. I could scarcely
see to compose the picture, but when my eyes became accus-
tomed to the murky shadows, there sat the Mahatma, cross-
legged, a spidery figure with long, wiry legs, a bald head and
spectacles. Could this be the man who was leading his people to
freedom—the little old man in a loincloth who had kindled the
imagination of the world? I was filled with an emotion as close
to awe as a photographer can come.

He sat in complete silence on the floor; the only sound was
a little rustling from the pile of newspaper clippings he was read-
ing. And beside him was that spinning wheel I had heard so
much about. I was grateful that he would not speak to me, for
I could see it would take all the attention I had to overcome the
halation from that wretched window just over his head.

Gandhi pushed his clippings aside, and pulled his spinning
wheel closer. He started to spin, beautifully, rhythmically and
with a fine nimble hand. I set off the first of the three flashbulbs.
It was quite plain from the span of time from the click of the
shutter to the flash of the bulb that my equipment was not
synchronizing properly. The heat and moisture of India had
affected all my equipment; nothing seemed to work. I decided
to hoard my two remaining flashbulbs, and take a few time ex-
posures. But this I had to abandon when my tripod "froze" with
one leg at its minimum and two at their maximum length.

Before risking the second flashbulb, I checked the apparatus
with the utmost care. When Gandhi made a most beautiful
movement as he drew the thread, I pushed the trigger and was
reassured by the sound that everything had worked properly.
Then I noticed that I had forgotten to pull the slide.

I hazarded the third peanut, and it worked. I threw my arms
around the rebellious equipment and stumbled out into the day-
light, quite unsold on the machine age. Spinning wheels could
take priority over cameras any time.

The secretary was waiting outside, all smiles. I had been in the
"presence"; I belonged. He asked graciously if I would like to
see a demonstration of spinning on Gandhi's own personal spin-
ning wheel—the portable one he carried when he traveled.

[OVERLEAF] *Mahatma Gandhi, April 1946, with his charka, or spinning
wheel, symbol of India's struggle for independence.*

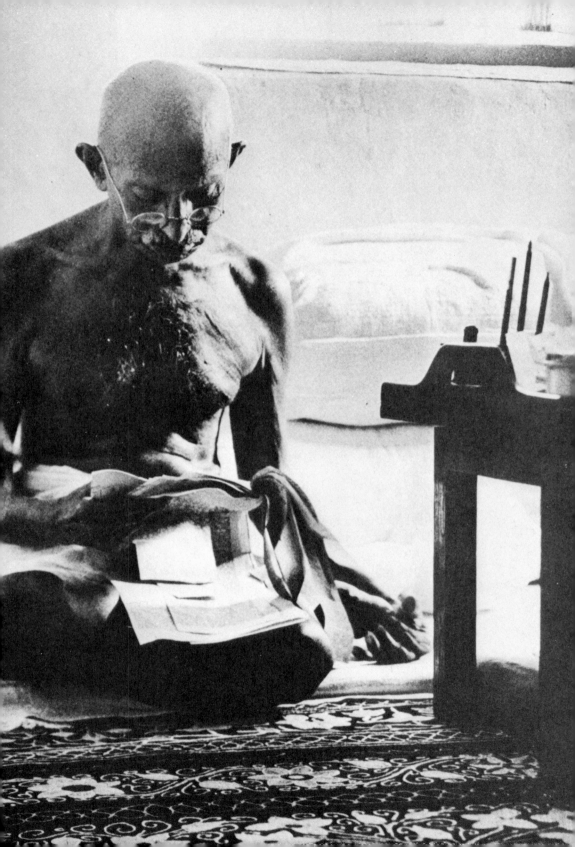

"I would enjoy that very much," I replied. I enjoyed it even more than I had anticipated, for, in the middle of the secretary's demonstration, the spinning wheel fell to pieces. That made me feel better about the machine age.

This was the first of many occasions on which I photographed the Mahatma. Gandhi, who loved a little joke, had his own nickname for me. Whenever I appeared on the scene with camera and flashbulbs, he would say, "There's the Torturer again." But it was said with affection.

As time went on, I saw this incident of the spinning wheel in a different light. Translated into the many situations a photographer must meet, the rule set up by Gandhi's secretary was a good one: if you want to photograph a man spinning, give some thought to why he spins. Understanding, for a photographer, is as important as the equipment he uses. I have always believed what goes on, unseen, in back of the lens is just as important as what goes on in front of it. In the case of Gandhi, the spinning wheel was laden with meaning. For millions of Indians, it was the symbol of the fight for freedom. Gandhi was a shrewd judge of economic pressures as well as spiritual ones. If millions of Indians could be persuaded to make the cloth they used themselves, instead of buying manufactured textiles from the British colonial power, the boycott would be severely felt in England's textile industry. The charka was the key to victory. Nonviolence was Gandhi's creed, and the spinning wheel was the perfect weapon.

Gandhi's evening prayer meetings gave him a great pulpit from which to comment on any subject, large or small. The crowds who came at twilight to hear him ran into thousands, his listeners into millions, as his prayer talks were broadcast each day. At prayers Gandhi gave the people homey little hints on health and diet, advising mothers to give their babies mudpacks for whatever ailed them. He instructed villagers that the wooden plow was more sacred than the tractor. He denounced the machine, saying that it would create a nation of slaves. He sometimes delivered a special diatribe against textile machinery.

The anti-machine references made at prayers always disturbed me, especially since they were delivered through a modern microphone. When the talk was finished, Gandhi would step off his

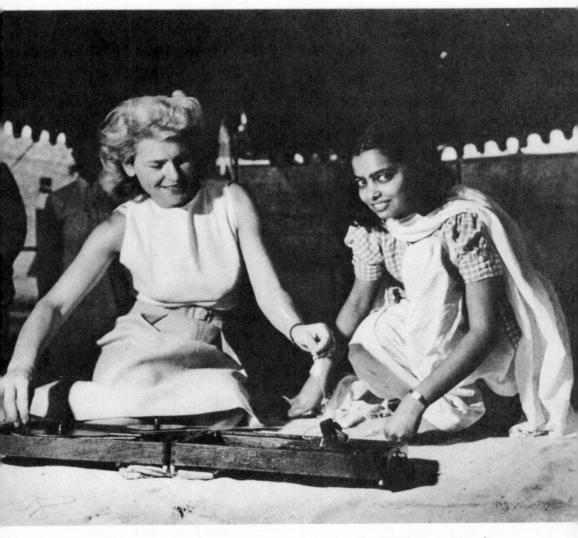

At the ashram, I practiced spinning with Sita, Gandhiji's granddaughter.

prayer platform into the milk-white Packard car belonging to the richest textile manufacturer in India, Mr. Birla, who had supported Gandhi and his followers for over thirty years. Of course, Gandhi took nothing for himself, and the members of his ashram lived in austerity. But still I was not satisfied by these inconsistencies.

It seemed to me that tractors were just what India needed, along with irrigation dams. India's tired, eroded strips of land, her dependence on the vagaries of the monsoon for water—these were desperate land problems that cried out for scientific agriculture.

Gandhi closed a gulf between the Middle Ages and the twentieth century. This was a source of his strength. His roots were in a simple pre-machine order. He grew up in an era when machinery was something that the foreign power possessed and developed at the expense of its colonial subjects. The raw materials India's people produced were sent out to feed machines on the other side of the world. To Gandhi, in his boyhood, the machine must have been the enemy. To him, in his seventy-eighth year, it was still the enemy.

Gandhi neither held nor wanted any government office, but he was consulted on every important question that came up during the negotiations for independence with the British Cabinet Mission. As the interminable freedom negotiations rambled on, the steamy weather that precedes the monsoon did not make them any easier. The moist heat seemed to collect in great, stagnant pools through which politicians, British ministers and all living creatures moved, gasping and sluggish.

Finally the freedom talks were shifted to the purer air of Simla, bordering the Himalayas. Moving Gandhi and his ashramites was an unforgettable event. Gandhi, believing as he did in the simple life, always traveled by third-class train. But third-class cars in India are as jammed as New York subway trains during the rush hour. A whole group of third-class trains were taken over for Gandhi, his followers and his goats. Since he had renounced cow's milk, it was essential for the goats to go along on trips. The goats also traveled third-class. I was reminded of a remark made by Mrs. Sarojini Naidu, celebrated Indian poet, who said, "If only Gandhiji realized how much it costs to keep him in poverty."

Since I was the only unattached woman accompanying this expedition, a small, coffin-shaped compartment was slipped into place for me. The compartment just ahead of me carried Nehru, and the car immediately behind me had Gandhi and his goats. This gives me the distinction, I'm sure, of being the only Ameri-

can woman ever to have slept between Nehru and Gandhi—with goats thrown into the bargain.

The mountain resort proved a delightful place to be. Nehru rode to meetings on horseback and—we learned—stood on his head for five minutes every day. The snowy peaks of the Himalayas made an appropriate background for summitry, but after ten days of talk, freedom was still undefined.

We traveled back to New Delhi and found the capital like the inside of a blast furnace. Gandhi, whenever he stepped outside his hut, looked like a great mushroom on legs under the huge wet Turkish towel he wore heaped and dripping on his head. The untouchable colony became a sort of summer White House, despite the heat, with Cabinet ministers, maharajahs and dignitaries of all sorts pouring through the gates, to consult with Gandhi.

Formal meetings were held at the imposing Viceregal Palace. On occasion, Gandhi conferred with Lord Louis Mountbatten, the last of the Viceroys. In Mountbatten's veins flows the royal blood of Victoria, first Empress of India and symbol of Britain's imperial grandeur. Being of royal blood, Lord Mountbatten could coerce the Indian princes into surrendering some of their prerogatives.

One dignitary was conspicuous by his absence—Mohammed Ali Jinnah. Jinnah was head of the Muslim League, the Qaid-i-Azam. He had a razor-sharp mind and hypnotic, smoldering eyes. It would be hard to imagine two men more different than Jinnah and Gandhi. They sat at opposite poles at just the time that India, moving forward into freedom, needed unity.

Gandhi stood for a united India for everyone. Jinnah insisted on a separate Pakistan for Muslims. Jinnah was a fashion plate, while Gandhi wanted nothing more than a strip of homespun to wear. Though he was careful to put on Muslim dress for public appearances, the Oxford-educated Jinnah loved European clothes, and his suits were London-tailored. Jinnah, though nonreligious himself, raised religious differences to the heights of fanaticism. He inflamed the masses with his fiery words, goading them to frenzy. Under it all, he was a spear of ice.

Jinnah did what very few men in history have been able to do. He carved out a new nation single-handed, and put himself at

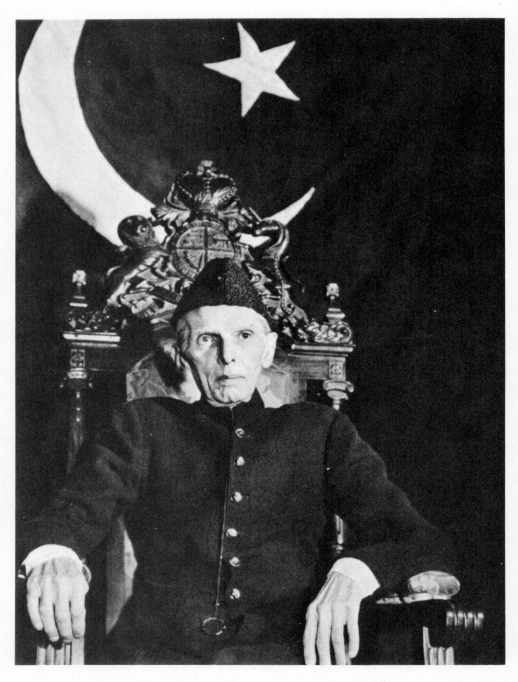

Mohammed Ali Jinnah, founder of Pakistan, which became a nation separate from India on August 15, 1947.

the head. For years, Hindus and Muslims had struggled side by side for independence from the British Raj. With freedom finally on the horizon, Jinnah masterminded the game so adroitly that within months he was to win his Pakistan.

Jinnah announced what he called Direct Action Day: "We will have," he insisted, "either a divided India or a destroyed India."

On the heels of this announcement, violence broke out in Calcutta. I flew there from Bombay and found a scene that looked like Buchenwald. The streets were literally strewn with dead bodies, an officially estimated six thousand, but I myself saw many more. Scattered between bodies of men were the bodies of their animals. Countless cows, swollen with the heat, were as dead as their masters.

In Calcutta, a city larger than Detroit, vast areas were dark with ruins and black with the wings of vultures that hovered impartially over the Hindu and Muslim dead. Like Germany's concentration camps, this was the ultimate result of racial and religious prejudice.

I did my job of recording the horror and brought the pictures out for *Life*, but the task was hard to bear.

The terror in Calcutta set off a chain reaction which spread through the country and was equally devastating to both religious groups. Months of violence sharpened the division, highlighted Jinnah's arguments. On August 15, 1947, one year after the riots in Calcutta, a bleeding Pakistan was carved out of the body of a bleeding India.

But other, healthier influences were at work. Despite all her difficulties, India was raising herself from the debris of an outworn order and was drawing up a democratic constitution. The new laws abolished untouchability and opened schools to untouchables. New laws do not automatically dissolve old inequities, but literacy speeds the process.

This period of transition was an extraordinarily interesting time to do a picture essay on the caste system. *Life* had asked for it, and I went ahead with the ardor of an anthropologist, trying to record something which slowly but surely would pass away.

In South India, which has been a stronghold for the caste system, I caught a glimpse of the old order. I visited the tanneries in Madras to photograph the untouchable families who worked in the leather tanneries, following their ancestral occupation. These were all the lowest of the untouchables—the scavengers— for no one else would touch the skin of the dead sacred cow. A young Madrasi schoolteacher managed to slip me in to see the children in the lime pits. At first I could see nothing. Until my eyes became accustomed to the smarting fumes, the children seemed to be dancing as they bobbed up and down, pressing the lime solution into the hides with their feet.

They were doing this deadly work without the simplest safeguards, such as rubber gloves and rubber aprons. The new constitution outlawed child labor in "hazardous" occupations, but at the time of our visit, the tanneries had escaped being classed as hazardous. There was an inspection, of sorts, but when the inspector arrived, he usually went to the office for tea with the management, I was told, and if he entered the factory at all, the smallest children were hustled out the back door.

I watched while a group of children piled heaps of skins over the pit's edge, climbed hastily out to an iron spigot, rinsed their arms and legs and scrambled back to the lime bath again. The schoolteacher explained, "Every twenty minutes, they should come out of the lime bath to wash in a neutralizing solution, but often the pressure is too great to encourage them to take the time."

"The soles of their feet and the palms of their hands will corrode from staying in the pits," whispered the schoolteacher. Eventually, the concentrated lime would begin to waste away the more delicate parts of their bodies.

The schoolteacher whispered that we must leave now as the manager was coming. We went out of sight of the factory, where we could catch the workers as soon as the shift changed. It was dusk when they came streaming out. At a little distance, the workers gathered under a venerable banyan tree, with intertwining roots and twisted branches.

The people had never seen an American woman before. They looked me over with curiosity in their faces. It was growing dark, and someone lit a lamp, which lighted up childish eyes grave and

wise beyond their years. I thought I had never seen such serious children—or such serious parents. Then the schoolteacher said, "The people want to hear from the American woman. Talk to them just a little," he pleaded. "I will translate your words for them."

It was hard for me to find words for people carrying so heavy a load. I remember standing there in the lamplight feeling more inadequacy before that audience of untouchables than I had ever felt before any other group in my life. I plunged in by speaking of the great things our two nations had in common. We had both yearned for freedom; we had worked for it, and we had won it. The mention of freedom is magic to Indians, and as the schoolteacher translated, the untouchables broke into cheers.

Then I spoke of how, even with independence, we Americans had found there were many things still to strive for. The status of Negroes, for example. Second-class citizenship dies hard.

I told them I had discovered while I had been in their country that Indian parents wanted the same things for their children that American families wanted: a healthy standard of living, education, the chance to win a wider horizon. I hoped they would get these things and get them soon.

The meeting was over. The schoolteacher and I walked away under a sky alive with stars. The children swarmed off into the darkness to crawl into the cramped chawls, as airless as dog kennels, which were their homes, to spend a few hours sleeping on the ground before climbing back into the lime pits at dawn. There would be hope for children like these, with the caste system being undermined by the new laws. The coming industrialization would be another powerful democratic influence. People of all sorts would work together and rub elbows. A machine cares nothing about a man's ancestors; it does not feel polluted by his touch, knows no prejudice.

CHAPTER XXV

THE
LAST DAYS
OF GANDHI

I WENT BACK home with my pictures and my impressions, and as usual after one of these big trips, I started writing a book. The work in India had been a most stimulating part of my life. It was an inspiration to have such a vast subject spread on an enormous canvas and peopled with such extraordinary personalities. Trying to understand this complex country so I could make it clear to others called out everything I had to give.

This book had not followed the course of my other books, where things usually got somewhat easier as I went along. I wrote half a book. Then, all at once, I saw what the trouble was. I just did not know enough to write a book about India, and I arranged to send myself back.

Just before my departure, religious violence in India and Pakistan again broke into the news. Independence, apparently, wasn't going too smoothly. *Life* commissioned me to do a story on the great exchange of populations and the new nation of Pakistan. And, at the last moment, CBS engaged me to do some live broadcasts. All this fitted in perfectly with my plans. And back I went.

During my absence, the terror had multiplied. The splitting of India into two nations, based on religious antagonisms, had increased the deadly hatreds and fears. Muslims caught on the Indian side of the new borders and Hindus caught on the Pakistani side were fleeing their ancestral homes in incredible numbers. All roads between India and Pakistan were choked with endless convoys of peasants and their bullock carts. Women rode on donkeys; men walked, often carrying the very young or very old on their shoulders.

There were heartbreaking subjects to photograph. Babies were born along the way; people died along the way. Thousands perished. I saw children pulling at the hands of their mother, unable to understand that those arms would never carry them again. There were scenes straight out of the Old Testament. The hoofs of countless cattle raised such a column of dust that a pillar of a cloud trailed the convoy by day. In the evening, when the refugees camped by the tens of thousands along the roadside, the light of the campfires rose into the dust-filled air until it seemed that a pillar of fire hung over them at night. I borrowed a Bible from a British soldier who was assisting me, and reread the Book of Exodus. According to Exodus, the Children of Israel numbered eight hundred thousand. Here there were six million people on the move while I was traveling with the convoys. And several more millions followed these.

I have always thought that if I could turn back the pages of history and photograph one man, my choice would be Moses. While I traveled with the migration, my respect for Moses grew, for I glimpsed the colossal problems he had to solve. But these people had no Moses.

As though the attacks of religious terrorists were not peril enough, the people had to endure the worst flood in forty years. Flash floods trapped entire encampments of refugees. I was almost caught myself in the rising of the River Ravi. The soldiers accompanying me had found a vacant hut in a reedy area between the canal and the river. It seemed like a good place to spend the night. I spread my bedroll on the roof. The soldiers built a beautiful fire and were heating food. Supper was almost ready when a British captain who had seen our jeep turn into the canal road hurried in to warn us to leave. We ran off at once, and

[OVERLEAF] *The Great Migration. A massive exchange of populations created great suffering when India was divided into two separate nations.*

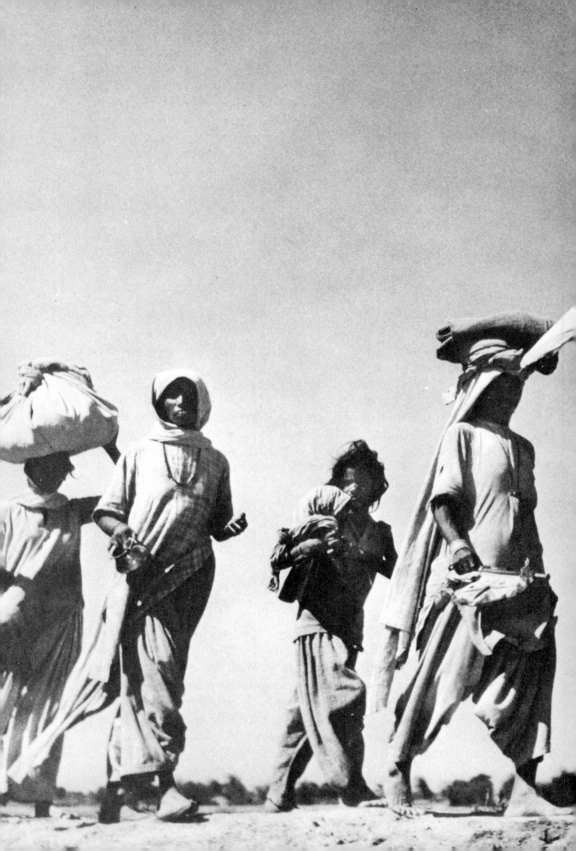

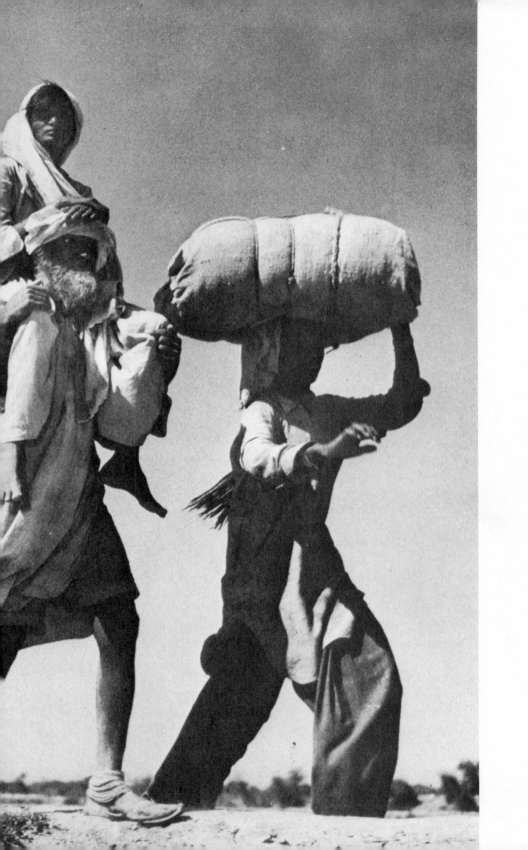

finally had to wade, waist-deep, pushing our jeep along the vanished ridge of roadway between swirling pools, deepening swiftly, and treacherously beautiful in the moonlight.

Week after week I followed the convoys until my cameras became clogged with grit, my clothes felt like emery boards and my hair was thick and gray with dust.

I returned to the comparative comforts of Karachi, the capital of Pakistan, and requested an appointment to take a new portrait of Jinnah for a *Life* cover. I was told at the door, "The Qaid-i-Azam has a bad cold." This, I learned later, was the reply given to everyone who called. I did some discreet inquiring and learned that a shocking transformation had taken place in Jinnah. His Olympian assurance had withered within weeks of his acquiring his Promised Land. He had developed a paralyzing inability to make even the smallest decision. Along with his dismaying withdrawal into himself, Jinnah was not seeing even his Ministers. I had struck up a kind of friendship on my last trip with his sister, Miss Fatima, and that stood me in good stead now.

Miss Fatima talked her brother into allowing me to take the portrait. There was one curious stipulation. I was not to move near to him for a close-up. And when I saw his face, I knew why. The change was terrifying. There seemed to be a spiritual numbness concealing something close to panic underneath. As I went ahead with my pictures, his sister slipped up before each photograph and tried gently to uncurl his desperately clenched hands.

He came to life only once while I was working. He had chosen Muslim dress for this picture, a handsome uniform of dark maroon, with a matching maroon fez of fur—customarily called the "Jinnah hat." I asked for a lighter one, fearing the dark fur would fade into the background. Fatima hurried up with a great armload of light-toned Jinnah hats made of the softest unborn lamb. The great leader waved his sister and all the fur fezes away in irritation. "No, no, no," he repeated like a truculent child. This must have been his last portrait. Jinnah died soon after.

I did a lot of thinking about the tortured look I had seen in Jinnah's face. I believe it was an indication that in the final months of his life, he was adding up his own balance sheet. Analytical and brilliant, he knew what he had done. Like Dr. Faustus, he had made a bargain from which he could never be

free. During the heat of the struggle, he was willing to call on all the devilish forces of superstition, and now the bloody victory had turned stale in his mouth.

If the terrible chain of events numbed Jinnah, in Karachi, to inaction, it stirred Gandhi, in Delhi to action of his own non-violent kind. He chose a weapon which was peculiarly Asian, and had brought him spectacular successes in the past. He announced at prayer meeting that he would undertake a fast directed against the savageries of religious warfare.

This would be the sixteenth fast of Gandhi's life. He was now seventy-eight. This fast could be his last. The previous fifteen had been directed against the British Government, but this fast was against the inadequacies of the new all-Indian government, which he had done so much to create. Being a Hindu himself, Gandhi found it intolerable that other Hindus should be massacring the Muslim minority. When Hindu refugees began storming Muslim mosques in Delhi, throwing out Muslim worshipers and moving their own families into these holy places, Gandhi felt the moment for action had come.

With this sixteenth fast, Gandhi was launching the hardest battle of his life—the battle to conquer inner hatreds. His method of nonviolence had led his people to independence. Now he was faced with the more difficult task of winning tolerance and unity.

It is difficult for a Westerner to understand the significance of a fast. I called on Pandit Nehru, who I was sure could help me understand. "Voluntary suffering," said Nehru, "has great effect on the Indian mind. Gandhi is a kind of sentinel who stands apart. The fast does two things: it introduces a sense of urgency to the problem, and forces people to think out of the rut—to think afresh."

Next morning, there was a little ceremony for which Gandhi's closest followers gathered. I was within arm's length of the Mahatma while he took his last mouthful of boiled beans, his last sip of goat's milk, and placed on the cot in front of him his famous dollar watch. The hands pointed to 11. The fast had formally begun. Some of his women followers began to cry.

Many people came to prayers that night in the garden, and

waited in uneasy silence for Gandhi to speak. He began talking very simply about the reasons for the fast—how all people deserved equal protection and equal freedom of religious worship, and emphasized that there must be no retaliation against acts of violence. "How long will I fast?" asked Gandhi. "Until I am satisfied that people of all religions in India mix like brothers and move without fear; otherwise, my fast can never end."

As he talked, I thought, it is really himself he has on trial. He has a religious position of his own to defend—his belief in the brotherhood of man, which is just as essential to Hinduism as it is to Christianity. His whole philosophy of nonviolence is at stake. He is pitting all the strength left in his thin, wiry body against the spirit of hate consuming his country. One could sense his power to call on the people's inner strengths, for he was closer to the soul of India than any other man. I believe that everyone who went to prayers that night had a feeling that greatness hovered over the frail little figure talking so earnestly in the deepening twilight. "I am not alone," were his closing words. "Because although there is darkness on the way, God is with me."

During the tense days that followed, the Mahatma became too weak to go to prayers in the garden. The people were clamoring for a sight of Gandhiji, and one day they were allowed to line up by twos and file through the garden at the back of Birla House, where Gandhi was staying. The doors of the porch were open. Gandhi's cot had been set between them, and on it lay the little old man, asleep.

I find it hard to describe my feelings at seeing this frail little figure lying there, with the silent, reverent people filing by. It would be impossible to imagine such a thing in America—a prominent person asleep and yet on exhibition to his public. There is an extraordinary amount of personal intimacy in the attitude of Indians toward their leaders. I have never seen it in any other country.

From then on, the public began taking a hand in the fast. Every hour saw an increase in the processions, in the formation of peace brigades, and massing together for open-air meetings. On the fifth day of the fast, there was a mammoth meeting at Urdu Park, which had packed all the wide meadows stretching between the historic Red Fort and the bubble-shaped domes of

the Jamma Mosque. Thousands had gathered on the grounds around Birla House when Nehru arrived. Sensing the temper of the crowd, he climbed to the top of a cement gatepost by the drive to speak. Nehru's eloquence is legendary, and I was glad to spot in the crowd an Indian newspaperman friend who could translate. "If our goal is good, the path to it should be righteous. If we want to be free, we must free each other first. Only a free people can lay the foundation to a free land," Nehru was saying. "These are the lessons of Gandhiji."

It was growing darker in the garden, and then something very beautiful happened. Hundreds of bicyclists turned their lamps on Nehru, and the garden seemed to be flickering with fireflies. "It is a sustaining thought," Nehru continued from his gatepost, "that there is something great and vital in the soil of our country which can produce a Gandhi, a personality of his character, even though a Gandhi may be born only after a thousand years."

It happened I had a dinner engagement with Nehru that evening. I hurried back to the hotel to change my clothes and rejoined him at his home. I remember my embarrassment at having changed to evening dress for what turned out to be a simple and very informal dinner. As I rose from the table to leave, Nehru got word that Gandhi's physical condition was alarming. All through the night, an astonishing range of religious leaders, who had never approached agreement before, were working on a peace program.

Early next morning, I went to Birla House and learned from Gandhi's happy followers that the Mahatma had received what they called a "spate" of telegrams. At exactly eleven o'clock on the sixth day, Gandhi broke his fast. It was a moving experience to be there and see the people laughing and crying for joy. Gandhi lay smiling on his mattress on the floor, clutching some peace telegrams in his long, bony hands. I jumped up to a high desk and got my camera into action. Gandhi's daughter-in-law rushed in with a tall glass of fruit juice, and he kissed her. Then Pandit Nehru, who was sitting by his side, made a little ceremony of holding Gandhi's glass of orange juice for him.

Then the women followers flocked in carrying trays of orange slices, which Gandhi blessed. This was *prasad*, food offered to

God. The women passed the fruit platters to the crowd, even handing up bits of orange to me, where I stood taking pictures, so that the foreigner, too, could share in the gift offered to God.

Gandhi's fast had aroused great soul-searching among the people. For a time, the violence died down. Certainly many problems remained unsolved. But Gandhi's heroic risking of his life had stirred the entire country, and the people bent their will toward peace.

But there were some exceptions. The militant society of fanatically orthodox high-caste Hindus known as the Hindu Mahasabha was vigorously opposed to everything Gandhi stood for. Through what they called an "awakening race spirit," they dedicated themselves to the return to the pure Hinduism of two thousand years ago, with its superior privileges exclusively for Brahmins. The society had their own youthful storm troopers, the R.S.S., Rashtrya Savek Sangh, the National Service Society. This reminded me of the youth movement in Germany—the savage Hitler Jugend. Oddly enough, the R.S.S. also used the swastika as their emblem, an ancient symbol which far predated Hitler.

Race supremacy theories cannot live with tolerance; therefore, a Hindu leader who flouted caste and advocated equality and brotherhood had to be destroyed. Several days after the termination of Gandhi's fast, a homemade bomb was thrown at him from the wall during prayers. Fortunately it fizzled out without hurting anyone. Gandhi reacted in a purely Gandhian manner. He assured his listeners at prayers that he held no malice against the poor, misguided youth who threw the bomb. He hoped the young man would realize his error, for it was a wrong done to Hinduism and to the country.

I had reached my last day in India, and on this final day I had arranged a special treat for myself—an interview with Gandhi—because although I had photographed him many times, and we had exchanged scraps of conversation with one another, I had never had a chance to sit down and talk with him quietly.

I found Gandhi seated on a cot in the garden, with his spinning wheel in front of him. He put on a big straw hat when I arrived, to keep the sun out of his eyes. It was a hat someone had brought

him from Korea, and he tied it at a gay angle under his chin. I told Gandhi that this was my last day, and explained that I was writing a book on India, and wanted to have a talk with him before I went home.

"How long have you been working on this book?"

"It's almost two years now."

"Two years is too long for an American to work on a book," said Gandhiji, laughing. He began to spin, as he always did during interviews.

My first question seemed a rather silly one at the time; later, it seemed almost prophetic. "Gandhiji," I said, "you have always stated that you would live to be a hundred and twenty-five years old. What gives you that hope?"

His answer was startling. "I have lost the hope."

I asked him why. "Because of the terrible happenings in the world. I can no longer live in darkness and madness. I cannot continue. . . ." He paused, and I waited. Thoughtfully, he picked up a strand of cotton, gave it a twist and ran it into the spinning wheel. "But if I am needed," he went on in his careful English, "rather, I should say, if I am commanded, then I shall live to be a hundred and twenty-five years old."

We went on, then, to speak of other things. I asked him many of the questions I had saved up to ask him: how to improve the condition of untouchables, particularly children such as I had seen in the lime pits; how to bring about land reform; was he positively against the use of science and machines in agriculture? And machinery in general? He assured me that he was. While frequently I did not agree with Gandhi's point of view, talking with him helped me understand it. He cared not at all about reshaping the structure of society. He cared a great deal about reshaping the human heart, and calling out the best in every man.

I turned to the topic which I had most wanted to discuss with Gandhiji. I began speaking of the weight with which our new and terrible nuclear knowledge hangs over us, and of our increasing fear of a war which would destroy the world. Holding in our hands the key to the ultimate in violence, we might draw some guidance, I hoped, from the apostle of nonviolence.

As we began to speak of these things, I became aware of a change in my attitude toward Gandhi. No longer was this merely

an odd little man in a loincloth, with his quaint ideas about bullock-cart culture and his vague social palliatives—certain of which I rejected. I felt in the presence of a new and greater Gandhi. My deepening appreciation of Gandhi began when I saw the power and courage with which he led the way in the midst of chaos.

I asked Gandhi whether he believed America should stop manufacturing the atom bomb. Unhesitatingly, he replied, "Certainly America should stop." Of course, when I had this talk with Gandhi, the atom bomb was not yet obsolete, nor had the hysteria of nuclear testing swept around the world. Gandhi went on to stress the importance of choosing righteous paths, whether for a nation or for a single man; for bad means could never bring about good ends. He spoke thoughtfully, haltingly, always with the most profound sincerity. As we sat there in the thin winter sunlight, he spinning, and I jotting down his words, neither of us could know that this was to be one of the last—perhaps his very last—messages to the world.

Since that momentous day, many people have asked me whether one knew when in Gandhi's presence that this was an extraordinary man. The answer is yes. One knew. And never had I felt it more strongly than on this day, when the inconsistencies that had troubled me dropped away, and Gandhi began to probe at that dreadful problem which has overwhelmed us all.

I asked Gandhiji how he would meet the atom bomb. Would he meet it with nonviolence? "Ah," he said. "How shall I answer that? I would meet it by prayerful action."

I asked what form that action would take.

"I will not go underground. I will not go into shelters. I will go out and face the pilot so he will see I have not the face of evil against him."

He turned back to his spinning, and I was tempted to ask, "The pilot would see all that at his altitude?" But Gandhi sensed my silent question.

"I know the pilot will not see our faces from his great height, but that longing in our hearts that *he* should not come to harm would reach up to him, and his eyes would be opened. Of those thousands who were done to death in Hiroshima, if they had died with that prayerful action—died openly with that prayer in their hearts—then the war would not have ended as disgracefully

as it has. It is a question now whether the victors are really victors or victims . . . of our own lust . . . and omission." He was speaking very slowly, and his words had become toneless and low. "The world is not at peace." His voice had sunk almost to a whisper. "It is still more dreadful than before."

I rose to leave, and folded my hands together in the gesture of farewell which Hindus use. But Gandhiii held out his hand to me and shook hands cordially in Western fashion. We said goodbye, and I started off. Then something made me turn back. His manner had been so friendly. I stopped and looked over my shoulder, and said, "Goodbye, and good luck." Only a few hours later, on his way to evening prayers, this man who believed that even the atom bomb should be met with nonviolence was struck down by revolver bullets.

I was only a few blocks away when the assassin's bullet was fired. News travels with lightning swiftness in India, and in a few minutes, I was back at Birla House. Thousands of people were already pressing toward the scene of the tragedy. The crush was so great, I could hardly reach the door, but the guards recognized me and helped me through. In the next moment, I was in the room where Gandhi, dead less than an hour, lay on a mattress in a corner on the floor. His head was cradled lovingly in the lap of his secretary; the devoted little grandnieces and daughters-in-law who had always surrounded him in life clustered around him now as he lay in his last sleep.

I remembered the joyful moment when he had broken his fast only ten days earlier in this very room. I had stood in this very spot and watched him smile up from this same mattress. Then everyone had been laughing for joy. Now they were silent and stunned. Few people even wept. The only sound was the endless chanting of the *Gita* by the women followers who sat along the edge of the mattress and swayed to the rhythmic recitations of the "Song of God," always sung at the death of a Hindu. The women kneeling along the mattress were beating their hands softly to the rhythm of the prayer.

Suddenly into the numbness of that grief-filled room came the incongruous tinkle of broken glass. The glass doors and windows were giving way from the pressure of the crowds outside, straining wildly for one last look at their Mahatma, even in death. No one expected Mahatmaji would die, even during the

fast and when the homemade bomb was exploded during prayers. And now that death had come, the sense of personal loss was almost beyond endurance.

I pressed my way through the grief-stricken crowd to the garden path where Gandhiji had met his end. The place was marked off with a humble little line of sticks, and a large and very ordinary tin can about the size of a large jam tin had been put down to indicate the exact spot where he fell. Already a radiance hung over the spot. Someone had marked the place with a candle. And kneeling around it were men and women of all religions, just as Gandhiji would have had it. United in deepest sorrow, they were reverently scooping up into their handker-chiefs small handfuls of the blood-stained earth to carry away and preserve.

I was swept by the crowd back to the gates, and there I found Nehru speaking. Once more, he had climbed up on the gatepost of Birla House to address the people. "The great light is extin-guished," he said. "Mahatmaji is gone, and darkness surrounds us all. I have no doubt he will continue to guide us from the borders of the Great Beyond, but we shall never be able to get that solace which we got by running to him for advice on every difficulty."

At this point, Nehru broke down and wept openly on his gatepost, and the crowd wept with him. Then he made a supreme effort to speak a final sentence. "We can best serve the spirit of Gandhiji by dedicating ourselves to the ideals for which he lived, and the cause for which he died."

All through that terrible night, people gathered in hushed groups in the streets. In the morning, I would have pictures to take, and broadcasts to think of. But this night, I gave myself over to walking the streets, sharing the shock and sorrow of the crowds. Within hours, the police had captured the assassin, Nathuram Vinayak Godse, a fanatical Brahmin, editor of a Hindu Mahasabha weekly in Poona. Later he would be given the death penalty. But to those masses of bereaved people, it was not merely one misguided individual who had murdered their Gan-dhiji, but an impersonal force that had dealt out death.

In this, they were very right. It was no accident that Gandhi was done away with by a fellow Hindu—one of those who stood for all that was worst and most rabid in the religion, just as Gandhi stood for all that was broadest and best.

By dawn, the lawn and gardens of Birla House and all streets leading into it were flooded with people. By the thousands they swirled through the Birla gates until they crushed in an indivisible mass against the house. And still they came, beating against the walls of the house in surging waves of mourning humanity. I doubt if there has ever been a scene like it. Certainly there has been none in my experience. The house, with its concrete terraces, was like a rocky island, holding its precious burden high above the sea of grief. Laid out on the roof of the terrace was the figure of Gandhi, tranquil and serene.

The morning sunlight lent a special radiance to the coarsely woven homespun which draped his body. He was carried down, placed on a flower-laden bier and covered with the yellow, white and green flag of the new free India. Then, that greatest of all processions began to move toward the sacred burning ground on the bank of the River Jumna. The human stream gathered to itself all the tributaries of the countryside. It grew and grew until it was a mighty river miles long, and a mile wide, draining toward the shore of the sacred river. People covered the entire visible landscape until it seemed as if the broad meadows themselves were rippling away until they reached the sacred banks. I never before had photographed or even imagined such an ocean of human beings.

Somehow I managed to get to the center of the dense, mourning throng, where the funeral pyre of sandalwood logs had been lighted. Occasionally I could catch a glimpse of the three Hindu priests kindling the fire and scattering perfumed chips on the blaze. Then a glimpse of Nehru's haggard face as he stood by the edge of the bier. Twilight was coming. The flames were rising high into the sky. All through the night, the people would watch until the flames burned down to embers.

The curtain was falling on the tragic last act. The drama I had come to India to record had run its course. I had shared some of India's greatest moments. Nothing in all my life has affected me more deeply, and the memory will never leave me. I had seen men die on the battlefield for what they believed in, but I had never seen anything like this: one Christlike man giving his life to bring unity to his people.

CHAPTER XXVI

ON A ROCKY CONNECTICUT HILL

HOME ONCE MORE, and the book raced to a finish. I called it *Halfway to Freedom.*

Writing was becoming increasingly important to me as a way of sorting out my ideas. Writing is a stern, though rewarding, taskmaster, as I had found out in the case of this Indian book. The effort to understand India, with her centuries telescoped into a handful of years, had a very deep effect on me. It was as though this young-old country helped me climb to a higher level of understanding.

As photographers, we live through things so swiftly. All our experience and training is focused toward snatching off the highlights—and necessarily so. That all-significant perfect moment, so essential to capture, is often highly perishable. There may be little opportunity to probe deeper. Writing a book is my way of digesting my experiences.

There was a deeper personal reason for writing books. I wanted to have a rhythm in my life: the high adventure—with all the excitement, the difficulties, the pressures—balanced with a period of tranquility in which to absorb what I had seen and felt.

My house on a rocky Connecticut hill, which my lectures had

helped me buy, means a great deal to me as a home base. I had been making payments on it, and whenever I could afford to do so, I added a slice of woodland. One Saturday morning I received from my bank an envelope bulging with important-looking papers. Oh, I thought, it looks as though I owe somebody a lot of money. Unfortunately, it was Labor Day weekend, and I had to wait until Tuesday before I could reach anyone at the bank. When at last Tuesday morning came, I phoned a vice-president and told him of my alarm. He laughed and said, "Oh, you've just paid off the mortgage, that's all."

This house, isolated by surrounding woods, is the best place I know for writing and for restoration of the spirit. Solitude is a precious commodity when a book is being written. I am a morning writer. The world is all fresh and new then, and made for the imagination. I keep an odd schedule that would be possible only for someone with no family demands—to bed at eight, up at four. I love to write out of doors and sleep out of doors, too. In a strange way, if I sleep under open sky, it becomes part of the writing experience, part of my insulation from the world.

I had a big rubber coverlet which protected me in case of light rains, but, of course, a big storm would drive me inside. While I was working on the Indian book, we had an extraordinarily clear and mild autumn, which lasted until December 11, when I was awakened by a furious blizzard. I threw my arms around my bedding and rushed indoors, and outdoor slumbers were halted for that season. As soon as spring was in the air, I was out sleeping under the stars again.

I had no ordinary bed. A bedroll was all right for a war, or for traveling in a primitive country, but I was in my own home now. There must be some elegance about the sleeping arrangements. I used a piece of garden furniture on wheels, with a little fringed half-canopy on top. It was wide and luxurious, and when it was made up with light quilts and a candle on each side, and reflected in the swimming pool, it was a child's dream of a bed made for a princess.

Every night I rolled it to a different spot, so I could frame my view of the night sky with the silhouettes of various tall trees. I would blow out the candles and watch the soaring, greenish lamps of fireflies. From the pool I could hear a chorus of seven

frogs whose voices I knew. Then I would drowse off. The end-
less drama of the heavens passed over me while I slept. I would
wake up for a small second and the stars had moved; again to
sleep, and awake to find the moon had risen. The next blink of
the eyes to discover that the grass and bushes were drowning in
mist. At the first hint of dawn, my cat, who had spent the night
guarding my bed, as though realizing the perils of darkness were
past, would jump up beside me to a little pillow of his own, and
together we would enjoy those last delicious moments of sleep.

While still in the hush before daylight, I would start my
writing, and by the time the sun rose, I was sealed in my own
planet and safe from the distractions of the day.

A book, while it is being written, has an intense life of its own
which you share. It leads you along unexpected paths. Charac-
ters take their own course. Give them a quiet chance, and they
seem to come alive and talk. You remember what they said in
real life when you encountered them, and perhaps for the first
time you get the full significance of their words. But it is hard
to reinvoke the people you are writing about when they are
drowned out by background noises.

I'm afraid my closely guarded solitude causes some hurt feel-
ings now and then. But how to explain, without wounding
someone, that you want to be wholly in the world you are
writing about, that it would take two days to get the visitor's
voice out of the house so that you could listen to your own
characters again? I particularly remember one unhappy occa-
sion when a man for whom I had considerable affection flew
halfway around the globe to spend the midwinter holidays in
this part of the world. I was just at that part of the chapter where
you hold all the strings in your hands and you're afraid you will
drop them if you don't tie them right down. And I would not
see him until the day after Christmas. After all these years, it is
on my conscience still; I hope he will forgive me.

Once the job of writing is done, my attitude takes a complete
rightabout turn. I love to have guests; the house is seldom with-
out one. *Life's* gifted photographer, Alfred Eisenstaedt, was a
hostess's dream. Eisie brought everything: wine, a choice steak,
marinated herring, his favorite phonograph records—lots of
them, from jazz, which he adores, to opera he could not live

With Captain Edward A. Steichen, "Dean" of American photographers. [BOB HENRIQUES, MAGNUM]

without—a box of chocolates for the maid. Once he even remembered the birds, and brought a bird's feeding station, which he hung on the branch of a tree.

Another dream guest was also a photographer: *Life*'s Eliot Elisofon, who is not only one of the greatest color photographers in the world, but one of the world's greatest cooks. Once, on a visit, we had planned to have *shashlik*, and I had no flaming swords to cook it on. After calling me a "kitchen cripple"—his label for people with poorly equipped kitchens—Eliot searched the garage and came back with a pitchfork. He scraped and scrubbed the rust carefully off the tines and speared the ingredients: cubes of lamb and beef, onion sections, shreds of liver, mushrooms, tiny tomatoes. The three-tined pitchfork had a suggestion of Gothic about it, and dripping with all those delec-

table ingredients, it looked like a piece of Giacometti's attenuated sculpture. We roasted the shashlik in front of the open fireplace, and it was perfection. Then Eliot carefully scrubbed the pitchfork and replaced it in the garage. But next time I came to New York, he led me on a city-wide shopping trip so that I never again would be a "kitchen cripple."

It would seem that those who lean toward photography also lean toward good food. Beaumont Newhall, the curator of the George Eastman House in Rochester and prolific author of books and articles on the history of photography, brings to his cooking a kind of mystery. His secret is stock. The process is a little like putting negatives into the developer. Almost anything can come out. We spent many days at my home going through some two thousand of my pictures, retrieving some from old magazines and scraps in the attic, to make a major exhibition of four hundred photographs. During the entire monumental task, a kettle of soup stock simmered on the back of the stove. At intervals, Beaumont would add various liquids to make up just the precise amount that had boiled away. And when it was at its pungent best and combined with beef or chicken or fish and set on the table, who could tell where the subtle flavors and aromas came from?

At one of our suppers, I carried highest honors for a salad I had made, using twenty-seven different salad greens—everything from long, canoe-shaped Chinese cabbage, through various spear shapes and crinkled forms, down to tiny cloverlike leaves of delicate fresh chevril. It was a photographer's salad, composed of large and small objects for contrast and depth, and the long green scale for gradation of tone. This mainly was a triumph of marketing. To get the range, I had canvassed greengrocers for miles around.

Alexander Schneider, violinist and great performer of Bach, taught me that trick of mixing several different lettuces, leaving the leaves whole and ranging from the neutral to the sharp and sour. But I doubt if he ever reached a high of twenty-seven!

Sascha—or Abrasha, which is his real name—came out often to cook or be cooked for, and he always brought his exquisite Stradivarius and put in hours of practice each day. He was working on the unaccompanied Bach suites, which required prodigious

With Alexander Schneider, noted violinist and magnificent cook.

feats of concentration. I loved to hear him practicing away in my living room. It seemed as though the notes clung to the walls after he stopped playing.

There was one day, I recall, when he appeared not to be concentrating as well as usual. He seemed to have slipped weirdly off pitch. I'm no musician, but to my untutored ear it sounded peculiar—like a phonograph record running down. I tiptoed into the room, and there was Sascha, strangely bent over. My first thought was "He is sick!" He was leaning over the TV set, routinely moving his bow, his eyes glued on every move of the ballplayers in the World Series.

Sascha's was one of the deep friendships. When I would say apologetically, "I don't know anything about music," he would reply, "The feeling I have for you has nothing to do with music. I only hope it will be reflected in my music." I had the same wish: that what I learned from him—and it was impossible not to learn from a dedicated, outgiving man like this—would be reflected in my pictures.

I consider myself fortunate to have my beloved house, long and low and just the right size for me, where I can write and rest and be with people I care about. Ed Murrow, who always worked under considerable tension, once said to me, "To be able to take advantage of a complete relaxation when you have a little free time in the midst of pressures is the mark of an integrated personality." This is a point of view I accept.

People sometimes ask me, "When you have such a lovely home, how can you bear to go off on these long trips and leave it?" But I don't think of it that way at all. This house is like a dear friend who you know loves you. It will be waiting when I come back again. It is so much fun bringing presents from all over the world to the house: wallpaper and pottery plates from Japan; brass soup bowls from Korea; copper and silver inlaid trays from the princely state of Jaipur; impala skins from the South African jungle to cover a pair of chairs; peasant-embroidered linen from the Carpatho-Ukraine to set the table.

The table itself is a local product. It is a slab of heavy clear glass which stands on two big pieces of tree trunk. The tree stumps were Sascha's happy idea. At a Norwalk sawmill we found two black walnut trees on the ground, waiting to be cut

up, and the proprietor obligingly sliced out exactly those sections of trunk where the trees forked. This gave us a beautiful double pattern of concentric circles. We left the stumps unfinished, and they become more beautiful as they gray with age.

For the living room, I designed a photomural of trees. It is enlarged from photographs I took in the Bohemian Forest. Just before the outbreak of World War II, I was covering the Czechoslovakian crisis for *Life* and I drove through this magnificent forest. The boys in *Life*'s darkroom helped me scale the pictures to precisely fit the wall spaces and give a continuous pattern. So it is trees, inside and out.

There is a big rock on my place—almost a cliff—which I shall always associate with the late Bob Capa, world-famous combat photographer who came out for a weekend between wars. The chill of autumn had set in, but Capa had discovered a warm streak of rock in my cliff that for some mysterious reason held the heat from the weak sunlight. We sat contentedly sipping bourbon old-fashioneds, quite comfortable on what Capa called my "steam-heated" rock. Not long after, Capa took off for Indo-China, where he was killed by a land mine—the first *Life* photographer to die in action.

My "steam-heated" rock is a good place from which to watch the advance of spring. Yellow daffodils give way to pale narcissus, which in turn bows out to azaleas in delirious colors. Just as I begin to mourn their passing, out comes the mountain laurel, venerable bushes, big as cumulus clouds.

But all these dwindle beside the dogwood trees which have packed themselves into my little wood in incredible numbers. They grow like weeds: tall trees surrounded by infants like a hen and chicks. It all is so breathtaking, so short-lived, that the enjoyment of it is almost pain. I want to go out and hold the flowering back with my hands, pin the blossoms on so they will stay.

I am not a formal gardener, any more than I am a formal cook. My idea of gardening is to discover something wild in my woods and weed around it with the utmost care until it has a chance to grow and spread. It delights me to see wild flowers which suburban growth has nearly swept from the landscape come up in my wood, year after year. Wild columbine reappears through cracks

in the rocks, maidenhair fern, jack-in-the-pulpit return to heavily shaded crevices. Then the wood vines appear from nowhere and creep up every tree trunk and cover every rock. By midsummer, the giant kudzu vine with its enormous leaves and swift-growing tendrils takes over the trees to their very tops and turns the whole place into a jungle. But by that time, I'm usually off to another turbulent assignment.

I think with every major photographic story there has been some man who, in his way, opened up his world for me and somehow stands for it in my mind. A man of stature from whom I could absorb a great deal. Perhaps it would be someone in the news-gathering field—a writer concerned with history in the making—who made wise suggestions, and whose findings, so generously shared, illuminated the whole situation for me. Some of these are extraordinary men with an astuteness and courage all their own. The lasting quality of some of these friendships has been a source of great happiness to me. Long after the job which brought us together is over, we are bound by deep ties of affection. A happy twist of circumstances brings us together, and time raises no barriers. The intervening years fall away, and we pick up the friendship where we left off.

Some of these men have meant more to me than either of my husbands. Perhaps fliers have meant the most, particularly certain of the seasoned ones whose early work meant pioneering in one way or another, and called for great daring and imagination. With men like this there was always a quick understanding, and if the work meant danger shared, that was always a bond. My most treasured memory of the war is the words of a superb flying officer. I had been planning to take a flight in which there were some elements of risk. Just before the takeoff, he said, "I'm going to fly you myself, because if you die, I want to die, too." Nobody died, but I shall always carry that short sentence like an invisible star.

Mine is a life into which marriage doesn't fit very well. If I had had children, I would have charted a widely different life, drawn creative inspiration from them, and shaped my work to them. Perhaps I would have worked on children's books, rather than going to wars. It must be a fascinating thing to watch a growing child absorb his expanding world. One life is not better than the other; it is just a different life.

At home by the pool. [PHOTOGRAPH BY EDMUND J. DORAN]

I have always been glad I cast the die on the side I did. But a woman who lives a roving life must be able to stand alone. She must have emotional security, which is more important even than financial security. There is a richness in a life where you stand on your own feet, although it imposes a certain creed. There must be no demands. Others have the right to be as free as you are. You must be able to take disappointments gallantly. You set your own ground rules, and if you follow them, there are great rewards.

In spite of all this philosophy of independence, I have more than once come very close to a third marriage. I'm certain I would have married Jerry if he had outlived World War II. I don't know how I could have refused to marry a man like that— so fair in his judgments, so well-adjusted that he met the difficulties of life with humor. One soon forgot his ugly face for his kind eyes. He was secure enough within himself that I could be sure he would never raise emotional obstacles if I was going off on a job. He would care a great deal whether I worked happily and undistracted.

At thirty-six Jerry was a college professor of abnormal psychology. He was greatly engrossed in the subject of rehabilitating criminals, especially young ones, and he had acted as consultant in various parts of the United States on the problem of juvenile crime. During the war, he was an American Army major

at the head of one of those hush-hush units which were connected with Army Intelligence. He was ingenious and brave, and he commanded great loyalty from his men. We got to know one another on my first assignment to the war in Italy. When I returned for a second Italian assignment, we hoped to see more of each other.

I was met at Naples harbor by one of Jerry's closest friends. Jerry had been transferred to another European sector. He had been leading missions of a highly confidential character. On the last of these sorties—only five days before, while I was still on the ocean—Jerry was captured by the Germans. He was wounded but alive when captured; that much the friend knew. I was numb with worry lest the enemy should know this was no ordinary prisoner. Having been in Intelligence, there was always the strong possibility that he would be tortured in the effort to get all the information he had. Through a most devious route, I got a little news: Jerry was in a hospital for prisoners of war. He had been interrogated at some length, but with his quicksilver mind, he had succeeded in totally confusing his questioners. Jerry was a past master at this kind of game of chess. About the torture, I would never be sure, but I was proud of him for outwitting his inquisitors.

I learned that the Vatican had an enormous department that endeavored to trace prisoners of war on either side of the conflict, and would undertake to deliver messages for loved ones by radio or other means. The message must be short, ten words at the most, and they would try. I needed only seven words: *I love you. I will marry you.* I signed it simply, MAGGIE. It went off, like a little bird in space. I shall never know whether it was received, but it eased my heart to be able to send it.

There was just one more scrap of news which filtered through the lines. The enemy town where Jerry was being held prisoner was raided. One bomb sheared the hospital in half. Jerry was in the side that was wrecked. He must have died instantly.

This was not quite the last of poor Jerry. For some time I continued to receive mail from him. Also, the letters I had written to him before his capture kept coming back marked "Return to sender" by the U.S. Army Post Office. Jerry had written me every day, sometimes several times a day. For weeks to come those sad little squares of V-mail followed me about.

CHAPTER XXVII

LAND OF

DARKNESS

AND

DIAMONDS

THERE IS a kind of magic about South Africa. I had always longed to go there, and in 1950, *Life* sent me to the Union of South Africa to do a photo essay on its problems and its people. I had always wondered what the veld looked like. I have seen the steppes in Russia, the *Hortobágy* in Hungary, and the prairies in our own central United States. The veld has a little of all three, but it has a special enchantment all its own.

The land is spacious, under an enormous sky. Around the entire ring of the horizon is a perpetual drama which you watch as though you were following the action on a revolving stage. Clouds build up to noble proportions. Hail falls. Stabs of lightning give way to rainbows. Squalls dissolve. The softest golden sunlight follows each storm.

When you drive around the Rand, where one gold mine follows another, the modern buildings of Johannesburg rise from the strangest landscape in the world. The road to the metropolis passes through a chain of man-made mountains, cone-shaped and in startling colors: warm shades of ocher to orange; cold shades

[OVERLEAF] *The modern city of Johannesburg sits deep amid hills of refuse from the gold mines.*

of bilious yellow, off-whites and sickly tan. In the soft center of each cone is a crater of sludge. This is mine waste, and the core is treacherous as quicksand. From time to time, children playing unwisely close to the slimy rim are sucked in to a terrible death.

Glimpsed above these strange hills, the skyline of Johannesburg shimmers in the noonday sun like a mirage in the desert. Many times in the weeks to come, I thought of the country as a mirage; things are not what they seem.

By night, noisy groups roam the corridors of Johannesburg's expensive hotels—much like Grand Rapids or Detroit at conventiontime; by day, the costly restaurants are filled with broad-beamed women in disproportionately tiny flowered hats—the type of women known in Afrikaner circles as 'n Hollandse meubelstuk (a piece of Dutch furniture).

The entire economy of South Africa is geared to gold. Johannesburg is literally built on gold. Under this modern city, under its splendid department stores, tall office buildings, its sturdy Dutch Reformed churches, the gold mines plunge directly down to the awesome depth of two miles.

I got my first glimpse of one of the oldest gold mines, Robinson Deep, on a Sunday. I had driven to the entrance, not expecting any activity on the Sabbath but just to get the feeling of the place. I was delighted when I found some very photogenic activity. In the mine compound, the miners were putting on a weekly show of their tribal dances.

I was struck by two of the native dancers who moved with such lively grace that I decided I must use them in further pictures. I am always looking for some typical person or face that will tie the picture essay together in a human way. I asked their names. I learned that black miners aren't known by their names; a miner is a "unit," with his number tattooed on his forearm.

Next morning, I explained to the superintendent that the two gold miners, Nos. 1139 and 5122, had impressed me so much that I would like to carry through with the pair, photographing them where they worked, where they ate, lived, slept. The superintendent told me the men were working very deep down in a "remnant area," where visitors were never taken.

"What is a remnant area?" I asked. The superintendent ex-

plained that it is a spot so honeycombed with old workings that cave-ins are a constant hazard, and with so little gold left that it has been abandoned. However, recent revaluation of gold had made it profitable for the company to send men back for scrapings.

The officials said, "We will move them up to a more convenient location, where you can take your pictures more easily." I said, "*Life* magazine doesn't do things that way; either I photograph them where they really work, or we'll forget the whole thing." They consented.

I was told to return the next day and put on proper mine clothes. I was astonished to find that these were heavy and warm, as if I were dressing for the frigid top of the world rather than for the hot depths of the earth. The superintendent explained to me that unless the body is thoroughly conditioned to the abrupt temperature changes under the earth's crust, a visitor might go through the heat of the lower depths, get wringing wet and catch pneumonia on the slow return to normal temperatures aboveground. My costume was topped with a crash helmet, and I wore a whistle hanging round my neck to use if we were trapped.

To me it was a solemn moment when I stepped into the mine cage and started the slow two-mile descent into the hidden space of the world. I felt something of the excitement of my first snorkeling in tropical waters: my first look into a new world. With snorkeling, all was sparkling and bright; here it was all gloom and obscurity. As the elevator lumbered downward, the darkness was broken only by occasional eerie cracks of light as we passed the mine stages.

At the bottom of the first mile, which is the halfway point in this vertical journey, you change to a smaller mine car which shoots down an incline. You travel that second downward mile in the sober realization that you are now below sea level.

When I stepped out, I felt no discomfort, for the air circulation system close to the elevator shafts was adequate. As soon as we started walking along the lateral passages, the atmosphere became very hot and humid. When we reached the little sloping pocket where the two men were working, I could hardly recognize my dancers. With rivers of sweat pouring down their

bare chests, and with sad eyes and perspiration-beaded faces, they hacked away. I was in the midst of making photographs when a strange depression and lassitude overcame me. I could hardly raise my hands; I had lost the power of speech.

The superintendent, noticing my distress, led me quickly to a more open mine-passage, gave me a little water, directed me to wash out my mouth, but not swallow it; then he took me to the foot of the shaft, where I was revived by the better air. Later I learned a man had died from heat prostration two months previously on this mine face.

I left the mine realizing that I had spent only four hours underground, and I would not have to return if my pictures were all right. But these men, who had danced so gaily and happily in the upper air, were destined to spend the better part of their waking hours underground with no hope of escaping the endless routine.

Although he works an eight-hour day, a miner is often underground as many as eleven hours. The white-skinned foremen must come up first, before the elevators take up the blacks. On each landing stage, as I made the ascent, I saw the black gold-miners clustered in large groups, awaiting their release to the outside air and the open sky. They would see little of this sky. They would sleep in concrete barracks without windows, rolled up like sausages on the floor, forty to a room, crowded into compounds surrounded with barbed wire. At night, they were locked in. Over their windowless bunkers arched the jeweled night sky, inlaid with the glorious Southern Cross and other celestial diamonds not mined in South Africa.

In a country where 8,500,000 blacks are, in effect, ruled by fewer than 2,500,000 whites who own nine-tenths of the land and all the mines, an efficient pass system is used to recruit cheap labor on a titanic scale. The finest reasons are given for the pass laws: "to protect the ignorant native" . . . "to prevent crime." The native African must carry four to eight passes on his person at all times. He needs a traveling pass to move from one area to another, a permit to seek work, an employment certificate when he has found work, a tax receipt, and a "special" pass to be out after dark. Only the man with a white skin can come and go as he wishes.

Gold miners working two miles straight down in the mines under Johannesburg.

The coming of white civilization to South Africa was outstandingly successful in channeling the black man into the service of the white, but it does little to fill the vacuum created by the disintegration of tribal civilization. The villages are sucked dry of able-bodied men, family life disintegrates, and the land erodes. The men are recruited to work eighteen months in the mines; then they are given six months off to go home and till the soil—and presumably breed more miners. A man's tribal homeland may be so remote that when he reaches his village, it is time to go back to the gold mines on a renewed contract.

Of course, the legal niceties are observed. The contract is read aloud to the mine recruits. No one can deny that the men heard the contract, saw it, and even touched it long enough to leave a thumbprint. And if a man wanted to do something else with his life, what could he do? His bondage begins at the age of eighteen, when he is old enough to pay taxes. He cannot pay in cows or in grain—which measure his wealth in an agricultural society—but must pay in the white man's currency, which he has to work in the mines to earn. Without the all-important tax receipt, he cannot get passes, and without passes, he cannot travel, work, exist. The tax receipt is just the first link in the paper chains which will bind him all the days of his life.

From the venerable gold mines of Johannesburg I went to the Orange Free State, where the big mining companies were prospecting for new gold. Borings had been made to a depth of several thousand feet.

The mining company which led the gold rush was just sinking its first shaft and had reached 2,000 feet. There wasn't much to see aboveground, and as for seeing anything belowground, no regular elevator machinery had been installed yet. The only way to go was the way the tools and men went: in a bucket.

And so, within the week, I found myself in an oversized bucket—large enough to hold the foreman and two helpers, all of us dressed in white oilskins and white helmets. My cameras were wrapped in a raincoat. The system worked from a pulley, like buckets in a well. As one went down the 2,000-foot drop with a load of tools and miners, the other came up with sludge.

We had reached the halfway point when we heard a loud rattling sound coming up out of the darkness, like a train rushing

Recruits for the gold mines, who have not been taught to read and write, sign their work contracts with thumbprints.

toward us. With a deafening clatter, it scuttled past us and up and quickly died away. It was the other bucket going up with its load of sludge. "Do they ever break loose?" I asked the foreman. Several weeks ago one had. It was carrying only tools, no men, but it hurtled down, killing seventeen men on the floor of the shaft. "It must go off like a gun," one of the men said. The foreman said, "Yes." And then speech was suddenly made impossible.

We were entering the region of the underground rains. There never was such a rain above the surface of the earth. We were swirled around as though we were in a giant champagne glass, or in the heart of a tropical storm. Water came from everywhere at once and bit and tore at us. The foreman was looking cautiously over his side of the bucket now. I ventured a look over mine. Far below was a disk of light the size of a dime. It grew to the size of a quarter, a silver dollar. It seemed to rush up toward us as though threatening to engulf us, and I realized that this was the bottom of the shaft—our destination—rising up to meet us. The curious loss of perspective when there is no frame of reference is something I had experienced in planes at high altitudes, but I was surprised to find it underground at the foot of a 2,000-foot well.

Thirty feet above the floor of the shaft, we swung to a stop so that I might have a good elevation for taking pictures. It was a little while before I could see what was going on. My eyelids seemed to be pasted together by the torrents which never ceased, but when I was able to open my eyes, I looked down on a crew of forty black men in white shiny oilskins crawling like ranks of white maggots over slabs of glistening rock and gravel and sludge.

Our bucket was rotating in the most disconcerting way—round and round, and no way to stop it with the cable from which we were suspended a couple of thousand feet long. There were wonderful subjects, but snatching a picture when you are constantly being swept past what you've seen is like grabbing the brass ring on a merry-go-round. The extra raincoat we had brought to be used as a sort of umbrella over me and the cameras whipped and flapped in the torrent. I had brought four Rolleiflexes, and as fast as one became soaked and useless, I started on the next. We had to go up now; our bucket was needed for tools. This was once in my life when I didn't say, "Just one more."

It was a great comfort to look above as we ascended and see that little square of daylight over our heads expand and grow. Suddenly it stopped growing. We came to a dead stop. Something was stuck in the braking machinery. We were only 25 feet from the surface, but to me that meant there were 1,975 feet

of the void under us. I wished the foreman had not told us of that accident with the bucketful of tools, or that I had not heard still another story about a bucket filled with miners, which tore loose, hitting another bucket filled with miners, sending both downward in the fatal plunge.

We dangled for a long twelve minutes. Then the machinery performed once more, and we stepped out on the crust of the earth safely and gratefully.

In the lovely rolling hills of Cape Province, enormous vineyards stretch to the far horizon. The wine country lies to the east, above the magnificent Table Mountain Falls, with its enchanting "tablecloth" of mist and spray, which appears mysteriously, hovers over the table-shaped top of the falls, shrinks, flutters, expands, vanishes.

The white owners of these spreading vineyards are just as interested in getting cheap labor as are the mine owners, but here in the vineyards, where the "coloreds" (the term used for halfcastes) are employed in large numbers, the plantation owners have evolved their own way of securing it. The method is simple and insidious, with a kind of insurance rider on the future. The procedure seemed so monstrous to me that I found it difficult to believe even when it was in front of my eyes.

Children as well as adults who work in the vineyards are paid partly in wine, which is deducted from their salary. This is recognized procedure, known as the "tot" system. The working day begins before dawn. At 5:00 A.M. the children receive their first wine tot, and before nightfall they will have four more tots. Not only does this save the winegrower money, but it habituates the youngest vineyard workers to a dependence on alcohol. Child laborers are desirable to plantation owners. Children will grow up into customers as well as employees, for soon the daily tot is no longer enough.

Nothing had made me so angry since I photographed "untouchable" children working in the tanneries of South India. Here in South Africa, the situation was particularly tragic because there was little chance a child of the vineyards could escape the pattern as long as apartheid, or separateness, was the approved state of society.

Saturday is payday in the town of Constantia. By midafternoon the town is sodden, and its main street is dreadful to see. The sidewalks and gutters are littered with the bodies of wine laborers who have used the cash portion of the week's pay to buy wine and still more wine.

Saturday is not only a day of revelry but a day to buy the week's groceries. The saddest sights of all were of women sprawled unconscious on the sidewalk among spilled groceries to which passersby helped themselves—often adding a kick for thanks. By twilight, the saloons are taken over by those who can still stand.

The last act of this shoddy drama is the arrival of the big winegrowers' trucks; they are quickly filled with workers lifted literally from the gutters. With the weekend ahead, nobody will trouble about the formalities. If the winegrowers fail to find as many farmhands as they need, they will go to the local jail, where there are sure to be a plentiful number of laborers sleeping off their big day. Cleaning out the jail is a convenient way to insure free labor for several days.

Jails have a usefulness all their own in South Africa. A farm jail system provides cheap labor for many farmers in the veld country. Under it, groups of farmers build and maintain cooperative jails and keep them stocked with prisoners. The shilling a day per prisoner which the farmer pays the government serves to beat down the wages for agricultural laborers who are not convicts. The prisoners are, of course, paid nothing.

For me the South African assignment was an exercise in diplomacy. I felt it called on all my powers. It underlined a dilemma in which I found myself with increasing frequency, both in and out of Africa. What are you going to do when you disapprove thoroughly of the state of affairs you are recording? What are the ethics of a photographer in a situation like this? You need people's help to get permissions and make arrangements; you are dependent on the good will of those around you. Perhaps they think you share their point of view. However angry you are, you cannot jeopardize your official contacts by denouncing an outrage before you have photographed it.

I like to do my work without lying, if I can. Telling the truth does not necessarily mean revealing the whole truth. I feel you

need not give away the pattern in your mind. There is an advantage in having those little mosaics before your mind's eye which will tell the whole story when it is complete—when each piece falls in place. The individual subjects will then add up to something *you* see, not what someone else wants you to see. Often your salvation lies in some little thing which you can praise. It was difficult to praise the plight of the vineyard children, but I could say it was splendid to have them working in the lovely fresh air. As for the farm jails, I could always say they were clean (and they were), which would please the Director of Prisons who was conducting me. I could commend the excellent meat stew I was given to sample. There was no need for me to point out that even farm animals must be fed well to work well. Still, each subject made one more tile in my working pattern.

Not every white citizen believes in apartheid. Some white farmers deplored the revelry in Constantia on payday, and some few carried it further to a strong denouncement of child labor. There were white citizens I met in many places as well as Constantia who were against the injustices of apartheid, but their voices were few and faintly heard.

Many times during my travels in South Africa I heard statements that could have been made in our own Deep South. "The Negro is lazy." . . . "The Negro hasn't the capacity for an education. He doesn't have the brain in his head that the white man does." . . . "Let him prove first that he can help himself." These remarks made me sad that America, standing as it does for equal rights of all citizens, had not led the way by example.

The shantytowns, which Alan Paton wrote about so movingly in *Cry, the Beloved Country*, have become the national ghettos of South Africa. They are inhabited largely by African house servants, who are not allowed to spend their nights within the city because of their black skins. Their homes are a tangled miracle of housing, shanties thrown together with crates, gasoline tins, burlap sacks, anything a homeless family might lay hands on. The shantytowns have reached enormous size and spectacular squalor. There are only the most primitive sanitary facilities, no health services, no police protection. That doesn't, by any means, keep the police out!

The police are usually Afrikaner farm boys, well steeped in white-supremacy psychology. They break into homes at any hour, on any pretext. It may be a "pass raid," in which they will pick up anyone found without the proper passes; they will rip through the location, tearing up the floorboards, pulling people out of bed, throwing mattresses on the floor, looking for illegal beer.

Once I accompanied the police on a dawn raid. It was a lesson in terrorization. People were just beginning to stir in the semi-darkness when the police charged through the compound with clubs and guns. Those who were commuters had to catch early buses to get to work. Men and women who had to leave early for their jobs had no choice but to use the primitive sanitary facilities without any chance of privacy in the midst of raiding police. Most vividly, I remember the faces and eyes of terror-stricken children who peeped cautiously through windows and cracks of doors, as the police tore through their squalid courtyards.

In one of the shantytowns, I visited a Sunday mass meeting in which the people dared to carry banners with the slogan STOP POLICE TERROR, and fiery speakers denounced police brutality. It must have taken courage to either speak or listen, as meetings are apt to be broken up with violence.

Fear is everywhere in South Africa. It nourishes the social system of apartheid and reaches to every heart, white and black. It breeds ever-increasing controls which the white impose on the black. The black man may not learn skilled trades. He may carry bricks for the white bricklayer, but he may not lay bricks. He may tote planks and building materials, but he may not learn carpentry. To the saviors of white civilization, a major safeguard is the continued ignorance and illiteracy of the black man.

Occasionally, a very strong character will break the pattern. I visited a remarkable native woman named Caroline Mauvoo, a big-bosomed, Southern-mammy type who "raised a little school," as she expressed it, because she thought it was "needful to help people deeper in trouble than myself."

She started the school in the summer under an apple tree. Her home, like those of many of her neighbors, was built of crates and gasoline tins, but she managed to crowd in her students in

bad weather. When the classes expanded, she sold old clothes until she had enough money to establish a school in a ramshackle farmhouse. An ever-increasing spirit of revolt is rising in the native reserves and shantytowns.

The white man's best guarantee of preserving the *status quo* is to keep the black man isolated. Nowhere is this isolation more complete than in the great diamond mines on the Skeleton Coast of South-West Africa, below the mouth of the Orange River. Along the wild rocky rim of the south Atlantic Ocean, the waves have scooped out gloomy caves and carved tall arches which stand up out of the sea with angry breakers boiling around their feet. I have seldom seen a more forbidding landscape. At first sight, it is hard to believe that such rich bounty is hidden just below the surface, waiting to be dug up.

No mere wanderer ever gets into the tightly guarded Diamond Coast. One hears legends about lucky travelers who found diamonds with the gravel in their shoes; these tales may be exaggerated, but certainly along this inhospitable coastline, there is an infinity of diamonds.

Along the bleak and almost empty highways, there are signs in three languages: Afrikaans, German and English, warning that anyone who steps off the road will be subject to imprisonment and fines up to $10,000. I never figured out how the wayfarer could answer a call of nature legally while touring these highways.

The old familiar barbed wire, which fills so many needs in South Africa, was much in evidence on the Diamond Coast. Here, whites as well as blacks are locked in at night behind miles of barbed-wire fencing, and whites like the blacks must be X-rayed on leaving. But there the resemblance stops. The white families live in a sparkling new town, with tennis courts and playgrounds. Black men have no provision made for their families. Their families live several hundred miles away over desert and mountains.

The black miners were squeezed into rows of modern and no doubt sanitary concrete cubicles, packed as tight as oranges in a crate. With vacant land and barbed wire in such plentiful supply, I wondered why the fence around the compound had not been extended to make more roomy quarters and perhaps a

recreation area. On Sundays, the miners washed their clothes.

On my first walk around the encampment with an escort of company officers, I saw a strange spectacle. An enormous Negro, dressed in a kind of man-from-Mars suit—bright yellow and heavily padded, with matching crash helmet—was writhing on the ground, trying to fight off a pair of savage dogs with dripping fangs. This was Lazarus, I was told; and this was Lazarus's job: to train dogs in ferocity so they would attack a man. Anyone rash enough to attempt an escape with diamonds was fully aware he risked having the whole savage dog pack in pursuit.

This was part of the miragelike quality of South Africa. The savage dogs had their place in the atmosphere of unreality that permeated everything in this country. The gold and diamonds for which half the population was searching were so unrelated to human needs, and so remote. Something happens in the London gold market or the Bank of France or in downtown New York, and it sends the men I saw or hundreds of others like them scurrying down into the moist warm darkness to scavenge for golden crumbs. On the Diamond Coast, the remoteness seemed even greater.

Diamonds are so plentiful that, if exported freely, they would lose all fashion value. From the costly chill of the impeccable stones that decorate some woman's wrist to industrial diamonds, the diamond industry is controlled by one of the tightest cartels in the world. The stones are exported a few at a time so their arbitrarily set worth may be maintained.

In some locations, diamonds are so close to the surface they can be swept out with a broom. Frequently the miners find large stones lying free. At the end of a day's work, I watched a long line of miners filing past the cashier's office. Each man opened up his little matchbox or torn handkerchief and turned in the loose diamonds he'd found during the day. Several had four or five large stones. I photographed one man who brought in eleven diamonds, valued at $33,000. For each large stone, the miners receive a bonus. "How much of a bonus?" I wanted to know. The bonus was sixpence per diamond. This was not paid in cash, but in the form of a credit slip which could be spent at the company store.

A diamond may be "forever" in the sense that it wears well

and won't break, but its value is not forever. Just try to sell a diamond, as I once did, and suddenly you find you have a "used" diamond on your hands—a "secondhand" diamond.

Among the diamond miners, there were two or three men fortunate in having been taught by missionaries. They were eager to share their smattering of literacy with their fellows. Lessons in reading, writing and arithmetic were somehow squeezed in between the work in the mines and the Sunday laundry.

I found a quiet heroism in this struggle for literacy, which was inspiring. These lessons would not make scholars of diamond miners. But perhaps they would open a chink in the wall through which they could glimpse wider horizons in the world outside. Just as a diamond is not forever, ignorance and slavery are not forever.

CHAPTER XXVIII

GUERRILLA
WARFARE
IN KOREA

People often ask me, "What is the *best* camera?" That is like asking, "What is the best surgeon's tool?" Different cameras fill different needs. I have always had special affection for the larger-than-miniature cameras, where I can have the pleasure of composing on the ground glass. My way was to key in the story with a view camera, or reflex of some sort, working for as beautiful and striking compositions as I could make. Then I cleaned up the corners with the miniatures. I had used miniature cameras to some extent ever since the Louisville flood in the middle '30s, but it took a Japanese riot to make a confirmed miniature camera user of me.

I had stopped off in Japan, where *Life* had a Tokyo office, in the early spring of 1952 when I was en route to the Korean War. I was in Japan only briefly, but long enough to photograph an anti-American riot in the Imperial Plaza. I worked from the top of our *Life* station wagon, where Jun Miki, *Life*'s Japanese photographer, had arranged my various cameras so I could reach them easily. When the first rock whizzed past my ear, I laid down my view camera on its tripod, never to pick it up again that day. While frenzied mobs surged around the car, striking up at

me with the staves of their Red banners, I shot out my pair of
Rolleiflexes in minutes, and I never had time to reload them. Two
other reflex cameras were almost impossible to adjust, with my
eyes streaming from repeated bursts of tear gas.

I fell back on the pair of miniature cameras which I had strung
around my neck. These focused easily and gave me a total of
seventy-two shots, which sounds like a lot, but melts fast in a
riot. It happened that these were Japanese-made Nikons and my
Japanese driver knew how to load them. Fast as one camera was
shot out, I handed it down through a big jagged hole in the side
window where a rock had sailed through. Somehow, my gallant
little driver managed to stay at the wheel and load my cameras
at the same time.

My growing facility with miniature cameras was of great im-
portance in Korea, where I dealt with human situations which
could be recorded in no other way. I flew by Army freight
plane, one of the bucket-seat models, from Tokyo, across the
Japan Sea, to Pusan.

I had asked my *Life* editors to send me to Korea for rather
different reasons than other correspondents had had. For nearly
two years the war had been raging relentlessly with no sign of
ending. The various aspects of this confused situation had been
reported with courage and skill.

Probably no war in history had been so thoroughly docu-
mented. My own magazine had given it brilliant coverage, with
David Douglas Duncan and Carl Mydans on the hot front at the
38th parallel almost from the beginning. Howard Sochurek para-
chuted in with the 187th Airborne. Michael Rougier and another
half-dozen of my *Life* colleagues had put their personal stamp
on hundreds of dramatic and sensitive photographs. With all the
major news services and broadcasting chains, each with its quota
of photographers, reporters and broadcasters on the spot, Korea
was the most consistently raked-over news center in the world.

Still I felt that there was an important area which no one had
covered: the Korean people themselves. Certainly with war
sweeping back and forth across their homeland, the people must
be deeply affected. I yearned to look into that great undisclosed
vacuum that lay south of the 38th parallel. What were the
Korean people doing? What were they saying and thinking?

Before leaving New York, managing editor Ed Thompson had said, "Maggie, take three months if you need it, roaming around Korea, and when you've found a new story you think is *your* story, cable us." I love the challenge of an assignment that sends me digging out dark places and trying to open them to the light. I did not dream then, as I talked with my editors in New York, that I would find among the people of Korea a savage, capsule war within the war.

I was traveling through the great rice bowl of central Korea when I first heard serious talk of Communist guerrillas. I stopped off at Chonju, the tiny capital of Cholla Pukto, where a group of United Nations military and civil advisers had set up head-quarters. Dusk was closing in, and I hoped I would be able to get food and lodging and, if I was very lucky, an idea. I was fortunate in finding all three.

The food was Army rations—adequate but unexceptional. As for lodging, I had been living out of my bedroll for weeks, and all I needed was a stretch of dry floor to unroll it on. My quarters turned out to be rather unusual. I was put up in a big, gloomy shack of a building, once part of a Presbyterian hospital.

In the morning, I learned I had been sleeping over the cellar where American General Dean had been held a prisoner by the Communists, after his capture at Taejon. Since then, the area had been won back for our side. I had known General (then Colonel) Dean slightly during the African campaign in World War II, where he had helped me cut some red tape. I remembered him as soft-spoken, self-effacing and straight-to-the-point. I crawled down rather reverently into the dank gloomy cellar and wondered how people in general and I in particular would be able to stand up as he did under endless questioning, fading health, and the loneliness of the dark cellar.

At early morning mess, I met the first shimmering of the Idea. A small knot of officers were talking about a daring guerrilla raid during the night on the outskirts of the town. An Army supply truck, bound for the United Nations front, had been ambushed, overturned and set on fire. The officers were particularly concerned that the holdup took place right on the "M.S.R."—our Major Supply Route that ran like an artery from the southern tip of Korea to the fighting front.

Only a few days before my arrival, there had been a spectacular train raid on the Eusak Express—a vital strand in our lifeline from the seaports to our men at the 38th parallel. American soldiers traveling on the Eusak Express drove off the guerrillas, but not before they had killed three GIs and some sixty civilians who were unlucky enough to be riding the death train.

I was very curious to hear more about the guerrillas. "They are as fast as rabbits, and as cautious as virgins," Major Davis said. Anti-guerrilla operations came under the jurisdiction of the Korean National Police, not of our United Nations armies. Maj. Lewis Davis in Cholla Pukto, Col. Earle C. Riedley in Cholla Namdo, and his excellent Sergeant Dupont, in civilian life a policeman in Providence, Rhode Island, were police advisers to the Koreans. Major Davis was a lanky, loose-limbed, freckle-faced Southerner, who in peacetime was a freight agent in Birmingham, Alabama. He led a kind of Wild West existence here in Korea. Although his work, I was sure, was often hazardous, I could tell from the way he spoke that he loved the excitement of it. To me, he seemed half cowboy.

The Major took me to his office to explain how the guerrillas came to be. Early in the Korean War, when the tide of battle was running against us, the North Korean Army pushed our United Nations forces down as far as the Pusan perimeter. The Communists used their period of occupation well, in an intense program of making converts, forming youth groups and organizing guerrilla bands. When our UN armies broke through and forced the enemy north in a great bypass operation, there was a substantial portion in the mountainous interior we were never able to reclaim entirely. The converts fled to this no-man's-land of the wild interior.

Certain officers of the North Korean Army stayed behind to direct roving guerrilla bands. Under the command of these picked officers, the guerrillas were virtually a hidden wing of the North Korean People's Army, harassing our communications lines, robbing and burning villages and terrorizing the peasants.

A relatively small number of guerrillas, skillfully directed, the Major pointed out, could tie down many times their own number. The regulars in the National Police and their unpaid "Volunteers" were overwhelmed by the Gargantuan task of patrolling

every stretch of rail looped through the hills, every major truck route, with its overhanging cliffs and myriad jackknife turns.

Major Davis's office walls were papered with large-scale maps and charts. I was struck by the names of some of these units: "Women's Work Battalion," "Anti-U.S. Regiment." To me, it was significant and ominous that there should be a guerrilla unit named the "Anti-U.S. Regiment," filled with fanatical youngsters who probably had never seen an American in their lives.

The degree of organization in these roving bands astonished me. Though constantly on the run, each unit had its political wing and its military wing, with sharply defined duties for each. The guerrillas even got out a weekly newspaper, mimeographed in a cave. When they ran short of paper, they used wallpaper. I remember seeing several in purple with an overlay of green and silver. One very chaste issue, white with gold designs, contained a Korean translation of a speech by Stalin. The "news sheet" lauded the Communist victories (greatly exaggerated) at the front and stated that the brutal Americans would be driven from the land. The paper was distributed by runners through the mountains.

I began to sense the broad outlines of my story. Here was a situation extensive enough to harass the UN supply lines and intimate enough to divide loyalties within families. Sometimes when a boy had run away to join the Communists, and a neutral villager informed his mother of his whereabouts, she would climb into the mountains and implore her son to leave the Communist band. I found it deeply moving that all this conflict of beliefs was so close to home that a grieving mother would brave the perils of the dark and the mountain crags to plead with her boy to come home. Here was a civil war with friend against friend, and brother against brother. Here was a war of ideas which cut through every village and through the human heart itself.

This was my story.

But how was I to get it? This quandary of where to break the surface and plunge into the story is an experience I have gone through repeatedly on other large picture-essays. But no matter how much I remind myself of this, it never fails to be upsetting. Suddenly all the most wanted subjects seem invisible or unattainable. I knew very well I could not climb to the top of Mt.

In a Korean village a wife, mother and grandmother lament the death of their boy in guerrilla warfare.

Chiri-san where One-armed Hwang, a sort of King of the Guerrillas, had his headquarters, and say, "I'm from *Life*. May I take your pictures, please?" The guerrillas, I was reasonably certain, had not read the terms of the Geneva Conference—which provides that war correspondents are noncombatants, who may be captured but not killed.

The camera is a remarkable instrument. Saturate yourself with your subject, and the camera will all but take you by the hand and point the way. This is just what happened to me in Korea.

When the story did begin to materialize, it came with such a rush that I was overwhelmed with the richness of it. There were too many photographic subjects crying out to be recorded.

Also, before I'd finished, there was a price on my head. I found this rather flattering. I don't think the Communist guerrillas knew what I was trying to do, but an American woman who went everywhere with cameras was a ready-made suspect. I never learned the cash value of my head to the guerrillas, but I hoped my price came high.

I soon found myself working and traveling almost exclusively with Koreans. I always welcome the chance to travel unaccompanied in a country new to me, because I think the people will open up to one foreign traveler where they might not to a group. This was particularly rewarding in Korea. It came as a surprise to me that the Koreans, despite their difficulties, were such hearty, outgiving, spirited people whose wit has well earned them the phrase "Irish of the Orient."

On several occasions when there was an inaccessible spot I wanted to reach, I was set down by Army helicopter in some prearranged field or clearing. The pilot, usually an American, would make sure before flying back that I was left in the hands of the local police.

I disappeared for weeks at a time. My only worry was receiving film shipments. *Life*'s Tokyo office did all but use a divining rod, and ended by sending everything in triplicate packages to three different places, hoping I would connect with at least one of them. The system worked.

I slept in some odd places. Frequently, I unrolled my bedding in police headquarters. I remember one such place which had a *futong* of bright, flowered material, fashioned like an oversized padded kimono with a great stiff collar and quilted sleeves. I had met *futongs* before, and learned that before scrambling into the stiff garment, half-kimono, half-mattress, you must decide whether to face the ceiling all night or the floor, because either way, you are held completely rigid until dawn comes to set you free. I would greatly have preferred my own army blankets, but the police were so proud of being able to produce this sleep chaser for a guest that I could not disappoint them.

On another occasion, the local chief of police came to my

room at night and stayed for several hours. I was startled when he invited himself in. With hardly a word, he seated himself cross-legged on the rice mat opposite me. Until late at night, he sat reading his Korean Bible, his lips moving; then he rose to his feet and went out as quietly as he had come.

I had still another contact with the Christian religion. In the foothills of Mt. Chiri-san, I went to the home of a priest whom I knew slightly, hoping he would take me in for the night. The good Father was away, and the house was locked up tight, except for the vestibule. I was sure the Father would be willing for me to take sanctuary under his roof. While I was preparing for the night, the priest's houseboy showed up and asked in pidgin English if he might drop in for evening prayers. He returned with four earnest-faced young men, who squatted as close as they could to the edges of the vestibule. We all sat in embarrassed silence until I realized that they were waiting for me to lead their prayers for them.

We were entering the typhoon season. When we were held up by rains too heavy for guerrillas or guerrilla hunters, I was installed in comparative luxury in the smallest hotel I've ever seen. It was little more than a row of cubicles with well-worn oiled paper serving as walls. The paper-bound cells surrounded a small courtyard which was knee-deep in creamy mud. I chafed at the delay until I became acquainted with a guest in the cell to my right. He was a schoolteacher of music and English. This was just the combination of talents I needed. As I am a very poor linguist, I seldom manage to pick up more than a few polite phrases in the countries I visit, but I always learn at least one song—not only to increase my midget vocabulary, but because a song has inestimable friendship value. This was certainly the perfect opportunity to learn a Korean song. I don't know how the other guests endured it with only the paper walls to deaden the sound, but as it rained and rained, we sang and sang.

Frequently I ran into Koreans who, like the music teacher, knew some English and were delighted with the chance to brush up on it by translating for me. Some of these were police interpreters.

One in particular, with whom I worked a good deal, spoke excellent English with an Irish accent, acquired during his up-

bringing by the Catholic mission Fathers. Captain Pak was bright, energetic and excessively courteous. While other translators would answer me politely with "Yes, sir," or "No, sir," Captain Pak replied to any comment I might make with "Yes, Father," or "No, Father."

Of all my varied lodgings, I loved sleeping in the police boxes the best. These little shacks, sprinkled along the mountain ranges and ringed around with bamboo staves, were so crammed with communications equipment, field telephones and rifles, that it always seemed a miracle that they could take in one more person. But somehow there was always enough floor space for a bedroll in some corner. I adored these places just as a small boy would adore sleeping in the firehouse so as to be right there when something broke. Wrapped like a sausage in my bedroll, I would doze off happily while the noises rattled around me and Korean voices yelled through the balky field telephones. I slept serene in the knowledge that if some guerrilla action broke, I would be in on it.

From time to time, after a successful term of guerrilla hunting and picture taking, I managed to break away for a much-needed cleanup to a spot I was beginning to regard as my Korean home. This was in Kwangju, a sprawling, dusty town, and the capital of Cholla Namdo province.

Kwangju was the center of our ROK training program, in which UN Army officers, usually American, taught South Korean soldiers how to use tanks and other battle equipment.

The commanding officer of Kwangju was Col. Albert Wing, a courtly gentleman who was the perfect prototype of a Southern colonel. One glance at Colonel Wing, and you felt sure he was born with silver eagles on his shoulders. I met him through the kindly offices of the UN Press Officer in Pusan, Col. "Buck" Rogers, who phoned ahead to make sure I would have some civilized place to stay when I was working in the interior. Colonel Wing said, "I have a house on the hill named 'The Mississippi,' although I come from Kentucky. It has several rooms for visiting officers. I think the young lady could stay here without being compromised."

No matter how full with guests The Mississippi was—once I displaced a visiting major general—or how muddy and bedraggled

I was, Colonel Wing would say, "Welcome home. The house needs a woman," and he would call his houseboy: "Come, Kim, and clean up the young lady's clothes." Kim would stay up all night washing my things and ironing them dry so I could go out fresh the next morning.

On one of these brief stopovers, Colonel Wing gave a party in my honor at the bungalow newly built to serve as an Officers' Club. Happily, on a last-minute impulse when I was packing for the trip, I had tucked a dress into my bedroll. The Colonel was immensely pleased, because he knew his men had not seen an American woman in some time. He introduced me with these words: "The social season begins and ends with Miss Bourke-White. You may stand in line to touch her hand."

During one of these brief contacts with what seemed like big-city life, I checked in with Major Davis to be brought up to date on the overall picture. As my work was taking me farther and farther into the wilderness, Major Davis insisted that I carry a .45, even if I used it only to fire in the air to warn guerrillas that I was armed. I knew some of my colleagues in the press carried some sort of weapon, even though this was against current practice for war correspondents. This was because of the enemy's lurid reputation for torture. But in my case, I told the Major, this seemed ridiculous. I didn't even know how to use a .45. The Major said, "I'll teach you."

He took me out to the base of a semicircular cliff, a spot used for target practice, and taught me how to hold and fire the revolver. To the complete astonishment of both of us, out of thirty-five rounds, I made thirty-three bull's-eyes. I can ascribe this spectacular feat only to my profession. Most beginners make the mistake of shutting their eyes when they start shooting. Any photographer who shuts his eyes when he starts shooting should be in another profession.

Back in Kwangju, a captain whom Colonel Wing had assigned to me while I was in the area felt that a .45 wasn't enough. I should have a longer-range weapon, a carbine which I could wear over my shoulder along with my cameras. Again I said, "That's ridiculous. I don't know how to use a carbine."

He took me to an enormously long rifle range used in training ROK soldiers to shoot. He instructed me in the prone,

squatting, kneeling and leaning-over-the-jeep positions, and out of twenty-five rounds, I shot twenty-five bull's-eyes. "I'll be no good at moving targets," I said. So he gave me some practice on that, and I shot a crow! The Captain said, "Someday you'll shoot twenty-five rounds in this range with a pocket pistol, and I will ask to be sent home as a psycho case!"

When I once more started back into the wilderness, Colonel Wing said, "My sympathy is all with the guerrillas."

The most colorful guerrilla hunter I worked with, and the most renowned, was Police Chief Han Kyon Lok. The Chief was a big man with a chestful of medals. He was a big drinker of Japanese Ocean whiskey, and when that supply ran out, he was an equally big consumer of a local product, Venus brandy. He was a big ping-pong champion. The silver cups and banners that crowded his office walls and shelves attested to his very great mastery of the game.

Chief Han ran his guerrilla raids as though he were a general, which in effect and power he really was. The command posts and observation points from which he directed his campaign looked like fortresses out of the Middle Ages. Crowning the mountaintops, they were ringed with double walls of tall, pointed bamboo staves.

Within our bamboo barricades there was always one deeply dug ditch we could jump into in case the guerrillas started mortaring us. They had a weird collection of firearms, including some Chinese machine guns, some old Russian carbines and burp guns, and whatever American rifles they could steal from our armed forces. With no regular ammunition supply, they relied on whatever they could capture on raids. When it did not match their miscellaneous firearms, they were ingenious at reconverting the ammo to the weapon. It seemed bizarre to me that in a world that contained nuclear fission, there should be a place on this globe where a sharp-pointed bamboo fence could still have any defense value.

In the turbulent weeks to come, as I worked with Chief Han and some other police chiefs, I came to think of this as a conflict between children. I remember the first time I was sniped at. The Volunteer Police with whom I was traveling rounded up our assailants and brought them in as prisoners. The youthfulness

Chief Han at a primitive mountain fortress ringed by bamboo barricades.

of these Communist guerrillas—this handful of sullen teen-agers
—made me indignant. "The impudence of it!" I thought. "Have
those youngsters been shooting at me? They ought to be in high
school!" Yet the Volunteer Police on our side were just as young.
They were very brave, though it made me sad that they were
glorifying guns at such an early age.

Often these Volunteers were assigned to areas where they
had played and climbed as small boys, with the advantage that
they carried in memory every steep slope, every patch of pro-
tective shrubbery and every clump of grass tall enough to hide
them. The disadvantage was that they were almost inevitably
forced to betray childhood friends, which added to the bitterness
of this already bitter conflict.

These youngsters were masters of camouflage. They made
little hats for themselves of leaves and flowers, and some of
them attached branches to their backs which looked like butter-
fly wings. I remember one very little boy who wore a charming
hat he had made with daisies. This seemed a bit fancy to me, but
not at all: he was shooting off a homemade mortar in a daisy
field, and when he manned his weapon, he was all but invisible.

Chief Han deployed these youthful Volunteer Police with
remarkable precision for such wild terrain. One group of teen-
agers would flush out the guerrillas from a mountaintop; a second
group would hide just below the edge of the strategic pathways,
ready to pounce on the Red guerrillas. There would be a fire
fight, and frequently boys on both sides would be killed.

The youngsters had to bring down their cumbersome victims
alive or dead, so that Chief Han could identify the slain, or in-
terrogate the living. Chief Han's main concern was to find those
who were officers from the North Korean Army and check
them against known lists. My chief interest was to find out how
they lived in the wilderness, in this strange existence they had
chosen.

I remember one tall captive in particular who told me he had
been quartermaster in his guerrilla band. "What on earth does a
quartermaster do in the mountains?" I inquired.

He answered that when the guerrillas planned a raid on a
village, it was his job to allocate looting priorities. Food usually
had first priority; paper and writing materials for the newspaper

These hats, worn by youthful Volunteer Police, were not for play but for camouflage in the deadly game of guerrilla warfare.

and other propaganda were always an important target. Highest priority was often placed on yardgoods.

"What do you do with yardgoods in the mountains?" I asked.

"I turn them over to the sewing machine expert."

"You mean you have a sewing machine in the mountains?"

"Yes, we have a Singer sewing machine in a cave. The expert takes the yardgoods, dyes them a dark color and makes guerrillas' clothes. Sometimes we were lucky enough to get nuns' robes—dark and lots of material."

The difficulties of the quartermaster's job were multiplying as the anti-guerrilla teams pressed closer. They were hunted so closely they dared not stop to cook the food they had stolen lest the plume of smoke from their campfire be spotted. Sometimes their looted food was awkward to transport, such as the cow they had captured. Their bovine prize had to go on her own four feet up into the mountain—a dangerous journey for both cow and comrade. These little glimpses of housekeeping problems in a world so different from my own fascinated me.

Whenever I had a chance to interrogate guerrillas we captured alive—particularly young ones—I asked why they had joined the Communists. What had been the appeal?

A young woman guerrilla from Kwangju, who surrendered to our side, threw some light on this. The greatest appeal to her and many other young people was literacy. "I was only a house-maid," she said, "but all my life I wanted to study. The Communist leaders pledged that all who joined would be taught to read and write. Also, they promised that I would have a position of increased dignity in the community. This was the first time in my life I was ever treated like a lady. It seemed such a good opportunity to get an education."

I asked whether the Reds had kept these promises. For a time they had, she said, even when the UN armies were regaining territory and pushing up north through Kwangju. The Communists ordered their converts to flee by the thousands into the mountains. The directions of the Central Communist Committee were explicit. They must carry a blanket and pens, paper and other writing materials and take to the hills. Their leaders warned them that if they stayed behind, they would be tortured by the cruel Americans; that the Americans were so demoralized and

corrupt they would soon collapse anyway, and those who held out as Red guerrillas would be rewarded. The youngsters had all been told that under a Communist way of life their families would prosper and the farmers would become secure and rich.

When they assembled in the hills, they went to school in the forest, and hidden by the green boughs, they studied reading and writing, using as a textbook a *History of the Bolshevik Party*. How I wished we had been ahead of the Reds in this! Perhaps then these impressionable girls and boys would have been learning to read not from a Soviet textbook, but from the Declaration of Independence and the Gettysburg Address.

As the guerrillas were more and more sorely pressed, everything began to disintegrate. The girl was given the job of cook for her unit, and every time they moved to another site, she had to carry her cooking pots and kettles herself. Her greatest dread was that she might lose her cooking utensils on some rapid dash to a new hideaway, and incur the wrath of the comrades. It was clear to her that the Reds had promised many things they could not fulfill. She longed desperately to get back to her home, and during a raid she came running out of a bush with her hands up and surrendered to our side.

When guerrillas were taken prisoner or brought in dead, Chief Han's men emptied their pockets to see what useful information they could glean as to future plans of attack. It astonished me that almost all guerrillas kept diaries. Sometimes they made very pretty ones, with scraps of bright-flowered cretonne on the covers. Usually these were more than diaries. They were minutes of frequent meetings their political leaders held in the hills. The emphasis was on ideology and self-criticism. A guerrilla had pledged to cut down twenty-nine telephone poles in one month. He confessed he had cut down only nine poles, but next month he would demolish forty.

On my last sortie with Chief Han, he scored a great victory. His Volunteers killed eighteen guerrillas. Two of them were officials of the North Korean Communist Army, one in the military wing of their roving guerrilla troop, and one in the political wing. The Chief had been hunting them down for quite some time.

I remember the day, bleak with rain. We were still under the

whiplash of the typhoon. The eighteen motionless figures lay, dismal and still, on the slope of a small incline, eloquent expression of a pursuit of false hopes ending only in death. They had been so sure they would win, because their topmost leaders had told them so.

We had reached a bald mountaintop by a "road" which was little more than a ledge of treacherous rocks. It had the sharpest hairpin turns I've ever seen, and at one side the steep cliffs dropped sharply down. The Chief was insistent that I finish my work early so we could get out of the mountains by daylight. We had been more conspicuous than usual, coming up with a convoy of five jeeps. The hairpin turns gave the guerrillas excellent opportunities for ambushes. Their technique with turns was to station one party on the inside of the curve, so the driver would not see them before he rounded the bend, and a second group at the end of the curve, so the jeeps would get fire from two directions. Once you were in between the two groups, there was little chance to back out of ambush, because one friendly jeep might knock another over the cliff.

Despite Chief Han's obvious impatience, I kept saying, "Just one more, just one more," like all photographers everywhere. The pounding rain slowed up my work considerably. As the light dwindled, I drew on my reserve of flashbulbs; Volunteers held extension cords as far as they would reach, so that I could side-light the figures and the background. The Chief paced up and down in an irritated way, and I knew that my "just one more" technique annoyed him a great deal. But this was once when "just one more" paid off. Since we were so late, the Chief took the precaution of sending the security police ahead to guard the worst stretches of road. It was almost dark when I finally put away my four very damp cameras and climbed into the jeep.

The five jeeps in our convoy crept slowly without headlights down the treacherous mountain road. We had been driving for a laborious half hour when we rounded a bend and above us saw a small blinking light. Chief Han, who was sitting beside me, said, "Something must be wrong. We have one of our police boxes up there, but they never give away their position at night. We'll stop and see what's going on."

Immediately all the men in the jeeps jumped out and pointed

their guns either up the steep cliff on one side of the road or down the precipice on the other so we would not be surprised from either direction. I was impressed at how quickly they took up defensive positions.

I jumped out of the jeep, too, with both my .45 and my carbine ready. I decided that this was the occasion for the .45, and I only hoped that if we were in a fire fight, I would not shoot my friends. I remember how the rain beat into our faces and eyes. I was standing next to the Chief's driver, who said in a quiet voice, "Doesn't that look like a man in white coming toward us?" "It certainly does," I whispered. In the next instant we both recognized that the moving creatures were nothing more than giant fireflies seen through the pelting rain.

Our relief was short-lived. We heard shots rattling through the rocky slopes. The guerrillas had come to keep their appointment with us, undoubtedly thinking we would leave the mountain in daylight. Our Volunteers had found them. Their delaying action gave us time to send up additional reinforcements. Later we learned that if we had succeeded in passing through that first ambush alive, we would have met a major obstacle around the next bend. The guerrillas had rolled a boulder onto the road, which had started a small avalanche of rocks loosened by the rain. With the avalanche and the boulder blocking our way, the guerrillas would have had a picnic with us.

Chief Han pounded me affectionately on the back. "Miss Peggy," he said, "you must always say 'just one more,' because if you had not said 'just one more,' my wife would be a widow tomorrow."

The Chief ordered a truck sent up mounted with a machine gun. We descended the long way around on the far side of the mountain. There is nothing more comforting than to have a machine gun in your party.

As we rolled down into the foothills, the Chief said, "We must celebrate our great victory. We will go to a wonderful Buddhist temple at Haenam for our victory party. Would you like that, Miss Peggy?" Naturally, the phrase leaped to my mind: "*Life Goes to a Party in a Buddhist Temple*," and I said, "Yes, that would be very nice. Thank you."

"This is a famous old temple," the Chief told me. "I'm sure

[OVERLEAF] *Chief Han celebrates his successes over Red guerrillas at a victory party in a Buddhist temple.*

you'll want to see some of the two-thousand-year-old art ob-
jects there." When we arrived at the temple, I found there were
art objects there—five of them—not two thousand but a bare
twenty years old.

The Chief had brought the five most beautiful *kisaeng* girls
from Mokpo by boat. He must have been sure of his victory,
because when we arrived, the kisaeng girls were already there
and had been waiting for us in the temple for two days.

A kisaeng girl is, I learned, the Korean version of a geisha
girl, and her duties are about the same. She sings very nicely,
she dances beautifully, she waits table daintily, and she has other
accomplishments. It was a wonderful party! We took off our
shoes and sat cross-legged on the floor and ate from a long table
about eight inches high. Tucked under the edge of the table,
ready for action, I kept my cameras, right at my side.

I followed my usual rule in the Orient of eating only food
that was cooked. I was willing to leave the raw cow's brain to
others. I took a mouthful of wild mountain spinach, but only
a cautious sip of the Korean soup *kimchi*, because I knew from
past experience that it was spiced like fire. When the Koreans
found I was willing to eat hard-boiled eggs, they brought me a
bowl of forty of them.

I did not dare to try the Korean sake, because I had to work.
But Chief Han had done his work, and the kisaeng girls *were*
working. They poured the sake from pewter teapots; they drank
from little teacups; it was warmed up just like tea. But the effect
was not the same. It did not require many teacups to make all
the banqueters feel wonderful.

No Oriental feast would be complete without song. The
Chief's favorite kisaeng girl, Miss Moon, sang; the other kisaeng
girls sang; the police officers sang; Chief Han bellowed out a
song; and then it was my turn. I'm sure that everyone expected
me to sing an American song. I had been practicing for some-
thing like this ever since my lesson from the music teacher. I
sang my little Korean song. I doubt if there has ever been more
handclapping in a Buddhist temple than there was that night
for me.

CHAPTER XXIX

NIM CHURL-JIN

In working on a large photo-essay such as this Korean one, I always feel as though I am building a piece of architecture, thinking of each subject not for itself alone, but as something to be integrated with the main theme. I am always nervous as a cat until the main building blocks are in place, and this story was no exception. I was perhaps in a deeper state of anxiety and suspense than usual. I had pictures that I liked and which I felt told a good deal, but I had not found the most important subject of all, which would bind the whole essay together. The keystone should be the human family.

Every photographer who has ever tried to express a thought in pictures knows the uneasy pain of hearing about tantalizing situations that would have been just right—or so you imagine—if you could have been there. Hearing wonderful stories is not enough for a photographer, and while the other man's job always seems easier than your own, the reporter can write a wonderful story built around what he hears. The photographer has to push his lens into focusing range somehow, and at just the right time. Nothing counts except the image he carries away on his fragments of film. The subject I was after was a subtle and elusive one. I could not cement my story together with just any family—no matter how photogenic the group might be. I had to find the right family—one that would illustrate visually, and I hoped dramatically, the cleavage in a family torn apart by the war of ideas.

As I traveled, I began hearing of some new and humane developments in the region of Mt. Chiri-san toward the south. The details I heard pointed toward a growing realization that just killing Communist guerrillas was no solution. There were close blood ties between many guerrillas roaming the mountains and the villagers living in the foothills just below them. And from reports I heard, it seemed that many of the converts were heartily disillusioned with the unfulfilled promises of the Communists. If only they could be induced to surrender and come back to our side, they could be rehabilitated into useful citizens. The important thing was to reclaim the youth.

The village authorities tried in ingenious ways to induce the local boys to cross the invisible boundary and return to their own villages. Surprisingly modern under such primitive conditions, they used tape recordings of familiar songs, broadcast at twilight, hoping if the boys heard, it would make them homesick. Sometimes the village elders would speak into a tape or through a loudspeaker on a hilltop: "You know our names and our reputations. There will be no recriminations against you or your family. We have been feeding your family, and they urge you to come home. Come back to your homes, and bring your guns; we may need them."

This was an area I must explore. I had an extra advantage, too: my favorite interpreter, with his Irish accent, worked in one of the police headquarters in the region. I knew I could count on him to help. I headed south to the southern slopes of Mt. Chiri-san and Captain Pak.

Arriving one morning, I dropped in at police headquarters. I talked my problem over with Captain Pak, and he understood how eager I was to get below the surface. "We have a prisoner who surrendered to us just last night," he said. I was only mildly interested. Weary from the long trip, I thought to myself, this will be just another of those fascinating stories which I hear and cannot see. But Captain Pak urged me to question the prisoner.

He brought in a bedraggled young man in his twenties. He was drab, pale, looked rather sick, and had a hacking cough. His name was Nim Churl-Jin. I asked Churl-Jin when he had joined the Communists and why he had surrendered. He had joined a Red Youth Group during the Communist occupation of his native province shortly before the big bypass of the UN forces.

When the Reds ordered the Youth Groups to take to the mountains, he went with the others and had been there for two years. He was plainly homesick, yet he acted a little afraid to go home. As he answered my questions, I could see he stood in particular awe of his older brother, who was the traditional head of the family, since the father had died. I drew a mental image of his brother—ultraconservative, head of the local YMCA, as rightist as Churl-Jin had been leftist. A frequent candidate for village office, he was running for councilman when Churl-Jin spoiled his chances of election and ruined his social position in the community by defecting to the Communists. The boy recalled only too vividly how hurt and angry his brother had been. But most of all, Churl-Jin was worried about his mother, who for two years had believed him dead.

In common with so many others I had talked with, Churl-Jin had become increasingly disillusioned with the Communists. They had promised the farmers would get a better life, but rather than working toward this end, they had done just the opposite. Churl-Jin was repelled by their brutal treatment of the villagers. Instead of helping the peasants, as they had pledged, they had beaten them up, seized their food, and burned their houses. Churl-Jin drew himself up proudly and said, "I was not brought up that way."

I thought his reply was magnificent! "This is it," I said to myself. "The conservative elder brother; the black-sheep younger brother who ran off with the Communists; and the mother who for two years had mourned her son as dead."

I asked the police, "May I take Churl-Jin home to his mother?" They consented. Captain Pak would go with me as guide and interpreter. Correspondents do not generally drive around the countryside with ex-guerrillas in their jeeps. There were no rules for this, so I created some. I would check in at every major police station we passed, so the authorities would know everything was in good order. But I must extract a promise from them. No one should inform the Nim family we were on the way. The whole value of my mission depended on the element of surprise. I wanted to capture the expression on a mother's face when she is reunited with her son. The authorities promised, and the promise was kept.

Our two-day drive went fast because I had many questions to

ask Churl-Jin. Once he broke in with a curious remark. "I can hardly believe it," he said. "Here I am in a jeep with an American girl, and I can cough now!"

I thought, "What on earth does he mean by 'I can cough now'?" Then suddenly I realized. He had spent two years in the mountains; he had had bad lungs, and sleeping in caves hadn't helped them any. The sound of a cough could give away a position. When he could not restrain his cough, the guerrillas beat him.

I was interested in everything Churl-Jin had to tell me about his life in the mountains. His position had been ordnance officer, and his job was to make the ammunition they were able to steal fit their stolen guns and weapons. For example, they had looted a good supply of mortar shells long after they had run out of mortars. Churl-Jin would dismantle the mortar shell—in itself a highly dangerous operation—and utilize the mortar powder for the core of a homemade hand grenade. He had a very light hand at making a fuse. The grenade he assembled with sharp chips of glass and metal in a beer can.

Again I marveled that the same world could contain a hydro-gen bomb and a hand grenade made from a beer can.

We were approaching the region where Churl-Jin was born. I instructed Captain Pak that whatever I did, he should stay behind me at a discreet distance, within hearing range. He must listen carefully to everything that was said, but not interrupt with translations until we had a chance to get together later.

We drove out of the mountains and down to the sea. A most beautiful smile broke out on Churl-Jin's face. I kept taking photo-graphs with my miniature camera over my shoulder toward the back of the jeep where he was sitting, hoping he would not notice me—and he didn't. As we got closer to his village, I found he wasn't smiling any more. He was biting his lips to keep the tears back.

We were in sight of his village. It was off the road, and no road led to it, only a footpath. In a flash, Churl-Jin was out of the jeep and trotting along the path to his village, and I was running after him taking pictures of his back as he ran. I saw that his house was the largest in the village; he had come from a good family. Before he went into his home, he stood at his own

gate and bowed in Oriental respect. I missed that picture, but I got the rest.

He went inside the courtyard, with its strings of drying vegetables. In the next few minutes, as though they had sprung out of the ground, friends and relatives flocked in to welcome him. Everyone was laughing and crying at once. His wife came up to him, and she said very simply, "My husband has come home." She handed him his two-year-old baby, whom he had never seen, and the baby boy cried as he was thrust into the arms of this strange father. Churl-Jin smiled a little at that.

Then I learned, to my despair, that the most important member of the family, the mother, whom we had come so many miles to see, was not at home. She was visiting relatives in a village five miles away. She would not be home before nightfall. I said, "Can't we send for her? Can't we find her somehow?"

"No," the others said. "No roads go there. She will be coming back over a footpath through the forest. There would be no way to find her."

In desperation I said, "Let's do something. Let's get into the jeep anyway and start. Maybe something will happen." We climbed into the jeep with Churl-Jin, and things began to happen.

We had traveled only a few hundred yards when we saw a man ahead of us walking swiftly on foot. Churl-Jin leaped out of the jeep, and I jumped out too, camera in hand. I knew this must be the brother—a fine-looking middle-aged man. He was shaking his fist in tears and anger, and saying to Churl-Jin, "What crime have you committed that you come back to us again? You ran away to the mountains; you went with the Communists for two years. You have hurt your country. What crimes you have committed!" And Churl-Jin hung his head before his brother and said, "My old crime has been wiped out by my surrender."

I asked his brother to get into the jeep with us. I thought he might be able to help us find the mother. And as we drove, he talked to Churl-Jin, saying, "You must stay and help your country. This is a good country." And Churl-Jin repeated over and over, "Yes, I will, brother."

We drove and we drove, a distance of much more than five miles. The sun was dipping close to the horizon, and there would

[OVERLEAF] *Ex-guerrilla Nim Churl-Jin is welcomed home by his wife and family and the baby he had never seen.*

be only a short time before we would lose the light.

In a whole lifetime of taking pictures, a photographer knows that the time will come when he will take one picture that seems the most important of all. And you hope that everything will be right. You hope the sun will be shining, and that you have a simple and significant and beautiful background. You pray there won't be any unwanted people staring into the lens. Most of all, you hope that the emotion you are trying to capture will be a real one, and will be reflected on the faces of the people you are photographing.

I don't know what angel watched over me that day. If we had been three minutes earlier or three minutes later, we would have missed it. For a short distance the path curved away from the trees, across open rice paddies, and wound back into the forest again. Things happened so quickly that I can hardly reconstruct the sequence. Suddenly the jeep stopped. Churl-Jin was jumping out again, and running across a brook. I ran after him, but he was way ahead of me. He was up the opposite bank. And it took me forever, it seemed, to get up it, because it was very slippery and I was trying to keep my two cameras dry.

Far ahead of us, coming through the rice fields on a narrow path, was a woman in white. She threw away her walking stick and started to run. By the time I got there, the two were in each other's arms, and she had her hands on his cheeks. She was saying, "It's a dream. It can't be true. My son is dead. My son has been dead for two years. It is only a dream." And Churl-Jin was saying, "No, Mother, it is not a dream. I am really Churl-Jin." And the two sank to the ground then, and she began rocking him back and forth in her arms. She was singing him a lullaby. Her son had come home.

Churl-Jin and his mother are reunited.

CHAPTER XXX

MY

MYSTERIOUS

MALADY

M<small>Y MYSTERIOUS</small> malady began so quietly I could hardly believe there was anything wrong. Nothing to see or feel except a slight dull ache in my left leg, which I noticed when I walked upstairs. This was not strong enough to dignify by the name of pain. Just strong enough to make me aware that my left leg was not properly sharing the duty of carrying around one photographer on shank's mare. I had the uneasy feeling that this was different from any ache I had ever had. Little did I dream this was the stealthy beginning of a lifetime siege during which I would have to add a new word to my vocabulary—"incurable."

For half a year there were no further developments except that the dull ache moved about in a will-o'-the-wisp fashion to other parts of my leg and even to my arm. But it confined its wanderings to my left side. Then something small but very peculiar crept into my life. I discovered that after sitting for perhaps an hour, as at lunch, on rising from the table my first three steps were grotesque staggers. On the fourth step my ability to walk returned. I first noticed these difficulties at the

luncheon table in the Tokyo Press Club. I had already been in and out of Korea several times.

I was highly embarrassed by these staggers and thought up little concealing devices such as dropping my gloves and retrieving them; with the smallest delaying action I could walk. I consulted with doctors I ran across, but my wisp of a symptom meant as little to them as it did to me.

When it refused to disappear after I got back to the States, I started the weary, time-consuming round of specialists. I learned the long list of diseases I did not have. I did not have cancer, heart trouble, infantile paralysis or arthritis. I was amazed that I could have contracted anything when I thought of the near misses of two wars. I had always been arrogantly proud of my health and durability. Strong men might fall by the wayside, but I was "Maggie the Indestructible."

A discerning friend suggested that I talk to Dr. Howard Rusk. Through our common interest in Korea I already knew Dr. Rusk, a greathearted man who had done so much with rehabilitation of polio victims, but it was a shock to think of myself in the same breath with a polio victim with all the crippling that term implied. (Later I was to find that severe crippling was a frequent conclusion to the malady I had.)

Dr. Rusk took me to the staff neurologist, Dr. Morton Marks, to whom my malady was no mystery.

"I am not going to give it a name," he said, "because someday you may see a very advanced case and that might discourage you. You can do a great deal to control your disease by therapeutic physical exercises. From now on, exercise is more important to you than rest. If you skip one day, you'll fall back two. If you skip three days, you'll lose six."

He called in the head physical therapist, Mr. Jack Hofkosh, to draw up a program of exercises "to help her save what she's got."

Save what I've got! He must be thinking of ten other girls, I said to myself.

Mr. Hofkosh was a short, powerful man, and his unusually large head was completely bald. Before long he became a kind of archangel to me, and during all the years of fighting against the creeping rigidity which was afflicting me so strangely, I

came to revere each feather of his invisible wings, but on that day of our first meeting I treated him as crossly as though I were a petulant child.

"Crumpling pages of newspaper into a ball, using all four fingers and the thumb in proper juxtaposition, would be excellent to strengthen the fingers of that left hand," he said. "And for the wrist nothing could be better than mixing up a cake batter. Soon you will be able to mix a cake with your left hand."

"I don't make cake," I snapped.

He carried the idea further by explaining the benefit to the wrists which would come if I would twist and squeeze out wet clothes under the warm tap.

"I don't wash my own clothes," I scolded him foolishly.

And then a few weeks later something happened that frightened me out of all that nonsense. I found I was losing my ability to write on the typewriter, even my own electric typewriter with its featherlight touch. My fingers were becoming far too stiff to reach the keys properly. The letter "C," for instance, seemed to have removed itself by miles from any position that I could reach. I was working on this book. Dictating is no good to me. When it comes to writing, my flow of thoughts always comes best on the typewriter. Maybe I won't even be able to finish my book, I thought with alarm. Maybe I should be less haughty about the benefits to be gained from squeezing wet clothes. Maybe I had better get back to that little man with his high-polished dome and master whatever exercises he wants to teach me.

From then on everything became an exercise. A *Life* assignment to the Colorado Dust Bowl, which included airplane photographs, meant that instead of setting the clock for 4:00 A.M. so as to meet the pilot on the airstrip just before sunrise, I set the alarm for 3:30 A.M. so that I would have time to crumple newspapers. When I left the tourist room or the motel where I had spent the night, the floor would be nearly hidden in the rising piles of crumpled newspapers squeezed into popcorn-ball size. If I traveled by myself on an airplane, train or bus, when I disembarked, the space under the seat overflowed with popcorn balls. Any well-appointed hotel bathroom was a clear invitation from the management to wring out all the beautiful turkish

towels under the warm-water tap. The bath mat was last. When my camera cases were all packed and my hastily assembled suitcases were bulging, I called for the bellhop, squeezed out the mat, plopped it into the bathtub, and out I went.

At home a session of watching television was an opportunity to practice precision movements with the left hand. I used colored crayons to fill in patterns in children's outline drawings.

Those child's colored crayons certainly earned their way. Soon a fair amount of control came back to the fingers of my left hand. No longer was the letter "C" unreachable. I took special pride in that left hand. I felt as though I had made it myself, and I was able to go on writing. The feeling of continuity this gave me helped to sustain me during the difficult years that lay just ahead.

Of greatest help to my strength of spirit was the fact that I could continue to work to some extent. Work to me is a sacred thing, and while writing the book was important to me, photography is my profession. My great dread in connection with my illness was that people would try to spare me too much. My editors were wonderfully understanding of this. When I told them I was under doctor's orders to walk four miles a day, they shuddered at the thought but gave me assignments where I could walk, run, climb, fly.

One of the assignments carried me to a part of British Columbia edging the Yukon, and over some of the wildest mountain ranges in the world. My superb pilot, who knew all the savage wind streams, flew me just above the icy crusts of glaciers, many of them unmapped and unnamed, which were wrinkled like the skin of an old elephant, and gray with the clots of boulders they carried. My bedroll, and a plywood door which served as a bed, traveled with me in the back of the plane. Before nightfall we could always find a lake with fish in it to land on, and if we were lucky, we would spot some tiny encampment of prospectors searching for uranium, surveying in the modern way with helicopters. There I could have a tent to sleep in if I wanted it, but sleeping outside under the silhouettes of perfectly symmetrical firs pointing to the stars was fine indeed.

It thrilled me that I could still accommodate myself so readily to sleeping on the ground, and I found it reassuring that I could

also work easily in the air, swinging my heavy but beloved airplane cameras that seemed so much a part of me. Each step on earth was becoming very labored now, and I could not hide from myself the certain knowledge that each year left me a little bit worse than it found me.

Not knowing the name of my ailment, I dramatized it, told myself I had something very rare. My doctors need not have been so cautious about naming it. When I did learn that I had Parkinson's disease, the name could not frighten me because I did not know what in the world it was. Then, slowly, an old memory came back: of a dinner meeting of photographers perhaps eight or ten years earlier. Captain Steichen spoke with tears on his cheeks of the illness of the "dean of photographers," the great Edward Weston, who had Parkinson's disease. I can still hear the break in Steichen's voice. "A terrible disease . . . you can't work because you can't hold things . . . you grow stiffer and stiffer each year until you are a walking prison . . . no known cure. . . ."

Was this a photographer's occupational disease? Then I learned that Eugene O'Neill had it. So, it was an author's malady! Soon I was to discover there were many illustrious members of the club in many fields: Justice Burton, who had to resign from the Supreme Court because of the progression of his case; Alexander Ruthven, retired president of the University of Michigan. Sister Kenny was a severe sufferer, and I think it highly likely that her experience with her own illness, and the benefits physical therapy had brought her, had a lot to do with her approach to polio. The thing that interested me most was not the fame and eminence of some Parkinsonians, but that they are "struck down," in many cases, when they are at a peak in their productive life—people who are creative and active, people who do not baby themselves, the never-had-a-sick-day-in-my-life type.

But the discovery that astonished me most was to learn that, far from being a rare malady, it could hardly be less exclusive. We don't know how many people have it, but they are in the hundreds of thousands. Its existence has been known for more than four thousand years (Parkinsonism is the shaking palsy of the Bible), and it has been named and documented for more than a century.

The disease's odd name comes from Dr. James Parkinson, a paleontologist as well as a practicing physician. In 1817, he published his observations of six victims of the disease, noting each weird and ugly symptom. This chronicle has become a medical classic, and yet in the 128 years from Dr. Parkinson's death to the onset of my own siege, little more had been learned.

Parkinsonism does not affect the thinking part of the brain but the brain's motor centers which coordinate voluntary movements. It is Hydra-headed. Push it down in one spot and it rears up in another. It is easy to list its two main symptoms: rigidity and tremor. But to know what Parkinsonism is you must know the surprise of finding yourself standing in a sloping position as though you were trying to impersonate the leaning tower of Pisa. You must know the bewilderment of finding yourself prisoner in your own clothes closet, unable to back out of it. You must experience the awkwardness of trying to turn around in your own kitchen—eleven cautious little steps when one swift pivot used to do the job. You must live with the near panic which you face when you have to walk into a roomful of people, and the uneasiness of the questions you ask yourself: Do I just imagine that I can't seem to turn over in bed any more? How will I get my feet moving when they want to stay glued to the floor? How will I disengage myself from a group of people and step away if they're all around me? How will I keep from knocking them down? What can I do with my hands when I'm only standing still? How will I get my meat cut up? What a waste of good steak! You feel so clumsy if you cut it yourself and so conspicuous if you have someone do it for you. How did I look this time? Did I get through it all right? Did people notice anything wrong?

Did people notice anything wrong? Of course they did. I don't know why with Parkinsonism there is this overwhelming compulsion toward secrecy. A wise woman doctor who had known me for many years said to me, "Your friends won't stop loving you if they learn you are ill. Perhaps it will have the opposite effect and they will understand and love you more. I think you are adding greatly to your difficulties in your efforts for concealment."

I knew this was good advice, and I wish I had been able to

take it. But that was for others. I was the exception. Nobody must know I was anything but a paragon of health.

If I could give only one message after sifting down this experience, it would be to urge others to banish the secrecy. I see now how futile are the obsessive efforts to keep the illness hidden. In most cases it isn't secret anyway, and it is the most harmful possible course to follow, because it robs you of the release of talking it over. I found that many of my friends knew all about it—in some cases they knew more than I. They were distressed most by not knowing how to help me. I was surrounded by a wall of loving silence which no one dared to break through.

Parkinsonism is a strange malady. It works its way into all paths of life, into all that is graceful and human and outgiving in our lives, and poisons it all.

I often thought with thankfulness that if I had to be saddled with some kind of ailment, I was fortunate that it was something where my own efforts could help. I was amazed to see what the human body will do for you if you insist. Having to plug away at some exercise and finding I could make small advances gave me the feeling I was still captain of my ship—an attitude which is very important to me.

I remember vividly the pursuit of my left pocket. I had made the melancholy discovery that I could not put my left hand in the pocket and place or retrieve an object there. The attempt to carry through this minor action, which most people do without thinking, brought about such rigidity that getting into that pocket was totally beyond me. So I began studying my right hand, the well hand. I had never realized what a complex series of movements are required to put a hand in a pocket. I plotted out the little sequence the right hand made and tried to teach it to the left. Then this project got lost in the larger campaign to get the arm swinging. Some time later, to my delighted surprise, I found that without thinking I had simply put my left hand in my pocket and pulled something out. This was an achievement I wore like an invisible jewel.

I never would have believed there could be such towering difficulties in relearning to walk—something we have all done so easily from childhood. I had not realized that I was trying to

compress into a few years something it took the human race millions of years to learn.

"Why is it so difficult?" I asked the doctor.

He gave me an interesting answer. "It is the newest skill along with speech that man acquired in the evolutionary process. It is also one of the most complex."

To keep your balance, your arms must swing. Mine had grown so rigid they refused to do so naturally. I had to *learn* to pick up my feet instead of shuffling along like an ill-shod ice skater, as Parkinson victims tend to do. I had to try to keep a straight back. Otherwise that chest, which seemed to be permanently bound in bands of steel, would contract even more and make me grotesquely round-shouldered, further destroying my precarious balance. I had to learn to toe out and step with my feet somewhat apart. This Mr. Hofkosh insisted on above everything else.

"You will need that broad base for balance; otherwise you will stumble and fall."

Mr. Hofkosh said, "Walk four miles every day. Walk *at least* four. Walk all day if you can. And remember all these things, and follow an imaginary line down the road, making sure you are putting your feet on opposite sides of it."

And so I walked. Every day, in snow or rain or sun, I walked and walked, and point by point I tried to embed all the separate items deep in my mind. I said to myself, see that little bush ahead? I am going to swing my left arm until we reach it. I am going to think only about straightening my back until we come to the first mailbox. I am going to concentrate on heel-toe, heel-toe till we get around the next bend in the road. I am going to step wide over that imaginary line and acquire the Hofkoshian pace.

Only intellectually could I recall that walking can be a pleasure. In the all-absorbing effort of trying to perform these interlacing movements, all rhythm and joy of motion were blotted out. But very occasionally at the end of one well-walked mile, and at a certain spot on a gently sloping wooded road, where there were lichen-covered rocks, cool ferns and the strong base of a tall tree, the awkwardness faded away and I seemed to glide into that interlocking mesh in which most people walk naturally, and for a short time—as though it had been out on loan—the

consciousness of joy in movement was restored to me. During this brief respite walking again became a happy thing.

Strangely, as I look back, this was not an unhappy period. The discovery that I could do so much by my own will and concentration was part of a deepened awareness that was making its own new pattern, and the fact that I could continue to work on my book was a great reassurance to me and helped give me a sense of purpose in my life.

I managed to avoid the great crashing falls which are the curse of most Parkinsonians (although I had some close calls), and I am sure that the steadiness I acquired in all my walking is responsible. The terrifying falls come about when a Parkinsonian, unbalanced as he is and unable to walk with control, finds himself running forward, taking shorter and shorter steps, caught in an acceleration pattern which he cannot escape. He is thrown helplessly forward, and often the unhappy sufferer completely lacks the muscle control to pick himself up again. He may lie where he has fallen until someone finds him.

Nor was I afflicted with the terrible tremor which plagues so many, and I believe my determination not to have it helped me fend it off. I was resolved not to let even the feeling of it get into my mind, and when I noticed even the slightest trembling, I stopped whatever I was doing and took exercises immediately to loosen the fingers and the shoulders. I knew I could not banish it forever, because I realized only too well I was on an escalator which was moving down while I was trying to run up.

Balance is a mysterious and highly personal thing. If my cat unexpectedly brushed the back of my legs with his feathery tail, it was enough to send me soaring off to the left side or to the right, whichever way my internal Tower of Pisa was leaning that day. Due to the benefits of the therapy, I could usually recover my balance. Even in an emergency, such as tripping badly, where I had to save myself quickly, I found if I could just raise one arm—throw it over my head as casually as though calling "Hi" to a passerby—I could stop that particular fall. Immediately I would turn my attention to a few balancing exercises to reinforce myself against the next threat of falling. As I walked into a room, I surveyed it much as a pilot in a single-engine plane surveys the ground beneath to spot a little landing strip just in

case of emergency. I picked something that would break my fall, in case I did fall.

Through all this I was writing on water, and well I knew it. I could not shout down the fact that Parkinsonism is a progressive disease. In spite of everything Mr. Hofkosh taught me, and everything I tried to do for myself, time moved on and Parkinsonism took its toll. When the relentless, unearthly pull which erases all control of balance—"forward compulsion"—started in earnest, this was something that could not be dismissed by a wave of the hand. This was the face of the enemy.

In the early spring of 1958 I went South to give a lecture in Asheville, North Carolina, and decided to go to the nearby beautiful Pisgah National Forest to write and walk. I had expected to find the whole mountaintop riotous with rhododendrons, but I was too early for this. The charming inn was lost in the rain clouds and I was the only guest. Everybody else knew better than to come at this time of the year. The weather never changed. It was uniformly drizzly, soggy, damp and dark. One thing kept me there.

There was a road winding its tortuous way through the mountain peaks. Down the middle of that road ran a white line stretching from me to infinity. The empty road was an elongated, fogbound gymnasium in which to practice the Hofkosh pace. Every day I did my four miles or more, straddling that white line. It was hard to believe there were great precipices plunging downward just beyond the shoulders of the road, or that one of America's proudest views, a sweeping panorama of the Great Smokies, lay beyond, blotted from sight by the impenetrable mist. At any time I wished, I could stop to bend over to touch my toes or do deep knee bends, in total privacy. At the end of my morning stint a great fire would be blazing away in my cosy room at the inn. After lunch I would add a few pages to my book and go outside again to follow the white line.

"Keep your knees up," I could all but hear Mr. Hofkosh saying. This was so arduous that to keep myself at it, I chanted a syllable at a time: Hof-kosh, Hof-kosh, with each rising knee.

If anyone had asked me, and frequently I asked myself, why I did all this, I would have been hard put to find an answer. I suppose in part it was a carry-over from my professional work,

where the highest praise my editors could give me was "Maggie won't take no for an answer."

Well-meaning people frequently advise that you must learn to accept your illness. My conviction was just the opposite. Try to take a realistic approach, yes. But accept an illness, never. Laying down my weapons in the middle of the fight was unthinkable. And there was, too, another reason, which went much deeper. Somehow I had the unshakable faith that if I could just manage to hang on and keep myself in good shape, somewhere a door would open.

And that door did indeed open.

CHAPTER XXXI

GIFT
OF SCIENCE

THE DOOR was opened by a very young and very gifted surgeon who quite by chance discovered the key to a cure for Parkinsonism. Dr. Irving S. Cooper was performing a brain operation on a patient who had Parkinsonism. He accidentally tore a small artery which nourished the rebellious nerves whose malfunctioning controlled Parkinsonism. After the operation, to his astonishment, the patient's terrible tremor and rigidity had dramatically ceased. He had an important clue, and fortunately he had the imagination to build on what he had found and the skill and inventiveness to use it.

That he looked a little like a Greek god, with the evenly sculptured waves in his blond hair and his impressive height, made him no less of a surgeon. He was still under thirty in 1952 when he began experimenting with a radically, magically new operating procedure. Like all great things, his procedure was simple. He drilled a hole in the skull the size of a dime. Checking everything on X-rays as he worked, he probed for precisely that spot which was responsible for the patient's difficulties. The more conservative members of the medical world were skeptical. Gaining recognition was an uphill road for him.

Getting to him was an uphill climb, also, for many of his patients, as I discovered when I tried to get some precise information about him and about the operation. I found it difficult to get a dispassionate or objective answer. Also, I was bucking the old school of thought about Parkinson's: you might as well wait for

surgery until you are old, because then the disease will be so advanced anything will be an improvement. That, to me, was almost immoral. My idea was just the opposite. Don't wait passively on the sidelines for a shambling old age. Go into it as young as possible. Bring all the assets you have, and play to win!

When I received my prized appointment for the operation, I discovered there was an eight-weeks waiting list, with some candidates coming from The Netherlands and other parts of Europe, but I did not mind the wait. I went right back to my exercises and redoubled my efforts. I was determined to bring to the operation the strongest body I could make.

This was the first operation of my life. That is, the first in which I was the patient. Of course, I had photographed operations during the war, but being the patient is quite different from being the photographer.

It had never occurred to me that I would not go to my own operation under my own steam, and I was rather startled on that great morning to find I was flat on my back, flat on something with wheels, and could see only the ceiling which was rushing over me, or so it seemed, at breakneck speed. Here, as the long, narrow, cream-colored corridor ceiling swept on relentlessly, I had a childish urge to stretch out my arms and catch something that would slow me down so I could have a minute to breathe and think. And then I said to myself, There is nothing more to think about. I've thought it through and made the decision. This is the most important step toward my goal. I'm in it now. This is it.

The ceilings had stopped in their race. As I lay there quietly waiting, the X-ray technician came and stood at my side. He was interested in my travels and asked, as so many people do, "To what distant part of the globe are you going next?"

I was thinking of another "globe," much smaller, and of the very personal and remarkable journey that was about to be conducted inside it. This would be the shortest journey of my life—it could be measured in inches; its importance was without measure. I realized this was an assignment, the greatest in my life, and to accomplish it sucessfully I must be willing to travel anywhere and must try to learn everything. As long as I thought of it in the context of my work, it held no fears for me.

There would be no pain; only an occasional feeling of pressure. I was very glad that as part of the technique I would be kept conscious during the operation. This was to help the doctors find the precise trouble spot. The doctors kept questioning me and asked me repeatedly to do special things.

"Maggie, raise your arm. Clench your fist. Stretch out your fingers."

Another doctor said, "Peggy, squeeze my hand as hard as you can. Squeeze my hand *tight*."

I never dreamed so much hand holding could go on during an operation.

It was reassuring that the doctors had learned my various nicknames and a comfort as the operation progressed to hear them speaking to me. At one point, Dr. Cooper said, "Maggie, can you hear me?" When I said yes, he said, "We'll be right here, but we're taking a few minutes out to take pictures." And I thought, *take pictures!* What am I doing in here? I should be out there helping them!

I do not know what phase the operation had reached when I was conscious of a remarkable feeling. I *knew* the doctors were doing precisely the right thing. I could tell by the kind of inner harmony and almost ecstasy I felt. In my mind I was saying, "Keep at it; keep at it. Go right at it. Keep on digging. Get out all the Parkinsonism. Get it all out!"

My instinct must have been right, because within a very short time Dr. Cooper was saying, "Maggie, everything is fine. It turned out beautifully."

It was about this time that I wanted terribly to take a deep breath. I remember no point in my life when I had felt the need for such a deep breath and felt it so positively. I was floating in a kind of half dreamworld. I was so lightly suspended there, I hesitated to move in the tiniest degree, and in the meantime the breath seemed to hover close like a wind-filled sail, like a bird's wing. Now I knew it was meant for me. I accepted the gift of breath and inhaled deeply, much, I suppose, as a baby does who needs just such a breath to be launched into the outside world.

The next few weeks were a continuous Christmas. Every second or third day brought its own magic gift. First came that long-awaited arm swing. My left arm swung and swung and

Dr. Irving S. Cooper, brilliant brain surgeon who developed a new method for treating Parkinsonism.

swung from the socket as though it was about to take off on its own, like an animated baseball bat. I would have found its new independence alarming had I not been sure I could teach it that it belonged to me. Next my back began to straighten up bit by bit as the chest began to free itself from the iron-stiff muscle bands that had been forcing me to stoop for so long. Then came a morning when I was given, as usual, a fresh hospital gown to put on, and I discovered that without even thinking I had tied the little laces at the back of my neck. A friend came to pick me up at the hospital and parked her station wagon near the entrance. Before I realized what I was doing, I found myself sitting in the front seat, surrounded by the glass and metal of the car. I had jumped in myself. In the old days it used to take a couple of strong-armed friends, no doubt wishing fervently for a derrick.

The most blessed gift of all was a modest inconspicuous one which arrived just two days after the operation. I was talking with someone and my hands were under a light blanket in my lap. The left hand began thrashing about as though it were trying to scrabble upward to the light. "What on earth is going on here?" I thought. I threw off the blanket and realized I was making a gesture as I talked, *with my left hand!* A gesture! A gesture is not something you will yourself to make. It comes from the heart. To me, it was a bridge from myself to that warm living world I had wanted so deeply to reenter. Now the way was open.

Not all the gifts were pleasant ones. Some were unwanted, puzzling, and had to be disciplined away. First there was the invisible magnet which seemed to be dragging my hands and wrists down to earth. My foot had somehow picked up the iron lid of a manhole which could not be shaken loose. A floating chunk of fog the size of a small suitcase seemed to be blocking my arms in any movement I wanted to make. My hands were out of focus somehow, so that if I reached for the bed rail, I missed and fell back in bed, and I could feel my fingers getting sucked into the field of the invisible magnet with its powerful downward pull. I remember lying there in my criblike hospital bed, trying to fight off my grief and fright.

My long training in physical therapy saved me from giving in to despair and helped me to approach the problem. I tried to analyze the errors. I was undershooting the mark by two inches.

I practiced raising my aim—trying to reach the bed rail, a towel rack, any handy target—making allowance for that out-of-focus two inches, and each time I succeeded, I tried to get the feeling of the reach into my memory. As always, the accomplishment of something on your own is a source of confidence and strength. And so it was now, when correcting the faulty arm reach.

In the meantime, the slab of fog had built itself into a real roadblock. Hoping to be able to use my typewriter during recuperation, I had brought it to the hospital. Now the fog was barricading my fingers, and it was physically impossible to reach the keyboard. I tried and tried. This was a stunning disappointment. I never dreamed anything could happen to upset my relationship with my typewriter, especially since I had already fought through the long siege of retraining the fingers once before, early in my illness.

Worst of all, I couldn't understand what was happening. When I found I simply couldn't pierce my way through the invisible but nonetheless real blockade, I tried to coax my arms to leap over it, making big springing motions, curving up and trying to zoom down on the other side in a desperate attempt to reach the keyboard. All this seemed to hold something deeper than pain—a sort of irritable, ragged-nerve feeling that defied analysis.

I remembered that during the worst of my illness, when I had had some particularly great difficulty trying to learn to move that rigid left shoulder, or relax that always stubborn wrist, if I kept hammering at it, the next day would bring its reward in increased serenity and the beginning of learning. So I kept banging away, using my whole arm like a ramrod, thrusting down to punch the keys with all my strength. Once on the keyboard, the fingers couldn't seem to stay where they belonged but kept falling off the keys, slipping in between and getting tangled up in any awkward spot. Why was this so extraordinarily difficult? Was it possible that my facility on the typewriter did not cross the great divide with me? Or, even more eerie thought, could I really be trailing the fingers of one hand in the past? Could it be that only one hand had made the successful crossing while the other remained in what I was fast learning to think of as B.C.—Before Cooper?

The next day I was terribly jangled and nervous. A therapist

brought me a typewriter exercise book with the simplest combinations of letters: a-n, a-s, a-t. I made a stab at these and found that things were somewhat easier. And a few days later I woke up feeling especially clear-headed and fine. I placed my electric portable at the foot of my bed and plugged in the wire but left the machine unopened. In the afternoon, I took off the case, inserted a sheet of paper and began to type. It was as though two out-of-focus prints slid into register; the keyboard had meaning once more. A few sentences, and I could tell my fingers remembered old movements, and that was enough for now.

Much later, when the dreamlike state of the operation was dispelled and I was trying to recapture whatever I could of evanescent memories of the operation itself, I realized that they always appeared against the same shadowy background: the edge of a wood with lichen-covered rocks and dark ferns, and the strong base of a tall tree which grew out of an island in the middle of the road. Against this all the images floated. Why, I wondered, did I see everything against this particular background? Then I remembered the little roadside things I had noticed in the weary months of the long walks. And I recalled the reward I sometimes received if I managed to struggle through that first hardest mile with any small semblance of coordination— that fleeting interlude with its soft reminder that walking is not always an obstacle race but can be a bright and light-footed thing. I feel sure it was no accident that during the peak of the operation, when I was being set free, my release came against this background.

After a few weeks of therapy, Dr. Cooper sent me to Dr. Howard Rusk's Rehabilitation Institute, my old training ground, to continue my physical therapy. My return to the Institute was like a welcoming parade up Broadway. As I walked along the corridor, swift and sure, with easy balance, heel-toe, heel-toe, and those arms swinging like a metronome, people began to run after me: the therapists, the doctors, patients who knew me, the elevator boys. They could hardly believe I was the same person. A doctor walking in back of me said, "How does it feel now?"

"Delicious," I said. "As though I had strawberry ice cream on the top of my head, melting and pouring down!"

Outside my window was a field of rubble left after the demo-

lition of a building. That's my kind of terrain, I said to myself. Just the kind of shifting ground a photographer must be able to keep balance on with ease. Then other skills the photographer requires came crowding back into my mind. I began to practice loading cameras and working to improve the small precision movements. Just being able to walk down a corridor wasn't enough.

So next I worked on "ambulation." I practiced running and stopping short, and making quick turns on shouted commands. Then I went outside with a therapist and walked through crowds in the street to be sure my new-gained balance was firm enough to stand up against the jostling of other people. It was. Then I ran up the rubble pile in a strong wind.

This had been a long road from the place where I lost my balance from the touch of my cat's tail. I had learned to walk again; I had learned to run again. What was going on inside me during the recuperation was more than a healing. It is hard to describe. It was a kind of drawing together of loose strands in my own life, and feeling closer to the lives of others, probing perhaps a little deeper than before, noticing more, caring more.

Dear "Eisie" came to see me at the Institute—Alfred Eisenstaedt, gentle and gifted photographer and my close colleague since the very first days of *Life* magazine. Finding me so happy and active with my new muscle-building program, Eisie put on that cloak of invisibility he wears when scouting out pictures and followed me through daily "classes," taking beautiful pictures of my rehabilitation activities. This sprang out of Eisie's generosity in wanting to give me a personal record of these days of my life.

The idea grew, and the collaboration became a *Life* assignment, with us two photographers working as a photographer-writer team. Eisie, having known me so well over a period of so many years, was quick to sense how deep this experience had gone with me, and how interested I had become in trying to learn and understand the human side of it all. He encouraged me very much in this. With so many people facing the same battle I had fought, Eisie was convinced my story could help others.

The days of concealment were over. If I had learned anything

PHOTOGRAPHS BY AL-
FRED EISENSTAEDT, *Life*

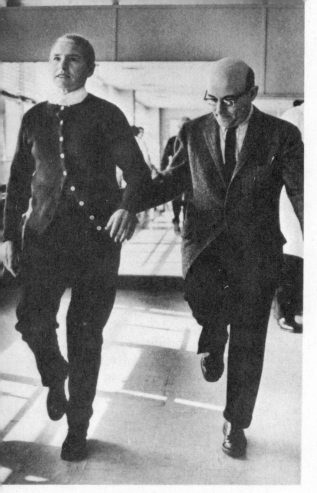

Learning to skip again.

*Exercising with physical therapist
Jack Hofkosh to develop balance.*

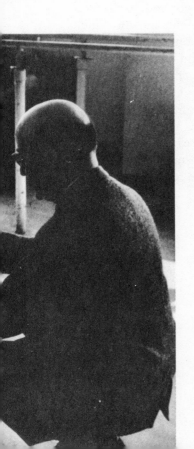

Starting off on the daily walk with my cat Sita.

from my experience that would help others, I was eager to share the knowledge I had gained.

When Dr. Cooper invited me to watch an operation like the one performed on me, I accepted eagerly. I had become so deeply interested in all this that I was eager to learn as much as I could absorb. Eisie went with me to see and photograph Dr. Cooper's operation. On the way, we talked about it.

"It isn't at all the way some people imagine an operation," I told him. "This is something quite different. It's the keystone of the whole treatment and is a dramatic and beautiful thing." I knew that Eisie, with his warm sensitivity, would be deeply stirred by the beautiful hands—Dr. Cooper's knowing hands at work, and the hand of the patient.

To be present during the operation was breathtaking both for Eisie and for me. For me, it closed the circle of the experience. As we left the operating room, I took one last backward glance. In this small room, the future years of my life were handed back to me. Now the world outside was beating at my windows: a thousand things to take pictures of, write about, learn about.

In this experience of mine, there was one continuing marvel: the precision timing running through it all. The ailment which was draining all the good out of my life is one of the world's oldest diseases. Against the somber background of this venerable malady, with its span of four millenniums or more, by great good fortune, I am born in the right century, in the right decade, and even in the right group of months to profit from the swift-running advance of modern medical science. My greatest need comes at that pinpoint in time when I can reap the benefits of science and be made whole. By some special graciousness of fate I am deposited—as all good photographers like to be—in the right place at the right time.

With my dear friend and talented colleague, Alfred Eisenstaedt.

POSTSCRIPT

THIS BOOK has been my constant companion for the last ten years through sickness, surgery and health. I did not go so far as to carry it to the operating table, but it was a comfort to have it under the same roof. It gave me a sense of continuity in my life to know the manuscript was there in its unfinished roughness, and as soon as I was able, I would be back to it—adding a few words a day, a few sentences a week, more as I grew stronger. And now, I cannot put away my typewriter without mentioning my deep happiness and continued surprise that an experience which I thought fit only for the wastebasket could be plucked out and used constructively.

"What happens next?" is a natural question. A Parkinsonian would add another: "Did you go back for a second operation?" The answer is yes. The first operation treated only my left side. Two years later, I went back to have the untreated side taken care of. The second operation was a triumph of surgery. It did all the right things, and it has held well.

Keeping up my daily exercises faithfully has helped greatly. The neighborhood children have also helped greatly by teaching me games—everything from jacks to badminton. Learning a game mastered so easily in childhood was for me the very symbol of returning health.

Vacationtime I spend at Martha's Vineyard at a lovely summer school in a pine grove on a bluff overlooking the Sound. The

School of Creative Arts was organized by a dancer, Kathleen Hinni, who has great gifts for inspiring creativity in children. One of the arts is dance, and its special value for me is that the basic exercises for body control in dancing are similar to those of physical therapy—and much more fun. And when I find myself charging down the studio with several dozen small girls, I have to coordinate and balance—or else!

A few months after the second operation, I went back to the hospital for a checkup. In the midst of the routine tests for co-ordination, I applied a test of my own that was not entirely routine. I whipped my jumping rope out of my handbag and gave a little demonstration. Through the sphere of the moving rope, I could hear the surprised exclamations of my delighted doctors. This gave me special pleasure, as there was a time, not so far back, when mastery of a jumping rope seemed more impossible of attainment than a trip to the moon.

Not long ago, I did have moon plans. When the possibilities of space travel were more problematic than today, I asked for and received the *Life* assignment to the moon, as soon as we could get transportation. My dearest hope was that the science of space travel would advance enough in our lifetimes to enable me to carry out the assignment. Perhaps knowing how to skip rope does not qualify me for the moon, but short of that . . . at the present gallop of science . . . who knows?